TINA MODOTTI

In 1913 Tina Modotti left her native Italy for San Francisco, becoming a star of the local Italian theatre before marrying the romantic poet-painter Roubaix de l'Abrie Richey. By 1920, she had embarked on a Hollywood film career and immersed herself in bohemian Los Angeles, beginning an intense relationship with the respected American photographer, Edward Weston.

On a trip to Mexico in 1922 to bury her husband, she met the Mexican muralists and became enthralled with the burgeoning cultural renaissance there. Increasingly dissatisfied with the film world, she persuaded Weston to teach her photography and move with her to Mexico. Her Mexico City homes became renowned gathering places for artists, writers and radicals, where Diego Rivera courted Frida Kahlo and Latin American exiles plotted revolution.

Turning her camera to record Mexico in its most vibrant years, her photographs achieve a striking synthesis of artistic form and social content. Her contact with Mexico's muralists, including a brief affair with Rivera, led to her involvement in radical politics. In 1929, she was framed for the murder of her Cuban lover, gunned down at her side on a Mexico City street. A scapegoat of government repression, she was publicly slandered in a sensational trial before being acquitted.

Expelled from Mexico in 1930, she went to Berlin and then to the Soviet Union, where she abandoned photography for a political activism that brought her into contact with Sergei Eisenstein, Alexandra Kollontai, La Pasionaria, Ernest Hemingway and Robert Capa. She carried out dangerous Comintern missions in fascist Europe, became an *apparatchik* in the early years of Stalinism, and played a key role in the Spanish Civil War. Returning to Mexico incognito in 1939, she died three years later, a lonely – and controversial – death.

For Mike

MARGARET HOOKS is an Irish writer and journalist living in Mexico City, where she is a collector and specialist in Mexican photography. She has written extensively on Mexico and Central America and is the author of *Guatemalan Women Speak*.

Margaret Hooks

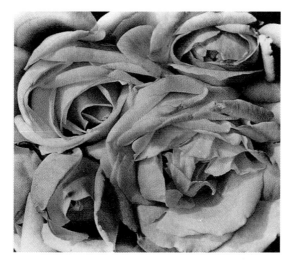

TINA
MODOTTI

Photographer
and
Revolutionary

An imprint of HarperCollinsPublishers

Pandora
An Imprint of HarperCollins*Publishers*
77– 85 Fulham Palace Road,
Hammersmith, London W6 8JB

1160 Battery Street
San Francisco, California 94111 – 1213

Published by Pandora 1993
Paperback edition 1995

1 3 5 7 9 8 6 4 2

A catalogue record for this book
is available from the British Library

ISBN 0 04 440925 7

Printed in Great Britain by
Scotprint Limited, Musselburgh, Edinburgh

CONTENTS

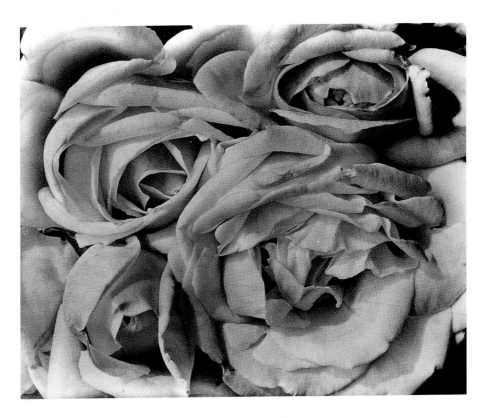

Roses, 1925 [TM]

PREFACE

An American art historian once disparagingly posed the question, 'Would we be interested in Tina Modotti today if we didn't have those pictures of her by Edward Weston?' While the question itself is revealing, the answer is, 'Most definitely, yes.' The sale through Sotheby's in April 1991 of an original print of Tina Modotti's 1925 photograph *Roses* for 165,000 US dollars – setting a record at the time for a photograph sold at auction – and the consistently high prices paid for her photographs place her work in the same commercial league as that of Man Ray, Imogen Cunningham and Weston himself. More importantly, the recent commercial success of Tina Modotti's photography mirrors a growing recognition of the artistic value and historical importance of her work.

Discounting a hiatus of several decades following her death in 1942, interest in Modotti's photography has steadily increased, as is reflected in the numerous exhibitions of her work in Britain, Mexico, the United States, Italy, Germany and France, as well as the ever more frequent writings and symposiums on her art and life. A pioneer among the relatively few women photographers of the 1920s, and despite having produced only about 400 images in all, Tina Modotti has had a significant influence upon generations of Mexican photographers, beginning with Manuel Alvarez Bravo and continuing through to the present day in the work of Graciela Iturbide.

Having learned the art of photography initially under Weston's tutelage, Modotti became an outstanding photographer in her own right, with her own clientele, her own methodology and certainly her own vision. In the space of a few years she achieved a standard of work it has taken lesser artists a lifetime to reach. Nevertheless, there has been a predominant tendency to view Tina Modotti through the filter of Edward Weston's camera and writings. Much of what has been written about Modotti until now has failed to remove her from Weston's imposing shadow. That another imposing companion, Vittorio Vidali, the 'Comandante Carlos' of Spanish Civil War renown, was inspired to project a 'portrait' of the later years of her life, rewriting his own history in the process, further illustrates the

fact that much of what is 'known' about Tina Modotti has been created by others.

Indeed, a large body of myth and misconception, rumour, innuendo and simply erroneous information has invaded the literature on Tina Modotti. The perpetuating of the simplistic tale of immigrant girl, turned Hollywood starlet, photographer and *femme fatale* has served to obscure the life of this remarkable woman. My aim has been to try to demythologize Modotti *the legend*, extricate her from the shadows of her lovers and locate the woman and the artist at the centre of her own history.

The flesh and blood Tina Modotti was a kaleidoscope of contradictions: she could be gentle and caring, laughing and joking with friends; a brooding melancholic and searching soul; a disciplined, single-minded and at times self-serving individual; an extraordinarily sensitive and creative artist; and a frighteningly efficient bureaucrat.

From an early age she was exposed to the vanguard ideas and attitudes of her era and opted to live her life on the crest of the changes these inspired. In her emotional relationships, her sexuality and career decisions, she made difficult choices which flaunted tradition – sexual independence over marriage, political commitment in place of personal security, revolution rather than art. An artist by temperament, Tina agonized over the conflict she experienced between life and art, between the purity of inspired creation and the demands of a world fraught with social injustice.

To comprehend what motivated Tina we must not only become acquainted with her complex personality through her work, her correspondence and the memories of those who knew her, but also become familiar with the times in which she lived. These include some of the most dramatic events of this century and Tina's participation in them is the story of an extraordinary life lived to the full, with a bold vitality.

Margaret Hooks
Coyoacán, Mexico
December 1992

PART I

1896 – 1923

Tina, Hollywood c. 1919

1

An Untimely Death

It was a typically cold, clear January night in the 'City of the Palaces'. Two figures paused in the doorway of a three-storey grey stone building on Isabel la Católica Street. The lamplight cast a dim yellowish glow on the almost empty, cobbled streets as Mexico City slowly returned to normal following the traditionally lengthy Christmas holiday season.

The young man, tall and well built, wore a brown sweater over his white shirt and red tie, the lapels of his black suit hidden beneath the maroon scarf he had tucked into his bulky grey overcoat to keep out the bitter cold of the dry winter season. He cautiously checked the street as he donned his broad-brimmed hat and adjusted the bulky Communist Party newspaper and small German booklet he carried beneath one arm.

He extended his other arm gently and glanced down at his companion. Nearly a foot shorter than her handsome partner, she was delicately beautiful, with lustrous, dark eyes set in a pale, oval face and long chestnut-coloured hair twisted loosely into a bun at the nape of her neck. She wore no hat, but had pulled around her ears the collar of the heavy coat that covered her usual simple apparel – a dark skirt, a light-coloured sweater and low-heeled black shoes.

As they walked towards their rendezvous, both worried about the turn that events had taken over the last few days. Their mutual friend, the Mexican muralist Diego Rivera, had advised the young man to be particularly careful, not to go out alone at night and to take seriously the warnings of a possible attack on his life.

The year was 1929 and the young man was Julio Antonio Mella, a Cuban law student exiled to Mexico three years earlier by Cuban dictator Gerardo Machado. Although only 25 years old, he was widely recognized as one of Latin America's leading revolutionaries. Seven

years his senior, his companion was both an accomplished artist and a dedicated political activist. They had been lovers for several months, living together in the woman's studio in the Zamora Building, a precariously tilted, multi-storey brick construction, the haunt of bohemian writers, artists and radicals.

Earlier that evening, they had laboured through an important political meeting with other foreign *émigrés* – among them, Italian Communist agent Vittorio Vidali, in Mexico under the pseudonym 'Enea Sormenti', exiled Peruvian left-wing journalist Jacobo Hurwitz and Mella's fellow Cuban, exiled student leader Rogelio Teurbe Tolón. As the meeting ended, Mella had received an ominous telephone call from an acquaintance who wanted to see him right away because he had some important information for him.

The young Cuban had made an appointment for 9 o'clock at La India, a seedy bar just three blocks away. Before leaving, however, he and his partner hurried to the task of drafting an urgent cablegram to Cuba, one which they believed would greatly affect his political future.

At 8.55 p.m., the couple left the building at 89 Isabel la Católica Street and walked north. Crossing Regina Street arm-in-arm, they discussed the imminent meeting with José Magriñat, the exiled son of a Cuban banker, whose dealings with the Havana government and underworld had caused Mella to regard him with some suspicion.

Palatial residences converted into offices and apartments flanked the couple on their left as they approached Mesones Street and saw the familiar burnt-red volcanic *tezontle* stone façade of the Mexican Communist Party headquarters. Passing the bustle of the solid five-storey Hotel Isabel, they turned into Republic of El Salvador Street and caught sight of the warm glow of the lights of the small, squat La India. Since she had never met Magriñat and the cable was very urgent, Mella's companion left him in front of the bar's Bolivar Street entrance and continued on to the telegraph office, where Mella promised to meet up with her shortly. Pausing momentarily as he watched her leave, Julio Antonio pushed his way through La India's swinging, stained-glass saloon doors shaped like the two halves of a champagne glass – obviously some artisan's idea of *haute couture*, since champagne was seldom ordered by the bar's clientele.

Magriñat was straddling a stool at the long polished bar, talking to the bartender. After ordering Mella a drink the pair spent 20 minutes discussing Magriñat's ominous news: that gunmen dispatched by Machado had arrived in Mexico City that morning with orders to assassinate the young revolutionary.

Julio Antonio left the bar hurriedly and walked towards the tele-graph office, passing brightly lit hotels, darkened grocery stores and Chinese cafés. Turning into Independence Street, he caught sight of the elegant Prendes restaurant, where nightly chauffeurs delivered Mexican high society into the hands of the establishment's eager, sub-servient doorman.

At 9.25, Tina was waiting impatiently in the lobby of the telegraph office, having deposited the cable, when Julio Antonio rushed in and relayed the news briefly. The couple decided to take the shortest route home. Walking along Independence Street, parallel to the city's main Alameda Park, they reached the corner of Morelos Avenue, where instead of exposing themselves by waiting for the tram they usually took, they opted to walk the remaining four short blocks home.

The darkened street was virtually deserted as they hurried along arm-in-arm. When they turned into Abraham González Street and walked beneath the glare of the street lamp on the corner, the time was 9.40 p.m. Tina clutched Julio Antonio's left arm tighter as they caught a glimpse of the Zamora Building. A few paces ahead, the Sanitary Bakery at number 22 had closed its doors for the night, but rays of light peeked out from around and beneath the doors.

Just as they were passing the five-foot stone wall that fenced off the vacant lot to their left, a neighbour, Antonio Ojeda, came out of the house at number 24. He noticed the approaching couple out of the corner of his eye. Suddenly, two shots rang out, shattering the stillness of the night. The detonations came from behind and to the left, so close that Tina felt the heat of the flash on her cheek and tasted the gunpowder smoke in her mouth.

Beneath the glare of the street lamp, Ojeda could see the outline of the couple and a second man either alongside or behind them. He jumped back into the doorway for cover as he saw a man run forward a few feet, then grab his stomach and chest, gasping in pain. The woman, in apparent shock, hesitated, then ran after him, reaching him as he first slowed, then dashed towards the Zamora Building.

At number 19, Virginia Vázquez rushed to her first-floor window, opened the heavy wooden shutters and stepped out onto the balcony, only to see Mella collapse in front of the doorway below.

'Everyone, hear this well,' he called out in a broken voice as he crumpled to the pavement. 'The Cuban government ordered my death.'

Ojeda ran to call the Red Cross just as a policeman appeared from around the corner. When he returned, other neighbours had begun

to crowd around the wounded man. Just then, an automobile drove up and stopped, two men got out and one came over to inspect the victim. Heavy set and tallish by Mexican standards, the man was wearing a dark suit and a Texan hat, but no sweater against the cold. Everyone watched as he walked up to Mella, pulled back his sweater and looked at the wounds.

'He's done for,' he called out to the other man, who was waiting by the car. Then both climbed into the vehicle and drove away.

Suddenly recognizing her neighbours, the Campobello sisters, Tina sent them for her friend Frances Toor, editor of *Mexican Folkways* magazine, who also lived and worked in the Zamora Building. 'Paca' came running just as the Red Cross ambulance arrived. While attempting to comfort Tina as Julio Antonio was put into the ambulance, she scribbled a note on the back of an envelope – 'Julio has been shot. Come to the Red Cross hospital' – and gave it to a neighbour to slip under the door of Carleton Beals, their friend and correspondent for *The Nation*, who lived in the same building.

Both of the shots fired at Mella, from a .38 calibre pistol, had hit their mark. One bullet had come from the left, above and behind, entering his left arm and fracturing his elbow. The other wound was deadly serious. This bullet, also fired from behind, had entered Mella's body just below his left shoulder and passed through his ribs, tearing the right lung and severing an artery before passing out through his stomach.

At the hospital, Mella was taken upstairs, placed on a stretcher and wheeled into the operating theatre. When police chief Fernando Rodríguez arrived from the sixth district headquarters, he found him still conscious and complaining about the delay in getting him into surgery. Rodríguez immediately started questioning him, noting down carefully his version of events. He read the statement back to him and Julio Antonio, too exhausted to sign his name, agreed with a nod that it was accurate. On a bench in the corner of the room, his blood-soaked clothes lay in a bundle. On top was the latest edition of *El Machete*, the Mexican Communist Party newspaper. His pockets were penniless.

Rodríguez left the operating theatre and joined his subordinate, Officer Guillermo Palancares, and a distraught Tina in the waiting room. The police chief took out his notebook and began to question her. Asked her name, she replied, 'Rose Smith Saltarini.' Rodríguez paused, then asked her age. Tina said she had been married but was now widowed and was a native of San Francisco, California. She added that she was an English teacher and lived on Lucerna Street,

at number 21. Rodríguez, aware that either Mella or the woman was lying, took Palancares aside and told him to allow her to stay through the operation, but to bring her to police headquarters immediately afterwards.

As the surgery dragged on, word spread of the murder attempt and friends, political activists and fellow Latin American exiles flocked to the hospital. Diego Rivera was one of the first to arrive. Carleton Beals, arriving home late, rushed over as soon as he found Frances Toor's note. An accomplished journalist, he talked his way into the operating theatre and found Mella surrounded by nurses and doctors labouring frantically to save his life.

Meanwhile, Officer Palancares, thinking there was little reason to stay any longer and believing Mella's companion's testimony crucial to the case, ignored Rodríguez's orders – as well as Tina's desperate pleas to be allowed to remain near Mella – and insisted she leave the hospital and accompany him to the police station.

In the operating theatre, Beals witnessed the surgeons' futile attempts to save Mella's life. Powerlessly he watched 'the life ebb from Julio's body, there under the white glare'. Leaving the room, he walked slowly downstairs to the anxious looks of Mella's friends and comrades, among them now Vittorio Vidali and the Mexican Communist Party's general secretary, Rafael Carrillo.

'Mella is dead,' he told them, a numb look on his face. It was 1.40 in the morning of Friday 11 January.

In the van on the way to police headquarters, Tina must have known that nothing in her life would ever be quite the same again. When Palancares asked her why she had given a different name from the one Julio Antonio had told Rodríguez, she knew that her attempt to protect herself from scandal had been farcical. Upon arriving at the police station, she confessed to Rodríguez that she had lied about her identity. She said she was a professional photographer and did not want to harm her reputation or her livelihood by having her name appear in the newspapers. Among her clients were some of the leading members of Mexican high society, who would be scandalized at her name being linked to the assassination of a Communist revolutionary.

Rodríguez proceeded to take a new statement. She now confirmed that her true name was Tina Modotti, her address was Abraham González Street, number 31, where she lived with Julio Antonio Mella, that she was a photographer, a native of Venezia Giulia, Italy.

2

Childhood and Immigration

Assunta Adelaide Luigia Modotti Mondini was born at 11 o'clock in the morning of 17 August 1896 in an upper room of a small house at 113 Via Pracchiuso, a modest street that winds gently uphill from the tree-filled main square of the Friulian town of Udine in the northern Italian province of Venezia Giulia. The third child and second daughter of Assunta Mondini Modotti and Giuseppe Saltarini Modotti, the baby became 'Assuntina' (little Assunta) to distinguish her name from her mother's. This was soon abbreviated to 'Tina', the name she was known by for the rest of her life.

Women ruled in this narrow stuccoed house with the four small wooden-shuttered windows and terra-cotta tiled roof. It was the Mondini family home, and Assunta and Giuseppe were living with Assunta's mother, Adelaide Zuliani Mondini, and her unmarried governess sister, Lucia Mondini. Assunta's father, Giuseppe Mondini, had died some time before. Tina's paternal grandfather, Domenico Saltarini Modotti, had also died before her birth, but her paternal grandmother, Domenica, was very much alive. A somewhat straight-laced matriarch, known to the Modotti children as *la nonna*, she gazes out sternly from a tiny, sepia-toned portrait the family cherished for years.

Giuseppe Saltarini Modotti was born in Udine on 16 April 1863, the fourth of ten children of Domenico Saltarini Modotti and Domenica Bartoni. In December 1887, he left his native Udine for the Mediterranean port of Genoa, an attraction since Marco Polo's time for young Italian men in search of fortune and adventure. Returning to Udine two years later, he resettled in the Pracchiuso neighbourhood, on the curving Via Francesco Tomadini, just around the corner from the Mondini family household. A machinist by trade, with some training in mechanical engineering, Giuseppe

Modotti briefly resided at 30 Via Tomadini, an orphanage, where he may have been employed in one of the workshops. A handsome young man of medium height, with small, piercing eyes and a thick, walrus moustache, he must have met Assunta Mondini shortly after his return to Udine.

Assunta Mondini was just seven months younger than her future husband, born on 25 November 1863, the day of the St Catherine's Day Fair which had been celebrated every year since 1486 on the expansive green at the entrance to the Via Pracchiuso, a site so ancient that a story of the pond which once occupied the site was recounted by Boccaccio in his *Decameron*.

Located where the rolling foothills of the Austrian Alps meet the fertile Italian plain sloping toward Venice and the sea, Udine was home to a proud people, the Friulanos. The city's Venetian *piazza* was one of the most beautiful of the Renaissance period and the lavish interiors of its many churches and palaces were decorated with centuries of frescos and friezes by both Venetian and local Udinese artists.

The Friulanos were both a pensive and an impassioned people, not nearly so Spartan as the Germanic culture which influenced them from the north, nor as tempestuous as their more southerly Italian cousins. Like most other Italian peoples, however, they were clannish and tended towards *campanilismo*, that is, figuratively speaking, they never strayed far from the call of the local *campanili*, or church bells. When marrying, they preferred a partner from their own village or neighbourhood; rarely would they marry someone from elsewhere in Italy, much less a foreigner.

The Modotti–Mondini neighbourhood, with its two and three-storey buildings and shops lining the cobbled streets angling off the Via Pracchiuso, was also known as the 'neighbourhood of love'. The local church was St Valentine's and St Valentine's Day was celebrated with much revelry. It was in this setting that Giuseppe Modotti courted Assunta Mondini, an attractive woman, shorter than her suitor, with long, thick, dark-brown hair combed back behind her ears, displaying a gentle face which in later life reflected a profound serenity. Since she was already in her late twenties and unmarried, Assunta was probably encouraged by her family to hurry the courtship along. It may have lasted somewhat longer than she desired, since within weeks of her marriage to Giuseppe Modotti in October 1892, and just prior to her twenty-ninth birthday, the couple's first daughter, Mercedes Margherita, was born.

Within a year, Assunta Modotti was pregnant again, giving birth in August 1894 to the couple's eldest son, Ernesto. By the time of Tina's

birth, Giuseppe Modotti had turned 33 and had a steadily growing family to support. His aspirations were much greater than his situation in Udine could match. He wanted to have his own workshop, to be a mechanical engineer, and his greatest dream was to be an inventor. His desire to improve both his own situation and the conditions he saw around him led to his involvement with a new group of associates imbued with a desire for change.

On 27 January 1897, some five months after her birth, Tina was christened at the parish church, Santa Maria delle Grazie. One of the witnesses, Demetrio Canal, provides a clue to her father's politics at the time. Canal, the editor of a fledgling socialist newspaper, was one of the leaders of a 'Socialist Circle' organized in Udine in 1897 and soon to be broken up by the police because of its support of a local textile workers' strike. Another leader of the socialist group was Luigi Pignat, a local photographer who made portraits of the Modotti children. His studio on Via Rauscedo was just around the corner from that of Pietro Modotti, the well-known Udinese photographer who was Giuseppe Modotti's brother.

Whether Giuseppe Modotti was a member of Udine's 'Socialist Circle' and ran afoul of the law is not clear, although his daughters later claimed that their father had been a 'socialist' and a staunch supporter of union causes. The fact remains that, either as a political or economic refugee, Giuseppe Modotti looked toward Austria for future employment. It was not a novel choice – at the turn of the century thousands of Italian workers and their families were emigrating to German-speaking Austria in search of work. Sometime between 1897 and 1898, Giuseppe Modotti and his family joined them, travelling north through the high mountain valleys of the Austrian Alps to the town of Klagenfurt. There, in the midst of a bitter alpine winter, the third Modotti daughter, Valentina, later known as Gioconda, was born in January 1899.

By then, Giuseppe Modotti was working as a machinist in a bicycle factory in the small town of Ferlach, just outside Klagenfurt. A company which normally made shotguns, it was having economic problems and had rented one of its buildings to a bicycle manufacturer. A unique feature of the bicycles was their bamboo frame, obviously designed to make cycling in the hilly terrain easier. A family version has it that Giuseppe Modotti invented this bamboo bicycle – a distinct possibility since he later proved to be a skilful inventor. Less credible is the family tale that he was the director of the factory. It would have been very unlikely at the time for a factory to be run by an immigrant and not an Austrian.

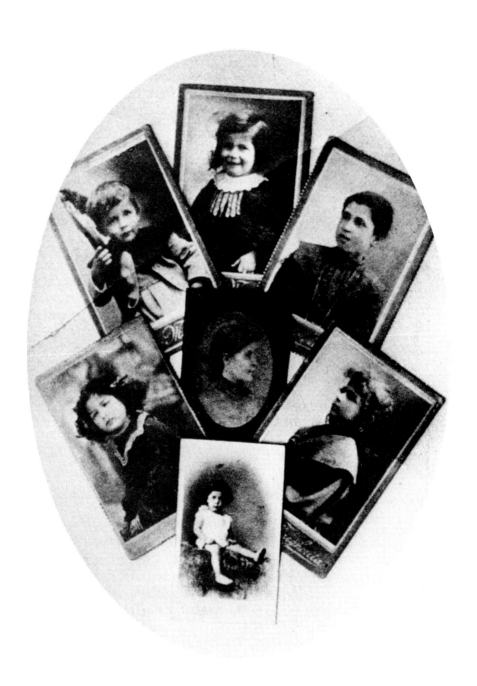

*Tina (top), aged four, with her mother,
brothers and sisters*

At the turn of the century, hard times came to Ferlach, causing Assunta and Giuseppe Modotti and their children to move again. A photograph of Tina taken about this time shows an unruly-looking, chubby, smiling child completely at ease in front of the camera. Before the birth of the Modotti's fourth daughter, Iolanda (Yolanda), in July 1901, the family moved to the village of St Ruprecht, on the outskirts of Klagenfurt, where the couple's second son, Benvenuto, was also born, in May 1903. It was in St Ruprecht that Tina had her first political experience. Years later she recalled how, sitting high on her father's shoulders, she heard the songs and speeches of a May Day rally where Italian and Slavic soap-box orators joined their Austrian counterparts in rousing the crowd.

When the Modotti children started school, German replaced their native Italian outside the home. Tina spoke it fluently, retaining slight traces of a guttural German pronunciation on her 'r' for the rest of her life. Years later, Mercedes Modotti remembered the words to German Christmas carols undoubtedly learned during their child-hood in Austria.

In 1905, prior to the birth of the Modottis' last child called Giuseppe ('Beppo') Pietro, after his father and uncle, Tina was uprooted in the midst of her primary schooling, when the family returned to their native Udine. It appears that for some mysterious reason, the eldest son, Ernesto, stayed behind in St Ruprecht. Local records show that he died there in 1918 at the age of 23. His life and death remain a mystery, the family rarely speaking of him. Years later, Yolanda Modotti would only say that 'he died very young'.

Back in Udine, the family lived on the Via Caiselli, a narrow street in one of the oldest parts of the city. The children had difficulty read-justing to life there, particularly at school. Tina later blamed her limited education on being kept back in school in Udine and being made to repeat her first years of primary education with a group of younger children.

In contrast with certain members of the Modotti clan, like his brother Pietro, who had established a substantial reputation for himself as a local photographer and become prosperous, Giuseppe Modotti's financial circumstances deteriorated sharply when he returned to Italy. He tried to build up his own business as a machinist, but work was sporadic. He must have heard glowing tales of America from his older brother, Francesco, who after an earlier visit returned to New York in 1904. Just before Tina's tenth birthday, in August 1906, Giuseppe decided to leave Italy for America, where, if all went as planned, he hoped to be able to earn enough money to send for

his wife and children.

His departure placed an immediate economic strain on the family, since money from America was initially slow to arrive. *Polenta*, the dish of Italy's poor, became the family staple, often watered down to stretch for several meals, as the family struggled to get by. Yolanda described the hardship of those years:

> ... it was difficult for all the poor people [and] we were poor ... How many nights you spent the night crying [from hunger] if you were a child and then you had to go to school ... when [Tina] was only a young girl, she looked to me, younger as I was, like a little lady, with those big, sad eyes in a hunger-stricken face ...

Yet despite the family's economic difficulties and the children's readjustment problems, these were not entirely unhappy years nor did they lack the usual childhood friendships. Tina

> had as a classmate at school the daughter of one of the richest men around, who [even though he] had a villa nearby, sent his daughter to the same school, and she became very good friends with her. And [Tina] was really embarrassed to invite her to her home, but the little girl would come along very happily and ate the *polenta* as though it were some exquisite dish. And the one who felt timid and embarrassed was [Tina], when the little girl took her to *her* house, because it was a kind of mansion ...

One treat for the Modotti children, it seems, was the visits to their Uncle Pietro's photographic studio, where they all had their portraits done. Pietro Modotti, a pioneer in candlelight photography, was a keen experimenter who had his own laboratory and wrote articles on his findings. Yolanda Modotti indicated her father also spent time at his brother's studio, where he must have learned at least the rudiments of the trade. She fondly remembered the visits to her uncle's studio and the samples of his portraiture hanging around the walls. Tina's first contact with photography and interest in the camera almost certainly stems from these visits.

Advertisement for Pietro Modotti's photographic studio, c.1912

Tina was a boisterous, rebellious child,

unable to remain still for an instant. A regular tomboy, she was always looking for adventures and getting into mischief, but her childish adventures were soon to be curtailed. Within two years of her father's departure, at just 12 years of age, her childhood ended abruptly when she went to work in a nearby silk factory to help support her family. Although so young, to the other children she seemed grown up, someone to be admired. Her childhood friend Giulia Montovani thought her 'so beautiful, so young and vivacious. To the eyes of a young girl like me she seemed to be an idol to model oneself on...'

It was about this time that Tina contracted typhoid fever. She became so ill it was feared she would die and her lovely long dark hair had to be cut short. Giulia looked on with envy as Tina recovered and her close-cropped hair grew thick and wavy:

> I remember her so well with her hair short and all curly after she had typhoid. She used to wear a ribbon around her head. In those times our parents would never even permit us to cut our braids! Imagine how much I envied her!

Tina was 14 when she was separated from Mercedes, her beloved elder sister. By 1911, Giuseppe Modotti had saved enough money to send for Mercedes to join him in America. Her departure left Tina as the only 'adult' wage-earner at home and the family was plunged further into poverty, which made an indelible mark on the young Tina. While her mother's many pregnancies and struggle to cope with her large brood of children made a lasting impression, it was the suffering and hunger of her four younger brothers and sisters that most deeply affected her. Yolanda Modotti remembers

> ... one night in early winter. Our fire and candle had gone out, as would often happen. My mother and I were waiting for Tina, clinging to each other to keep warm. We were sad and upset because there was nothing to eat.

That night when Tina returned home they heard her running up to the door; she usually arrived heavy-footed and exhausted. Opening the door, she cried, 'Guess what I have?' and telling them all to close their eyes, she placed a package on her mother's lap: ' "Bread, cheese and salami! It's enough to last through tomorrow!" My mother asked her, "How did you get this?" ' Stammering, but trying to explain it as something completely ordinary, she said that she had never really liked the blue shawl that had been given her as a gift by Aunt Maria and that, on the other hand, the girls at the factory had admired it so much that she had decided to raffle it off: ' "Now, wasn't that a good idea?" '

When I was older I understood why my mother had started to cry, as Tina, her knees knocking from the cold, insisted that she had not cared for the shawl. At the time … it only seemed strange that she should not have liked the little shawl, since she had shouted with joy when they had given it to her and it was really the only [decent] garment of her scant winter wardrobe. When I began to understand how gallant the little liar had been … I was overcome with a great admiration and respect for her.

It was soon Tina's turn as the next eldest, to join her father, a move that would mean three wage-earners in America and the possibility of bringing the entire family over sooner. The year of greatest Italian immigration to the United States was 1913, when a full three per cent of Italy's 25-million population emigrated. There were emigration offices in all the major Italian towns and in Udine the entrance to the office was plastered with posters offering the tempting possibility of work upon arrival in distant lands.

In late June, a thin and deceptively fragile-looking Tina packed her bags and donned the 'ridiculous' hat she had decorated with artificial flowers and fruit in excited anticipation of her entry into the new world. She was just 16 when she boarded the SS *Moltke*, a steamship sailing from Genoa to New York, with the substantial sum of 100 dollars, double that of most of her fellow passengers. But, given the arduous train journey she was to undertake alone across America's prairies and mountains, the amount was probably warranted.

The trip across the Atlantic lasted exactly two weeks. On 8 July 1913, 'Saltarini-Modotti, Tina', measuring just over five feet, stepped up amid the noise and babble of Ellis Island to confront US immigration officials. She claimed to be a 'student', probably because of the growing animosity from local trade unions toward Italian immigrants. She also claimed to have no 'nearest relative or friend' back in Italy, perhaps to avoid being refused entry and sent back. In reply to the standard questions asked of all immigrants, she declared that not only had she never been in prison, but that she was neither an anarchist nor a polygamist!

Giuseppe Modotti had paid for her ticket through to her final destination – a foreign-sounding Taylor Street, in San Francisco, a city that had become a mecca for Italians. To Tina, the name of the street where she was to live for the next few years must have seemed as strange as the American bread and coffee she sampled on the long train journey across the United States which would reunite her with her father and sister.

3

The Golden Gate

When Tina Modotti stepped off the ferry that carried her from Oakland across the bay to San Francisco, like so many other new arrivals she would have been struck by the beauty of this graceful hillside city with its immense natural harbour. Waiting for her at the North Beach dock were Mercedes and the barely familiar figure of Giuseppe Modotti, whom she had not seen in seven years. One can imagine the thrill of the ride to her new home through the streets of the strange, exotic city, with its ornate and gaily painted wooden houses, a line of pastel-coloured confections along the steep slopes of the city's streets, so different from the centuries-old, dark, stone buildings of Udine. Not everything was unfamiliar, however. Most of the shops and businesses along Columbus Avenue, the main thoroughfare of the city's 'Little Italy', had Italian names and displayed familiar products:

> ... pasta (spaghetti and macaroni in golden cords, yards long), pendant sausages ... solid wheels of cheese ... and straw-covered, round-bottomed *fiaschi* of Tipo Chianti ... an olfactory bonanza of garlic cloves, robust ripening cheeses, spices, dark-roast coffee and fresh-baked bread.

After the poverty and deprivation Tina had experienced in Italy, San Francisco and her new home at 1952 Taylor Street must have seemed like paradise. The two-storey building was located on the north-east slope of Russian Hill, one of the better parts of town, aloof from the more cramped areas of the Italian quarter. The first-floor, two-bedroom flat had an airy, light living-room, with an elegant, filigreed fireplace and a coveted bay window with a tiny glimpse of the sea. The location and the window reflected the definite social move upscale which Giuseppe Modotti had achieved in his seven years in

America. Only the more prosperous Italian immigrants occupied the slopes of Russian Hill and a bay window was 'a local symbol of prosperity and prestige which caught even fleeting sunlight and brightened homes on foggy days'.

But Giuseppe Modotti had endured much hardship when he first arrived in America. As Yolanda Modotti recounted, 'My father had to come to America but unfortunately soon after he arrived there was a strike in his industry that lasted a year and a half ... ' Giuseppe probably first looked for work on the East Coast, where his brother Francesco lived, and where labour turmoil was greatest. The year of his arrival, the United States entered an economic depression and 'thousands of workers in every large city were idle, in poverty and misery'. News must have reached the East Coast Italian community of opportunities in the West. In San Francisco, particularly, the economy was booming as the city was being rebuilt following the devastating earthquake of 1906.

When Giuseppe Modotti arrived in San Francisco, he quickly caught the spirit of enterprise sweeping Little Italy, where financial institutions were encouraging small borrowers to take out loans for home construction and business ventures. It seems that Giuseppe decided to take a chance and form his own business. Although a machinist by trade, he had seen how a photographic studio had provided his brother Pietro and his friend Luigi Pignat with a comfortable living. Adopting the American form of his name, 'Joseph', he appears to have found a partner and opened a photographic studio a few paces from Washington Square, in the heart of the Italian community, and placed an advertisement in *Crocker-Langley's 1908 City Directory*. In large type and bold ink, it read:

MODOTTI JOSEPH & CO.
(J. Modotti and A. Zante)
Artistic photographers and all kinds of view work,
1865 Powell

The location was a few simple upstairs rooms in an area with lots of pedestrian traffic and potential customers. Giuseppe Modotti was probably spurred to take this step by what seemed a golden opportunity. In 1908, the only photographer of any stature in the Italian community, Giovanni Battista 'J.B.' Monaco, decided to make a pilgrimage to his native Switzerland. His departure left a vacuum, which it seems Giuseppe Modotti hoped to fill. But, for some reason, his business venture proved unsuccessful and within a year the Modotti photographic studio had closed.

By the time Tina arrived, her father had long had his own machinist workshop on Montgomery Avenue in Little Italy. His business flourished but he was dissatisfied with just repairing machines, so he also made them. An enthusiastic inventor in the early 1920s, he designed a popular ravioli machine, later advertised and sold throughout the quarter. One day, while searching with friends for a name for the machine, he mentioned it was his youngest daughter's birthday: ' "Well, we are celebrating Yolanda's birthday, how would you like to call it Yolanda?" and everybody said, "Wonderful!" So Yolanda became the name of a type of ravioli!'

The economic boom following San Francisco's earthquake had also provided employment for Mercedes Modotti. She had found work as a seamstress at I. Magnin, a firm advertising itself as 'importers, manufacturers and retailers of ladies', children's and infants' wear'. When Tina arrived, not only did she share a bed with her sister, but Mercedes had also arranged for her to work alongside her in I. Magnin's sewing room. Tina and Mercedes had always been close and shared many of the same interests. They were about the same height and build, but Tina's dramatic beauty overshadowed Mercedes' prettiness.

The work at I. Magnin was tiring and unrewarding. The seamstresses were packed into the production area and worked long hours, but Tina exploited her free time to the full, joining her father, sister and friends on the regular weekend picnics and outings to the surrounding countryside which delighted San Francisco's Italian immigrants. A vibrant part of San Francisco, Little Italy had come into its own by 1913 as more male heads of family became prosperous enough to bring their wives and children to America. Politics was in the air as immigrants brought with them a tradition of union activism. Organizations like the anarcho-syndicalist IWW, better known as the 'wobblies', had a Latin branch right in the centre of the quarter. Culturally, while the theatres had remained silent for the season

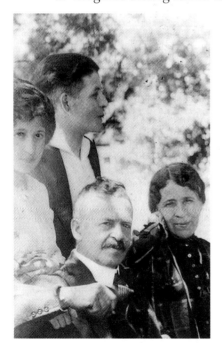

Giuseppe and Assunta Modotti (seated), Yolanda and Beppo Modotti (standing), c.1920

were rumours of an imminent theatre revival.

When the inauguration of the Stockton Tunnel, which linked North Beach to the centre of San Francisco, exposed Little Italy to a whole new world of ideas in 1914, Tina looked to expand her horizons beyond I. Magnin's sewing room. Romantic good looks were then in vogue and Tina had grown into a slim and petite young woman, with a delicate expressive face framed by a mass of dark wavy hair, large dark brown eyes and a full sensual mouth. Her beauty soon attracted the attention of her employers and her aspirations bore fruit when she was hired part-time to model I. Magnin's newest designs. Yolanda Modotti remembered that 'they used to use Tina for modelling the clothes; she had a very nice figure. She did modelling mostly [at I. Magnin] ... and she enjoyed it.'

The year following Tina's arrival may also have marked the beginning of her interest in the theatre. In 1914, hopes for a North Beach theatre renaissance were whetted with the performance of *Madame X* at the downtown Cort Theatre by Mimi Aguglia. When Aguglia's run at the Cort ended in August, she announced that she would take her repertoire to the Washington Square Theatre, only two blocks from Tina's home. Giuseppe Modotti and his daughters were great

*I. Magnin,
San Francisco
c. 1913*

theatre lovers and, like most local Italians, they particularly appreciated opera. While Tina and Mercedes went to performances whenever they could, Giuseppe Modotti collected musical instruments and loved to sing arias at home. A bit of a ham, he would stand on a table and perform for the neighbours. 'Modotti is singing again,' they would say and crowd around to hear.

Giuseppe Modotti also liked to get up on a table and discuss more serious matters, holding forth about unions and workers' rights. When World War I broke out in August 1914, he and his brother Francesco, who had since moved to San Francisco, were firmly opposed to it, reflecting a position adopted by socialists and 'wobblies' alike. Tina later remembered household discussions 'where my father and my uncle – socialists – spoke of what was going on in the United States, where the movement of socialists and trade unionists against the war was strong'.

By September, news of German dirigibles, artillery duels and Italy's coming involvement in the war dominated the headlines of the local Italian newspaper, *L'Italia*, and the Italian community was understandably alarmed. Those who had family members near the battle zones in northern Italy, as did the Modottis, were particularly concerned. But as 1915 approached, it was San Francisco's upcoming Panama–Pacific Exposition which occupied the attention of local newspaper-readers. Timed to coincide with the opening of the Panama Canal, the exposition – which marked a turning-point in

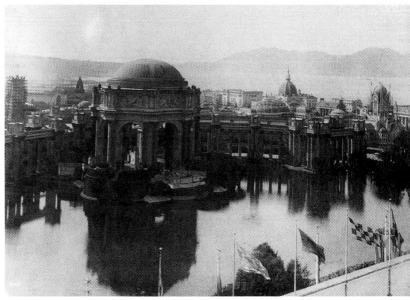

Palace of Fine Arts Panama–Pacific Exposition, San Francisco, 1915

Tina's life – was trumpeted as a tribute to the productivity and creativity of humanity. It was seen by many as the expression of all that was at the vanguard of human progress. Whatever ideals may have been on the minds of organizers, it succeeded in turning the city into a veritable fairground. A popular attraction was *Stella* – 'the nude painting that breathed', whose wonders could be ogled for the reasonable price of ten cents. Predictably, the exhibition also became a hotbed of artistic ferment and progressive ideals. Visitors flocked to the prominent booth decked with the portrait of Susan B. Anthony, the mother of the US women's rights movement. The booth was staffed at all hours by suffragettes, meetings were held frequently and activists invited visitors to sign their petition to give American women equal voting rights. More than 500,000 did.

Of interest to most visitors – among them, the 18-year-old Tina – was the Palace of Fine Arts with its exotic Lagoon. Here an international art exhibition, including modern art and photography, dominated the public's attention. The venue itself was 'unearthly and dreamlike'. Across the Lagoon was the Temple of Sculpture with 'the women on its top weeping over their mysterious coffers … ' The Palace itself was filled with works of art gathered from around the globe. The modern art section included paintings by Edvard Munch and works by the Italian futurists never previously seen in the United States. There was a showing of Pictorial Photography and among the professional exhibitors was 'Edward H. Weston of Tropico, California'. Weston also visited the arts exhibition and 'had his life changed' at the Fair where he was exposed to the modern concepts of symbolism and Expressionism for the first time.

Tina in turn, was exposed to a world never imagined on the streets of Udine. She could begin to envisage the possibility of another life, of breaking out of the mould which restricted Italian immigrant women. The Exhibition of Fine Arts was truly 'more than a gathering together of great paintings and sculptures. It was a school … ' But the 1915 exposition not only affected Tina's life in the abstract, it changed it in a very concrete way. It was at this exhibition that she met the young painter and poet Roubaix de l'Abrie Richey. In the language of the period, 'the two young people met each other unexpectedly in the Palace of Fine Arts and their common ideals and admiration for art was transformed into mutual love … '

Roubaix, whom everybody called 'Robo', was 24 at the time. He was tall, slender and roguishly handsome, with 'fine classic features, a piquant little moustache and large eyes that knew many moods. There was a resilient grace about him that matched [Tina's] own.'

The epitome of the bohemian artist with his capes and canes, he had a clear disregard for convention. Born in the state of Oregon, the son of James and Rose de l'Abrie Richey, with family roots in Louisiana's French creole society, Robo had spent his childhood and early youth in a rural setting with his younger sister, Marionne, as his only play-mate. The family was not religious – indeed, Robo was 31 before he entered a church – but there was a deeply spiritual, almost mystical side to his character, borne out by his constant search for the exotic and beautiful in life and an aversion to the realities of the material world and to his own society. Despite his foreign-sounding name Robo was an American, but one of those Americans seldom at ease in his own country.

Perhaps his longing for the exotic and the beautiful is what attract-ed him to Tina. Surely part of what made him attractive to her was that he belonged to this new world she had glimpsed at the exposition. She was breaking with convention in falling in love with someone out-side the Italian community and her relationship with Robo would lend support to her eventual decision to abandon it.

4

To the Opera!

Bohemia in the 'City by the Bay' had a long and colourful history and echoed with legends surrounding the likes of Mark Twain, Ambrose Bierce and Jack London. Although many of the originals of the famed Bohemian Club had moved on by the outbreak of the First World War, a new crop of artists and writers constantly arrived to take their place. Not only war, but revolution was in the air, both in Mexico and Bolshevik Russia, and it was intellectually *de rigueur* to foresee a bright new international order arising out of the turmoil of the times. Among themselves, the San Francisco bohemian set talked almost endlessly of free love, art for art's sake and the utopian dreams which were their inspiration.

Tina and Robo's circle of friends was immersed in this cultural radicalism. One friend was the sculptor G.B. Portanova, another was his live-in companion, the aspiring painter Stefania Pezza. Drawn to San Francisco by the allure of the 1915 exposition, they had come from Rome to bask in the artistic ambience generated by the fair. Another friend was the colourful and very eccentric Dorothea Childs, whose speakeasy tavern became an illegal watering hole following the onset of Prohibition in 1917, a place where bohemians flaunting social mores mixed with prostitutes, draft evaders (known as 'slackers') and other 'undesirables'. The artists and intellectuals of San Francisco and Oakland had long shown particular admiration for the zest of the city's Italian quarter, frequenting the trattorias of Little Italy where some had rented studios.

Inspired by the return of the Italian theatre to her neighbourhood in 1916, Tina took the logical step from her nascent modelling career to auditioning for parts in amateur productions. Little is known today about the amateur theatre clubs which existed throughout the San Francisco area, but we do know that Tina was 'admired and applauded' for her

roles in their small productions. Motivated by this success, she attempted to move into professional acting. Both she and Mercedes frequented the performances at the Liberty Theatre, only a few minutes' walk from Taylor Street, where the price of admission was a reasonable 25 cents, which even working girls from I. Magnin could afford.

It was not difficult in Little Italy to get a small part in a professional performance. A director could stand on the corner of Columbus Avenue and Stockton Street calling out the name of vacant roles and be swamped with would-be actors. Whether a local talent scout spotted Tina in an amateur production or whether she actually took the plunge at such a street-corner audition, by 1917 she had landed a part with the newly formed light opera company *Citta di Firenze* (City of Florence), under the direction of Alfredo Aratoli.

Tina was a novice among more experienced actors and theatre reviewers were slow to comment on her performances. But in early July, after a run of several months at the Liberty, *L'Italia* published what appears to be Tina's first mention as a professional actress, in a special evening performance of the light comedy *Stenterello ai Bagni di Livorgno* in honour of the director-actor Aratoli himself. The performance was followed by a late-night supper for the company and their friends and admirers at the local Gianduja restaurant and Mercedes Modotti was there to accompany her sister on this important night.

As it was her debut season, Tina was yet to be considered fully a professional, but she soon caught the public's eye and became one of the leading lights of the new company, acquiring 'great popularity in the Italian colony'. Her newfound talent must have been a delight, albeit a slight shock, for her family. Yolanda Modotti recalled that Tina did not have much of a voice, but her singing was adequate and

AL TEATRO LIBERTY

La serata d'onore di Tina Modotti

Signorina Tina Modotti

La Compagnia Comica Città di Firenze, diretta dal'artista Alfredo Aratoli, sta per lasciarci dopo alcuni mesi d'una fortunata stagione al Teatro Liberty. Essa sta ora dando la sua ultima settimana.

Questa sera avremo una serata eccezionale in onore della signorina Tina Modotti, la intelligente e giovane attrice che ha saputo accattivarsi le simpatie generali del pubblico e formarsi uno stuolo di am-

'Evening in honour of Tina Modotti' at San Francisco's Liberty Theatre, 1917

her acting ability, combined with a great stage presence, made her the
toast of Little Italy's theatre-going public within a few short months.

In September, the City of Florence company opened the final week
of its successful season at the Liberty with a special evening perfor-
mance in her honour. *L'Italia* announced the event, leading the article
with a photograph of a smiling Tina, dressed in a Victorian-style long-
sleeved blouse with ruffled cuffs, her chin resting on her folded hands:

> This evening there will be an exceptional performance in honour of
> signorina Tina Modotti, the intelligent young actress who has won the
> approval of the general public and acquired a host of admirers. She will
> perform in the lovely, well-known comedy *Dall'Ombra al Sole* [Out of the
> Shadow, into the Sun], playing the part of Lisetta ...

The performance was a watershed in Tina's transformation from
Italian immigrant seamstress cum model to professional actress. The
next day's review in *L'Italia* described her acting talent as 'unfettered,
self-styled and integral' and her performance in the difficult part of
Lisetta as 'all fire, vivacity and seduction':

> Tina Modotti, the pretty signorina we have so often admired and applaud-
> ed in the small amateur theatres of the city, could not have made her
> debut in the professional field with a comedy more suited to her mix of
> sentimental vocals and emotion, causing her to be appreciated for her
> innate artistic sensitivity, which will someday bring her the glory of a bril-
> liant and enviable career.
>
> The years will pass, and the times will change, but the performance of
> yesterday evening will always leave in her all of that freshness of a soul in
> love with her art ...

The performance ended to an infinite number of encores and Tina
was swamped with bouquets of flowers and gifts, among them a mag-
nificent toilette set from the Aratoli company and a pair of diamond
earrings, a gift from her acting mentor, Oreste Seragnoli.

No sooner had Tina finished her first successful season on the local
stage than news arrived from Italy of major military defeats and mas-
sive evacuations of civilians. *L'Italia* ran daily front-page articles on the
war, pumping up the Italian community's patriotism and providing
eager readers with news of what was happening to friends and relatives
back home. In December, Tina received a letter from her 14-year-old
brother Benvenuto, telling her that the Modotti family had also been
evacuated. She was so concerned that she immediately took the letter
to *L'Italia* to have it published, so that others from the same region
would know what was going on:

The first letters have begun to arrive in San Francisco from the Friulian refugees who have relatives here. One of these is precisely the signorina Tina Modotti ... One of [her] brothers writes, on behalf of the others ...

'The sad emotions of today are such that I barely find the strength to recount the changes which we have come up against. I will only say that from our Udine we have had to come as refugees to a small village in Abruzzia among people who are absolute strangers, though they are very hospitable. We had to leave in great haste, without thinking about our clothing or anything else ... We journeyed three days and three nights. We arrived safe and sound, but our thoughts keep returning to our Udine and to you who seem so far away.'

It was devastating news for the Modottis in San Francisco. Tina's mother was 54 and hardly fit to endure a forced march in the depths of winter with three young children. In addition, 18-year-old Valentina Gioconda could not have been of much help since she was several months pregnant when they left Udine. On 18 January she gave birth to a son, Tullio. The boy would never know his father, an Italian soldier, separated from Gioconda by the war.

News of the war was striking a nationalist chord and leading to widespread mobilization in favour of humanitarian aid for the refugees. The United States had entered the conflict in 1917 and there were 'ice cream-less days', followed by 'porkless Saturdays', all in an effort to cut down consumption of fat, which was used in the manufacture of bullets. The Italian colony held masked balls, ladies' clubs did benefit flower arranging and there were Red Cross fund-raisings in support of Italy's war victims.

Tina threw herself into the war effort, acting in a 'Love of Country' benefit performance in mid-February. The local newspapers built up the public's enthusiasm and patriotism in the weeks leading up to the performance of *La Gerla de Papa Martin* (Papa Martin's Pannier), and two days before the performance a photo of Tina accompanied an article in *L'Italia* with the caption: 'La signorina Tina Modotti, the noble and intelligent Tina who will play the part of Amelia in the drama *La Gerla de Papa Martin*.' The theatre was packed on the night of the performance, the public paying up to 75 cents for a seat. Tina's was a supporting role, but once again she had great reviews.

Tina was basking in her success when she became involved in the first of the various scandals which were to accompany her throughout her life. The personal and professional relationship between her friends, the sculptor Portanova and Stefania Pezza, had deteriorated into a civil suit filed in Superior Court in which Pezza was claiming damages for Portanova's failure to reimburse her for having paid his

fare to San Francisco in 1914 and for virtually supporting him in the interim. Tina was called to testify as a witness in the case and was apparantly mistakenly named as the model for his nude statue *Rigenerazione* (Regeneration), commissioned by the owners of Nob Hill's luxurious Fairmont Hotel. The first account in *L'Italia* of Tina's role in the trial said that

> Portanova was inspired by the classic countenance of this pretty signorina in the execution of the statue *Rigenerazione* and the beautiful outline of the lady that Portanova has sculpted is none other than that of the features of signorina Tina.

Curiously imprecise about which part of Tina's anatomy had inspired Portanova, the article went on to say that a 'Miss Katthrin [sic] Cope of the Continental Hotel' was also Portanova's model and that the 'perfect and sinuous curves' of the statue were in fact hers, which Tina confirmed in her testimony the next day. The trial was becoming quite notorious, probably due to its racy testimony and the eyebrow-raising sum of 25,000 dollars Pezza was sueing for. Tina, obviously wary of the aspersions the scandal might cast upon her promising acting career, hurried to draft a letter to *L'Italia*'s editor, opera impresario Ettore Patrizi. Dated 28 February, the letter ran as a correction in the paper the next day:

> Some newspapers, including your own, speaking of the Pezza–Portanova trial, have referred to the undersigned as a model. I beg you to correct this affirmation, because I have not served as a model for the sculptor, Portanova, but rather, being a friend of both parties, I consented a few times out of pure courtesy to permit the said artist to sketch the outline of my head while he was giving the final touches to his statue *Rigenerazione* ...
> Many thanks.
> Tina Modotti

Her letter bends the truth somewhat, as Tina had earlier testified to receiving cash and cheques for posing for the statue. On 5 March, the jury ruled against Portanova and in favour of his 'assistant'. The issue of whether or not Tina had modelled professionally for Portanova remains unclear. However, it is the first record of Tina being a model and inspiration for works of art in what would become a celebrated history of posing for painters and photographers.

The Portanova scandal fell from the pages of the newspapers, obviously much to Tina's relief, for she had other tasks at hand – namely a new season at the Liberty with the City of Florence company. Throughout the spring and summer season at the Liberty, her perfor-

mances were highly acclaimed. Italian opera had once again returned to the Washington Square Theatre and in April Tina acted for the first time in the theatre nearest her home. The comic sketch *Don Francesco* was part of a City of Florence performance sponsored by the left-leaning local newspaper, *La Voce del Popolo*, to benefit the Italian Red Cross, a cause which Tina supported throughout the war. In May, she helped the organization again, as an usherette, collecting donations along with other noteworthy young women of the community at a 'Grand Patriotic Festival' held in the same theatre. Just a few days later, her name appeared in a review of the successful dramatic production of Paolo Giacometti's *La Morte Civile*: ' ... signorina Tina Modotti, who in the part of the young daughter of the convict was excellent, both in diction and in the action on stage'.

In mid-summer, local theatre took an exciting turn with the formation by Amalia Bruno and Oreste Seragnoli of a new company producing both Italian theatre as well as some of the best modern drama Europe had to offer. Tina was invited to join the new company and her name featured prominently in announcements for the troupe's Fourth of July debut performance at the Washington Square Theatre. Her first role was in a 'beautiful little work in one act, with the title *Amor nell Tempo di Guerra* [Love in Time of War] by Romolotti ... the signorina Modotti received special applause at the end of her fine scene'. Social and political theatre was obviously not out of bounds for the Bruno–Seragnoli company: Tina's debut had been preceded by a two-act play on Germany's invasion of France and another called *The Factory Strike*. It was followed the next day by *The Russian Revolution*, a play which became part of the new company's repertoire.

After playing the lead role in Dario Noccodemi's comedy *La Lettera Smarrita* (The Samaritan Letter), Tina appeared in Bayard's comedy *The Urchins of Paris*. She was 'extremely gracious, exquisite' in a mid-

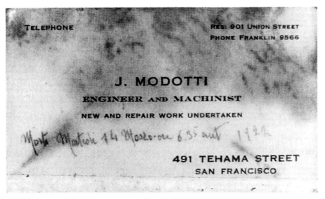

Giuseppe Modotti's business card, San Francisco, c. 1918

August performance of Rovetta's *I Disonesti* in honour of Seragnoli and 'much applauded' in the 'total success' of a one-act drama called *Papa Stefano*. She played the part of Regina in a 'praiseworthy execution' of Ibsen's play *The Spectres*, which was performed as well as 'in any theatre in Italy'. Then she prepared for her role in *La Nemica*, a play about a mother's love for her soldier sons, staged by *L'Italia* to benefit Italian war victims. 'The part of Marta Regnault,' wrote the paper's theatre reviewer,

> was played by the signorina Tina Modotti, who all in our colony have so often admired and who, we may well say, is loved by all as much for her goodness as for her brilliant artistic capabilities. She is still at the beginning of her career, yet [showing] truly great progress day after day, and yesterday evening she surprised even her warmest admirers by the dramatic intensity with which she was able to invest her role, especially in the great final scene of the first act … in this scene signorina Modotti obtains, if it can so be said, her diploma as an artist, and if she continues to study as she does, her career is assured.

With the possibility of the war in Europe coming to a close, and with both of his daughters working and his business prospering, Giuseppe Modotti made preparations to send for the rest of his family. Sometime during the summer of 1918, he rented an ample flat at 901 Union Street, a more prestigious location higher up Russian Hill. On the first floor of a graceful Victorian-style building, the flat had a terraced garden at the back and an enormous corner bay window high above the street below which provided a wonderful view of San Francisco Bay. Giuseppe also moved his business to Tehama Street, south of Market Street, an area of expansion for successful Italian businesses, and added Assunta Modotti's name to his listing in the *San Francisco City Directory* in anticipation of her arrival.

But Tina enjoyed the new, spacious living arrangement only briefly, as events in her life took another turn. Recognized throughout the community as one of the most promising young actresses, she was invited in August to join yet another new company along with Amalia Bruno and Oreste Seragnoli. The *La Moderna* company would perform at the Washington Square Theatre and was to provide 'a permanent theatre in the Italian quarter with serious artistic intentions'. Joining the North Beach theatre's old guard were several accomplished actors recently arrived from New York via Los Angeles, among them the already well-known Frank Puglia and his wife, Irene Veneroni, whose younger brother, Guido Gabrielli, would later marry Tina's younger sister, Yolanda.

The formation of *La Moderna* was seen by the public as the most

exciting development of an already exciting 1918 Italian theatre season. Not only was San Francisco theatre drawing the attention of New York opera circles, but the growing Hollywood film industry had its eye on local talent. The eminent director D.W. Griffith visited some of the Italian productions looking for works to adapt to film and many local actors had their hopes set on a Hollywood career. Among them was *La Moderna*'s own Frank Puglia, who became a well-known Hollywood character actor. Argentina Brunetti, the daughter of two of Tina's fellow actors, recalled that sooner or later, 'They all came to Hollywood ... to get into the movies.'

To publicize *La Moderna*'s formation, local newspapers published novel playbills featuring individual photographs of the company's actors. Tina appears with a new hairstyle – a very modern fringe – in the upper right-hand corner. Her presence among the actors had obviously been hailed beforehand to draw her growing number of fans. But the fans were to be disappointed, for throughout September and early October their favourite actress failed to appear in any of the company's works. Her followers must have been perplexed – but all was revealed on 16 October, when a prominent article on the local news page in *L'Italia* told the story behind her absence.

A photograph accompanying the article shows a newly sensual Tina, in low cut dress, with pouting mouth and languid hand resting dramatically upon a voluptuous breast. This photograph, which Tina carried with her for many years, was obviously the work of a photographer accomplished at promoting stars and was one of the first publicity

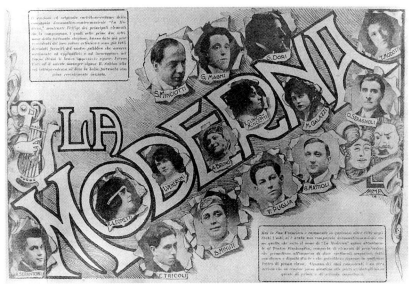

Playbill for La Moderna *theatre company, San Francisco, 1918 (Tina top right-hand corner)*

'Tina Modotti Sposa', San Francisco, 1918

shots Tina had taken to promote her career as an actress, probably in anticipation of breaking into Hollywood films.

The headline of the article revealed all: 'TINA MODOTTI SPOSA' (Tina Modotti Marries). The text must have caused quite a stir, for Tina had married outside the Italian community:

> The numerous frequenters of the Washington Theatre who have seen the name and the beautiful artistic face of the signorina Tina Modotti figure in the playbill among the members of the *La Moderna* company, have waited in vain for several weeks for the appearance of this young, attractive, intelligent actress of whom so much good is spoken and in whom we saw a distinctive artistic future … [But she] has decided to become part of a love poem of two persons. A few days ago she married signor R. de l'Abrie Richey, an excellent and notable young Canadian American [sic] and member of a distinguished family and passionate devotee of painting … But Tina Modotti's goodbye to the theatre doesn't mean she's saying goodbye to art, for it is the intention of the young actress to continue her studies, probably dedicating herself to the American prose theatre. Undoubtedly, a beautiful future is in store for her …

Encouraged by her success in local theatre and determined to forge ahead with her career, Tina had decided to try her luck in Hollywood. Robo was not opposed to the move, since his mother and sister were already living in Los Angeles. His and Tina's relationship appears to have flourished in San Francisco, although much of the time he must have been relegated to living in Tina's shadow, as her career had blossomed. In moving away from the security and warmth of her family and community Tina was taking a defiant step into the Anglo-Saxon world which, in spite of the five years she had spent in America, must have still seemed strange and unfamiliar and more than a little daunting. She had not only defied the bells of *campanilismo* by marrying a non-Italian and moving away from her community, but she was also preparing to manoeuvre within the intricate maze of the Hollywood film industry.

5

Kindred Spirits

In 1918, Los Angeles was America's last frontier. Oil derricks anchored the local landscape and the film industry had sunk its roots firmly into Hollywood, providing not only a new mass entertainment for American families, but an artistic and intellectual milieu fuelled by a steady influx of actors, writers, set designers and potential movie stars. It was the advent of the automobile age and the era of jazz, marathon dance contests and the 'flapper', the post-World War I version of the liberated woman; the age of a new, cynical, 'lost' generation which loathed mainstream mores and rejected established values.

It was a time of fascination with Eastern mysticism, of massive fundamentalist tent revivals and Prohibition, labour agitation and attacks against Communists, anarchists and minorities by the Ku Klux Klan. At outdoor amphitheatres on warm, moonlit evenings, there were classical symphonies and epic theatrical productions, often with an exotic, oriental flavour. The Los Angeles basin was a valley of darkness and light, and Tina and Robo arrived into the dazzle and swirl of it all.

Robo's sister and widowed mother were living in a small house on nondescript Harrington Avenue, but within a few months they had moved with the young couple to Hollywood. Robo found a job in the cloakroom of a local cabaret, which would leave him plenty of time to pursue his art. Tina had a series of publicity photographs taken and began making the rounds of the studios that lined the boulevards beneath the Hollywood hills.

Although the majority of Los Angeles' immigrant population was either Mexican or Italian, little Latin ambience existed in the bustle and hubbub of this essentially modern American boom-town. Tina found the city strange and foreign, yet it was also a tantalizing challenge which enhanced her newly found independence. She had,

after all, transcended the confines of San Francisco's Italian colony, which, however prosperous or pleasant, had the limitations of any cultural ghetto.

Life was certainly not Italian in the Richey household, but neither was it traditional, middle-class America. Robo's younger sister, Marionne, worked as an uninspiring clerk, but his mother, Rose, was hardly conventional. Her fine aristocratic features and long white hair piled in a dignified fashion atop her head belied a strong, sometimes overbearing, character. She occasionally wore a man's necktie, a suffragette trademark and one that singled her out as a woman of spirit and independence. She mixed freely with Tina and Robo's eccentric friends and did nothing to prevent their intellectual soirées and wild all-night parties. Tina and the older woman were deeply fond of one another; Tina affectionately dubbing her mother-in-law *Vocio*, Italian for someone who is rather loud or talkative, a nickname that stuck for many years.

Despite her move into this new world, Tina did not lose touch with her own family or San Francisco. Her mother, Benvenuto, Beppo and Yolanda arrived in America in February 1920. Gioconda was unable to leave Italy because she apparently could not obtain a passport for her son. When they stepped off the ferry, Tina and Robo were there to greet them amidst a large group of family, friends from Little Italy and Mercedes' co-workers from I. Magnin. After a few brief days when the rest of the Modottis got to know Robo better, the couple returned to Los Angeles, but there were other family reunions, both there and in San Francisco.

One record of those visits is an almost comic parody of the classic family snapshot: a slouching Robo towers above Giuseppe Modotti,

Tina and Robo with their families, California, c.1920 (left to right: Robo, Giuseppe, Mercedes, Benvenuto, Uncle Francesco, Beppo, Marionne Richey, Tina, Assunta, Rose Richey, Yolanda)

followed by the rest of the Modotti and Richey clans in order of height. Tina is unmistakable, standing between her mother and Marionne Richey, with her feet firmly planted and her hand on her hip. From beneath the brim of one of the fashionable hats she was so fond of, she stares at the camera with an air of assurance, a sense of self acquired from a growing confidence in her ability to move in Los Angeles' liberated artistic circles.

Tina's first Hollywood photographs show her calm and self-possessed before the camera. Though she was only in her twenties, she already had traces of 'a magnificence and a nobility' which was to become her hallmark. She attracted much attention as she moved from audition to audition. Years later, Mexican art critic Lolo de la Torriente still vividly recalled her in those early days as:

> ... not very tall, a supple and well-formed body, soft curves, an expressive face with a broad forehead, fiery dark eyes, a sensual mouth and plum-colored hair ... Her movements were slow and harmonious. She had a soft voice and a lively and tender gaze – everything about her was natural.

Tina's English may not yet have been perfect, but that would hardly have bothered silent film-makers who were looking for natural beauties to act out America's fantasies on film: they wanted heroines, vamps, *ingénues* and *femme fatales*. Tina's first work was in small supporting roles, but they at least provided her with that longed-for possibility of 'being discovered', of getting a leading part in a good, serious film.

Hollywood film still of Tina, 1920s

Robo, meanwhile, spent hours 'labouring monk-like' in front of his easel. He was developing a reputation as a designer of exotic fabrics using the techniques of Javanese batik. His creations, described as 'exquisite tapestries of illusion', were eventually used on Hollywood film sets and worn by Tina in at least one of her film roles. In 1921, Tina and Robo were photographed at work in their studio by *California Southland* magazine, which gave a romantic version of their bohemian existence:

> Even though the artist colony of Los Angeles is noted for a certain individualism and picturesque quality, one would hardly expect to find in a small, lone studio a French [sic] artist and his Italian wife making batiks much superior to those of the Javanese themselves. Such, however, is the case. Amid surroundings which recall medieval Florence, M. Roubaix de l'Abrie Richey and Mme. Tina create these fabrics of vivid and curious design …

Both the photo and article show that Tina's experience as a seamstress and fashion model played an important part in producing the

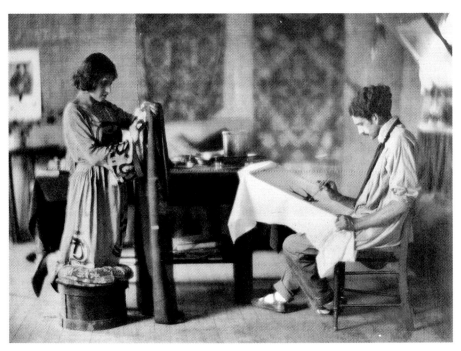

Tina and Robo at work in their studio, Hollywood, 1921

garments. As Robo sits with beringed fingers, an artist's smock and flowing black tie, painting the intricate patterns, Tina is hand-sewing one of the gowns. Though she hated the work of factory seamstress, Tina delighted in creating such artistic objects.

Another favourite pastime was making dolls, perhaps in part the fulfilment of a dream from an abruptly truncated childhood. But these were not little girls' dolls; they were adult dolls, caricatures, into which the adult Tina sewed her mischievous wit. She made a special gift to her friend, Betty Brandner, of one of these dolls, a kind of self-effigy dressed in a nun's habit and bearing the name 'Tina'. Tongue-in-cheek, at once self-mocking and irreverent, she named her dolls

'the nuns of the perpetual adoration'. May they protect you and may all their blessings be for you – I had no time to make another one therefore I've sent the one I had with no 'Tina' on it. You see the signature should be waxed on first thing. The little ribbon keeps the cloth from stretching. If it was some brighter colour, purple perhaps, it would be more decorative, but this is all I had … May the 'three sisters of the perpetual adoration' find your desert a further reaching altar for 'their prayers and penances'.

Tenderly, Tina.

The much sought after dolls were fun and creative but there were more serious subjects that intrigued Tina in Los Angeles. She eagerly devoured the works of Oscar Wilde, Edgar Allan Poe, Sigmund Freud and Friedrich Nietszche, as did most of her circle. A woman with a profession, an unorthodox marriage and the freedom these accorded, she was open to the new radical ideas being discussed at the time. Robo was a keen exponent of these as well as progressive political ideas and must have added to the earlier influences of her father and uncle. A more strident proponent of radical thought was their friend, the former Greenwich Village 'King of Bohemia', Sadakichi Hartmann. Half-German, half-Japanese, a lanky film and photography critic with a lecherous reputation, Hartmann was the quintessential intellectual *agent provocateur*. Once jailed for having written a symbolist play on the love life of Christ, Hartmann was a friend of both the anarchist Emma Goldman and the photographer Alfred Stieglitz.

Another radical that Tina and Robo came into contact with was the future Poet Laureate of Britain, John Cowper Powys, then on an extended lecture tour of the West Coast art and literary circuit. A self-described 'lover of poetry and a Parlour Bolshevik', Powys later

wrote a preface to Robo's sole volume of poetry and prose. Probably initially sought out by Robo, Powys had a tendency to remain somewhat aloof from his Southern California coterie of literary admirers and would-be poets, once referring to them deprecatingly as those 'weak amateur[s] of letters, such as dwell in their thousands amid the orange groves of Santa Barbara and Los Angeles'.

Within orbit of their circle were also members of the small but vibrant community of Mexican exiles, such as artists Rafael Vera de Córdova and Enrique de la Peña, in Los Angeles to escape political turmoil at home. A particularly close friend was Ricardo Gómez Robelo, a poet and translator of Poe and Wilde, who was Mexico's Attorney General in the administration that had lost power in 1914. A gothic figure who adopted as his own tragic persona that of Dostoyevsky's 'Rodion Romanovitch Raskolnikoff' from *Crime and Punishment*, Gómez Robelo had followed the Mexican exile trail to Los Angeles, where *El Heraldo de Mexico* published his second book of poems in 1920 and Robo did the illustrations, a series of strange, haunting depictions of love, sex and death.

It was probably through his Mexican friends that Robo was introduced to a curious English-language monthly published in Mexico City called *Gale's Magazine*, which described itself as the 'Journal of the New Civilization'. Founded in 1918 by Linn A. E. Gale, a somewhat quackish, red-bearded American 'slacker' who had become a driving force in the fledgling Mexican National Socialist Party, it ran editorials with romanticized accounts of Mexico as the 'Egypt of America' and the 'Land of Promise', and published stories on everything from collectivization in the Yucatán to Margaret Sanger's birth-control theories. The magazine had a readership among Southern California radicals and by May 1920 Robo's cartoons began to appear on its cover. Somewhat crude, both in their message and execution, Robo's political caricatures portrayed fat, cigar-smoking New York banker-types as symbols of Wall Street. They were depicted either as violently plundering Mexico, the blood of their Mexican victims dripping from dagger point, or perspiring profusely at the sight of banners that read '*Viva el Bolshevismo*', borne by protesting Mexican oil workers! Crude as they were, the caricatures obviously pleased Gale, for by September Robo was listed as one of the short-lived publication's regular contributors.

While Robo put ink and politics to paper, Tina was enjoying some success in Hollywood films and reviewers were taking notice of the small parts she had been playing. In 1920, a critic for the leading industry magazine *Variety* had seen enough of her on screen to

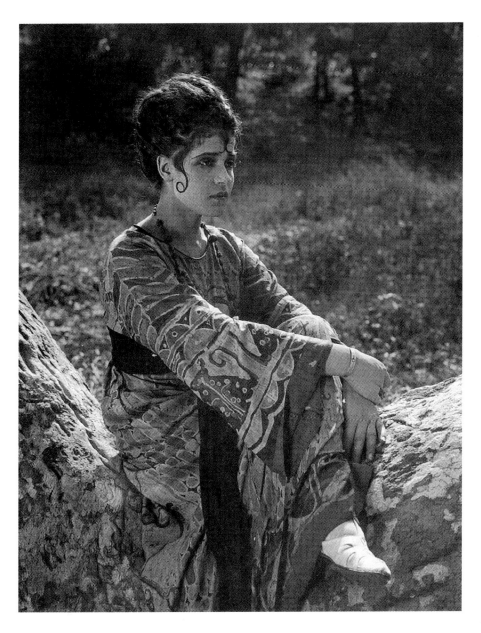

Film still of Tina from The Tiger's Coat,
Hollywood, 1920

From The Tiger's Coat, *Hollywood, 1920*

Hollywood film still of Tina, 1920s

remark that her calibre as an artist was well known. Her steady progress resulted in her playing the leading role in a 1920 production, *The Tiger's Coat*, a love story built around a case of mistaken identity in which Tina plays the heroine. It is a simple tale in the silent-film mould: a tall and handsome hero falls in love with the heroine, then rejects her when he discovers she is an imposter, not the wealthy woman she claims to be but in fact her faithful Mexican servant. In some scenes, Tina's 'Latin-ness' is emphasized with very Spanish-looking curls and she wears an exotic batik dress designed by Robo. Eventually the hero repents and love triumphs. In the 'clincher' scene, Tina is clasped about the waist and drawn towards him for the final kiss which tells the audience they will live happily ever after. Reviewers apparently blanched, yet directed their criticism not at the actors but at the film's thin storyline and flawed direction.

The year 1920 was a momentous one for Tina. It marked her involvement with another group of Los Angeles artists through a man who was at its axis, the acclaimed photographer, Edward Weston. Key to this encounter seems to have been an 'extremely bright, sensitive, and self-effacing' dancer called Ramiel McGehee. Not very tall, with gentle eyes and mouth and a receding hairline that combined to give him an elfish appearance, Ramiel – whose real name was Clarence – moved with ease among Hollywood's entertainment community. It may have been 'through McGehee's contacts with the movie colony [that Weston] met a truly extraordinary woman who was to shatter and then reconstruct his life'.

Ricardo Gómez Robelo, drawing by Robo Richey, 1920

The woman was Tina, and by the time she met Edward Weston he was already a leading figure in the photography world. Among his distinctions were a bronze medal award from the 1915 Panama–Pacific Exposition and in 1918 his work was exhibited by the prestigious London Salon of Photography. In 1911, in the suburb of Tropico, across the omnipresent orange groves from Hollywood, Weston had built 'a little shack surrounded with flowers' on a plot of land owned by his wife and established his first studio there. A small, wiry man, with warm brown eyes and an almost palpable virility, he often

sported 'the American idea of an European artist's costume: cape, flowing tie, cane and velvet jacket'. At 34, he was already the father of four young sons and had an increasingly turbulent family life, due largely to his growing circle of avant-garde friends and his propensity for extra-marital flings with many of them.

In addition to Ramiel McGehee, the two other closest members of Edward Weston's inner circle were his assistant, the photographer Margrethe Mather, an attractive, eccentric and intelligent woman who had met Weston after he first opened his studio in Tropico. The other was a Dutch-born, self-described 'intellectual anarchist' named Johan Hagemeyer. His staunch pacifist opposition to World War I, his friendship with Stieglitz and his love of photography had bonded him to Edward Weston on their first meeting in 1917. Together, these four were constant in their often outrageous pursuit of beauty, experience, and knowledge, in their hatred of middle-class morality and the homogenization of American society.

The small hive of Los Angeles artists, intellectuals and film set intersected at places like Jake Zeitlin's rare-and-used bookstore, the hub of the city's intellectual life. They attended many of the same gallery openings and theatre performances and got to know each other at their frequent parties. Tina's and Edward's circles were converging as early as 1918, when Weston also met John Cowper Powys, whose ideas made a strong impression upon him. In 1919, their circles came even closer, when Edward, Tina and Robo each had their portraits made in Los Angeles by photographer Jane Reece. Following their meeting, the newly expanded Weston–Modotti–Richey circle was soon in continual contact, riding the 'Red Car' trams back and forth to appointed soirées and events. They read avidly, often aloud to each other, and loved classical and oriental music. Their intellectual discussions were effusive and impassioned, as were their parties. There was 'a good deal of kissing and dancing ... and the various sexes were not clearly delineated. Everyone knew everyone, and the permutations of the love affairs – like an electric current – attracted one person to another.'

Betty Brandner, a thin, dark-haired dancer, was probably introduced to the Modotti circle through McGehee. A former lover of Edward Weston, she became a close friend of Tina's. So did Miriam Lerner, a one-time girlfriend of Hagemeyer and member of the Young Socialist League, who worked as a secretary to local oil baron Edward Doheny. Tina was very close to both of them. 'I spent Saturday night at Miriam's,' she wrote to Brandner,

and most part of yesterday ... we had lunch together and went to Exposition Park to see an international exhibition of watercolors. It seemed as if you were among us, dear, for we all had you very near to our hearts and naturally we spoke much of you and wondered what you were doing. A watercolor at the exhibit reminded us of you as you looked the night of Miriam's party. Take good care of yourself, Betty. I look forward to the time I can come to see you ...

Tender kisses and my thoughts to you, dear.

Parties at Edward's, parties at Miriam's, parties at Tina and Robo's, they were indeed Bacchanalian affairs with much dancing and drinking of wine and *sake*. Sadakichi Hartmann, using his good looks and witty chatter to full advantage as he danced his way about the room, was warned off by Weston for apparently being too insistent in his advances toward Margrethe Mather. McGehee, his mind always somewhere in the far-out East, danced wild dervish whirls, once falling against a table and tearing the ligaments in his side. Tina's friend from San Francisco bohemia, Dorothea Childs, the tavern keeper and free love advocate, now in Los Angeles with a 'vaguely lost expression in her large soft grieved brown eyes', would get drunk and collapse with Edward on the floor.

Gómez Robelo was also there, with his large frame and brooding character, a soul-mate to the melancholic Robo. Gómez Robelo added an exotic air to the parties and, drink in hand, loved to hold forth on the disparities in Anglo and Latin approaches to sexuality. He was thoroughly taken with 'the most terrible spiritual genius' of Margrethe Mather and later recalled the 'intense, dreamy and vibrant life' he lived in Los Angeles, with 'the parties at Weston's and at Robo's, with the magic of art and congenial, exquisite friends and Saki [sic]'.

Although appearing the amicable hosts of the festivities at their Hollywood studio, Tina and Robo's marriage was beginning to give way under the strain of so much diversion. Tell-tale signs show up in the imagery and themes of Robo's melancholic poetry, much concerned with unrequited love and missed opportunities, as well as in his erotic, Aubrey Beardsley-like illustrations for Gómez Robelo's book of poetry, *Satiros y amores*. He portrays pathetic scenes of rejection, of imploring men rebuffed by cruel or indifferent women and Tina, it appears, was coming to the painful conclusion that behind her bohemian husband's romantic appearance was the soul of a dreamer, destined to failure in a world he was ill-prepared to cope with. Not too long after, she would clearly spell out his shortcomings:

Like all persons of sensitive and tender perceptions, he would withdraw within himself if the least feeling of antagonism was manifested … With Life he was never friendly. He faced it with hostility and was forever endeavoring to escape its realities, and to live from the heart … Perhaps it was the realization of Life's unconscious cruelty and indifference and his impotence to conquer Life that turned him against it.

Robo recognized his inability to face reality. 'A man cannot get away from the facts,' he wrote in a letter to Sadakichi Hartmann:

There is a terrible threat there – facts must be faced and conquered lest they conquer us – yet I am irresolute and wavering and filled with shadows. Too long have I dreamed and hesitated – too long my soul shrank from those cold heights where nothing is concealed. Facts are not always beautiful, and I wish only to be beautiful. It is tenderness that melts my spirit. But to be free – to be clear and unstained, one must have the iron in his soul. Oh, the curse of shadowy, dreaming, hesitating souls!

Robo, the consummate dreamer and visionary, suffered bitterly the tragedy of his unexpressed emotions. 'Equally interested in writing and painting, he passed from one phase to the other at different periods of his life, unable to decide which of the two was his best medium of expression …' Unfortunately, it seems that neither was. In an 'Introduction' to Robo's writings, collected posthumously in *The Book of Robo*, Cowper Powys referred to his 'immature talent' which found expression 'more quickly, more easily, in cynical and satirical ways, in destructive ways, than in positive creation'.

It was probably not only Robo's impotence in dealing with life that was a problem for Tina. It appears that she did not find their relationship sexually satisfying, either. She later described her feelings toward him at the time as maternal, and though they were still very close, it seems her marriage no longer satisfied her either emotionally or sexually.

Among Robo's illustrations in *Satiros y amores* is a drawing of a Latin woman wearing a shawl, looking with contempt at the man she has just stabbed; the victim looks strikingly like Robo himself. Another of a nude woman in Spanish lace, whose features closely resemble Tina's own, is entitled *Temptation*; yet another shows a woman with her face half-hidden behind a fan – in a pose similar to one which Weston would use later in photographing Tina – looking down upon a kneeling satyr, who offers her his heart. Perhaps the horns upon his head were a thinly veiled indication that at least one of Tina's admirers may have already cuckolded him.

There is no doubt that Tina's circle of admirers was growing.

Temptation, *by*
Robo Richey, 1920

Edward Weston recalled very clearly those 'days of 1920 – I, at Tina's and Robo's – when Robelo lived, and I was first enamoured of Tina. Robelo was too, and God knows, many others.'

Robo once created a metaphor which he used to describe Tina: 'Tina is wine red and something very precious that one puts gently down to become more precious as they carefully put it down.' This most succinctly describes the conclusion which Robo must have been slowly and painfully arriving at: that his and Tina's marriage was failing and it was time to 'put it down'. If he was looking for somewhere to escape to, perhaps he was already dreaming of a far-off place, a place that his friend Gómez Robelo had told him about. One of his illustrations for *Satiros y amores*, in which Tina is clearly the model, is strangely prophetic. A Spanish *señorita* sadly strums the guitar, while her songbird, escaped from the cage she has kept it in, flies away toward a horizon punctuated by a snow-capped volcano.

By early 1921, there was an electric attraction forming between Tina and Edward. The snow on the streets of Hollywood in January, a very unusual occurrence, might have alerted them to something magical in the air, and if that was not omen enough, the first-ever sighting of the aurora borealis over Los Angeles must have been an indication that something rare and beautiful was about to occur. Their love affair probably began in the safety of his studio, when, as Tina wrote, one 'late afternoon – *saki* was spilt on my hand ... and we listened to Sarasate's "Romance" for the first time together ...' According to Weston, their 'start' came after a letter of his, to which Tina replied:

> Once more I have been reading your letter and as at every other time my eyes are full of tears – I never realized before that a letter – a mere sheet of paper – could be such a spiritual thing – could emanate so much feeling – you gave a soul to it! Oh! If I could be with you now at

this hour I love so much, I would try to tell you how much beauty has been added to my life lately! When may I come over? I am waiting for your call.

At times, Weston would look at Tina and be so overcome with emotional excitement that he would break into laughter and she would look at him in surprise. His deep brown eyes – 'slow and absorbent, as if he were always – and doubtless he was – searching to see and hold the deep inner image of every person, place or thing' – seemed to penetrate her inner being. He made his first portraits of her and was thrilled with the results. By April, in a letter to his friend Hagemeyer, he wrote ecstatically that 'Life has been very full for me – perhaps too full for my good – I not only have done some of the best things yet – but also have had an exquisite affair … the pictures I believe to be especially good are of one Tina de Richey – a lovely Italian girl.'

For Tina the affair was a passionate awakening which propelled her into the realm of the senses. Overwhelmed by her emotions she transferred them to paper in a letter to Edward:

> One night after – all day I have been intoxicated with the memory of last night and overwhelmed with the beauty and madness of it – I need but to close my eyes to find myself not once more but still near you in that beloved darkness – with the flavor of wine yet on my lips and the impression of your mouth on mine. Oh how wonderful to recall every moment of our hours together – fondle them and gently carry them in me like frail and precious dreams – and now while I write to you – from my still quivering senses rises an ardent desire to again kiss your eyes and mouth – my lips burn and my whole being quivers from the intensity of my desire …

Art, Love and Death

Tina was Edward Weston's favourite photographic model throughout 1921. Modelling was a serious vocation for Tina, one which she pursued alongside her career as an actress. She had posed for many stage and screen publicity photographs and was completely at ease in front of the camera. Nor was Weston the only art photographer she modelled for; she had also sat for Jane Reece and Arnold Schröder and would shortly pose for Johan Hagemeyer.

Tina's modelling for Edward Weston was different, however, for the man behind the camera was not only a great photographer, but her lover, the person who aroused such deep passion in her. With him she was no longer a mere object in the photographic frame, the passive subject of the photographer's art, but rather a participant in the photographic process. She seems to have considered the stunning portraits he made of her to be the combined labour of artist and model to produce art in its truest form. In September 1921, she wrote that his asking her to sit for him once more had filled her with pride: 'Oh! I hope he does something very great again!'

The physical passion and emotional turmoil which absorbed Tina and Edward at the beginning of their relationship induced the moods Weston captured during the sittings. These portraits of Tina are truly remarkable in their sensuality and texture, among them, *The White Iris*, a seductive semi-nude in which Tina's face, with eyes sensuously closed, and barely glimpsed naked breast are romantically juxtaposed with the delicate iris flower. Like most of the nude studies Weston made of her, it is remarkably different from his other 'strikingly sexless and impersonal' nude images. Weston rarely showed the faces of the women he photographed nude, as his biographer Ben Maddow notes: 'Since so many, and perhaps all, of the nudes he photographed were women he slept with, it's interesting that, with only a few excep-

tions – two of them women he loved very deeply – the nudes have no faces.' Tina was one of those two, significant, exceptions.

Edward Weston's interest in photography dated from the age of 16, when he took his first photographs with a small Kodak Bull's-Eye 2 camera during school holidays spent on a Michigan farm. The camera was a gift from his father, a New England medical practitioner. In fact, Tina and Edward's family backgrounds could not have been more different. Weston came from a long line of New England doctors, preachers and schoolteachers and his mother had died when he was only five years old. One critic described him as being somewhat cold and reserved, resembling 'a very timid caretaker' with a manner as 'serene and indomitable as a Jesuit's'. But there was a feminine and outrageous side to this rather reserved exterior. Throughout his life, Weston took delight in dressing up as a woman at masquerade parties and he had a long history of liking to shock people. This dated from his childhood in a Chicago suburb, where his sister described him sitting straight-faced on the kerb in front of his home with a large rat under his cap, astonishing passers-by when they saw it moving around on his head.

Edward Weston with his Seneca, [TM?] c.*1924*

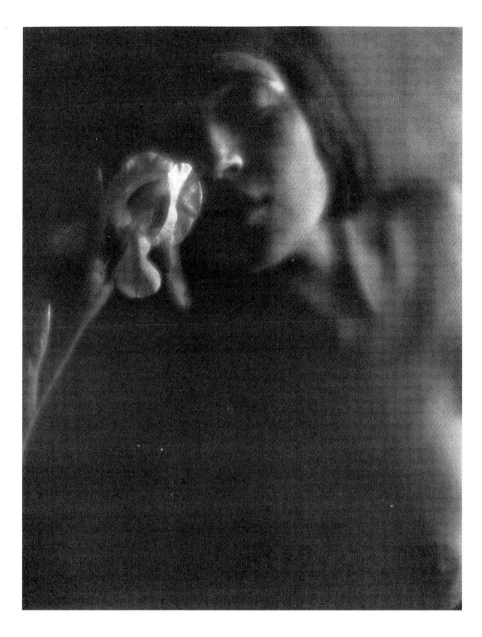

The White Iris. *Photographer: Edward Weston, 1921*

After moving to Los Angeles in 1906, he had married his sister's friend, Flora Chandler, a schoolteacher whose family owned vast real estate holdings. By the time he and Tina met, he had four young children. Although this complicated their relationship, it appears they were able to hide their affair for some time from Flora, who was somewhat excluded from Weston's bohemian circle. Flora Weston was a generous, emotional woman – once described as being like an electric fan that couldn't be turned off – but she could be extremely jealous and Weston gave her plenty of reason to be. She was usually successful in discovering his amorous adventures. His oldest son, Chandler, then only 11, still remembers his mother sending him on errands to his father's studio so that he could spy on him.

Tina's affair with Edward must soon have become obvious to Robo, however, who was a close member of their circle. He seems to have reacted with his characteristic fatalism. Perhaps it was at this point that his and Tina's marriage devolved into the platonic relationship Tina later described to friends. Tina revealed his behaviour under such circumstances when she wrote, 'The people whom he loved made an indelible mark on his life, and for them he never relented his interest even after circumstances, or other reasons, caused a final parting.' As Tina and Edward's affair evolved, Weston continued to frequent her and Robo's studio, where he made several portraits of Richey, who continued to cherish his friendship.

Despite his good will, however, Robo began looking longingly towards Mexico. He had long had an interest in the country and it increased when his friend Gómez Robelo announced he was returning there. Ricardo had been contacted by his old friend José Vasconcelos, then rector of Mexico's National University, who promised him an important post in the Public Education Ministry he planned to create. Gómez Robelo encouraged his American friends, especially Robo, to join him in the Mexican cultural renaissance Vasconcelos was predicting. It must have seemed an attractive offer to Robo. In *Gale's*, he had read glowing descriptions of the ancient Tenochtitlan, now the buzzing metropolis, Mexico City. Particularly appealing would have been what the magazine described as 'the Mexican racial tendency of overlooking more practical and prosaic things while delighting in gorgeous flowers, beautiful parks … and magnificent monuments'.

By the summer of 1921, with Los Angeles broiling in an insupportable heat wave, Robo informed Gómez Robelo that he had decided to join him. His leaving seems to have been a process marked by months of indecision and delay, as he tried to convince both Tina and

Edward to accompany him. In fact Weston did make plans, which he later changed, not only for the trip to Mexico but also for him and Robo to share a studio there. Tina was also in an indecisive mood, obviously torn between the affair with Edward and the possibility of a new exciting life with the husband she was still fond of.

The upheaval caused by her affair with Edward and the disintegration of her marriage was compounded by her growing disillusionment with Hollywood. Following *The Tiger's Coat*, she acted in two other films: *Riding with Death*, released in 1921, and a light comedy about marital jealousy with Keystone-cops type antics, *I Can Explain*, in 1922. In the latter, she played a modest supporting role as, once again, a Latin beauty – a South American importer named Carmencita Gardez who adds a few laughs to a comical love-triangle adventure. Tina was, however, becoming tired of being typecast as the lovelorn Mexican servant or the fiery Latin lover. The film poster for *The Tiger's Coat* referred to her 'exotic allure' and, as Weston commented after seeing one of her films, 'The brains and imaginations of our movie directors cannot picture an Italian girl except with a knife in her teeth and blood in her eye.'

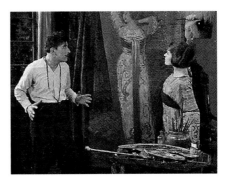

From The Tiger's Coat, *Hollywood, 1920*

There is little doubt that Tina and Edward's respective circumstances placed a strain on their relationship, leading to a cooling off in the late summer of 1921. It seems Tina had caught some of Robo's growing enthusiasm for Mexico, perhaps seeing it as an alternative to the turmoil in which she was embroiled, because by August she too was making plans to leave.

First she visited San Francisco, to say goodbye to her family, in particular, to her father, whose health was now deteriorating. While there she met Weston's friend and artistic alter-ego, Johan Hagemeyer. A lover of literature and opera and a devotee of modern psychology and progressive ideas, he and Tina had much in common. Hagemeyer had been involved with a group of intellectual anarchists and IWW activists, all poets, and by the time Tina met him, he was already an accomplished photographer.

The letter which Edward sent advising Johan of Tina's visit hinted at a crisis in their relationship and his fear that his friend might take

advantage of the situation: 'She has your address – which I was *kind* enough to give her – knowing your favor in the eyes of the ladies! Alas! it is with mixed emotions that I see her go!' A week after her arrival, Tina composed a rather proper note to Hagemeyer asking when they might meet and signing it with her married name, Tina de Richey. A few days later she spent a few hours rich with pleasure in his company, looking at books and listening to opera music. The intensity of the meeting with Hagemeyer, however, only served to increase her emotional confusion.

By the time she returned to Los Angeles, she had decided to make a brave effort to express all she felt. Before seeing Weston, she struggled to put her feelings in order and wrote to Hagemeyer that

> the impressions left to me of the afternoon spent with you were so many and so deep they overwhelmed my mind … not even to myself can I clearly answer why I suppressed the great desire I had to call on you once more. Was it power of will? Or was it cowardice? Maybe the same spirit moved me then, that moved Oscar Wilde to write this paradox: 'There are only two tragedies in this world; one consists in not obtaining that which you desire; the other consists in obtaining it.' The last one is the worst – the last is a real tragedy.

Tina's new-found sexual freedom, released by the affair with Weston, brought with it doubts about what she really wanted. She had obtained much that she believed she had desired – a career in

Johan Hagemeyer.
Photographer:
Edward Weston, 1921

Hollywood films, marriage to a man she had loved, a relationship with another which brought her sexual and emotional fulfilment. And yet, while attaining all this, had she really fulfilled her needs? She was clearly struggling in a maze of uncertainty and indecision and her obvious attraction to Hagemeyer – though probably only as a surrogate for Weston – served to disturb her even further.

When she first returned to Los Angeles, Tina could not bring herself to see Edward. Instead, she wrote to him that she would soon be leaving for Mexico, telling him about the wonderful afternoon she had spent with Hagemeyer, who, she added,

'made me think of you, and you remind me much of him'. In a letter to Johan, she referred to Weston somewhat coolly – perhaps with forced reserve, since she was obviously trying to avoid the difficulty seeing him involved: 'I have not seen your friend Edward since I returned,' she wrote, 'but he asked me to pose once more for him before leaving for Mexico.' She could not deny Weston this 'last' artistic engagement, so the sitting was arranged and its outcome resulted in Tina abruptly changing her mind about accompanying Robo to Mexico.

In early December, Robo left for Mexico alone, but with promises from Tina and Edward that they would soon join him. With his departure, their affair resumed its previously fevered pitch. In late January, Tina wrote:

> Edward: with tenderness I repeat your name over and over to myself – in a way that brings you nearer to me tonight as I sit here alone remembering – .
>
> Last night – at this hour you were reading to me from an exquisite volume – or were we sipping wine and smoking? – or had darkness enveloped us and were you – oh, the memory of this thrills me to the point of swooning! – tell me, were you at this hour – kissing my left breast?
>
> Oh! The beauty of it all! Wine – books – pictures – music – candlelight – eyes to look into – and then darkness – and kisses – .
>
> At times it seems I cannot endure so much beauty – it overwhelms me – and then tears come – and sadness – but that sadness comes as a blessing and as a new form of beauty – .
>
> Oh Edward – how much beauty you have added to my life! …
>
> Your last letter laid under my head till morning – Was it its faint fragrance that awoke me? Or the spirit of your desires and mine – that seemed to emanate from it?
>
> Yes – to be drunk with desires to crave their attainment – and yet to fear it – to delay it – *that* is the supreme form of love …

While the intensity of her and Edward's sexual relationship thrilled, it was obviously also disturbing for Tina. Is this why she delayed fulfilling her desire? Or perhaps the 'supreme form of love' was a result of Edward's family situation, causing him more restrictions in pursuing their affair. It is clear, however, that the lovers' reprieve was but an interlude, for in the same letter Tina refers to 'the hours which will still be ours', indicating that the time was approaching when they would have to part.

Robo was writing exciting letters from Mexico City, where he was a guest of Gómez Robelo, now the influential director of the Fine Arts Department of the Public Education Ministry. The Mexican capital

was an 'artist's paradise', where there was more poetry in 'one lone *zerape*[sic]-shrouded figure leaning in the door of a *pulque* shop at twilight or a bronzen daughter of the Aztecs nursing her child in the church than can be found in Los Angeles in ten years'. These striking images must have penetrated Tina's unconscious, where they lay dormant, to emerge years later in some of the most powerful photographs she took in Mexico.

Gómez Robelo's prediction of a cultural renaissance was becoming reality and art was indeed everywhere in the air, swept in on the wake of Mexico's decade-long revolution. Robo described his visit to historic Coyoacán on the outskirts of Mexico City where an open-air art school had been established and he had seen

> work by children from seven to ten years of age in the night school – some of the finest things I have ever seen, children, peon children! There is a great turning backward to original sources here – they have grown tired of trying to imitate foreign art and are now seeking to find theirselves in theirselves ... It is indeed to be commended ...

Robo's letters indicated that he had finally found the place where he felt completely at ease as an artist. His enthusiasm knew no bounds as he attended evening concerts at the National Preparatory school, where during the day he saw Mexican artists in their coarse overalls already at work on their mammoth mural paintings. Robo was also awaiting the opening of an exhibition Gómez Robelo had arranged of his batiks and the work of fellow American artists and photographers. To this end, he had brought with him paintings by Blaine and Horwitz, and photographs by Arnold Schröder, Jane Reece, Margrethe Mather and, of course, Edward Weston, who had included his portraits of Tina.

Tina's beauty was to acquire mythical proportions in Mexico City even before her arrival, largely due to Gómez Robelo's infatuation with her. Her reputation as a *femme fatale* was fuelled by Robo's illustrations for *Satiros y amores*, which had been circulating in Mexico City since Gómez Robelo's return. Before the exhibition of American artists opened to the public, he had been showing the works privately to 'some artists and newspapermen', primarily his male friends, to whom he would not have hesitated to play up his *friendship* with the *lovely model*. Not only were the entirety of the works well received by these insiders, as he wrote to Weston, but 'Tina's portraits have proved to be the best liked and I am teased to death.'

The opening of the exhibition was put off to innumerable *mañanas* in typically Mexican fashion and Robo wrote to Weston proffering Gómez Robelo's apologies and offering to 'post notices saying that if

a sufficient number will order your photos you will come and make them here. What do you say? … Write me about your pictures and if you will come.'

While Edward remained undecided, Tina was planning to leave shortly. With Gómez Robelo expecting 'to have some new prints' of Weston's for the exhibition, she gathered together more of his photographs to take along. In the first week of February, as the time of her departure drew near, word must have reached her that Robo had become seriously ill. She hurried to finalize her travel plans and boarded a train for Mexico. It was during the train journey itself that she received a telegram with tragic news. Robo had died in a Mexico City hospital. Suddenly, Tina was thrust into a frightening situation, *en route* to a country she did not know, whose language she did not speak, with the distance between her and her lover growing greater by the moment, and the spectre of her dead husband looming ahead.

Robo's illness had been very brief. He was seen at public gatherings just a few days before he had been hospitalized with smallpox. Instead of being taken to the nearby American Hospital – probably the daily fee of 20 dollars was too high for his budget – he was taken across town to the General Hospital. He reportedly languished there for five days before dying an 'almost violent' death at 8.30 on the evening of 9 February.

Just two days later, Tina arrived to bury him in the American Cemetery, where records show arrangements were made for a simple grave paid for by the American Benevolent Society, the kind usually reserved for those with little or no money. The plain headstone, engraved in Spanish with Robo's name and the dates of his birth and death, was dedicated simply from *Su Esposa* (His Wife).

The tragedy of Robo's death was not lost on Tina. She later wrote that having been

> too weak or too unlucky to attain what he desired … he finally went to Mexico, attracted by the beauty and the charm of the past still lingering there.
>
> There he found an environment better suited to his temperament. He found sympathy and romance – but only for a little while. Death came, swift and inexorable, and he vanished, February 9, 1922, from a world in which he did not belong …

Despite her grief, Tina could not but have been impressed by her first encounter with Mexico. The open-air markets and streets were thronged with pedlars, hawking everything from tin pots to religious images. Donkey-drawn carts and shiny automobiles jostled for space,

while huddled women wrapped in soft grey and blue *rebozos* patted corn *tortillas* the rhythmic slap, slap of their palms as ancient as the great Tenochtitlan itself. The icy peaks of the twin volcanoes Popocatepetl and Iztaccihuatl glittered on the horizon and trams trailed off to places with the equally exotic names of Tacubaya and Chapultepec. The bustling city centre, with its thriving commercial section and colonial churches, expansive mansions, plazas and parks, was still small and manageable and, more importantly, was being transformed into an artists' village. Congregated within a few square blocks around the National Palace was all the art and culture Mexico's revolutionary intelligentsia could muster.

Tina decided to stay at least long enough to ensure the opening of the exhibition which Robo had been so instrumental in organizing. In doing so she was plunged into the heart of the artistic revolution. Folk art had just come into vogue, with pride in Mexico's native artistic heritage receiving a boost through a major exhibition of folk art at the centennial celebration of Mexican Independence the previous September.

The new Secretary of Education was José Vasconcelos, whose neat black suit and unassuming, clerk-like appearance belied a visionary, the dynamo of a far-ranging cultural and educational revitalization. At the core of his concept was free and universal instruction, combined with free concerts and art exhibitions – art and culture for the people. He had brought the country's best artists back from Europe and put them to work painting the walls of public buildings with murals that would stress the nationalism and 'indigenism' integral to his cosmic vision for Mexico. King among the painters was Diego Rivera, who in addition to the avant-garde ideas he had acquired in Paris, arrived back with hundreds of sketches he had made in his study of Italian fresco technique. The flamboyant Rivera was a huge whale of a man with bulging eyes and small, delicate hands. By the time Tina arrived, he had donned faded overalls and a paint-spattered jacket and had taken over the painting of the first mural project in the National Preparatory School auditorium. Rivera and his technical assistant, Xavier Guerrero, a small, sombre Indian painter with the features of an Aztec idol, were well along in the execution of the mural Rivera entitled *Creation*.

The gargantuan painter's then fiancée, Guadalupe Marín, remembered meeting Tina in 1922, in the company of Gómez Robelo. 'She was slim, elegant, refined and very pretty,' she recollected. 'Lupe' Marín herself was a strikingly handsome, tall, olive-skinned woman, whose piercing green eyes and wild, unkempt black hair were a

perfect match for her rebellious temperament. 'Sarcastic, unruly and whimsical', she had come to Mexico City from Guadalajara with the express intention of marrying the already famous Rivera. Tina met Lupe at a time when she was perpetually at Diego's side in the Prepa auditorium, bringing his lunch in an immaculately prepared picnic basket and modelling for the *Creation* mural with her close friend and confidant, Concha Michel. 'Comrade Concha', as Diego called her, was a hands-on-hips, husky-voiced folksinger who had been expelled from a convent school for setting fire to one of the saints in the chapel!

The Prepa was near the National School of Fine Arts, where Gómez Robelo eventually presented the American artists' exhibition in March, along with the 'photographs brought by Miss Tina Modotti'. The exhibition was both a critical and financial success and the photographers' work, especially the Edward Weston prints, created a stir.

In a double-page spread in the weekly *El Universal Ilustrado*, then the most widely read cultural supplement in Mexico, a Weston photograph of Tina looking sidelong into the camera and holding an open Japanese fan was reproduced largest of all. A couple of weeks earlier, an obituary on Robo glowingly describing his batiks and paintings and illustrated with his drawings appeared in the same publication. Most prominent is the drawing, recognizable as Tina, of a naked woman with a thorny rose held between her legs, which in *Satiros y amores* is called *Temptation*. We do not know how Tina reacted to this or to the stir caused by Weston's portraits of her, but she was delighted with the outcome of the exhibition. She wrote to Edward that it was a huge success and that he had sold many prints.

She did not, however, have much time to enjoy either Mexico City or the success of the exhibition. Only six weeks after being widowed, she was dealt another severe blow when her father died suddenly on 14 March. After some 18 months of stomach ailments, Giuseppe Modotti had been admitted to San Francisco's St Luke's hospital on 7 March and diagnosed as having stomach cancer. Tina rushed back to San Francisco to be with her family. Giuseppe Modotti was cremated and his ashes interred on 16 March at Cypress Lawn mortuary. An obituary in the local Italian press expressed the community's 'heartfelt condolences' to the family. 'As a result of a serious and ongoing malady,' it began, 'the compatriot Giuseppe Modotti, father of our well-known and admired artist Signora Tina Modotti, widow of de Richey, died yesterday … '

California Interlude

Tina returned to San Francisco to confront a difficult and decisive juncture in her life. The double deaths of her father and husband signified a break with the past and added an urgency to her plans for the future. To give herself time to reflect upon her new situation, she decided to avoid distractions and see only her family during her visit.

By a strange coincidence, Tina and her mother, although 33 years apart in age, both found themselves widowed within a matter of weeks. Tina must have understood better than anyone else Assunta Modotti's tragedy. She had endured such hardship and poverty, raising her children alone for 14 years while Giuseppe Modotti was in America, only to have him die less than two years after they had been reunited. Now she was in a country she felt no ties to, without her partner and with her children grown up and living their own lives.

Mercedes and Yolanda were both still working at I. Magnin; Yolanda now unhappily married to Guido Gabrielli. Benvenuto and Beppo had refused to take over their father's business, causing Giuseppe great disappointment, and the Modotti workshop closed down shortly after his death.

Tina stayed on in San Francisco for nearly a month. She later recalled with some embarrassment how in 'a moment of mysticism' following Robo's death, she wrote a poem, apparently published at the time. San Francisco engulfed her in memories; it was the scene of her meeting and courtship with Robo, and of her arrival into her father's arms, innocent and eager to begin a new life. Now both were dead and she was on her own. Despite her vow not to visit friends, she soon turned to Johan Hagemeyer for support:

> I hesitated long whether to get in touch with you for I had made it my
> programme before coming here not to see anyone outside of my fami-

ly. But the other day – finding myself alone – an uncontrollable desire came upon me to hear *Nina* again. And so I did – and as I listened to it the agitated life of these past few months became dimmer and dimmer ...

Hagemeyer served as a sounding board to help Tina clarify her thoughts in a time of crisis, as she tried to come to terms with her loss. 'Fond as I am of this place,' she wrote before going to see him,

> yet I am anxious to leave it – it holds too many memories for me – here I live constantly in the past, and 'Life,' said George Moore, 'is beautiful at the moment, but sad when we look back.' For me life is always sad – for even in the present moment I feel the past. Mine must be a spirit of decadence, and by living here I only give vent to it – but yet – I feel that only by living in the past can we revenge ourselves on nature – I wonder how you feel about all this – perhaps we can talk it over.

Two weeks later, Tina left San Francisco for Los Angeles. After struggling with the ambiguities of her new situation, she had decided that her next step would be to round off the chapter of her life with Robo. Perhaps it was guilt over his sudden death or the pain he had been caused by her affair with Edward that made her immediately throw herself into sorting out his work and planning an exhibition of his paintings and batiks. By mid-May, she had organized a two-week showing of his work at the MacDowell Club of Allied Arts. A local newspaper published a Weston portrait of her alongside an article on the event. Dressed in black, and controlling her emotions with 'a momentary quiver of the lids and a quick little paroxysm of the throat', Tina revealed the essence of her motive to the reporter: 'I am thinking of him – dying alone, with no member of his family near him. It was terrible.'

She also began preparing a selection of Robo's writings for publication. He had begun work on a novel and invented a language called *Ziziquiyana* in which he concocted words based on images and sounds. By the end of the year, Tina had edited a collection of his poetry and prose, *The Book of Robo*, with an 'Introduction' by John Cowper Powys and a 'Biographical Sketch' by herself.

In the process of settling her 'debt' with Robo, Tina was becoming increasingly aware of her new independence. Realizing that she was no longer a married woman, she began to use her own name again, signing herself Tina *Modotti* de Richey. Her new-found independence must have grated on Edward, who was feeling increasingly restricted by his marriage to Flora. Although devotedly attached to his children, he believed that his family duties were inhibiting his art.

A further irritation was his lack of economic independence. Weston's photography had won him many accolades, but it did not keep him from having to depend upon Flora Chandler's teaching and real estate income to support the family. The purse-strings of the household were firmly in her hands.

Tina could not have enjoyed this situation either and there is some indication that she encouraged Weston to become increasingly independent of his family, probably as much from an unwillingness to continue playing the role of 'mistress' as from concern for the restrictions imposed by his family life. In a letter to Ramiel McGehee, Margrethe Mather refers to a certain night when a distressed, weeping Flora came to see her,

> blaming herself for holding Edward back – I told her – in front of Tina – that she was responsible for Edward's success – without the balance of her and the children – the forced responsibility – Edward would have been like the rest of us – dreaming – living in attics – living a free life (O God!) etc. etc. not growing and producing as he had. Opinions to the contrary ...

The implication is that Tina's opinion was one of those to the contrary, an indication that she and Margrethe were engaged in a kind of tug of war over Weston.

Tina was still disillusioned with her acting career. Her role as model and film actress in the artistic creations of others must have been both frustrating and unfulfilling when contrasted with the creativity of Weston, Hagemeyer and Mather, and the other artists in their circle. She began looking for another means of self-expression, one which would be personally gratifying and at the same time provide her with a livelihood. Weston, always generous in sharing his skill and art with others, encouraged her to take up photography, and it appears that by early 1923 she had decided to do so. Several years later, she recalled this period:

> Going back to photography Edward – you don't know how often the thought comes to me of all I owe to you for having been *the one important* being, at a certain time of my life, when I did not know which way to turn, the one and only vital guidance and influence that initiated me in this work that is not only a means of livelihood but a work I have come to love with real passion and that offers such possibilities of expression ... My heart goes out to you with such a deep feeling of gratitude ...

Margrethe Mather probably did not welcome Tina's intrusion into her territory, taking over as Weston's closest apprentice and assistant,

a role which she had long enjoyed. Margrethe had been Weston's almost constant companion since 1912, but their relationship was complicated by the fact that she was 'mostly, though not wholly, a lesbian', which was presumably why she resisted Weston's persistent sexual advances for years. She was very eccentric, given to wearing capes and extravagant hats or slopping around in men's shoes. Although her erratic moods caused her to disappear for days on end, dissipating much of her considerable talent for photography in bouts of drinking, Weston often described her work in glowing terms.

But Tina eventually won the tug of war with Weston's family and Margrethe. Her understanding of his frustrations drew them closer during this difficult period. Likewise, his sensitivity at the time of her father and Robo's deaths, which had deeply saddened him, must have further endeared him to her. He travelled with her to San Francisco to visit the Modotti family, and came to be warmly accepted by them. He made an especially poignant portrait of Tina and Assunta Modotti in this period, entitled *Tina and Mother*, which portrays the older woman seated, while her daughter stands protectively over her, her face a soft glow, the personification of a comforting presence.

But Tina and Edward still felt restless and particularly dissatisfied with life in Los Angeles. They found the increasingly restrictive laws, Prohibition and the growth of the Ku Klux Klan unbearable. Their mutual confusion about the direction to take seems to have resulted in a minor crisis that led to a temporary parting. It is not clear how the decision was made, nor who initiated what appears to have been an amicable separation, but the break occurred in October just before Tina left once more for San Francisco. According to Ben Maddow, who had access to Weston's daybooks before he destroyed the early entries, Tina not only went with the aim of visiting her mother, but also with the intention of looking into the feasibility of opening her own photographic studio. It may have been that under Weston's guidance she had already become sufficiently proficient with the basics of photography, or perhaps she simply had a romantic yearning to realize her father's old dream and make a success of a photographic studio in San Francisco.

Weston had planned a journey of his own, to Ohio to see his sister Mary and her family. On board the train for San Francisco, Tina wrote to him to wish him well on this trip, which would profoundly affect his life and photography. Obviously already missing him, she wrote in a wistful mood:

I looked out at the black night – at the houses lit from within – at the

trees shadowy and mysterious – I thought of you – of your trip – of your dear letters to me and the desire to draw near you was so intense – I suffered – the best in me goes out to you my dear one. Good-bye – good-bye Edward – may you attain all you deserve – but is that possible – you give so much – how can 'Life' ever pay you back? I can only send a few rose petals and a kiss – .

During her visit, she contacted her cherished friend Hagemeyer, eager to see him and to hear if he had any news from Weston. In what was becoming a pattern, she was fonder of Edward in his absence than when they were together. Meanwhile in Ohio, Weston was taking photographs of the great steel plant and smokestacks of the American Rolling Mill Company that marked the beginning of a new and exciting period in his work. His brother-in-law gave him the money for a trip to New York, where he finally met the master of the photo-secessionists, Alfred Stieglitz, and other prominent avant-garde photographers. Convinced that the New York trip was important for him, Tina sent him two air-mail 'special' letters containing 20 dollars each. While she knew the extra cash might also be used for more pressing needs, she discreetly indicated it was for him to see the Broadway hit *Chauve Souris*, which he did and thoroughly enjoyed.

Evidently, Tina's idea of having her own photographic studio was untenable or the possibility of re-entering her San Francisco past was too daunting, for she had dropped her plan and returned to Los Angeles by 10 November, in time for the opening of the first major US exhibition of Mexican folk art and modern painting. Accompanying the exhibition were Mexican artist Adolfo Best Maugard, the brain behind the project, and the painter Xavier Guerrero, the artistic director. Tina was involved in some capacity with the project, since at the time she was making gifts of the exhibition's catalogue, inscribing one copy 'For Miss M. d'Harcourt with best compliments from the Mexican Exhibit & from Tina Modotti-Richey/12–1922'. The catalogue was compiled by the American writer Katherine Anne Porter, with photographs by Roberto 'Tito' Turnbull and a cover designed by Guerrero. In addition, Turnbull filmed the exhibition, which included some 5,000 pieces of every kind of Mexican folk art imaginable. A showing of modern watercolours and oil paintings by Guerrero and Best Maugard was also held.

Xavier Guerrero remained in Los Angeles for several months, during which time he must have been an important influence in persuading Tina to return to Mexico. She was so dissatisfied with life in California that she was probably not hard to convince, because by the time Edward arrived back in Los Angeles around Christmas she had

Xavier Guerrero at the
Mexican folk art exhibition,
Los Angeles, 1922

decided to move to Mexico. They seem to have had a reconciliation as soon as he returned, and when Tina mentioned her plans to go to Mexico Edward saw it as an 'opportunity' for him to go as well. Leaving their previous confusion behind, the couple moved decisively to consolidate their relationship and plan their trip. By early January, Edward had left Flora and moved into his studio and he and Tina had begun to work out a verbal 'contract' whereby they agreed to move together to Mexico under certain specific conditions.

In professional and artistic terms, Weston agreed to 'teach Tina photography', taking her on as his 'apprentice'. In return, she would work for next to nothing – room and board, in fact – as his studio assistant. In addition, since Weston spoke no Spanish and Tina had learned on her previous visit to Mexico that her native Italian lent itself to understanding and speaking Spanish, the arrangement meant she would virtually run Edward's photographic business in Mexico, taking on 'a lot of responsibility, worry and hard work'. Probably not so clearly spelt out in their 'contract' was the extent to which Tina would be responsible for the running of the household and the caring of Edward's eldest son, Chandler, who was to accom-

pany them. The professional terms of their agreement appear to have been understood as being completely independent of its amorous aspects. Indeed, in emotional terms the agreement appears to have been open-ended, as both their behaviour would later bear out. If it was, as Weston later told Hagemeyer, seen as a kind of 'trial marriage', the two were to be wedded together under the most liberated notions of sexual freedom. There seems to have been a clear understanding that both were free to pursue 'extra-marital' affairs at will.

After Weston went to live in the studio, Tina spent an increasing amount of time there, probably even living there part of the time. The studio was a tiny two-roomed wooden structure. Comfortable chairs were scattered on a rustic back porch and fruit trees and cornstalks grew in the garden. Many disapproved of Edward's decision to leave his wife and abandon his children to go off to Mexico with Tina. And some of the disapproval was tinged with prejudice, as Yolanda Modotti remembered: 'There was a big hoo-hah because [Weston] was leaving his wife for an Italian.' Weston later reflected that

> A long period of personal conflict was required before I finally decided to break away and leave my family for Mexico. To the outer world I was a deserter, but I was not. If I had remained under conditions which could not have been, and never will be, changed, I would have mentally poisoned all around me; destroyed them, my work, myself.

He resisted the pressure with the support of his closest friends. In early January, he wrote with resolve to Hagemeyer:

> We leave for Mexico in March – Tina, Chandler and I – this seems quite definite at this writing – I am working desperately in order to 'burn my bridges' behind me. Shall we meet again? I hope in some far off country.

Their departure was planned for March, but was postponed so often, primarily to earn extra cash, that friends teased them mercilessly. Weston, taking the 'open' nature of their new understanding to heart, went off in early April for two or three days 'on a little adventure'. Tina had progressed sufficiently by then either in her knowledge of photography or in her responsibility for the business or both to be in charge of the studio while he was gone. No sooner had Edward left town than Hagemeyer showed up. It is not clear whether his swift arrival meant he expected to have his own 'little adventure' with Tina in Weston's absence.

Notes in Hagemeyer's diary of the time show that by then Tina was at least proficient in developing and printing, and that she may even

have been taking photographs on the outings they made together. On Saturday 14 April, Hagemeyer wrote that he had been out at the studio with Tina and the sculptor Gjura Stojana for a 'great, great day – red tulips – night at the house'. By the next day, Weston had returned and Hagemeyer wrote that in the morning 'T[ina], M[argrethe] E[dward] and I [were] working at the tile factory.' Later they went again to see Stojana and he again made a note: 'What a day!!! Oh! T[ina] drunken with pictures, wine – rose petals.' The following day it was: 'T[ina] and I developing … willow confessions.' We can only speculate about what Tina and Johan confided to each other in the darkroom, but when they emerged there were further photographic sessions at Stojana's and walks through the hills, golden with mustard flowers.

Tina and Edward enjoyed Johan's company for about ten days of intense discussion on a wide range of topics, especially photography. Not only did Tina join Hagemeyer on the photographic outings, but some of his portraits of her – very different in mood and texture from those of Weston – may also have been made at this time. Weston described those days:

> Together or with Tina or Margrethe – sometimes all four of us – we spent many vivid hours – at Stojana's – the Philharmonic – once an evening with Buhlig listening to his reading of that amazing poem *Waste Land* by T.S. Eliot …

During their last few weeks in California, Weston set the tone for his and Tina's relationship in Mexico. It is possible that even before they left Los Angeles, Tina's feelings for him were becoming more platonic and their relationship was already on a more professional basis. In a last-ditch attempt to break down Margrethe Mather's defences, Weston had persuaded her to go away with him:

> They spent ten days together, at last, in a beach house; this pleasure was granted because Weston was about to make his first trip to Mexico. He said the experience was pure ecstasy for both of them; but he had his doubts years later, and told some of his friends that he was certain she faked the orgasms. Maybe so, but it was a gesture made out of love, for she was truly desolated by his departure – with another woman!

As with most of the women he seduced, Weston took many nude photographs of Margrethe. In these striking, strangely detached images of her body sprawled on the sand, we cannot see her face, but we do know something of what she was feeling. Weston somewhat callously recalled that when he left her, 'She literally was on her

knees, begging to be my slave ... [begging me] not to leave her.'

On 29 July, a hot and muggy Sunday, Tina, Edward and Chandler were accompanied to the SS *Colima* by half a dozen friends and family. Rose Krasnow, the wife of Peter Krasnow, Weston's Ukrainian-born artist friend, drove them 15 miles south from Los Angeles to the port of San Pedro. Ramiel McGehee, so close a friend that Weston had written to him, 'I have seldom loved as I love you', had meticulously packed his bulky camera lenses, developing chemicals and personal effects for him, and made his own way to the pier to say goodbye. Margrethe Mather did not make an appearance.

For Chandler Weston, the very thought of the trip was exciting. But for his younger brothers, it must have been 'horrendous ... to witness this separation'. Indeed, Weston's three young sons waved sadly when the ship pulled away from its berth. Flora Weston made a courageous effort to stifle her hostile feelings, calling out to the woman who had assumed her place at her husband's side to look after him and her child. Tina stood watching alongside Edward and Chandler, as the figures of those at the pier blurred, then disappeared, 'till finally only the gleam of white from a handkerchief' could be seen ... and then they were at sea.

PART II

1923 – 1929

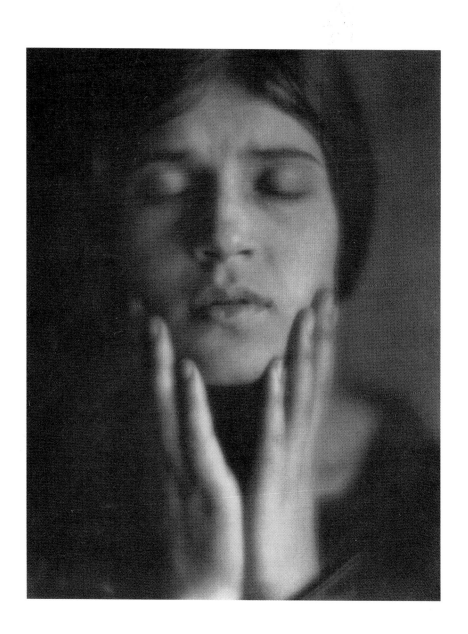

Tina reciting. Photographer:
Edward Weston, 1924

8

Strange New World

The SS *Colima* pulled slowly out of San Pedro and headed south for Mexico and the Pacific port of Mazatlán. Once at sea, it was a new world for the three travellers, full of sights and sounds and smells that made their lives in Los Angeles seem immediately distant. It was the smells that were most noticeable at first, and hardly romantic, for the *Colima* was a United Fruit Company cargo boat carrying a load of very unpleasant smelling animal hides.

Resigned to bear the odours along with Tina, Edward and Chandler were eight or nine other passengers. The crew members and captain were all Mexican, 'colorful and inefficient' yet at the same time a relief from the familiarity of the life they had left behind. Tina began her role as interpreter right away, helping Edward communicate with the Spanish-speaking crew. Her rapport with the ship's captain resulted in their receiving special privileges. Much to Weston's chagrin, since he was convinced it was only because of Tina's beauty and charm, the captain went out of his way to please – allowing them to use his private deck, inviting them for drinks in his cabin and lending them his launch to go ashore.

On their second night out, the ship 'cut through silent, glassy waters domed by stars – toward what unknown horizons?' as Weston wrote in his daybook. The next day the air of romance hit the reality of the rolling seas, the small sluggish ship heaved and pounded, and Tina soon became seasick. But she quickly recovered and joined Edward and Chandler sunbathing in deck chairs, reading and watching the flying fish.

Snapshots were taken to record the occasion. In one, Tina and Edward sit together in the shelter of the ship's lifeboats. As the shutter is pushed, Tina looks up from the magazine she is reading and smiles broadly at the camera. Basking in the bright sunlight, apparently shel-

tered from the breeze, her head is covered only by a scarf and she wears a bright print blouse and light-coloured, calf-length skirt, dark stockings and the sensible shoes she always favoured. Weston, more formal in long-sleeved shirt and tie with a peaked cap to shade his face from the sun, sits quietly across from her, apparently lost in contemplation.

Six days into their journey, the *Colima* pulled into the silvery moonlit waters of Mazatlán harbour, anchoring just after midnight. In the morning, the three travellers excitedly prepared to go ashore. It was Tina's first visit to this part of Mexico. The town was filled with 'cool patios glimpsed from sun-baked streets which sheltered coconut palms, strange lilies, banana trees'. To escape the fierce mid-day heat and the tropical humidity, they sipped cool drinks on the patio of the Hotel Belmar. Later, an afternoon 'cocktail' with the captain became a tequila party with a dozen or so revellers: 'Strange,' Weston remarked, 'how one can understand a foreign tongue with tequila in one's belly.'

After spending the weekend in Mazatlán, the ship sailed towards Manzanillo, arriving there early on the following Tuesday. Going through customs tested Tina's charm and interpreting skills as brusque inspectors looked suspiciously through Weston's camera gear. The group later toured the town in a horse-drawn coach with the ship's captain and while they were pausing to have a drink on the

Tina and Edward on the boat to Mexico, 1923

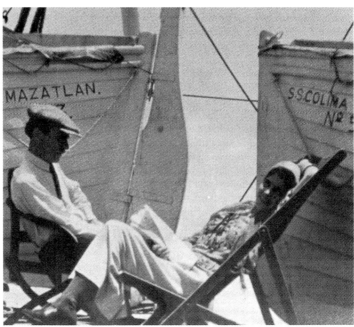

waterfront, a trio of street musicians approached them and played 71
the ballad of *La Borrachita* (The Little Drunk Girl). A slightly tipsy
Edward summed up his feelings: 'My Anglo-Saxon reserve was put
to test – and lost. But it was more than the music – the hospitality –
the blue sea – which broke my resistance: I knew that this day
marked an end – and a beginning.'

From the balmy port of Manzanillo the train meandered through
miles of coconut and banana plantations towards the tropical city of
Colima. At every stop, local Indians sold exotic fruits – deep yellow,
perfumed mangoes, fresh slices of fleshy white coconut in its dark
brown husk, smooth green avocados and lemon-syrupy sugar cane.
There were also steamed corn *tamales*, wrapped in pale green waxy
banana leaves and stuffed with tender iguana meat; sticky, sugar-
frosted candied fruits and refreshing cool drinks.

Colima was sleepy, provincial Mexico, its age-old traditions scarce-
ly shaken by the revolution. The central plaza, with its stately palm
trees, was surrounded by hotels and municipal buildings. The streets
running off it in classic Spanish grid pattern gave the town a
European rather than American appearance. Tina dusted off her
skills learned in the Udine marketplace, bargaining with an old
Indian selling a bunch of aromatic long-stemmed spikenard. She
desperately wanted them, and though the old man got the better of
the bargain, she at least got her flowers!

In the evening, they found a small girl sitting in the torch-light
against a pillar in one of the town's long, arched promenades which
by day shelter pedestrians from the scorching sun. Her name was
Carmen and she was dozing over her tray of roasted pumpkin seeds,
offered as snacks to passers-by. Chandler Weston remembers that
Tina was 'very emotional' and the poverty in Mexico affected her
deeply. Perhaps it was the memory of the hardship of her own youth
and the suffering of her younger brothers and sisters that caused her
to be so moved at Carmen's plight, blurting out:

'Will you come with me, Carmen, to Mexico? You shall be my little sis-
ter.' Carmen's eyes dropped, this time with a shy, almost frightened
hesitancy; we must ask her mamma who would soon return.

Carmen's mother was suspicious of the strange foreigners who
wanted to take her daughter away; Carmen's father would never
allow her to go, she explained. She became friendlier when Tina and
Edward gave them gifts of jam and other delicacies, and finally
waved goodbye to the little girl.

The train from Colima passed through Guadalajara, where Tina,

Edward and Chandler spent a day before travelling on to Mexico City. During the night, as they approached the capital it rained so hard the roof leaked all over Tina's sleeping berth. Arriving at 8.30 in the morning, they went directly from the station to the Hotel Princess. The hotel, with its wrought-iron, canopy-covered balconies, overlooked the lush Alameda Park and was within sight of colonial churches and the elegant, art-deco Teatro Nacional. It was a first-class hotel, with a large dining-room downstairs, and advertised 'American service and comfort' at a mere three dollars and upwards.

Those first days, as Tina and Edward looked for a house to rent, must have been full of laughter and fun at the surprises of their new environment. On their first outing, a bustling weekday in the heart of Mexico City, they hailed a cab in front of the hotel, hoping to go sightseeing. Weston recalled a few moments of bargaining between Tina and the driver, and then, having settled on a price, she stepped happily up into the cab:

> Now Tina is not thin – neither is she fat – but as she stepped in, she also went down, for the cab floor gave way and there she straddled, one leg on the step, the other passing through a hole in the cab floor! Pedestrians and loungers had a good laugh, covert or open; they also had a good look, for Tina's legs are well worth an extra stretch of the neck to see. As gracefully as possible, we regained our lost dignity and bravely hailed another cab, while the first driver, mumbling oaths and apologies, stood contemplating his wreck.

First impressions are always important, and Tina and Edward's were favourable. The hated middle-class morality of the United States was now behind them and they made no concessions to it. They used their own names, refusing to pose as a married couple, and no-one in hotels or elsewhere questioned why Tina Modotti and Edward Weston were living together or sharing a room. The dreaded Ku Klux Klan would not bother them here. Just about the time they arrived, a pompous Mexican who styled himself the local Grand Wizard made the mistake of showing up at the newspaper *Excelsior* in a white sheet and hood to protest an anti-Klan editorial and was carried out feet first when pistol-packing Mexican journalists proved to be quicker on the draw!

Tina and Edward were also thrilled that Prohibition stopped at the Rio Grande, and Weston in particular showed an intense interest in local bars, called *pulquerias* after the traditional brew, *pulque*, a maguey-cactus, distilled, green mash that oozed with alcoholic potency. Mixed with fruit to make it more palatable, the more daring

– and experienced – described it as having the taste and appearance of semen! With Tina translating, Edward made a long list of the bars' fanciful names, usually painted in gay colours at the entrance: 'An Old Love', 'Hope in the Wilderness', 'Death and Resurrection' and 'On the Waves'. They explored the city centre with its ancient churches and magnificent cathedral, dining at the 'House of Tiles', a romantic sixteenth-century former palace, famous for its blue-tiled façade. The building had been requisitioned in 1915 by the anarcho-syndicalist 'wobblies' and briefly converted into the 'House of the World Worker', but had long since devolved into a typical American restaurant and drugstore with the very un-Mexican name of 'Sanborns'.

After a week of tourism and house-hunting, the couple found what they thought was a suitable abode: the house of an old *hacienda* in Tacubaya, about 40 minutes from the centre of Mexico City. Although it had a proper street address, *El Buen Retiro* (The Good Retreat) was in a rural setting, with views of the snow-clad volcanoes and the castle of Chapultepec. The rooms opened onto a spacious inner courtyard with exotic shrubs and trees, a delight to Tina, who adored plants and flowers. In the middle of the courtyard was a water well and hand pump, the source of ice-cold water for morning baths in the open air, 'standing naked on the sunlit patio, with the musk-rose, the twittering birds … then basking in the early morning sun'. The large rambling house resembled a manor fallen upon hard times: ten high-ceilinged rooms with thick walls and tall arched windows with wooden shutters. The rent was steep at 125 dollars per month, but they had acquired a lodger to pay nearly half. Llewelyn Bixby-Smith, the young son of a wealthy California family, had just arrived in Mexico to study photography with Weston.

On the first night, there was gunfire outside their shuttered windows, which opened onto the street. This was not, as Weston noted, the 'ordered calm of Glendale'.

It was at *El Buen Retiro*, in the frame of a tall arched door and of a window with a wrought-iron balcony, that the first serious photographs of Tina in Mexico were taken. They show her in a dark dress and shawl, in melancholic poses, a solitary, withdrawn figure. Weston later described these portraits as belonging to the romantic school and not reflecting his new attitude towards photography.

They had much work to do still on their new home. Furnishing it was a problem, until they discovered *El Volador*, a huge indoor flea-market behind the National Palace with an incredible variety of wares. After stocking up on Puebla pottery and other odds and ends, they also bought

an old inlaid chest which ... after much bargaining on Tina's part, was ours for fifteen pesos. And, oh yes, the string of eighteen amber beads – lovely uncut ones, half-hidden in the clutter of an old Italian's stall – was purchased for two pesos.

The 'old Italian' was Cesare, whose stall Tina frequently returned to. He seems to have been the first *paesano* she met among Mexico's Italian immigrant community, which had been growing steadily since Mussolini's takeover in Italy the previous year.

Tina and Edward were amicably received by most of the Mexicans they met. Xenophobia was not so prevalent then and, as a close friend recalled, 'There wasn't yet such a hatred of *gringos* and Mexicans didn't have such an inferiority complex about the United States ... ' In addition, men in post-revolutionary Mexico had become more willing to listen to women, as women began making inroads into areas previously closed to them. Tina's role as Weston's interpreter and the organizer of his studio seems to have been accepted without question.

Within a few days, Tina took Edward to see the work of Diego Rivera, who had now completed his *Creation* mural and had moved on to painting the walls of Vasconcelos' new headquarters, the Public Education Ministry building. Both were thoroughly impressed with Diego's work and Weston lamented not being able to speak to him directly, because he spoke no Spanish and Rivera no English. Much had happened in the mural renaissance world since Tina's 1922 visit. The artists working on the murals had organized themselves into a union, the 'Syndicate of Revolutionary Painters, Sculptors and Engravers of Mexico', and negotiated a contract to paint 760 square metres of the Public Education building, with payment calculated at the standard rate for plastering work!

Xavier Guerrero, who was still Diego's chief assistant, was later dubbed the 'uncommon common denominator' of Mexican muralism. He had rediscovered the lost fresco technique of Mexico's ancient Indian civilizations by carefully comparing stucco techniques used by his father, a house painter in Guadalajara, with the remains of indigenous frescos. Shortly before Tina and Edward's visit, Guerrero's experiments had convinced Rivera to abandon the encaustic method he had used in the first murals in favour of the fresco technique that would make him famous. Although Guerrero's contribution was forgotten with time, Rivera initially gave him full credit for what was hailed as the discovery of the ancient *Mexica* Indians' secret.

After a month in Mexico in which they were too busy working on

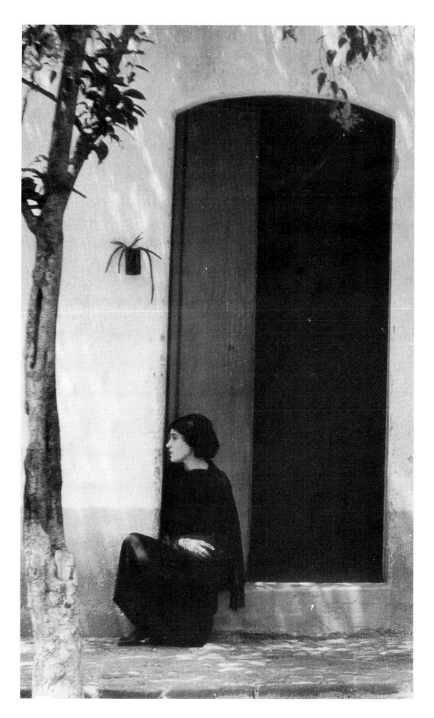

Tina, El Buen Retiro, Tacubaya.
Photographer: Edward Weston

their new home to have even one night out, Tina and Edward went to dinner with Roberto Turnbull, whom they had met during the folk art exhibition in Los Angeles. Not only had he provided the still photographs for Katherine Anne Porter's catalogue to accompany the folk art exhibition, but he even employed the writer's shapely legs in a film about a man working in a basement who falls in love with the legs of a woman passing by a street-level window above. The story line, Porter later said, was the young man's 'pursuit of the upper part of this girl'.

Diego Rivera had also made a dinner date with them, but failed to show up, so Xavier Guerrero and his sister Elisa came in his stead. They went together to Monotes, a lively café serving cheap and filling supper snacks, directly in front of the popular Teatro Lirico, where the tables and chairs were rustic, and traditional Mexican weavings served as tablecloths. *Monotes* literally means 'Big Monkeys', a Mexican euphemism for 'Big Caricatures'. The restaurant was owned by the brother of the painter José Clemente Orozco, and his brilliantly biting caricatures of Mexico City street life lined the walls. Elisa Guerrero, dressed in an Indian *huipil*, an embroidered blouse, from her native state of Coahuila, with her black hair braided and wound about her head, became the focus of Weston's attention from the moment he set eyes on her. They agreed to practise their Spanish and English together, making an appointment for the following Thursday. In their first session, the language lesson Weston most remembered was Elisa teaching him to say 'I love you'. Since she wanted to learn English and he Spanish, he reasoned that apart from their other desires, their classes would provide many a pleasant evening.

But there was not a lot of time for frivolity, as fixing up *El Buen Retiro* was no small task and Edward and Tina were caught up in a whirlwind of plumbers and painters. The place had to be made both habitable and suitable for a photographic studio. Tina, ever 'down to earth' in such matters, as Chandler remembers, threw herself into the many chores, among them trying to secure a telephone line for the studio. Other tasks included everything from buying furniture to dog biscuits for Llewelyn's dog, one of her first photographic subjects, not to mention making mayonnaise. The renovating was tiresome work which left them all with blistered hands and aching backs, but when it was finished the effort seemed worthwhile. Edward had the room of his dreams, furnished simply with items Tina had bargained for at *El Volador*. But already he was feeling homesick, as though he was not in Mexico of his own free will. He may have been

missing his children or experiencing some guilt at abandoning them, because his first letter home was a defiant attempt to justify the step he had taken. His assurances that nothing more than 'a fine friendship' existed between him and Tina and his half-serious reference to falling in love with a 'dark-skinned *señorita*' can probably be dismissed as no more than his trying to reassure Flora. Nevertheless, he and Tina already had problems and in some aspects their relationship was floundering. Edward noted in his daybook that

> Barefoot, kimono-clad, Tina ran to me through the rain – but something has gone from between us. Curiosity, the excitement of conquest and adventure is missing. 'Must desire forever defeat its end.'

These elements were not missing from his flirtation with Elisa Guerrero and he kept his first date with her on 30 August, within four weeks of their arrival in Mexico. His and Tina's agreement on an open-ended relationship was already in practice and it remained to be seen if their love for each other could weather it.

Meanwhile, all was not well with their choice of a home and business. Friends had warned them it was madness to think of running a studio so far from the city, and now even they had become pessimistic. Confirmation of their misgivings came in mid-September, when the telephone company informed Tina that *El Buen Retiro* was beyond the reach of the existing telephone lines. Without a telephone, there could be no photographic studio, for there would be no way for clients to make appointments.

Despite their disappointment, for they loved the big, rambling' house which had begun to seem like home, and in spite of the six-months lease they had signed, Tina and Edward began to look for a new house. Their aim was to find one closer to the city, where they could set up a darkroom immediately and print Weston's photographs for an exhibition of his work in mid-October which Tina had helped to arrange. They searched for days till they found something suitable – an elegant house on Lucerna Street in the Colonia Juárez, a fashionable neighbourhood not far from the centre of town, which allowed them the possibility of recreating the bohemian lifestyle they had had in Los Angeles.

9

Mexican Odyssey

Tina and Edward's move from rural Tacubaya to the Colonia Juárez brought them closer to the heartbeat of the Mexican capital. The lake bed city was still reeling from the years of revolution, its daily life pitching back and forth between bursts of feverish growth and political upheaval. While shops filled with goods pointed to the prosperity of the post-revolutionary economy, rent strikes and labour agitation could still bring the city to a standstill on any given day.

Tina and Edward's neighbourhood was just a short walk or tram ride from the enclave of Mexico's cultural renaissance, the virtual city within the city where the artists and writers congregated around the National University and the Education Ministry that subsidized their writings and paid for their murals. Clearly, the Juárez district had been created to permit the national and foreign élite of the Porfirio Díaz dictatorship to have their elegant, European-style residences close to, but not consumed by, the hubbub of the city centre. The palatial homes along the tranquil neighbourhood's wide tree-lined avenues were punctuated by small cluttered corner shops. By day, pedlars offered their services at the back doors of the mansions, and street vendors pushed handcarts selling succulent fruit sherbet to uniformed nannies and their wealthy little charges. At dusk, newspaper boys on nearby Bucareli Avenue called out the evening headlines and at night the eerie squeal of the steam whistle from the charcoal-fired carts of the baked yam sellers echoed through the lamplit streets.

To Tina and Edward, the Colonia Juárez meant the possibility of a successful photographic business. The monied families who lived there were not only inclined toward the flattery of having their portraits made by a new American photographer and his Italian assistant, but could also pay handsomely for the privilege. They were mostly influential, upper-class clans of primarily European origin, like the

Amor family, which had opposed the agrarian revolution in an attempt to protect their huge sugar plantations.

The new house was enormous and the rent of 130 dollars was high, but Llewelyn paid his share and Tina and Edward planned to rent out other rooms. Although the location was perfect, the house was too grand for their taste and they blanched at the hideous decor of its tasteless, *nouveau riche* owners. They all wanted the simpler upstairs rooms and servants' quarters, with their proximity to the flat roof *azotea*, perfect for taking photographs, sunbathing or just watching the magnificent Mexican clouds. Tina won the contest, getting a room on the second floor which opened onto a balcony above an inner courtyard and stable, above which they built their darkroom. Within days, she had managed to get a telephone installed and the photographic studio was underway.

Tina on the azotea.
Photographer:
Edward Weston, 1923

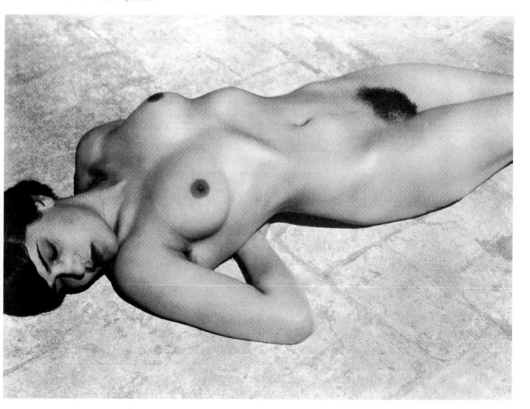

Chandler was given the task of building a wooden gangway from the balcony to the top of the stable and over to the darkroom. He hammered some boards together, strong enough to support an average person's weight, then watched in fear and awe when Diego Rivera made his first visit. Ambling ponderously across the makeshift bridge, the planks groaning and swaying with his every step, the 300-pound giant miraculously made it safely to the other side and the boy heaved a sigh of relief.

The first photographic task was to meet the deadline for the exhibition, arranged for the third week of October in the 'balcony' room of the Aztec Land, an all-in-one tea salon, English-language book store and folk-art shop on Madero Avenue. Tina posed for more portraits to add to those made during their first month at *El Buen Retiro* and she and Llewelyn bought the wood to build a darkroom. With everyone helping, Weston hastened to prepare the photographs for the showing.

Nearly 1,000 people turned out during the two-week exhibit, with hundreds signing the guest book – including Tina, with an oblique message to Edward: 'Long life to your work – the only thing which "never fails" you – Tina Modotti-R, Mexico 1923.' Among the eight prints sold were six nudes of Margrethe Mather. Not surprisingly, the nude studies created quite a stir. In fact, the number of male art lovers visiting the exhibit outnumbered the women by ten to one! Weston later lamented their motives as having been less than artistic, complaining at their 'snickering over nudes that I certainly made with a clean mind'.

The Aztec Land exhibition marked Tina and Edward's debut into the vibrant whirl of Mexico City bohemia. Everyone who was anyone showed up – among them Adolfo Best Maugard, dapper in his elegant three-piece suits, cane and white gloves, whose theories on the teaching of painting had won him a top post in the Fine Arts Department; and their old friend Gómez Robelo, ravaged by tuberculosis, from which he would die within a year. Many new friends were made, in particular a young Spanish couple, the painter Rafael Sala, later to become Rivera's assistant, and his wife, Monna Alfau, a former journalist hired by Vasconcelos to work at the National Library. And of course, Lupe Marín arrived, striding like a panther, in the company of Diego Rivera.

One day, a strange little middle-aged man showed up with his dramatically beautiful young mistress, and Tina and Edward met 'Dr Atl' and 'Nahui Olin'. These were the adopted Aztec names of Gerardo Murillo and Carmen Mondragón, two painters who lived

together in a former monastery where they indulged in a wild sexual
abandon which scandalized their neighbours. He was recognized as
the godfather of the folk-art movement and was possessed with a pas-
sion for volcanoes. She was the daughter of a famous general, and
had married and separated from the painter Manuel Rodríguez
Lozano, alleging he was homosexual. Legend says that she had
become slightly crazed from having intentionally or unintentionally
smothered their infant daughter by rolling onto her in bed. The fact
is, she was an accomplished painter and writer with flashes of bril-
liance, had posed for Rivera's *Creation* mural and was a member of
Mexico's nascent feminist movement.

Weston's exhibition was highly successful and resulted in numerous
portrait sittings and he and Tina being wined and dined by their
recent acquaintances. It was Tina's initial contacts, made during her
first visit to Mexico, that opened up this new world to Edward. She
was now officially his pupil and assistant, becoming the principal pro-
moter of his work and his contact with the Mexican press and other
artists, explaining the ideas he lacked the ability to communicate in a
foreign tongue and sometimes translating for him the vanguard ideas
of Mexican artists.

Within days of the exhibition they were seeing a lot of the Salas,
attending an exhibition of Rafael's and visiting them at their Coahuila
Street home. Another friend who visited the Salas at the time was
the young Mexican artist, Rufino Tamayo, Rafael's assistant on the
Iberoamerican Library project. Tamayo frequented the Salas' home
and another haunt of Tina and Edward's – the
artists' colony on the property owned by the painter
and sculptor Germán Cueto on Mixcalco Street, in
the heart of the commercial district near the cen-
turies-old Merced market. With the founding of the
revolutionary artists' syndicate in 1922, Cueto had
built a collective art workshop in the patio, renting
the several houses which faced each other across a
narrow alleyway at the back of the property to other
artists. His most famous, and rowdiest, tenants
were Diego and Lupe.

It was here that Tina may have found the subject
of what is today considered her first serious photo-
graph. Germán and his wife, Lola Cueto, had
founded a marionette theatre, for which Germán,
an adept sculptor in all media, and Lola, a painter
and designer, made the puppets and did the stage

My Latest Lover!
1923 [TM]

design. The performances were held in the large patio of their home. In February, Tina proudly sent Johan Hagemeyer a tiny photograph of a moustachioed, *serape*-wearing Mexican marionette, whose dark costume and *sombrero* meld into his black silhouette, cast upon a light-coloured background. She called it 'My Latest Lover!', and in an accompanying note wrote: 'See? What I have for a lover today? I send you his image … ' It may have been the photo of Tina's 'lover' that so pleased Edward, when in a letter to Johan the following day he mentioned that Tina had taken a photograph 'I wish I could sign with my name – that does not happen often in my life!'

Tina and Edward were frequent visitors to Mixcalco Street, for parties and traditional six o'clock hot chocolate at the Riveras' home, a warm place, colourfully decorated in Mexican style – yellow pine tables, rustic wood-and-leather furniture, straw mats on a red terracotta tile floor and Diego's Cubist paintings on the walls. They met not only the Cuetos, but others of the Mixcalco group, including the green-eyed firebrand of the artists' syndicate, who spent as much time agitating as painting, the muralist David Alfaro Siqueiros.

Now there were lots of nights out, with ventures into local *cantinas*, and as Christmas approached Tina and Edward often strolled through the menagerie of colours and smells from food and crafts stalls in the Alameda. They began their fabled Sunday outings with an expedition to the ancient village of Xochimilco, once the site of the floating gardens of the Aztec emperor Moctezuma. The canals and the bright geraniums on wrought-iron balconies reminded Tina of Italy. The barges which drifted through the maze of waterways were gaily decorated with flowers and had women's names written in petals above their prows: Paloma, Luisa and Gabriela. As they drifted along through flower gardens bright with pansies, marigolds and daisies, barges pulled up alongside with Indian women cooking local delicacies over tiny charcoal stoves. Other barges floated past with musicians who for a few *centavos* would play a favourite tune.

There were also the short-lived Saturday soirées hosted by the millionaire Oscar Braniff, son of a wealthy American-born industrialist. Tina became friendly with his wife Beatrice and she and Edward were invited to their garish home on the elegant Jalisco Avenue. The Braniffs' famous Saturday luncheons were a somewhat abortive attempt to create a fashionable Mexican 'salon'. They attracted everyone from French-educated, upper-class dandies to Communist painters in overalls looking for a free meal. Diego shocked more than a few when he brought his vegetarian lunch consisting of grapes and apples tied up in a red bandana to one of their banquets! It was at the

Braniffs' that Tina and Edward met the young French painter Jean Charlot, a master at woodcuts, who was then assisting Diego on his earliest murals.

December brought not only the inauguration of Plutarco Elías Calles as the country's new president, but the roar of cannons and the threat of revolution. Dissident congressmen and military officers backed Adolfo de la Huerta, a former general and once interim president, in a rebellion that lasted from early December to March. Progressives rallied to support the government troops against the rebels, amid reports from the countryside that de la Huerta's supporters were executing Communists and peasant leaders. The socialist governor of the Yucatán, Felipe Carrillo Puerto, was murdered in cold blood by de la Huerta's troops on the eve of his marriage to Alma Reed, the bright young American journalist. Tina's friends in the painters' syndicate pooled their money to buy guns in an ill-conceived attempt to form a volunteer squad to support the government:

> Xavier Guerrero nosed out a splendid bargain, and the Syndicate became the owner of a pile of short arms, guns and pistols. It was only when they were shown to a firearms expert that the question was raised – would they prove lethal for the target or for the man who pulled the trigger?

Everyone was affected in some way by the turmoil: communications were cut, isolating the capital; shops were closed and houses abandoned as wealthy Mexicans and foreigners fled the country. Tina and Edward used the extra cash they had on hand to stock up on dwindling foodstuffs. From their home they could hear the distant rumble of artillery fire. But since most fighting was further afield, for Mexico City dwellers the uprising mainly meant higher prices and a general cramp in their lifestyle.

It could not put a damper on New Year's Eve, however, when Lupe Marín and her women friends planned a celebration at Tina and Edward's home, convinced it was better for dancing. Early in the day, Lupe and friends arrived with their pots and pans and the ingredients and cooked up a host of traditional spicy Mexican dishes. The food was washed down with hot rum punch by the 30 or so guests, among them Diego, Charlot, the Salas and their friend, the ruggedly handsome Manuel Hernández Galván, a former revolutionary general, now a Mexican senator.

The New Year's party was such a success that Tina and Edward decided to host their own Saturday night *fiestas*. With the Braniff soirées cancelled due to the rebellion, the Modotti–Weston house-

hold became the prime venue for the raucous gatherings of Mexico City bohemia. Mexican and foreign artists, writers and folksingers rubbed shoulders with cabinet ministers, Communist militants and Mexican generals, who sometimes bared their anatomies after a few drinks to compare war wounds. There was little attempt at serious discussion – it was the 'art' of having a good time that mattered. The eating, drinking, singing and dancing lasted all night, occasionally deteriorating into pistol shots at dawn, as party guests became over-excited. A lively and vivacious Tina was at the centre of it all, some-times serving up masses of Italian spaghetti and red wine, always the focus of the male guests' attention.

There was a multitude of nationalities among the revellers, Weston counting seven on one night, and they each took turns at cooking their national dishes. The Indian 'Gupta', aided by his friend the agrono-mist Khan Khoje, cooked delicious curry and rice; there was *borscht* and black bread with Russian candy and the Mexicans made *pozole*, *enchiladas* and *chilaquiles*, all spicy, corn-based dishes. The only ones to disappoint were the Germans, who were too frugal. One German woman served only sherbet and stale biscuits, much to Weston's chagrin. Latin American exiles also came along, as did German profes-sors like the economist and Communist militant Alfons Goldschmidt, with his foreboding wife, and the ubiquitous 'Dr M', Leo Matthias. There were few Americans at first, but they drifted along eventually and included Frances 'Paca' Toor, the tough, gregarious anthropologist and expert on Mexican folk art, who loved to sing the revolutionary ballads called *corridos*; the Mexican-born Anita Brenner, a writer who would become a major promoter of Mexican art and artists; and the baby-faced Carleton Beals, correspondent for *The Nation*, who cov-ered Mexico's internecine political scene.

Tina was not especially fond of dancing, but Edward loved it and, after a few drinks, became just 'vulgar' enough to dance suggestively with Nahui Olin and Dr Matthias, shocking the starchy Frau Goldschmidt. Indeed, Weston loved dancing as much as he loved masquerades and cross-dressing. He needed little persuasion to don women's clothes and frolic at costume parties. For a Mardi Gras party held at their home in 1924, Tina and Edward exchanged clothing:

> She smoked my pipe and bound down her breasts, while I wore a pair of cotton ones with pink pointed buttons for nipples. We waited for the crowd to gather and then appeared from the street, she carrying my Graflex and I hanging on her arm. The Ku Klux Klan surrounded us and I very properly fainted away. We imitated each other's gestures. She led me in dancing, and for the first few moments everyone was

baffled. After a while I indulged in exaggerations, flaunted my breasts and exposed my pink gartered legs most indecently. Lupe was enraged by my breasts, punched at them, tried to tear them loose, told me I was *sin verguenza* – without shame …

The parties were a prelude to outrageous nights on the town. The rough-and-tumble, working-class dance halls, where dapper, Cuban band leaders' all-black orchestras played the torrid rhythms of *danzón*, tango and rumba to the pulsing bodies of 'maids, seamstresses, rumba butterflies, workers and ruffians', were not to be missed. In these truly unruly places, everyone was searched for weapons as they entered and police dubbed one the 'Bucket of Blood' because of the frequent shoot-outs. 'Throwing lit cigarettes on dance floor prohibited, because the ladies burn their feet' read the sign above the dance floor at the Salon Mexico, where sleazy politicians mixed freely with writers, journalists and rumba singers.

One evening, Paca Toor suggested trying the Gran Salon Azteca. It was

a bizarre place, a big perspiring hall of shabby folk, though the girls, however stained their hands from scrubbing floors or wrapping soap or filling cartridges at the national munitions works, usually managed to dress up with cheap rayon beaded dresses, clockwork stockings and fancy bow garters, and put plenty of grease in their shiny black hair.

Tina and Edward were willing and, along with Anita Brenner, Jean Charlot, Federico Marín and a few others, arrived at a hall blaring out

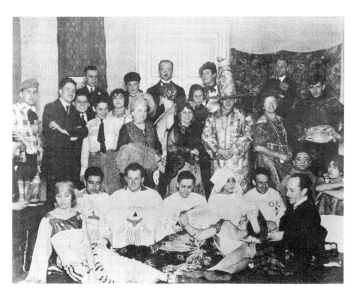

Masquerade party in Mexico City, 1924 (Tina third row wearing tie; Edward front row wearing skirt)

the sounds of jazz and *danzón*. The locals eyed the strange group of *gringos* curiously and Paca, perhaps already a little tipsy, shocked the leader of the orchestra by requesting something as European as a waltz! They were nearly run out of the place by the booing and hissing, but the bandleader summoned his musicians to the occasion with his baton, and Paca had her waltz.

Through Diego, Tina and Edward met a more serious group whose reunions were more political than bohemian and included more Americans. The hosts were a lively couple from New York: Bertram Wolfe, the son of Russian *émigrés*, and his wife Ella, a very intelligent, blue-eyed dynamo who went under the name of 'Olga'. Founding members of the American Communist Party, Bert and Ella taught English at the 'Miguel Lerdo de Tejada' high school, where Carleton Beals also taught part-time. Of course, the Wolfes also brought with them to Mexico a 'Party' task: the unifying of the highly factionalized Mexican Communist Party. They both adored Mexico and quickly adapted to life in the city, holding open house on Friday nights.

It was through their contacts with the muralists and the Wolfes that Tina and Edward became caught up in a whirl of revolutionary politics. At the Wolfes' gatherings, they heard a talk given by Elena Torres, a leading feminist and founder of Mexico's 'Woman's Party', who was engaged in full-time feminist organizing, surprisingly funded by the Mexico City police. Many of the people Tina and Edward met at the Wolfes' were involved in a new, radical publication called *El Machete*. The novel idea of Siqueiros' wife, the slim and stylish Graciela Amador, the newspaper was an extra-large broadsheet with a long blood-red machete held in a clenched fist on its masthead and was full of strident red, white and black woodcuts by Guerrero, Rivera and Siqueiros. It was guerrilla journalism at its finest: to escape detection by the government, the artist-editors worked in secret on the paper and in the early morning hours scurried through the streets, 'loaded with papers, brushes, and a pail of glue ... pasted *The Machete* on strategic walls, and retreated before dawn'. Contributors to the first issues read like a 'who's who' of Tina's acquaintances: the triumvirate of muralists was complemented by Alfons Goldschmidt and Bert Wolfe and, because it was still independent of the Communist Party, non-members like Gómez Robelo and Rafael Sala were involved.

Tina also became closer to the group of young artists and intellectuals known as the *Estridentistas* (Strident Ones). She and Edward had already visited the *Estridentista* haunt, the Café de Nadie, and

April, along with carved, caricatured masks by Germán Cueto, and
paintings and engravings by Charlot, Rafael Sala and Fermín
Revueltas, a young alcoholic artist who had studied at the Chicago
Art Institute, and the even younger Leopoldo Mendez, 'the last of
the overalled dandies', who had been a student at the Coyoacán
open-air school when Robo visited it.

The *Estridentistas* were led by Manuel Maples Arce, a handsome
and mischievous *veracruzano* who wore a carnation in his lapel,
scooted around town on a motorcycle and began his literary career
by reciting provocative verses on the crowded dance floor of a popu-
lar casino! Another founder of the movement was the tall gangly
Germán List Arzubide, a writer and radical activist, whose enormous
grin inspired a Cueto mask. Other writers in the group included the
diplomat Luis Quintanilla, who abbreviated his name to the phonetic
'Kin Taniya'. Maples Arce once nebulously described the group's
aesthetic as being 'a theory of images ... controlled by means of spatial
geometry' and one of his books was titled *Andamios Interiores*
(Interior Scaffolding).

The *Estridentistas* also stressed the urban, the machine and the
futuristic but they were above all masters of the 'statement' – as outra-
geous, provocative and radical as possible. They loved shocking slogans;
a favourite was 'Chopin to the Electric Chair!' They once ran an adver-
tisement in a Mexico City newspaper advertising a half-price sale on
'latest-model' women, including

> Picturesque woman for travel ... Before $500 [pesos], now $250
> [pesos]
> Sumptuous woman for soirée ... Before $290, now $145
> and the most expensive, *Estridentista* woman ... Before $10,000, now
> $5,000

Tina may not have been an '*Estridentista* woman', but her early
photography was certainly in keeping with their aesthetic. Their
whirlwind of social activity had not distracted her and Edward from
photographic work. During the first week of March, he and Tina
went together to take photographs at the Russian circus performing
just a few blocks from their home. Both used the same camera –
Weston's 3¼ x 4¼ Graflex – and the results show that even at this
early stage Tina was developing a vision of her own. Edward's prints
of the big tent are pure abstraction, an exercise in form, while Tina's
show the same preoccupation with form, but within the context of
the social surroundings. People come to her circus and she locates

them there, where they pin down the left-hand corner of her image of the soaring tent.

Although she was kept busy running Weston's studio, Tina was determined to become a professional photographer and under Weston's tutelage she was learning the essentials of the trade. While she sometimes used his Graflex, she most often used an unwieldy Korona view camera, which needed a tripod. Weston taught her his basic method of enlargement which she would use virtually for the rest of her career: from the original negative, she made an enlarged positive and from that she made a new larger negative, using this to make the final print by contact. At this time, they both preferred using platinum or palladium paper which made printing slow and tedious but gave the final print rich, warm tones.

Throughout 1924, Tina made several portraits of friends. One of them was Carleton Beals, to whom she sent the following in jest:

June–29–1924

This 'coupon' entitles you to have your 'mug' immortalized by
the supreme 'artiste' undersigned –

Tina Modotti

(Arrangements in regards to this have been made with
the 'folklorian' Mrs. Francis Wineberg [Toor].)

On her own, or with Chandler as her camera assistant, Tina now had photographic 'assignments and commercial jobs' including one for cartoonist Enrique de la Peña which involved 'some architectural things that he wanted to record'. She and Edward made photographic outings all over the city, like the one to Dr Atl's home at *El Convento de la Merced*, where they both used the Graflex to take shots of the thronged streets from the roof.

Tina's first published photograph was taken on an outing during Easter to the abandoned seventeenth-century Jesuit college and monastery at Tepotzotlán. Accompanied by their maids, Elisa and Dominga Ortiz, Tina and Edward joined the Salas and their friend, Felipe Teixidor, for the journey, first by train, then on foot and horseback to the monastery. They explored the fabulous gilt chapels and admired the intricately carved church façade, and slept at night in the bell towers or in the monks' cells, awakening at dawn to spectacular views of the valley below. They usually spent the daylight hours apart, taking photographs of the architectural wonders of the monastery or the dramatic surrounding countryside. Teixidor remembered meeting up for meals at the end of the day inside the darkened monastery:

One cell was the meeting place ... and since there wasn't any electric light and Tina saw that the candle was always falling over, she grabbed a roll of toilet paper and placed the candle in it. But, the sanitary facilities weren't ... well, you can imagine; so, that every once in a while, one of the gang would come in and grab the paper and out went the light!

Tina made photographs of the complex angles and arches of the colonial building, including a geometrical abstraction of the interior of the church tower which could easily have been titled 'Interior Scaffolding', in the *Estridentista* vein. She was very pleased with it and used a novel technique in printing it. Weston complimented her on the result but was a little uneasy at the technique:

> She printed from an enlarged positive, so she has a negative print and shows it upside down. All of which sounds 'fakey' and, in truth, may not be the best usage of photography, but it really is very genuine and one feels no striving, no sweat as in the Man Ray experiments.

Professionally, Tina and Edward were getting along well, but their love relationship was unsteady and their feelings towards each other fluctuated dramatically. Despite occasional passionate encounters, they maintained quite separate lives. Tina, it seems, was determined not to become simply Weston's appendage nor to be seen as just his mistress. Edward was spending many hours alone and complaining at length of Tina's numerous admirers and suitors. There appears to have been a fundamental problem regarding the understanding they had reached in Los Angeles. Both were clearly complying with the terms of their professional agreement – his to teach her photography and hers to work as his assistant for room and board – but their mutual understanding with regard to sexual liberation seems to have been more difficult for Weston to accept. While he appeared to have no trouble with the open nature of their relationship when he could use it to justify his own affairs, he had more difficulty accepting Tina's right to do likewise. While their friendship and affection for each other remained strong, Weston peppered his daybooks with allusions to something having gone from between them, of how they rarely found themselves alone together, that weeks had gone by without their lips having met, of how they would be 'just friends for that twilight hour ... '

Clearly, there were complications, not least of which was having a 13-year-old boy around the house, one who had an uncanny knack for arriving home at the most intimate moments. Once Chandler arrived home without a key and banged and banged on the front

Circus Tent, *1924 [TM]*

door to no answer. In desperation he climbed the iron grille-work of the door onto the balcony, knocked on the window, and 'distracted Dad from his attentions, anointing Tina with oil and that sort of thing; it was rather disconcerting to them'.

Tina continued to model for Edward and it was during 1924 that many of his most famous portraits of her were made. He made several of her highly expressive face as she recited poetry and though they were slightly underexposed, they were both excited by the results. The photographs he made of her at this time reflect the intensity of their feelings for one another. His nude studies particularly show the depth of his passion for her. He was enthralled with her body, probably made more desirable because they now had less physical contact, and certain of the images he made are almost pornographic in their objectivization. In one, an expressionless Tina stands naked, arms folded behind her head, a near-parody of a calendar 'pin-up'. In another, her head and face are hidden and her body contorted as she bends over, in a reclining position, the bare soles of her feet and

*Nude, Tina.
Photographer:
Edward Weston,
1924*

exposed buttocks emphasizing vulnerability to the eye of the observer.

It was on a bright sunny day that Weston caught Tina in a particularly emotional state. Capturing 'some of the tragedy of our present life', he rushed to click the shutter after his kissing her caused her to break into tears. With professional precision he carefully noted down the exact shutter speed, the filter and film used and observed how he now felt that there was no longer a mechanical separation between himself and his camera, that the shutter was an extension of his brain, released as naturally as moving his arm.

In addition to his emotional insecurities, money problems were also nagging at Edward. His income from commercial portraits was not sufficient to support them all. Things came to such a crisis that Tina offered to rent out her room and sleep in the dining-room. Edward found it humiliating to have to ask his wife Flora for money although he usually managed to justify the requests on artistic grounds and Flora always came through – often just in time to stave off disaster. It was the high rent at the Lucerna house which convinced them to move again in May. They left surreptitiously, in the early morning, to avoid paying back rent, but the landlord caught up with Tina and threatened to take them to court.

Their new home was in the Condesa neighbourhood, on Veracruz Avenue, and they nicknamed it *El Barco* (The Boat), because of its unusual triangular shape. In fact, the studio room had two round windows like portholes in what resembled the prow of a ship. Although it was smaller and noisier than their previous home, they both enjoyed the active street life and Tina especially loved the organ grinder serenades under the windows, which were reminiscent of her native Italy. The house also had a wonderful *azotea*, essential for taking photographs and sunbathing.

On the anniversary of their first year in Mexico, at Tina's suggestion she and Edward went to a 'professional' photographer to have a joke 'wedding anniversary' portrait made. Tina coyly holds a dusty bunch of plastic flowers against her cheek as the 'happy' couple poses against a romantic backdrop, both trying desperately to control their mirth.

'The Boat' house,
Avenue Veracruz 42

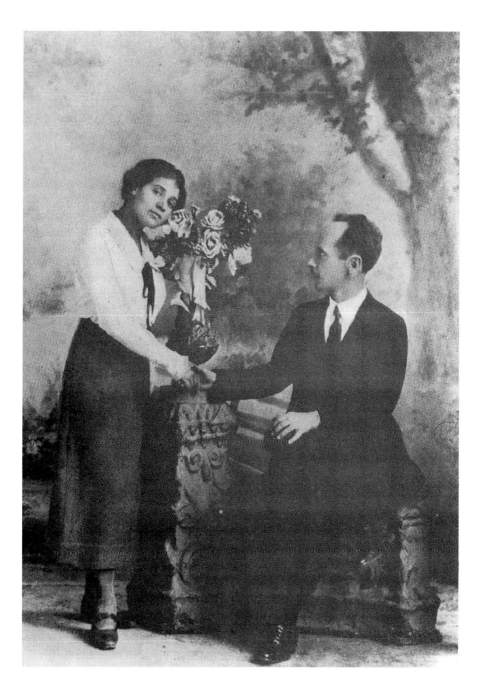

Tina and Edward's 'anniversary'
portrait, 1924

After a year in Mexico, Tina realized how much her feelings for the country and its people had intensified. In a merry mood, sipping a glass of wine, and describing herself as 'a woman who has done a lot of things in her life', she was interviewed by local newspaper reporters and described how different she felt in Mexico compared to the United States: '[Mexico] reminds me of Italy. That's why when I am in Mexico I feel Mexican. On the contrary, in the United States I felt I was in a foreign country.'

Weston did not share these feelings and had been talking about leaving since early June. Whether this was because he was missing his children, his financial difficulties or his jealousy over Tina's romances is unclear. If Tina actually consummated all these romances is also unknown, but she certainly did enjoy the attention men showered upon her. Monna Alfau and Felipe Teixidor believed Manuel Hernández Galván to have been 'enamoured' of her and Teixidor believes she responded to the Mexican senator's overtures.

Pepe Quintanilla, the younger brother of Luis Quintanilla, was also involved with Tina around this time. According to Teixidor, the young and ethereal Pepe was both sensitive and intelligent, and he and Tina did have a lengthy sexual relationship. Pepe was very similar to Robo in character and even in physical appearance. Felipe described a photograph he once owned of Tina and Pepe in a romantic pose. He believed Tina took the portrait herself, but his description fits a photograph of Tina with a man now identified as Pepe Quintanilla reproduced in an article on Weston's photography in *El Universal Ilustrado* and attributed to him.

It seems that Weston knew about Tina's affair with Pepe Quintanilla and accepted it to some extent, perhaps even sharing some of her affection for Pepe. Was it because he reminded him of Robo, who had been so close a friend, that he was able to take the photograph of Tina and Pepe in such a pose? In an entry in his daybook, he describes Tina and Pepe joining him and some other friends on an outing to the theatre:

> Between acts Pepe and I went out to smoke; we wandered up and down, arms about each other's waists, each thinking his own thoughts – but speaking of the weather!

All summer long, Edward agonized over whether to stay in Mexico. In July, with just a few days to go before his visa expired, he and Tina went to the lovely mountain town of Amecameca, in what appears to have been a last-minute effort to work things out. In an

Dos Cabezas (*Tina and Pepe
Quintanilla*). *Photographer: Edward
Weston, 1924*

abortive attempt to reignite their passion, they covered their pillows with white geraniums and sweet-smelling stock. But the bed was hard, the pillows lumpy and although they did snuggle together to keep warm, the icy air off the volcanoes did nothing to rekindle their desire. Nevertheless, it seems they managed some kind of reconciliation, because back in Mexico City, Edward decided to stay on until at least September.

In September, Tina made a brief return to her old career. Through her friendship with the Quintanillas she was persuaded to appear at the Olimpia Theatre in *The Mexican Theatre of the Bat*, Luis Quintanilla's version of the Russian *Chauve Souris* that Weston had seen in New York in 1922. The pot-pourri of Mexican folklore, pantomime and poetry was novel for Mexicans. Tina performed well in a challenging role and the show was hailed as an artistic success in the local press.

It was Weston who was well-received in October, when he held his second exhibition at Aztec Land. This time, Tina signed the guest book: 'Tina Modotti – your apprentice of the past – present – and may she be of the future. Mexico – 1924.' Clearly, the apprentice was making steady progress as a photographer in her own right, for following the Aztec Land exhibition she had accumulated enough quality prints for her first public showing. She hung several prints alongside Weston's at the *Palacio de Mineria* in a government-sponsored fine arts competition, which also included paintings by their friends Jean Charlot and Rafael Sala. Weston was proud of his 'dear "apprentice" ' and noted that Tina's prints 'lose nothing by comparison with mine – they are her own expression'.

Although Edward had postponed his departure until December, he noted in his daybook that his time in Mexico had come to an end and, likewise, he believed, his relationship with Tina. She discussed her future with him for hours on end, telling him, 'You must not decide now, Edward, wait until you reach California, then you will have more perspective. As for me, my mind is clearly focused, I want to go on with you, to be your "apprentice" and work in photography.'

On 18 December, in the English-language section of *El Universal* newspaper, it was announced that 'Mr Weston … is leaving his studio in charge of Miss Tina Modotti, whose work has also been the subject of much favorable comment.' It was a sad and tearful parting. Edward, accompanied by Chandler, who had desperately wanted to stay in Mexico with Tina, boarded a train and headed for Los Angeles just two days after Christmas.

10

Out of the Shadow

Tina threw herself into a flurry of photographic work in the days following Edward's departure. She took over the running of the studio, dealing with the clients and making platinum prints from the most recent of Weston's sittings. She debated the qualities of the latest photographic paper with the staff at *Kodak Mexicana* before buying darkroom supplies, and readied herself to do battle about long-overdue payments from print sales at the last Aztec Land exhibition.

She also embarked on a spate of cleaning and rearranging the house, moving into Weston's room, where she hung a portrait of him on the wall alongside his photographs of Robo and her mother. With only herself, the cat and the servant occupying the entire house, she found its emptiness overwhelming. On the very first evening, she wrote to Edward:

> ... already I have been hurt by it and that in spite of having gone through the day in a sort of daze – I had the illusion that you had just gone to town and would be back in a little while – only for moments the truth flashed through my mind and then the pain and loneliness almost choked me ...

Although there appears to have been an understanding that Weston would return, Tina seems to have felt that this was by no means certain. She resolved to write to him in place of keeping her usual diary, and the spate of letters that followed show her remorse and immediate anguish at their parting. She plaintively tells of her suffering and accuses herself of not having been 'worthy' of him, asking him, 'Tell me – please – that perhaps I have not been as bad as I imagine ... ' Her melancholic mood extended to a melodramatic gesture of trust and love. In December, she composed a will leaving him all her belongings:

I – Tina Modotti – do hereby will – upon my death – to Edward Weston
– all my personal property: furniture – books – photographs – etc. and
all photographic equipment: lenses – cameras – etc.

He can retain for himself what he wishes and distribute the rest
among my family and friends – I hereby express also my desire to be
cremated.

None the less, whatever guilt and loneliness Tina felt soon
dissipated. She seems to have been drawn out of her melancholy by
running the studio, by her own artistic ventures with photography
and by her friends the Salas, Paca Toor and the Quintanillas. She
spent New Year's day at Monna Alfau and Rafael Sala's home, along
with Felipe Teixidor and Nahui Olin, all of them writing a delightful
joint letter to Weston. Monna, a garrulous Spaniard, was a good
friend of Tina's at this time, although they later drifted apart. She
remembered Tina as lively and fun-loving then, with a great sense of
humour and lust for life.

But Tina's closest friend in Mexico was Paca Toor, who had arrived
in Mexico in 1922 for a summer-school session at the National
University. Enchanted with Mexican culture and bored with her den-
tist husband, she left him and decided to stay on in Mexico. In khaki
trousers and heavy boots, she roamed the backroads of Mexico on
foot and burro-back discovering Mexican folk art. Paca and Tina
spent a lot of time together and were good-naturedly competitive
with each other. At one point, Tina was so envious of Paca's copy of
James Joyce's *Ulysses*, then banned in the United States as 'porno-
graphic', that she wrote to Weston, 'Someday I surely want that book
even though I have to steal it.'

Other friends at the time were Luis Quintanilla and his American
wife Ruth Stallsmith. The Quintanilla family was an aristocratic
Mexican clan and, despite his forays into the *Estridentista* fold, Luis
had followed the family tradition and gone to work for the Foreign
Ministry. Tina's affair with his brother, Pepe, seems to have continued
in Weston's absence. Pepe was careful not to become too intrusive
and Tina was grateful for his understanding of her present frame of
mind. In a letter to Weston, she rather obliquely describes him as 'a
gentle abstract presence'.

Alongside her studio work with some of Weston's sitters, Tina was
trying to develop her own clientele. It was not an easy task, since
there were other established photographers around, including the
German-Mexican photographers Guillermo Kahlo and Hugo
Brehme, both respected for their documentary and portrait work.
One of Tina's first clients in 1925 was the young Mexican actress,

Frances Toor, 1927 [TM]

Carleton Beals, 1924 [TM]

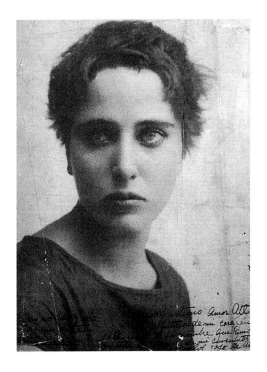

Nahui Olin, c.1925 [TM?]

Stanislav Pestkovsky, c.1925 [TM]

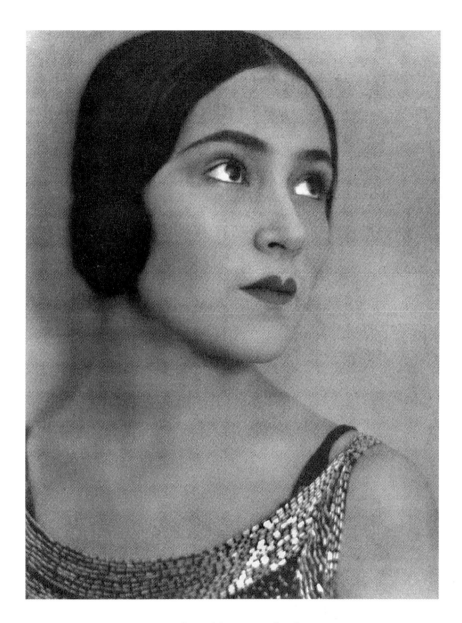

Dolores del Rio, 1925 [TM]

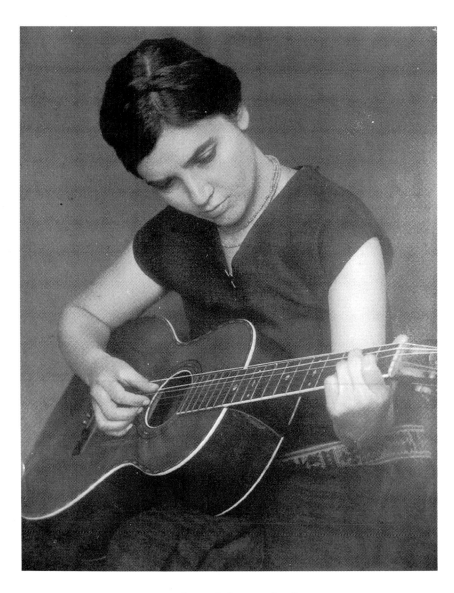

Concha Michel, c.1928 [TM]

Dolores del Rio, her portrait of whom was published in September 1925 in *El Universal Ilustrado*, with an article heralding del Rio's coming success in Hollywood films.

It seems that about this time another of Tina's clients was a French dancer, for she was referred to years later in a cryptic newspaper article which alluded to a rather flamboyant raconteur. Travelling the world in a variety of guises, carrying half a dozen passports and a series of nude photographs of women, among them one of Tina, the man insisted he knew Tina 'very well'. He is supposed to have shown the reporter a packet of love letters bound with blue ribbon which he claimed were written to him by none other than Tina herself. They were, the story went, 'the only ones he had kept, perhaps the only ones he would not destroy … ' This sophisticated man of the world was almost certainly Guglielmo 'William' Lopez, a handsome Anglo-Italian native of Malta, master of nine languages and self-styled Don Juan, known as the 'Gentleman Globe Trotter'. Tina photographed him in 1925 and her three portraits of him ran in *El Universal Ilustrado* in April 1926 along with the caption: 'William Lopez, one of the most extraordinary men in Mexico, [as] seen by Tina Modotti.'

The public display of Weston's explicit nude images of Tina, coupled with her openness about her sexuality, created a mythology of wanton promiscuity around her that fuelled the fantasies of many men in Mexico. Tina herself later recognized that 'scandal errupted when they saw Westons's nudes, particularly the nudes of me. It was too much, even for the Mexicans.' Some invented their own affairs with her or lasciviously discussed her supposed affairs with others. Scores of those who knew her fell in love with her and many of those who had never even met her became enamoured of her through Weston's photographs. Her friend, Rafael Carrillo, then head of the Mexican Communist Party, was no exception:

> Tina was a very beautiful woman, very beautiful, but more than that she had a truly extraordinary graciousness about her that caused all the men [who knew her], myself included, to fall in love with her. It wasn't because she was a flirt, or that she wanted this to happen, it was a natural thing …

The 1920s was a time when it was increasingly acceptable for women to smoke, cut their hair, use contraception and believe in 'free love'. Tina agreed with this concept and her inability to have children enabled her to practise it without fear of pregnancy. Other women looked on enviously at the ease with which she formed relationships. Anita Brenner once noted in her diary how she 'would like

a life like Tina's, diffusing much joy by numerous cohabitations and also fine prints'. Tina liked to flaunt her sexual freedom to a certain degree, perhaps to shock, or maybe just out of bravado. Felipe Teixidor recalls an evening when he and the Salas and some others of their group sat around writing observations about their characters on pieces of paper, then showing them to the others. Felipe remembered that when it was Tina's turn she coyly showed a slip of paper which revealed: 'Tina Modotti – profession – men!'

However, in Weston's absence, Tina was most occupied with her true profession, photography, which she came to call her 'precious work'. Commercial portraiture was now her livelihood and consumed much of her energy, but she still found time for making the photographs she loved. While Weston's influence on her work was still obvious, Tina was also responding to other influences and striving to

Tina Modotti with [artist] *Miguel Covarrubias on the roof of Avenida Veracruz 42 Photographer: Edward Weston*

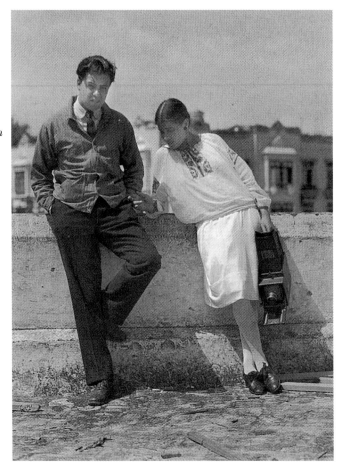

Flor de Manita, c. *1925 [TM]*

find her own vision. Throughout the year, she produced some of her most acclaimed photographs: *Telegraph Wires, Roses,* and *Flor de Manita.*

In fact, Tina had bought this eerie, blood-red flower with the tentative outstretched 'palm' on a visit with Charlot and Weston to the shrine of the Virgin of Guadalupe in December. In March, Charlot commented in a letter that Tina had made 'some nice photos (especially of this plant that looks like a hand)'. This probably marks the beginning of a series of photographs of flowers that she made and exhibited in 1925, images described as 'the white massed purity of roses' and 'lilies with a delicacy and innocence reminiscent of Fra Angelico but depicted in some gray dawn of which Fra Angelico never dreamed'.

On an outing with the Salas, Tina attempted an architectural study of an aqueduct, but became frustrated when she saw that the bellows of her camera had cut her negatives. She was still easily distracted when working outdoors with the view camera. The Korona lacked the mobility of a Graflex and needed the unwieldy tripod. Tina preferred to work indoors and even turned to the interior of her home for subject matter. Her studies of architectural elements such as *Open Doors* and *Staircase* were made in the Veracruz Avenue house. Along with *Telephone Wires, Stadium* and *Glasses,* they show a modern, geometrical influence of the kind exhibited in the work of the *Estridentistas.*

Tina soon found a major outlet for her photography in the magazine Frances Toor founded in 1925. *Mexican Folkways* was a visually exciting, bilingual magazine on Mexican art and 'folk ways' and Paca enlisted the help of some of the most talented people in Mexico at the time: Jean Charlot became art editor; Carleton Beals, Dr Atl and Anita Brenner wrote articles in the first issues; Monna Alfau did translations; and Tina duly placed an advertisement for her and Edward's studio.

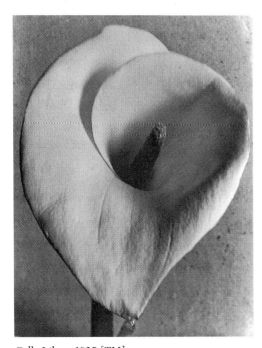

Calla Lily, *c.1925 [TM]*

Lily and Bud, c.*1925 [TM]*

Calla Lilies, c.*1925 [TM]*

Tina's photographic career in 1925 was not without its crises, however. The first came in April when she was particularly short of money and agreed to take a job at *Casa Guastaroba*, a bookshop run by an Italian friend, Ettore Guastaroba. She lasted all of five hours, walking out half-way through her first day. She immediately wrote to Weston telling him he could laugh at her if he liked, but when she left Guastaroba's on her lunch break, she knew she could never go back:

> I felt *a protest of my whole being* – it was something instinctive – not reasoned … the moment I got out – I knew I was free free and that I would never go back.

Pitting her devotion to art against the mundane necessity of earning money was a trial but Tina had little difficulty choosing. She was swept with 'a new ardour – a new enthusiasm to take up photography again – to manage to live in any way that is not nine hours of uninteresting dedication to "Casa Guastaroba"'.

By June, however, Tina was caught up in further internal debate over the problem of what she called her 'tragi-comedy', the dichotomy of art and life. Could the two be separated? Her life was getting in the way of her art, and vice versa. She wrote to Edward in early July that she was having trouble being productive. She clearly felt inadequate when judging herself by Weston's single-minded dedication to photography and his dictum of solving the problem of life by losing oneself in art. From the limited perspective of her time, she expressed this in global terms as a problem particular to women:

> … women are negative – they are too petty and lack power of concentration and the faculty to be wholly absorbed by *one thing*.
>
> Is this too rash a statement? Perhaps it is, if so I humbly beg women's pardon – I have the unpardonable habit of always generalizing an opinion obtained mainly from an analization of *just* my personal self. And speaking of my 'personal self': I cannot – as you once proposed to me – 'solve the problem of life by losing myself in the problem of art' …
>
> Now what is this, 'my problem of life'? It is chiefly an effort to detach myself from life so as to be able to devote myself completely to art – .
>
> And here I know exactly that you will answer: '*Art* cannot exist without *life*.' Yes – I admit but there should be an even balance of both elements, while in my case life is always struggling to predominate and art naturally suffers – .
>
> By art I mean creation of any sort. You might say to me then that since the element of life is stronger in me than the element of art I should just resign to it and make the best of it – but I cannot accept life as it is – it is too chaotic – too unconscious – therefore my resistance to it – my combat with it – I am forever struggling to mould life according to my temperament and needs – in other words *I put too much art in*

Doors, *1925 [TM]*

Staircase, *1925 [TM]*

Glasses, *c.*1925 *[TM]*

Scaffolding, c.1925 [TM]

Arches, *1924 [TM]*

my life – too much energy – and consequently I have not much left to give to art.

This internal debate was probably brought about by Tina's growing involvement with a group of people whose daily concerns were the 'problems of life' on a political level. Even while Weston was still in Mexico, many of their friends had been involved with *El Machete*. Tina may also have become involved with the newspaper during this early stage, since from mid-1924 translations of anti-fascist articles from the Italian had begun to appear. At about this time, she was presented to Jorge Fernández Anaya, a member of the Communist Youth League, as 'an anti-fascist ... gathering funds to combat Mussolini in Italy'. Fernández Anaya remembered clearly that Tina then 'used to aid the refugees who had fled the persecution in Italy'.

With her strong anti-fascist leanings, fostered by the Modotti family's opposition to Mussolini, it was easy for Tina to take another step, one facilitated by her friend Alfons Goldschmidt, who had come to Mexico in 1922 at Vasconcelos' behest. In June 1924, Weston – who was never attracted to 'the movement', never quite sure whether 'evolution or revolution' was the road to social change – noted that one evening at the Goldschmidt's 'a new Communist group was formed. I shook my head when he asked for my name.' The implication, not stated, was that Tina responded positively.

Considering the German professor's political past, the group that was formed, as reported in *El Machete* shortly thereafter, must have been the Mexican section of 'International Workers' Aid'. Goldschmidt had helped form a similar organization in Berlin which later became the German section of International Workers' Aid and subsequently part of International Red Aid.

Another political influence was Bertram Wolfe, who, upon returning in October from a Comintern meeting in Moscow, visited the Modotti–Weston household with Ella, 'full of enthusiasm for the Soviet Union'. Bert also brought back the idea, spawned in Moscow, for an international 'League for the Struggle against Imperialism', transforming it into a Latin American version known as 'The Anti-Imperialist League of the

Ella Wolfe.
Photographer:
Edward Weston, 1924

Americas'. Coinciding with this emergence of Communist-spawned front organizations was an event of momentous impact for the Mexican Left – the establishment of diplomatic relations with the Soviet Union and the arrival in November of the first Soviet ambassador, Lenin's old Bolshevik confidant, Stanislav Pestkovsky. A bearded, debonair man, of whom Tina made a striking portrait, Pestkovsky was neither doctrinaire nor a stickler for diplomatic protocol. He hosted parties at the Soviet legation where diplomats, artists and workers in overalls mixed and mingled. In 1922, Pestkovsky had helped found 'The Association for Aid to International Revolutionaries', a Soviet-backed solidarity organization aimed at helping political prisoners and exiles and their families world-wide.

Tina's opposition to Italian fascism and the existence in Mexico of organizations like International Workers' Aid and The Anti-Imperialist League apparently led her to adopt a broader, anti-imperialist position. By the end of 1924, Fernández Anaya remembers, she had become very active in international solidarity. During a meeting of The Anti-Imperialist League, he said, Tina accepted an invitation to give a brief talk, presumably on Italian fascism, prior to which she was introduced to the audience as an 'anti-fascist fighter'.

Detail of Tina in Diego Rivera mural, Chapingo, c.1926 [TM]

Pestkóvsky was undoubtedly partly responsible for *El Machete* becoming the official organ of the Mexican Communist Party in 1925. The paper had had financial difficulties since its inception, but in early 1925 it suddenly found sufficient funds to move from weekly to bi-weekly publication, boosting its circulation to 10,000 copies. There was now greater emphasis on Communist Party activities and the name of the young General Secretary, Rafael Carrillo, appeared with greater frequency. A young, wiry, former rural guerrilla fighter, Carrillo was a vegetarian, like Diego and the Wolfes, with whom he was particularly friendly, and Tina had met him shortly after she arrived in Mexico. Even before May 1925, when the Communist Party gained definitive control, the newspaper had published a column of news from International Workers' Aid, the organization which Tina apparently joined in 1924. With greater frequency, these items were translations of articles against fascism from Italian publications, always under the organization's symbols – a prisoner waving a white handkerchief from the bars of a prison window.

Clearly, Bert and Ella Wolfe's Communist Party activities increased dramatically with Pestkovsky's arrival. Ella's fluency in Russian, English and Spanish, and her trusted Party status, led Pestkovsky to hire her to work undercover as a decoding clerk in the Soviet legation. Bert, meanwhile, ran afoul of the Mexican government, with his union organizing and anti-government articles in *El Libertador*, the organ of The Anti-Imperialist League. By the end of June, the government had expelled him as a 'pernicious foreigner' under Article 33 of the Constitution, a law which permits the Mexican government to expel foreigners at whim. When he was detained, the secret police had asked if he preferred the '33' or the '30–30', the rifle widely used by Mexican troops and firing squads! Realizing the implication, Bert opted to leave the country quietly. Ella stayed on for a few months, turning over her flat when she finally left to another of Tina's friends, Xavier Guerrero.

Guerrero was then assisting Diego Rivera on a mural project at the agricultural college in Chapingo. Diego had been invited by the school's radical director, Marte R. Gómez, to paint the interior walls of the ex-chapel and other parts of the building. Xavier Guerrero, the young Mexican painter Máximo Pacheco and Pablo O'Higgins (Paul Higgins), a tall red-haired American, were to assist him on the project. Pablo had first met Tina in the spring of 1924, shortly after arriving in Mexico to work as Rivera's assistant, when she went to take photographs of Diego's murals at the Ministry of Public Education.

Sometime in 1925, it is unclear how early, Tina began posing for Rivera's Chapingo murals, together with Concha Michel, the folk-singer who had introduced Lupe to Diego. Along with Diego and his assistants, she rode the narrow-gauge railway with its small, wooden carriages to the station directly in front of the gates of Chapingo. From there she continued through the tall wrought-iron entrance and down the long cobbled driveway lined with giant eucalyptus and ash trees to the chapel where most of Rivera's work was done.

Weston's biographer, Maddow, claims that because of Weston's jealousy, Diego was only able to work from nude photographs of Tina and, clearly, at least one of the figures in the Chapingo murals was taken from a Weston portrait. However, Weston himself later noted that Diego worked from drawings he had made of Tina. In fact, Diego later gave a present to Ella Wolfe of a nude pencil study of Tina that had been used for the Chapingo murals. Certainly, by December, Weston noted, with no apparent surprise, that Tina was posing for Diego. Although Lupe Marín was the model for the central figure in the chapel murals, Tina posed for the impressive *Virgin Earth* and *Germination* figures.

Tina's association with the muralists was certainly not limited to Rivera. Since their meeting in Los Angeles, her friendship with Xavier Guerrero had continued and by late summer, as she was preparing for Edward's return, she spent time with him and Siqueiros in Guadalajara. Guerrero had apparently been sent to

The Little Mule,
1927 [TM]

Guadalajara on Party business and while his and Tina's friendship probably deepened at this time, it appears to have remained platonic. Xavier was the antithesis of the light-skinned, curly-headed, unruly Siqueiros. Short, stocky and dark-skinned with straight black hair, he was the archetype of 'the quiet Indian', so silent that friends referred to him jokingly as *El Perico* (The Parrot) or, later, in a description coined with more than a little malice by Diego, *El Mono con Sueño* (The Sleepy Monkey). The mute façade, however, belied a lively Mexican wit, with its love of the macabre.

It was probably with the help of Guerrero and Siqueiros that Tina arranged a joint exhibition of her and Weston's photographs in Guadalajara. It was the second showing of her work in Mexico and was planned to coincide with Weston's return. Working out of her room in a downtown hotel, Tina rushed around the city looking for a suitable place for the show. The painter Carlos Orozco Romero, the husband of Lupe Marín's sister María, helped her secure the Jalisco state museum as the venue and the photographs were hung around the walls of a rectangular room for the exhibition's 1 September opening.

Between dealing with printers and government officials, Tina gave interviews to the local press. Dressed as a 'suffragette' in a dark tailored skirt, high-necked silk blouse with a man's black tie and smoking one of her favourite *Buen Tono* cigarettes, she received reporters from local newspapers. Enthusing about the 'enigmatic and suggestive' eyes of the 'great artist', the reporters listened intently while Tina told them how she hated retouching, liked big cities and loved all things Mexican. When she showed her photographs, their reaction was effusive:

> … she shows us her marvelous reproductions. Frankly, we do not know which to choose. The flowers are of a surprising reality and it is admirable how a sole stem and one lone flower become something so interesting. We are enthused by the composition of the heads which file before our eyes, lacking those ridiculous 'poses' so manipulated by vulgar photographers.

A few days before the show opened, Tina travelled to Colima to meet Edward, who was arriving with his second eldest son, Brett. The exhibition was a critical success and Siqueiros published a review in the local press, claiming the photographs in the Modotti–Weston exhibition could not be 'more real: the rough is rough; the smooth, smooth; the flesh, living; the stone, hard'. But economically speaking, the event was disastrous and throughout the five days' showing only six prints were sold.

It was on the return journey by train from Guadalajara to Mexico City that Edward realized his 'dear apprentice' had changed radically. Displaying her newly developed social conscience, Tina refused to go first-class, insisting on travelling in a second-class carriage. Edward and Brett had bought tickets in Los Angeles for first-class sleeping berths and, in a brave attempt to adjust to this new situation, Weston spent a sleepless night alternating between checking on his cameras and Brett in first class 'and Tina in second in the dim light among the Indians, sprawled over each other on the hard seats, dozing or drunken or garrulous'.

'Manyfold Possibilities'

The Cuernavaca train climbed slowly south from Mexico City, offering spectacular views of pine-covered volcanoes and golden harvested maize fields. After reaching the cold, damp mountain town of Tres Marias it headed down into the warmth of the ancient valley of Anahuac. Below, bathed in bright sunlight, Cuernavaca, the 'City of Eternal Spring', stood poised at the entrance to the valley, its steep, cobbled streets a maze of colonial churches and expensive villas, their lush gardens ablaze with the scarlet and purple bloom of bougainvillea.

In late November, after Tina and Edward returned from Guadalajara, their friend and photographic client Fred Davis loaned them his Cuernavaca home for a few days. Davis had come to Mexico to run a rail-bound news agency aboard American trains travelling back and forth across the Mexican border. He became enchanted by Mexico's folk art and customs and decided to move to the capital, where he opened a shop and gallery on Madero Street. His spacious weekend house, with its sweeping lawns and enormous palm trees, was the perfect place for a romantic weekend. Accompanying Tina and Edward was Tina's sister, Mercedes, who had arrived in Mexico in October for a visit, and their friend Carleton Beals.

Beals had come to Mexico in 1918 after a brief spell in jail as a World War I draft evader. The young Californian radical and his wife, Lillian, left Mexico in 1921 to spend two years in Italy, where Beals wrote his first journalism articles on Mussolini's rise to power. Back in Mexico, he became the correspondent for *The Nation* and separated from his wife. Tina's 1924 portrait of him shows a clean-shaven, impish-looking young man hardly resembling the bearded subversive depicted earlier in US embassy dispatches.

It did not take long for Carleton to make an impression on

Mercedes Modotti. He recalled a dozen years later simply accompanying '[Edward], Tina, and her sister Mercedes, a strikingly beautiful and romantic girl, on a brief visit to Cuernavaca'. But Mercedes' letters in Italian to Beals speak of a passionate affair which seems to have had its climax on this trip. Tina and Edward had visited Fred Davis' house the previous year, when he and Tina were staying at the home of American socialite Alice Leone Moats, and Weston had made a daylight study of the giant palm in Davis' garden. On this trip, he spent hours trying to capture the trunk in full moonlight.

While Weston wasn't labouring with his camera under the palm, Mercedes and Carleton were having considerably more fun beneath the same tree: 'You, under that palm and our faces on that unforgettable night,' Mercedes later wrote to Carleton, 'in a moment of *grande amore*, of great abandonment, and of infinite sweetness … ' Beals may not have been as swept away by it all as Mercedes, but he did send her a poem about the palm and later dedicated a volume of his poetry to her. The affair was apparently quite serious, for Tina later referred to Beals, in affectionate jest, as *cognato*, Italian for brother-in-law.

Mercedes' trip to Mexico lasted nearly two months. She obviously got along well with Edward – she had even posed nude for him when he had been in San Francisco earlier that year – and her visit kept the household in a state of constant excitement. Tina organized numerous outings with her sister and Beals. On one occasion, Beals procured a government car and they drove to Chapingo to see Rivera's murals. Referring to it as the 'Sistine Chapel of the Americas', Beals believed it to be Rivera's best work: 'Sensuous, simple and powerful, this work takes its place beside that of the Italian masters.'

It was during Mercedes' visit that Weston became obsessed with the toilet of the Veracruz house. The 'sensuous curve of the "human form divine" ' which he saw in the *excusado* thoroughly excited his creative sensibilities and lent further credence to his 'form follows function' theory. He set to work, setting up his 8 x 10 Seneca camera on the floor, spending hours on all fours in the bathroom and getting in everyone's way

Mercedes Modotti on the azotea *of 'The Boat' house, 1925*

in the process. He was thrilled when the toilet shone magnificently after a scrubbing by the servant, Elisa, and was undaunted when teased about his efforts. Brett offered to sit on it to improve the image and the ever-romantic Mercedes suggested filling the bowl with red roses. But Edward persevered and the result was an exquisite portrait of the gleaming porcelain *objet d'art* which, when later published in *Forma*, a government-subsidized arts review, created such a scandal that it caused suspension of the publication.

Mercedes' Mexican holiday seems to have been a high point in her life and served to bring the sisters even closer. A snapshot of a smiling Mercedes, which Tina probably took, shows her in typically Tina dress, wearing a strikingly beautiful Japanese kimono, on the roof of the Avenida Veracruz house. Just before she left, Tina and Edward organized a farewell party for her which matched the spirit of the old days at Lucerna Street. Carleton, Paca, Diego and Lupe, the Salas, Pepe Quintanilla, Hernández Galván and Jean Charlot were among the guests, as was the object of Charlot's unrequited affection, the 20-year-old Anita Brenner, who arrived still bandaged from a recent automobile accident.

Mercedes left Mexico the first week of December and Tina returned to Chapingo to pose for Diego. But scarcely a week had gone by when she received news that her mother was ill. She left for San Francisco hurriedly, arriving to find Assunta Modotti very ill indeed. As the weeks passed and her mother recovered, Tina found her reception by old friends, the inability to work and life around the family very unsettling. She may have been particularly troubled by the potential danger faced by her brother, Benvenuto, whose leadership of the Italian anti-fascist group *Rivendicazione* had come to the attention of the Italian authorities.

Assunta Modotti,
c.1926 [TM]

Assunta Modotti's hands,
c.1926 [TM]

Some of Tina's distress was caused by returning to San Francisco as a professional photographer and not being taken seriously by old acquaintances. She had brought her Korona camera with her and looked around for a darkroom and studio where she could work. She had also brought along prints of her photographs, including *Roses* and *Glasses*, to sell and hoped to arrange an exhibit in the Los Angeles Japanese quarter. In a letter to Edward she lamented that the difficulties she faced had cast her into a 'gloomy' mood:

> ... I just feel impotent – I don't know which way to start or turn. You know what they say about a prophet in one's own country – well – in a way it works for me too: you see – this might be called my home town – well of all the old friends and acquaintances not *one* takes me seriously as a photographer – not one has asked me to show my work ...

Among the photographs Tina made during her San Francisco sojourn were several of her youngest sister Yolanda. She was probably also behind the camera for family snapshots taken on the Modottis' rooftop veranda. But it was through contact with new friends that

she found her true photographic bearings, moving in the circle which included the photographers Consuelo Kanaga, Dorothea Lange and Imogen Cunningham. She accepted Dorothea Lange's offer to use her darkroom and studio for a sitting with a client and later attended a small party at her home. But it was with Consuelo Kanaga that she spent more of her time. Consuelo had worked at the *San Francisco Chronicle* as a reporter before switching to photojournalism. She later became a labour rights activist and photographer for the US government's Work Projects Administration in the 1930s.

Tina was encouraged by Consuelo Kanaga's appreciation of her work and impressed by her initiative and willingness to help: 'Consuelo is to introduce me to somebody who *may* buy a print of the roses. She is also helping me turn in my camera for a Graflex *if* we find a bargain. Really she is so admirable.' Tina visited Consuelo and her husband frequently and was grateful for their help, particularly in her quest for a Graflex, which she saw as imperative to advancing her career. Unfortunately, to buy even a second-hand one, she would have had to sell her Korona, to which she was sentimentally attached; most likely it had come from Weston.

Perhaps it was her contact with successful women photographers like Cunningham, Lange and Kanaga that caused Tina to re-evaluate her photography and reflect upon the direction it should take. Her San Francisco visit certainly strengthened her resolve to take her work and herself as a photographer more seriously: 'I am going to work hard when I return to M[exico],' she wrote to Weston, 'and differently – if I can get a Graflex – I have always been too restrained in my work *as you well know* – but I feel now that with a Graflex I will be able to loosen up … ' She was 'bursting' with so 'much I want to talk to you about – all my impressions of the US – all my reactions – all my ideas of working different- ly at photography … '

Yolanda Modotti,
c.1926 [TM]

Now that *mamacita*, as she called her mother, had recovered, Tina prepared to leave San Francisco. She dropped off a print of *Glasses* for Imogen Cunningham to pass along to the Mills College gallery in Oakland and left for Los Angeles via Carmel, to visit her close friend Tilly Pollack, a Dutch-Javanese woman with whom she felt a special kinship. Pollack was once a mainstay of San Francisco bohemia and may have been the Javanese link for Robo's batiks. She had moved to the village of Carmel, with its artists' colony, unpaved roads and kerosene lamps, and opened a tea room-gallery. Hagemeyer showed his work there and Tina may have planned to leave some of hers for exhibition too.

Back in Los Angeles, she stayed with Robo's mother, Vocio. Her attempts at arranging an exhibition of her work in the Japanese quarter proved unsuccessful, and so it appears were her efforts to sell a couple of Xavier Guerrero's paintings that she had brought with her. She was thrilled that she did manage to sell her copy of James Joyce's *Ulysses*, originally acquired with great difficulty, for 20 dollars to a local book dealer. But, most importantly, it was at this time that Tina seems to have made the break with her past and determined to devote herself totally to photography. She wrote to Edward that at Vocio's she had spent an entire morning

Máximo Pacheco
mural on archway,
c.1926 [TM]

looking over old things of mine here in trunks. Destroyed so much. It is painful at times but: 'Blessed be nothing.' From now on all my possessions are to be just in relation to photography – the rest – even things I love, concrete things – I shall lead through a metamorphosis – from the concrete turn them into abstract things – as far as I am concerned – and thus I can go on owning them in my heart forever …

Tina arrived back in Mexico City on 28 February 1926 armed with a recently acquired Graflex and immediately threw herself into her work. In her task of recording the muralists' work, Tina soon became their preferred photographer, replacing the ailing Guadalajara photographer José María Lupercio. The February–March issue of *Mexican Folkways* carried a skilfully composed detail of a Diego Rivera mural. The same edition of *Folkways* ran the first of its advertisements for her

> Photographs of the Murals of Diego Rivera
> In the Ministry of Education Building
> Mexico City
> 65 of them all equally interesting, (9½ by 7½), 50 cts. each

Tina's first accredited art photograph in *Folkways* appeared in the next issue and depicted the giant papier maché *Judases* burned during Easter week in Mexican religious ceremonies. In the same issue, Diego Rivera wrote a review of Tina and Weston's photography and, after praising Weston's work, said

> Tina Modotti, his pupil, has done marvels in sensibility on a plane, perhaps more abstract, more aerial, even more intellectual, as is natural for an Italian temperament. Her work flowers perfectly in Mexico and harmonizes exactly with our passions.

Tina's 'ideas of working differently at photography' were beginning to find concrete expression. She felt compelled to depict through her art the reality of Mexico and the first photograph that clearly illustrates her attempt to unite what were becoming the two major themes in her life – art and politics – is the image published in the August–September 1926 issue of *Mexican Folkways* under the title *Worker's Parade*.

From a rooftop, Tina looked down upon a column of marching

Advertisement for Tina's photographs in Mexican Folkways, *1926*

Worker's Parade, *1926 [TM]*

peasants and their large straw hats, symbols of rural Mexico and agrarian reform. The image is almost certainly of the 1926 May Day march en route to the Zocalo and was made with her hand-held Graflex. A companion photograph shows more clearly the Mexico City tramlines that appear in the upper left-hand corner, as well as the urban workers' contingent marching alongside the peasants. While the subject matter of this image is political, most striking is its sense of movement and the sunburst-like patterns of light on the peasants' hats. This photograph marks the beginning of what was to become the *leitmotif* of Tina's photography – the melding of the formalism and concern for composition she learned from Weston with her growing interest and involvement in Mexican revolutionary politics.

Just two days before that photograph was made, Tina was provided with a new photographic opportunity when a contract was drawn up between Edward Weston, Anita Brenner and the rector of the National University. The agreement was for Weston to make up to 200 photographs of Mexican religious and folk art to accompany Anita's text for a book underwritten by the university and eventually published in 1929 as *Idols Behind Altars*. It was to be a four-month task involving arduous travel and much dealing with Mexicans of all stripes under difficult circumstances. Weston knew such an undertaking could not be accomplished without Tina's help and at the same time he wanted to take along his son, Brett. His demands were making Anita's life 'rather nerve racking. Weston doesn't want 1,000 pesos and 2 half fares. He disdains it. He wants 3 half fares because he wants Tina to go too.'

No third rail pass was forthcoming and Weston apparently relented, for on 3 June, with military passes arranged and recommendation letters in their pockets, he, Tina and Brett left on the first leg of the project. Tina took her 3¼ x 4¼ Graflex, Weston his 8 x 10 Seneca and his own Graflex, and they carried with them a variety of lenses and tripods. Braving the floods and downpours of Mexico's rainy season, they travelled on the tortuously slow and inevitably late trains and buses, sometimes even traversing mud-laden roads on mule back, much to Tina's disgust. To cut costs, they slept three to a room and endured rickety beds and bugs in cheap hotels, often converting their room into a makeshift darkroom to develop their negatives.

On the first leg of the expedition, they travelled from Puebla to the rugged southern state of Oaxaca, where a thin veneer of Hispanic Catholicism overlaid the rich culture of the Zapotec Indians. From the expansive Valley of Oaxaca, with its windswept skies, they travelled to mountain villages to photograph sixteenth-century churches.

They visited the ancient pyramids at Etla, where they were nearly arrested by a hostile local police chief. In Oaxaca City, they were enchanted with the local black pottery and spent hours bartering in the craft markets, Tina playing her Italian identity to the full to foil the vendors' anti-American sentiment. They stayed at the clean and inexpensive Hotel Francia, where D.H. Lawrence had lodged the previous year, a short time after he had made their acquaintance in Mexico City, when Weston had made his portrait.

After returning to the capital to make prints, they set forth again for a month of travel through western Mexico. High in the mountains of Michoacán, in the lakeside town of Pátzcuaro, they were joined by the unlikely figure of René d'Harnoncourt, a handsome Austrian count, whose 6-foot 7-inch frame and penchant for checked knickerbockers made quite an impression upon the Purepecha Indians! A chemist by training, the penniless d'Harnoncourt had left Europe to seek his fortune in Mexico, where he graduated from freelance artist to buyer of antiques and pre-Columbian artefacts for Fred Davis at the Sonora News Company. René entertained them with tales of European court life, sang Austrian folksongs and lent them a copy of Lawrence's *The Plumed Serpent*. Apparently, poor Lawrence's obvious bewilderment and fear of Mexico was the cause of much hilarity on their part.

Mexican Mask,
c. 1926 [TM]

A photographic tragedy almost occurred on the Lake Pátzcuaro island of Janitzio. They had been received with hostility by the island's Indians, who were traditionally suspicious of outsiders. As Weston set up his camera to take a photograph, a wedding procession approached 'led by an old hag whirling round and round, wildly gesticulating with a pair of steer horns … ' They beat a hasty retreat, leaving the tripod and camera in the care of their Indian porter. 'Then happened a near tragedy, for to my horror the old horn-waving witch charged my camera,' Weston wrote. Luckily the porter was adept enough to dissuade her from throwing it to the water below.

Clearly it was Edward who had signed the contract and took the vast majority of the photographs, but Tina's participation in both

practical and aesthetic terms was integral to the project's success. She served both as translator and 'fixer' – kissing the 'greasy hands of lecherous priests' in order to photograph churches and religious statues at a time of extremely high church–state tensions. Her fluent Spanish allowed her to pose as a Mexican to bail them out of tight spots and enabled her to bargain for better prices on just about everything. She also discovered art objects to photograph which Weston had overlooked. In fact, in Weston's opinion the assignment could never have been completed without Tina's vital help. She also took many photographs for the project and several of them appear in Anita Brenner's book. The individual photographs carry no credits, making it hard to detect precisely which photographs are hers, but in the book's acknowledgements, Brenner thanks 'The two photographers who shared this commission, Edward Weston and Tina Modotti, [who] are too well known and respected as masters of their craft to expect in *Idols Behind Altars* any acknowledgment less than

Germán List Arzubide,
c. *1926 [TM]*

Telegraph Wires, c.1925 *[TM]*

Sugar Cane, c.1925 *[TM]*

deeply grateful ... ' In later years, she repeated the assertion that 'Tina did a good deal of this work interchangeable with Edward, so that it would be impossible really to say whose photographs are which ... '

By the time they had returned definitively to Mexico City, the *Idols* trip had taken its toll on Tina and Edward's relationship. Even before signing the contract, Weston had been thinking seriously of leaving Mexico. He and Tina had ceased to be lovers virtually since his return to Mexico the previous year and now their photographic partnership was also breaking down. Tina had become a skilled photographer, capable of earning her livelihood in her new profession. Interestingly, Weston no longer made portraits of her; it seems that as his passion dissipated, so did his desire to photograph her. During their travels, his pent-up resentment against her, perhaps exacerbated by his problems with Anita Brenner over the terms of his contract, must have prompted what was a scathing attack on women in general in a July letter to his friend Hagemeyer. After commenting that sex was all men needed from women and all women could give a man, he launched into a tirade against modern, intellectual women, lambasting them in vulgar, sexist terms.

Edward and Tina's separation in first and second-class train carriages had been indicative of what was to come. Weston almost immediately began to express feelings of loneliness and rejection in his daybook. By early October, he was noting his 'loss', in apparent reference to their relationship. He later referred to his extreme jealousy throughout his time in Mexico, provoked by Tina's taking other lovers. Of course, he had not exactly been lover-less himself – within two weeks of his arrival in California he had begun a passionate affair with Miriam Lerner and, after returning to Mexico, continued to write love letters to her. At the time he was bemoaning his 'loss', he said he was already being 'compensated' for it by an intimate relationship with a new servant, Elena Ortiz. The 'little brown Indian girl', as Weston described her, was 'a nice plaything', 23 years his junior. Although Elena was just a sex-object to him, their passionate, on-again off-again affair lasted through Tina's visit to California and after her return until the autumn of 1926.

Following the *Idols* expeditions, Tina spent very little time with Edward. It was clear to her that he had become bitter and resentful. To him, the 'barrier' between them had become insurmountable, although a rather shaky friendship seems to have endured and they still made occasional jaunts to visit mutual friends. With Anita Brenner, they went to visit Nahui Olin, whom Tina had photo-

graphed along with other women friends, including María Marín and
Paca Toor. Tina was 'enchanted' with Nahui's sunny, rooftop apart-
ment with its 'flowers, parrot, dogs, cats, art … and blue and colored
tiles in her patio and rooms'.

Tina was also devoting a lot of time to her own photographic pro-
jects. Her print of *Telegraph Wires* was reproduced in a new book on
Estridentismo by her friend, Germán List Arzubide, who also used
several of her photographs in the magazine he had founded in April.
Horizonte included *Estridentista* poetry, prose and drama and was
lavishly illustrated with the work of Charlot, Orozco and Tamayo.
Over the next few months, several of Tina's photographs were repro-
duced in the magazine on their own, unaccompanied by text, making
her one of the first photographers in Mexico to see her photographs
reproduced as works of art, not illustrations.

Throughout 1926, Tina's photography began to receive as much
attention as Weston's. She exhibited new prints on 7 October in a

*'The Little Great
Works of Tina
Modotti' published in*
El Universal
Ilustrado *in 1926*

*Indian mother
breastfeeding her
baby, c.1925 [TM]*

mixed-media exhibition at the *Galeria de Arte Moderno*, along with
Weston, Rivera, Charlot and others. A review of the exhibition in *El
Universal Ilustrado* the following week was accompanied by three
illustrations, two of which were her photographs. One of them, of an
Indian mother – Luz Jiménez, the Salas' servant – breastfeeding her
child, was said by the reviewer to have 'figured with great success' in
the showing.

Three weeks later, Tina's work was again featured in the publica-
tion in a review entitled 'The Little Great Works of Tina Modotti'. All
three of the photographs accompanying the review are relatively
unknown: one, a still life of a painted gourd in the form of a fish, jux-
taposed against a boldly striped Mexican fabric; another, a profile
portrait; and the third, washing on a clothes line. The reviewer asks if
there is 'profound poetry in a simple tenement clothes line', and
answers that in this photograph, 'yes' there is.

As Weston printed the last of the *Idols* negatives and prepared to leave Mexico, his romantic interest was temporarily aroused by a blue-eyed Irish-American from Chicago. Mary Louis Doherty worked as secretary to labour leader Luis Morones and was a close friend of Xavier Guerrero and Katherine Anne Porter. But Mary, also a friend of Tina, resisted Weston's overtures, believing it disloyal to pursue the romance with him. Unaware of the real state of his and Tina's relationship, she rejected his advances, telling him: 'We have all believed in the legend of Edward and Tina, you are leaving now, and I want to still believe. It was a beautiful picture.'

But the 'legend of Edward and Tina' was over. Tina seems to have already moved out of the boat-shaped house on Avenida Veracruz, only returning briefly after Weston's departure to pack her belongings. But she did go to see him off, along with Pepe Quintanilla, Felipe Teixidor, Roberto Turnbull, Frances Toor and Mary Doherty. In the taxi on the way to the station Tina and Edward embraced for the last time. 'The leaving of Mexico will be remembered for the leaving of Tina,' Weston wrote in his daybook aboard the train.

The following day, in the emptiness of their former home, Tina sat down to write to him. She alluded to Ezra Pound's poem, *Canto LXXXI*, which begins:

> What thou lovest well remains,
> the rest is dross
> What thou lov'st well shall not be reft from thee
> What thou lov'st well is thy true heritage ...

Reflecting upon the importance of Weston in her life and the 'heritage' of their relationship, she said of the poem:

> You are *that* to me Edward – no matter what others mean to me *you* are *that*– only you were embittered and had lost faith in me–but I never did because I respect the manyfold [sic] possibilities of being found in all of us and because I accept the tragic conflict between life which continually changes and form which fixes it immutable ...

12

Photography and Revolution

The perilously tilted Edificio Zamora straddled the corner of Abraham González and Atenas Streets, having miraculously survived the cannon barrages of barrack uprisings and the destructive force of earthquakes. Residents and visitors alike jokingly referred to it as the 'Tower of Pisa' and taking the elevator to the top was likened to riding a cable car up a mountain slope! In late 1926, Tina moved into a modest three-room flat with wooden floors and high ceilings on the fifth floor. Her love of rooftops led her to turn a servant's room there into a simple studio, giving her dominion over the *azotea* with its wonderful view of the volcanoes.

Frances Toor also lived on the fifth floor, but her real domain was on the first floor, in the offices of *Mexican Folkways*, the magazine she ran almost single-handedly. Diego Rivera had taken over from Jean Charlot as the magazine's art editor. In March, Tina was kept busy printing sets of some one hundred details of his murals. She was

> oh so busy with copies – Sunday worked again at Segretaria [sic] – more fragments of new frescos. Diego is so enthusiastic about my copies that he would like me to even repeat the ones Lupercio has done already – too big a job however, I said no ...

It was during this period that Tina began an affair with Diego which lasted until mid-1927. Diego's obesity was no obstacle to his seductive powers. He was, in fact, a notorious womanizer, which caused Lupe Marín much distress. Long before his and Tina's sexual spree, there had been rumours of Diego and Lupe's impending separation and Tina must have been aware of their marital problems. Whether they influenced her behaviour is not clear, but it does appear that in early 1927, both she and Diego took advantage of Lupe being pregnant and housebound with her young daughter,

Guadalupe, to look after.

Lupe herself believed the affair began when she was pregnant with her second child, Ruth. Clearly, Tina was seeing a lot of Diego, at least from March onwards, when she was spending so much time photographing the murals. By May, Anita Brenner was noting in her diary that Tina had become Diego Rivera's 'megaphone'. But it was not until mid-June, just after she had given birth, that Lupe realized Diego was being unfaithful to her and she sent a really nasty letter to Tina. Indeed, Lupe seems to have broadcast her reaction, for Anita noted with thinly veiled glee that 'Tina got hers from Lupe Marín.'

As a result, it appears Tina promptly ended her affair with Diego, angry at him for having told Lupe about it. In a letter written at the end of June, she indicated that she was no longer seeing the painter so regularly: 'I shall by all means show them [Weston's photos] to Diego in some way or other – I am supposed to go to the Seg. [Education Ministry] this coming week to copy his last fresco and shall take them along hoping to find him there.' Although Tina's affair with Diego only ignited a coming eruption in the Rivera household, the romance of Diego and Lupe would never recover its force. In fact, Rivera soon left his wife and children to go on a trip to the Soviet Union and when he returned several months later Lupe had moved in with the poet Jorge Cuesta.

Diego and Lupe's daughter, Guadalupe Rivera Marín, c.1927 [TM]

Tina's renown for the skill with which she reproduced the muralists' work was spreading among Mexican artists and requests for such work began pouring in. Also living in the Edificio Zamora at that time was the enigmatic Bruno Traven, author of *Treasure of the Sierra Madre*, an adventurer and wandering revolutionary with a keen interest in photography and film-making. He was planning a film which would use the murals to tell the story of the Mexican revolution, based on Tina's photographs of the muralists' work. Tina provided Traven with scores of prints but the film was not

made until decades later and ultimately none of her images were used.

When, in early 1927, Paca Toor enlarged the format of *Mexican Folkways*, Tina's name appeared on the new masthead as a contributing editor, the only woman in that capacity. She had become the magazine's premier photographer and her photography was by no means confined to copying the work of the painters, as she continued with her creative work and her portraiture. Her portrait of American writer John Dos Passos was probably made in early February. In Mexico since November 1926 for a five-month visit, Dos Passos undoubtedly met Tina through Xavier Guerrero, with whom she was spending an increasing amount of time, even while she was involved with Diego.

But it appears it was not until after her affair with Diego had ended in June that Tina actually fell in love with Xavier Guerrero and wanted 'to simplify life, in particular with men'. It was only after her ideas on art and politics had changed that Tina was really to appreciate the charms of this painter cum revolutionary she had known for five years. Their relationship, which marked a turning point in Tina's life, began during a period of what Anita Brenner termed her 'mystic radicalism'. Tina had become increasingly idealistic and was moving towards a deeper commitment to revolutionary art and politics, and there were few in Mexico with as visionary a belief in the power of revolution as Xavier Guerrero. Her conviction to work for 'the cause' was influenced by Guerrero, as was her photographic vision. She later told him:

> It was you who opened my eyes, you who helped me in the moments in which I felt that the pillar of my old beliefs had begun to totter beneath my feet.

Guerrero was not simply a wild-eyed revolutionary, however. He could also be calm and compassionate, qualities which must have endeared him to Tina. A short time after the assassination of Francisco J. Moreno, a Communist member of the Veracruz state legislature, Xavier Guerrero and his sister, Elisa, looked after Moreno's eight-year-old daughter, Francisca. During the week, Francisca went to a boarding school run by communists in the impoverished Colonia de la Bolsa, coming home to spend weekends with Elisa, Xavier and Tina, who played with her and took her on outings. Like Tina in her youth, Francisca became ill with typhoid fever and had her hair cut short. Tina made two portraits of her at the time. In one, she stares directly into the camera, her dress fastened at the neck with

Francisca Moreno, 1927 [TM]

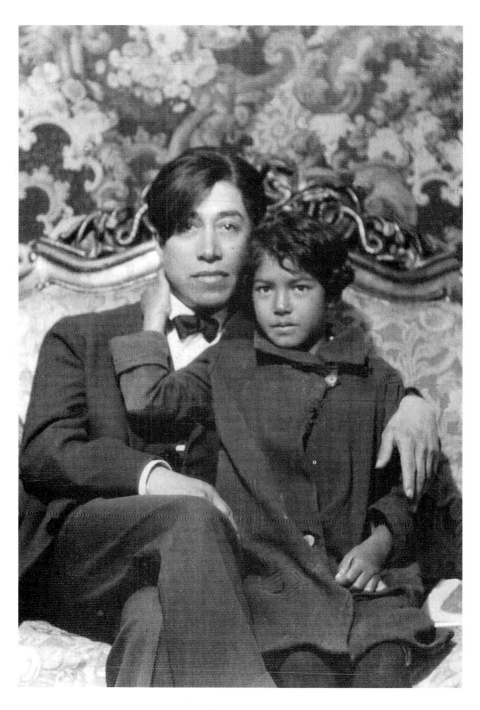

*Xavier Guerrero and Francisca
Moreno, 1927 [TM]*

the star-shaped badge of the Young Communist Pioneers, sent to her
from Moscow after her father's death. In the other, she sits cuddling
up to Xavier on the sofa in Tina's apartment.

A big event for the little girl was when she and her schoolmates
went to greet the new Soviet ambassador, Alexandra Kollontai, upon
her arrival in Mexico. For the Russian feminist revolutionary, the first
woman ever to be named ambassador, this diplomatic posting was a
kind of exile, designed to distance her from the Moscow intrigues
following Lenin's death. Kollontai's style was different from
Pestkovsky's: the quintessential diplomat, she dressed elegantly,
spoke fluent French and English and attempted to smooth the ruffled
feathers of Mexican government officials annoyed by her predecessor's
blatant support of Mexican Communists. During Kollontai's brief
tenure in Mexico, Tina visited her frequently. Francisca remembers
that on several of their outings, Tina 'took me to the Russian embassy,
where she knew a lot of people'.

Years later, Tina mentioned that she and Kollontai, with whom she
maintained contact after she left Mexico, shared many of the same
ideas. She recounted how Kollontai had once told her laughingly that
while she had been in Mexico, some of her Mexican friends had tried
to make her understand that in certain circles

> I did not have a very good reputation because I had posed nude for
> Weston and that my figure was in that famous Diego Rivera mural in
> Chapingo. She told me the things they had said about her when she was
> young and added that she had always done what she considered right
> and did not concern herself with what others thought ...

But Kollontai was not happy in Mexico; she disliked being so
removed from events in Europe and her efforts to improve bilateral
relations with Mexico proved unsuccessful. Within six months Moscow
had posted her to Norway. Her farewell party became a fiasco when
the Legation was raided by the Mexican police and Tina and several
others were arrested. Using the current crisis of the Cristero religious
rebellion to fabricate a flimsy excuse, the police claimed that 'hearing
singing they thought that an illegal religious meeting was being held'.
The real reason may have been the recent discovery at the Soviet lega-
tion in London of the names of Soviet agents operating in Mexico. 'As
[the] party broke up, the police rushed the place, rounded up all the
guests and took them off to the police station.' They tried to arrest
Kollontai herself, but First Secretary Leon Haykiss intervened and she
was allowed to spend her last night in Mexico at the Hotel Geneva. It

was Tina's first brush with the Mexican police, but she was in good company, for several other important figures, including a leading politician, were arrested at the same time.

Probably through John Dos Passos, Tina was introduced to the radical US magazine *New Masses*, which published her translation of Xavier Guerrero's article on revolutionary art in the May issue. But her main contact with the publication seems to have been Ernestine Evans, who wrote for the magazine and was the wife of the Soviet news agency TASS's New York bureau chief, Kenneth Durant. Ernestine, accompanied by Ella Wolfe, visited Mexico in early 1927 to work on her book *The Frescoes of Diego Rivera*, which would be illustrated with Tina's photographs. The visit was packed with bullfights, sightseeing and parties, including one at Tina's apartment in mid-March. After returning to New York, Ernestine wrote to Mexico encouraging artists to contribute to the magazine and the first of several of Tina's photographs was published the following January.

While Diego Rivera had long since resigned from the editorial board of *El Machete* over a dispute with the other muralists, Xavier Guerrero continued as one of the *responsables*. Tina became more involved with the newspaper, not only continuing with translations, but also branching out into photography. In June 1927 she took what could be considered a 'promotional' photo, of a lone worker reading the newspaper. In the October 1927 issue, an uncredited photograph of the *El Machete* and Mexican Communist Party offices is considered to be hers.

'The Hands Off Nicaragua Committee' with the American flag captured by Sandino, 1928 [TM]

Vittorio Vidali, 1927 [TM]

Following the US occupation of Nicaragua in early 1927, Tina collaborated with the 'Hands Off Nicaragua Committee'. Jorge Fernández Anaya remembers going with her to ask for funds from government officials and wealthy Mexicans to support Augusto C. Sandino's army. She also photographed a memorable event for the 'Hands Off Nicaragua Committee', the turning over to them of an American flag captured by Sandino's troops. Later, Germán List Arzubide, en route to an anti-imperialist conference in Germany, smuggled the flag through US customs by concealing it wrapped around his body under his clothes!

Her apartment in the Zamora Building became a kind of radical 'salon' for local Communist leaders and Latin American exiles. By July, faced with the imminent execution in the United States of the Italian radicals Nicolas Sacco and Bartolome Vanzetti, the Mexican Communist Party had formed the 'United Front for Sacco and Vanzetti' and a special call was made for Italian exiles to join. Tina responded, of course, and helped organize many of the events. Several of her friends were surprised at her growing activism, among them Jean Charlot, who wrote to Weston, 'Tina goes hard on social work.'

It was through the Sacco and Vanzetti protests in the summer of 1927 that Tina met two men who would have a profound effect on her life. One was Julio Antonio Mella, a frequent speaker at Sacco and Vanzetti rallies, who had come to Mexico in 1926 after fleeing the dictatorship of Gerardo Machado in Cuba and had quickly become a leading figure among Mexican Communists. The other was the Italian, Vittorio Vidali, then using the alias 'Enea Sormenti'. Sent by Moscow to Mexico in 1927, one of Vidali's tasks was the revamping of the Communist Party's front organizations. This included aligning the existing prisoners' aid organization with 'International Red Aid', a Communist front organization whose stated aim was to collect and dispense funds for political prisoners world-wide. His mission was to coordinate Red Aid activities in the region from Mexico, while overseeing the activities of the Mexican section. His impact on the Mexican Communist Party was almost immediate and within months he was a member of the Central Committee. A native of Trieste, a short distance from Tina's birthplace, Vidali was both a veteran of the street-fighting and gun battles which had wracked that port city following World War I, and a seasoned Soviet agent.

Tina's commitment to Communist revolution seems to have been steeled by the execution of Sacco and Vanzetti. In late 1927, under Vidali's influence and with Xavier Guerrero's encouragement, she took

'A proud little agrarista', Mexican
peasant boy, c.1927 [TM]

a definitive step towards political militancy and became a card-carry-ing member of the Mexican Communist Party. Although Mexican Party officials did not know that Tina and Guerrero were lovers, it appears that Vidali did. He remembered that he, Tina and Xavier

> had a long talk before she asked for her card. She took political activity very seriously; the step of joining the Party she took with the full understanding of the responsibility it implied. When she committed herself to something, she wanted to comply one hundred per cent …

At this point, Tina was still striving to balance the disparate ele-ments in her life. She continued to see her old, less political friends, showing them recent examples of her own and Weston's photographs with the passion and enthusiasm of one who is very serious about art. Although she often apologized to Weston for not answering his let-ters promptly, she did correspond with him frequently, sending him examples of her and other people's work, including a copy of Nahui Olin's new book with a striking Weston portrait of Nahui as a fron-tispiece. Their friendship and respect for each other were still strong, and when she wrote to him telling him how important he had been to her, Weston immediately responded:

A washerwoman's hands, c.1927 [TM]

Tina dear, if I have been an important factor in your life, you have certainly been in mine. What you have given me in beauty and fineness is a permanent part of me, and goes with me no matter where life leads. This thought needs no elaboration! My love goes out to you always – Edward

Although Tina had once believed that social concerns could not be expressed through photography, she had now embarked upon a photographic period that disproved this. Putting her art at the service of revolutionary politics, she used her camera to portray social injustice, photographing workers, political rallies and the poor, like the Mexican peasant boy with his big *sombrero*, whom she dubbed 'A proud little *agrarista* or better, son of one.' The portrait was reproduced with colour tinting on the cover of the January 1928 *CROM* labour federation magazine, and appeared on the cover of *AIZ* magazine in Berlin two months later. It was apparently made during a peasant unity congress in late 1927.

As a Party member, Tina's work included recording such political events and she was often the only woman present at the very solemn meetings of the congress in the humid Veracruz city of Xalapa.

Documenting the occasion, she made photographs of a march behind a hammer-and-sickle banner and captured the audience of attentive, serious farmers and platform speakers, who included Xavier Guerrero and Julio Antonio Mella. Clearly, she did not spend all her energy at such an event simply photographing the proceedings. It provided her with the opportunity to photograph workers loading bananas onto ships in the nearby port of Veracruz and she also made a delightful collective portrait of a peasant family outside their adobe home, almost inundated by a mound of drying ears of corn, a symbol of agrarian reform, the cornerstone of the Mexican revolution.

Ear of corn, sickle and bandolier, 1927 [TM]

Back in Mexico City, Tina continued with her professional portraiture and art reproduction work, making photographs of the paintings of Californian artist Everett Gee Jackson and giving prints of the work of the Mexican muralists to his wife, Eileen Dwyer, for publication in the October edition of London's *The Studio* magazine, which was in

Hands holding tool, c.1927 [TM]

Worker carrying beam, c.1926 [TM]

A peasant family in Veracruz, 1927
[TM]

the process of going transatlantic as *Creative Art*. This episode led to a quarrel with Anita Brenner. In her diary, Anita called it 'black betrayal on Tina's part', apparently convinced that because she had commissioned the Orozco photographs she had the right to Tina's negatives.

Since the end of 1926, Tina had been contributing photographs to *Forma*, a new magazine edited by the painter Gabriel Fernández Ledesma. The first and foremost Latin American art journal, *Forma* was subsidized by the National University and the Public Education Ministry and, rather curiously, came complete with its own 'censor', the writer Salvador Novo. In late 1927, in an article dedicated to her work, *Forma* published some of Tina's photographs of industrial scenes, which List Arzubide planned to use in his forthcoming book *Song of Man*, a eulogy to workers and their daily tasks. Tina was very enthusiastic about this *Estridentista* project and had immediately offered to supply the photographs, making a series on workers especially for the project. Unfortunately, while the text and photographs were prepared, the book was never published.

It was on an assignment for *Forma* that Tina had a particularly distressing experience. She went to the former *La Merced* monastery to photograph the work of the students at the open-air 'School of Sculpture and Wood-Carving', including the red-cedar doors, richly carved with figures of animals. On a previous visit, Tina had been enchanted by the animals which the students kept on the premises to use as models. Arriving early on a Monday morning, she found to her horror that the coyote had broken out of its cage and savaged the other animals. Tina surveyed the carnage as the dead animals were cleared away and *Forma* editor Fernández Ledesma was amazed by the change that came over her: she 'looked so aghast, taken aback, her face full of fear ... [and] pain'.

It was also in 1927 that Tina began a series of dramatic still compositions which epitomized the aspirations and achievements of the Mexican revolution. 'A perfect synthesis of a great social ideology' was how one Mexican critic later described her arrangement of the ear of corn, the sickle and the bandolier that appeared in the autumn 1927 edition of *Mexican Folkways* to illustrate the popular *corrido*, 'El 30–30'. She went on to make several more of these icons of the Mexican revolution, incorporating into them other revolutionary emblems, such as the guitar and passages from Articles of the Mexican Constitution.

There is no doubt that Tina's photography, and life, underwent a radical change in 1927, the year that she joined the Mexican Communist Party and began her relationship with Xavier Guerrero.

But the person she described as having 'opened her eyes', an event of supreme importance to a photographer, was about to leave Mexico. The Central Committee of the Mexican Communist Party had decided to send Xavier Guerrero to Moscow for three years to the Lenin School, a Comintern institution for the training of prominent foreign cadres. Tina apparently accepted the Party decision without protest, even delving into her savings to help pay for Xavier's passage. In exchange, thinking that she might be able to sell it, he left her his .45 calibre pistol. Little did he realize that it would later serve to complicate her life and cause her considerable distress.

Hammer and sickle, c.1927
[TM]

13

Enemies of Tyranny

The *El Machete* office was much more than just a simple newsroom. Along with the Communist Party offices next door, it served as a centre for political and social activities. Following the belated arrival of the new Soviet ambassador, the plump and balding Alexander Makar, *El Machete*'s pages announced a spate of fund-raising festivities on the premises, such as the all-night dance with the 'Chicago City jazz band'. During the day, the typewriters rang as the *Macheteros* pounded out their message with an evangelical zeal. None of the writers were professional reporters, but what they lacked in newspaper skills they made up for in conviction. The bespectacled Spaniard, Rosendo Gómez Lorenzo, nicknamed 'Captain Coldblood' because of his impervious manner, was the publication's editor, and most frequently at the typewriters were Party Secretary General, Rafael Carrillo; Moscow's representative, Vittorio Vidali; and the Cuban revolutionary with heady plans for the island's liberation, Julio Antonio Mella.

Tina had known Julio Antonio casually since the Sacco–Vanzetti campaign, but it was her growing collaboration with *El Machete* in the spring of 1928 that brought them into closer contact. This coincided with her first venture into photojournalism, making a series of contrast photos for the newspaper. It appears the idea originated with Mella and that he even accompanied Tina to take some of the photographs. Rafael Carrillo remembers that she worked very closely with Mella who gave her 'the paper's vision'.

On what was probably her first 'street photography' assignment, Tina went to the slum neighbourhood of Colonia de la Bolsa to record the misery of people's lives there. The result was the first in a series of photographs that began in the 15 May issue of the paper under the heading 'The Contrasts of the Regime'. Tina's photograph of five desolate children, their faces robbed of childhood, outside the

The El Machete *offices and Mexican Communist Party headquarters, 1927 [TM]*

shack that is their home is contrasted with a photograph of well-dressed wealthy children being taken for a walk in the park by their nanny.

This contrast series, probably what Tina later referred to as her 'propaganda' photos, continued for a number of weeks and included such subjects as a baby in a fancy pram and a baby in a wooden box; a four-poster bed and a person sleeping in the street; palatial homes and hovels; and a *montage* of a down-and-out worker sitting on the pavement, with a hoarding advertising men's elegant evening wear superimposed above his head. While the political message was strong and could be grasped with ease by *El Machete* readers, the impact of the images is somewhat obscured by the heavy-handed captions and the contrast mechanism. More successful were the single images used following this series, dramatic street scenes of poverty and degradation, like the one of the woman who lies in a drunken stupor outside a *pulqueria*, and another of a mother who breastfeeds her infant in the midst of squalor.

The hours spent together working for *El Machete* allowed Tina and Julio Antonio to get to know each other better and by June they had

fallen passionately in love. The 25-year-old Mella was tall and handsome with lively green eyes, a legacy from his Irish mother, and dark, thick, curly hair like that of his mulatto father. The first of two sons born to Cecilia MacPartland and her lover, the Santo Domingan businessman Nicanor Mella, 'Julio Antonio' was Mella's adopted, revolutionary name – his real name was Nicanor MacPartland. This young 'Adonis of the Left', as some referred to Mella, was in fact a deadly serious revolutionary, a fiery speaker whose oratory brilliance endeared him to fellow students at the National University, where he was enrolled as a law student, as well as to workers and peasants in Mexico City and the provinces. Like most Cubans, he was usually gregarious, but his fellow law student Alejandro Gómez Arias remembered that he could also be 'introspective and silent', a man 'possessed' by his ideas. Publicity around his weeks-long hunger strike in a Cuban prison had propelled him into the limelight and he had become the foremost Latin American revolutionary, a position of considerable political power.

As their relationship evolved, Tina and Julio went on photographic assignments for *El Machete*, helped each other with their respective political tasks and frequented Alfonso's Chinese café on Argentina Street, where the more audacious students gathered for hours of heated conversation. Alfonso served the cheapest meals in town and his large glasses of milky coffee and stodgy *pan dulce* (pastries) were the staple of every student's diet. Here, Tina met Mella's *cuates*, his friends and fellow students: Gómez Arias, also a brilliant orator; the

Mexican peasants reading El Machete, *1928* *[TM]*

*Poverty and
elegance: Photomontage, 1928 [TM]*

Street scene outside a
pulqueria, *1928 [TM]*

eccentric Juan de la Cabada, Mella's jovial sidekick; the serious and
intense Baltasar Dromundo; and the flamboyant dandy, Germán de
Campo, whose appearance belied a dedicated student leader, des-
tined to be assassinated during student protests the following year.
Dromundo remembered that in the summer of 1928:

> At one point, [Mella] started to appear in the company of Tina and,
> when I realized that something more than their common ideology unit-
> ed them, it seemed the most natural thing in the world to me.

These students became friends of Tina's, recalled former law stu-
dent José Muñoz Cota. Arriving at the Café Alfonso on her own or
with Mella, Tina would

> come and talk with us ... about social things, about art from a social
> point of view. She was a free woman; I mean, she did not have the
> usual limitations that women in Mexico had. She was very intelligent
> and quick to express herself, a rapid thinker ... extroverted and very
> sure of herself. What immediately attracted you to her was her great
> human empathy.

In spite of their obvious compatibility and strong sexual attraction,
Tina was reluctant to commit herself deeply to the relationship with
Julio Antonio. Mixed with the excitement of this new love was the
troubling aspect of her loyalty to Xavier Guerrero, with whom she
corresponded frequently, sending him her photographs, which he
submitted to Soviet publications. Throughout the summer months,
she considered her and Julio's everyday less-secret affair a 'transgres-
sion' against Guerrero's trust in her. Mella's situation was also emo-
tionally complicated. He was separated but not divorced from his
Cuban wife, Oliva Zaldivar. Having grown tired of Mella's constant
political activism, which cut into his ability to support her and their
baby daughter, Natalia, she had gone back to her family in Cuba.

It seems that about this time Tina had fallen into financial difficul-
ties, probably as a result of not charging friends for photographic
work and being overly generous to them and to Party causes: 'One
might think it was an error; I think it was a virtue,' Dromundo said,
recalling Tina and Julio Antonio's generosity. 'What they had they
spent on the Party [or] on other people; they were truly magnani-
mous and as a result they sometimes didn't have a cent ... ' Still,
every month she diligently sent five dollars – not an insubstantial
sum at the time – to her sister Gioconda, who was bringing up her
child on her own in Italy. In fact, Tina became so short of money at
one point that she was unable to buy clothes she desperately needed.

A letter to Xavier in the Soviet Union elicited a rather unsympathetic response:

> I'm sorry about your clothes, you call it tragic or nearly tragic; you exaggerate, and I am certain it is your Italian-ness combined with a little bit of Mexican-ness. I will send you something from here, but … don't expect anything like [you had] in Los Angeles …

Her friend, Ernestine Evans, was a little more sympathetic. From New York she wrote to their mutual friend Carleton Beals asking him to tell Tina to expect a visit from the American socialist 'Alex Gumberg [who] is going to be at the Hotel Regis and is fetching her a dress'.

Guerrero also warned Tina about allowing her apartment to be used for parties:

> I don't agree that you should help out those who do nothing for the P[arty], letting your house be used for a drunken party by some girl who should know better by now. Do not forget that you are alone and we should not provide our enemies with ammunition. They watch us so closely in order to find some scandal to attack us with, whenever they can. Now, more than ever, you should in no way draw attention to your home …

Guerrero's concern was actually a legitimate question of security. Tina's apartment had become what Vittorio Vidali later referred to as 'the meeting place for comrades and later the site of reunions of the Party directorate'. It was also a focal point for national and international Party delegates arriving in Mexico City. In fact, Cuban Communist and later Spanish Republican general Enrique Lister recalled that while working in Cuba in the 1920s, he had heard talk of Tina Modotti as 'the contact in Mexico for the Communist International'.

It was around this time that Tina developed a skill she had not known she possessed: she had become a 'very effective' public speaker. Vittorio Vidali had set up a regional bureau for International Red Aid activities and had appointed Tina to head the organization's Mexican section. He continued to oversee regional activities and remained the titular head of the organization in Mexico. But Julio Rosovski, alias 'Ramírez', a Russian *émigré* and Party stalwart, said Tina was not only the one who did most of the work but that the entire 'Mexican section of International Red Aid was in fact directed by Tina Modotti … '

In May, she organized a rally to protest the prison death in Italy of

Railway worker's daughter, 1928 [TM]

Woman with flag, c.1928 [TM]

a young worker named Gastone Sozzi. At the meeting Tina gave the keynote address, accusing the fascist government of having turned Italy into 'a great prison and vast cemetery'. Her comments were duly noted by the Italian embassy in Mexico, which cabled Rome about her activities. In August, she organized a Sacco and Vanzetti memorial rally and, although disheartened by the poor turnout, she planned another event to show that Mussolini was colluding with the Vatican's attacks on Mexico over the Calles government's persecution of the Church. At the rally, accompanied by Julio Antonio and Diego Rivera, she addressed a packed hall calling upon Mexico to break diplomatic relations with Italy.

In order to juggle her political work with her photography, Tina had to maintain what Mexican photographer Lola Alvarez Bravo describes as a rigorous 'respect for her work schedule, whether it was Party work or her photography. Sometimes I found her in her black overalls that she wore in the laboratory … she would just go into the darkroom and refuse to receive anyone.'

If fulfilling this demanding schedule was trying for her, it did not show. Lola remembers that although she always seemed extremely busy, Tina did not appear frantic, rather her demeanour was 'very calm and serene'. Except when she was taking photographs, it appears. Lola's husband at the time, the photographer Manuel Alvarez Bravo, once recalled that Tina looked 'tortured' when taking photographs, that 'she would really screw up her face, she was concentrating so hard'.

Alvarez Bravo also remembers that Tina relegated receiving friends to the late afternoon hours. These visits became heady discussions on art and photography, when she would show her latest work and any photographs that might have arrived from Weston. But even with visitors present, if Tina saw something she wanted to photograph she would run for her camera, like the day when a lorry carrying sand stopped outside the building and she rushed to photograph the workers sprawled on the load.

And of course her new lover did not escape her lens. Tina made many photographs of Mella: in one he feigns sleep on a grassy lawn, others were apparently nudes taken on the *azotea* of the Zamora building

Manuel Alvarez Bravo, c.1930

and there are photographs of him jaunty in his Texan hat and as he turns, smiling, from working at his typewriter. But it is probably her photograph of his typewriter that is the truest portrait of Julio Antonio the revolutionary. Mella considered his typewriter a symbolic weapon in the fight for liberation and Tina's photo represents it as a vehicle for ideas on art and revolution.

Mella also believed this photograph of his typewriter to be a synthesis of Tina's photography and politics. Writing to her in September, he referred to the 'keyboard which you have socialized with your art'. Likewise, Benvenuto Modotti wrote congratulating his sister when another of her photographs, *Hammer, sickle and sombrero*, appeared on the cover of the October issue of *New Masses*: 'And you, you little liar, you once told me that one cannot express social concerns through the art of photography. You are the one who has proved yourself wrong.'

Among Julio's student friends who began frequenting Tina's apartment and the parties there were Alejandro Gómez Arias and Germán de Campo. It was through Germán's friendship with Mella that Tina was introduced to Gómez Arias' former girlfriend, a young painter already infamous for her precociousness and disdain for convention, the 23-year-old Frida Kahlo. Gómez Arias recalls that Tina had a profound impact on Frida and that the two women became close friends. Contrary to popular belief, Tina rather than Diego Rivera was the one who brought Frida into the Communist Party. She also influenced Frida's appearance, encouraging her to dress more soberly, as 'befitted' a Communist. As a result, for a brief period Frida wore a simple skirt and blouse – a style that was Tina's hallmark when the fashion among many of her friends was for exotic indigenous clothing. Most importantly, however, it was Tina who brought together Frida and the man who would radically change her life, Diego Rivera.

Diego was a frequent guest at Tina's parties, and it was predictable that he and Frida would have a chance to get to know each other there. Frida was fascinated by the pistol-packing Diego and recalled that in a typical fit of outrageousness, he pulled out his gun during one of Tina's parties and plugged a hole right in the middle of a photograph – whether or not it was one of Tina's is not clear! In a testimony to their friendship, Diego united Tina and Frida for posterity by making them the central figures in a mural he began later that year on the third floor of the Public Education Building. In a panel called 'In the Arsenal', Tina stands near Frida, who is wearing her gift of a hammer-and-sickle brooch, both of them handing out arms

Mella's typewriter, 1928 [TM]

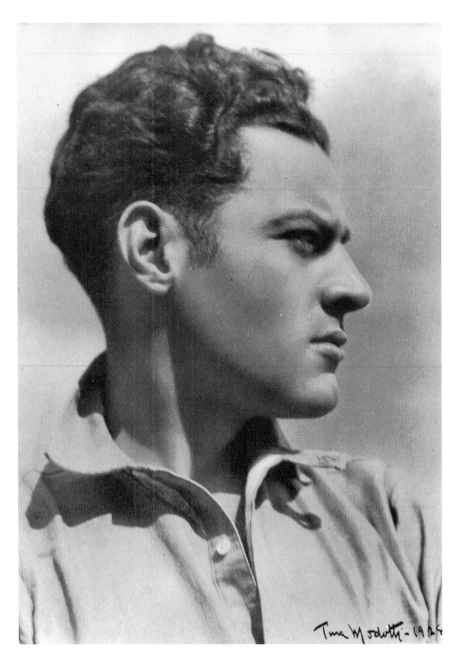

Julio Antonio Mella, 1928 [TM]

to insurrectionists who include Siqueiros and Mella. Vidali, meanwhile, in one of his many disguises, looms over the shoulder of the young Cuban.

Another young woman who became a close friend of Tina's at this time was Luz Ardizana. Unconventionally attractive, Luz was short and scrawny with closely cropped hair, a tenacious fighter for communism who trained in guerrilla warfare on her free weekends. Dressed in coarse work shirts and men's trousers, she confused peasants visiting the *El Machete* office, who at first mistook her for a boy. Together Tina and Luz, whose befitting nickname, *Lucha*, means 'fight' or 'struggle' in Spanish, would sing *Bandiera Rossa* and other Italian revolutionary songs and go off on trips around Mexico to political rallies.

By September, Tina had entered into a crisis in her relationship with Julio Antonio. Intent on the overthrow of the Cuban dictatorship, he travelled to Veracruz in an unsuccessful attempt to organize a guerrilla expedition to Cuba. It was a very painful parting for them both, for they could not be sure that Mella would survive his dangerous mission. As soon as he arrived in Veracruz, he sent Tina a telegram and sat down to write her a long and decisive letter. He chided her gently for being gloomy 'about what we have together, as though it were the greatest crime in the world'. But, he said, the reality of their situation was that he loved her 'tempestuously', and that she had told him that she loved him equally. The problem was what to do about it:

> After months of torture without any real hope … you now say that, yes, you truly feel you 'are ready to resolve it'. So, you weren't before? What's more, how? You still don't know. Neither do I … Is there a solution or not? Tina, it is not in me to beg you. But, in the name of all we love, give me something more definite …

Although Tina and Julio Antonio were passionately involved, he sought a firmer commitment from her. He wanted to live with her and for them to be a 'proper' couple. To Tina this meant having to advise Xavier Guerrero and that deeply troubled her. It was a moral crisis, unlike any she had experienced before. Her previous carefree attitude to sex had changed considerably since joining the Communist Party. In her new idealism, hurting another comrade, a fellow fighter for 'the cause' was a serious matter. But Mella's heart-wrenching letter must have had its effect, because within a few days, she wrote to Xavier Guerrero the 'most difficult, most painful' letter she had ever written:

... when I think of the pain that I am going to cause you, I seem to myself to be more of a monster than a human being; and I don't doubt that you will think that of me. At other times I see myself as a poor victim of some terrible fatalistic power with a hidden force which to my misfortune makes me act the way I do in life. But ... I sincerely believe I've had intrinsically good intentions, that I've always put the well-being of others before my own, that I am not cruel for the sake of being cruel – the proof of this is that when I have to do what I have to do now to you, I suffer as a result, perhaps more than you do.

But it's time that I say what I have to say: I love another man, I love him and he loves me and this love has made possible what I never thought could happen, in other words: the end of my love for you ...

Without naming Mella, she reassured Guerrero that her new love would make her no less dedicated to the cause, 'this has been my greatest concern, greater even than my concern for you ... because the work for the cause is not ... the result of loving a revolutionary, but a conviction firmly rooted in me'.

She offered to leave Mexico by the time he returned and said she would await his reply before taking any further steps. Guerrero's hurt must have been deep, for he replied with a terse telegram: 'Received your letter. Goodbye. Guerrero.' Later, his anger exploded in a 'very violent' letter he sent Tina via Rafael Carrillo, from whom they had hidden their relationship. Rafael was shocked. 'Why this flurry of insults because she's living with Mella?' He decided against giving Tina the letter and, for the time being, she was spared the full measure of Guerrero's wrath.

Party discipline required Tina to report her relationship with Julio Antonio to her Party superiors and she told Vidali upon his return in September from the Sixth Comintern Congress in Moscow. Tina's relationship with Mella was a serious matter, since she had been involved with two ranking members of the Central

Communist Youth Association, Mexico, 1928 (seated second from left, Jorge Fernández Anaya; standing on right, Russell Blackwell) [TM]

Committee simultaneously. But the Party apparently had no objections and Mella moved out of his tiny apartment near the Lecumberri prison and moved in with Tina. Baltasar Dromundo recalled that one day Julio Antonio simply told him he was living with Tina and that very same day invited him over for a glass of wine to celebrate.

The happiness Tina had felt with the other men in her life paled in comparison with the fulfilment she felt in her relationship with Julio Antonio. Friends and acquaintances remember he was absolutely devoted to her and although they were very discreet in public, at home they gave full rein to their passion. 'We were very happy, Julio Antonio and I,' Tina said later. 'We were really just like two sweethearts.' Their domestic life was tender and affectionate. They took turns at cooking, she making her delicious pastas when they had the money or, when

> Tina had a Party meeting and he arrived home first ... Tina would find the meal ready, the table laid, almost always with some little decorative touch, a flower or a piece of fruit or a little note he had left for her ...

It was probably during this intensely emotional period that Tina made her outstanding portrait of Mella, a noble profile that captures his strength and visionary spirit and immortalized his visage for generations of Latin Americans. Together they hosted informal political meetings at home, where Party members had wide-ranging discussions on art and literature and their role in revolution. Mella also organized political education groups for members of the Communist Youth Association, led by the zealous young New Yorker Russell Blackwell, explaining the works of Lenin and Stalin, and translating excerpts into Spanish. While Tina did not take part in these theoretical discussions, she did make photographs of the members of the organization. On another occasion, at their request she took a souvenir photograph of a group of enthusiastic young Mexicans who were leaving for Nicaragua the following day to fight with Sandino's army.

She also made photographs of Soviet embassy receptions about this time, one of which clearly shows her print, *Hammer and Sickle*, hanging prominently on the embassy wall. But when the non-Communist muralist Orozco wrote from New York requesting that Tina photograph his murals to promote his work there, she set about the task with a bulky 8 x 10 box camera inherited from Weston, following the painter's very specific instructions to the letter. 'In her help to artists, she was untiring,' recalled Jean Charlot. 'For days we

Detail of a mural by
Orozco, 1928 [TM]

worked throughout the daylight hours, stopping only for a beer and sandwich brought by Tina's friend Julio Antonio Mella.' Tina was enchanted by Orozco's work, commenting that when comparing it to Rivera's, she had decided she did not like Diego's latest things

> at all, and I tell him so, but he insists that even seen only as 'painting' they are the best things he has done. As time goes by, I find myself liking Orozco's more and more, I feel the genius. His things overflow with an inner potentiality which one never feels in Diego's things. Diego comments too much, lately he paints details with an irritating precision, he leaves nothing for one's imagination.

While there is little doubt about Tina and Julio Antonio's emotional and sexual compatibility, they were further united by an almost mystical fervour for 'the cause' which went beyond Marxist-Leninist theories. Tina described herself as an 'enemy of tyranny' at the time and Mella believed with a missionary zeal that he was destined to liberate Cuba from dictatorship. Before his Veracruz expedition, he pledged her to secrecy: 'You KNOW NOTHING, understand? when it comes to them [Communist Party leaders],' he wrote to her. The adventure was aborted, however, when an informer alerted Machado. When Mexican Communist leaders found out what Julio Antonio was up to, they threatened to expel him from the Party.

In fact, Mella had been at odds for some time with the Party leader-

ship and the Comintern over various issues. With Julio Antonio's Cuban exile group resisting control by the Mexican Party, Vittorio Vidali had returned from the 1928 Comintern Congress via Havana with a resolution from the Cuban Party which called for 'Mella's group in Mexico to subordinate itself to the C[entral] C[ommittee] of the Mexican Communist Party'. In a letter to Bert and Ella Wolfe in December, Rafael Carrillo wrote that when shown the resolution, Mella had erupted in 'fury' against the Mexican leadership and sent them 'an insulting resignation' letter. Within a few days, he reconsidered and withdrew his resignation. Julio Antonio had probably angered leading Comintern officials during his visit to Moscow in the summer of 1927, when he met with Catalán Communist Andrés Nin and other members of the Trotskyist 'Left Opposition'. Some, like Rafael Carrillo, believe he may have met Trotsky himself. There is no longer any doubt that Mexican Communist Party leaders suspected him of supporting Trotsky. Carrillo, himself affirmed in his letter to the Wolfes that 'Mella has always had Trotskyist "weaknesses".'

Clearly, as the New Year approached, Mella had many enemies, not least of which was the Mexican government. As a fiery and popular orator, capable of rousing students, peasants and workers to anti-government action, he would most certainly have attracted the attention of the Mexican secret police. Meanwhile, in Cuba, Machado was very disturbed at reports of his plans to overthrow him. On 15 December, a curious incident occurred when an *agent provocateur* disrupted a meeting by raising a Cuban flag. An argument ensued because the owners of the hall had asked the Cubans to avoid

José Clemente Orozco at work, 1927 [TM]

any political displays and Mella intervened and pulled down the flag. At the time, he paid little attention to the incident.

To celebrate the New Year, Tina and Mella attended a New Year's Eve gala organized by the Party. There was live music and dancing and Concha Michel brought her guitar and sang her favourite *corridos*. All of the Communist artists and their friends were there. Adelina Zendejas remembers that Tina 'entered ahead of [Mella] and I was impressed because she was such a beautiful woman, with her hair pulled back in a bun at the nape of her neck ... Frida arrived with them.'

The New Year was ushered in and within days disturbing newspaper reports arrived from Havana portraying Mella as having desecrated the Cuban flag during the event in Mexico City. Knowing that the reports were designed to undermine his reputation in Cuba, Julio Antonio considered his response carefully. Meanwhile, in other alarming reports, he was told that Machado had sent a gunman to assist special agents in Mexico City in his assassination.

On Tuesday 8 January, Tina had her camera with her at the Communist Party headquarters on the occasion of the visit of two envoys from the American Communist Party. The reason for the *gringos'* visit is not clear, although former Mexican Party leaders acknowledge that visits from their US counterparts were often to relay Comintern directives. The photograph that Tina made that day has remained buried in Mexican newspaper archives for six decades. A commemorative photograph, it shows prominent Communists, posed to record the moment for posterity. Among those in the back row is Julio Antonio, flanked by several Cubans and Mexicans, with Siqueiros immediately to his left. In the front row, between the two unidentified US Communists, sits Vittorio Vidali.

Two days later, on 10 January 1929, Mella went about his work as usual, preparing to attend a meeting that evening at Red Aid's headquarters on Isabel la Católica Street. Tina arrived for the meeting at about 7 p.m. The other participants were Mella and Vidali, Jacobo Hurwitz and Rogelio Teurbe Tolón. Following the meeting, Tina and Julio Antonio drafted a telegram to the editor of the newspaper *La Semana* in Havana, in which Mella denied any involvement in the alleged desecration of the Cuban flag. Tina agreed to drop the cable at the telegraph office and meet Mella after his encounter with José Magriñat. As they set out, they hardly suspected that within an hour, Julio Antonio would be lying on the cold pavement a few feet from the safety of the Zamora Building, bleeding to death in Tina's arms, the victim of an assassin's bullet.

PART III

1929 – 1935

*Tina, following Mella's
assassination, 1929*

14

Trials of Love and Death

In the fading afternoon sunlight of Friday 11 January, Tina walked slowly up the steps of the Mexico City courthouse. She was dressed soberly, but not morbidly, in a dark suit and an open-necked polka-dot blouse. On her right arm she was wearing a wide black band with a militant red star. She had come the few blocks from Communist Party headquarters to give further testimony regarding Mella's murder the night before. As she walked up the steps of the courthouse, a group of reporters spotted her and rushed toward her. One of them thrust a copy of a newspaper at her and asked for a comment. The black ink of the headline jumped off the page, one phrase burning into her consciousness: 'THE PASSION MOTIVE.'

Tina found it hard to believe that she was actually being implicated in the murder of the man she had loved so deeply. It was a turn of events for which she was totally unprepared. After leaving police headquarters the night before she had gone directly to the morgue, where Julio Antonio's body was laid out. In the early morning she had returned home only to be besieged by reporters insisting on interviews. Still in the clothes she had been wearing when Mella was shot, she answered the door to them, her eyes swollen from weeping, her hair in disarray. She protested that she had no sleep, that it was an 'impertinence' to expect her to give interviews in her state, and that the press coverage would be 'very damaging' to her professional reputation. They persisted and she finally gave in, recounting for them the story of her and Julio Antonio's brief time together.

The interview was interrupted by a phone call telling her that Mella's corpse had been taken to Party headquarters. She quickly changed her clothes, grabbed her camera, and went to the Party offices, where in a flurry of activity plans were being laid for a protest march that evening. After photographing Mella's corpse, she took her

turn in the guard of honour alongside the coffin, surrounded by flowers and candles, with a huge red star and gold hammer and sickle on the wall behind. The press wanted, and got, their photograph of her 'standing guard over the corpse of the student Julio Antonio Mella' before she hurriedly left, summoned to the courthouse.

Avoiding any comment on the newspaper headline, she entered the court building and went to the offices of Alfredo Pino Cámara, a judge renowned for hearing sensational cases, to give evidence to him and his assistants behind closed doors. Regardless, her statements were released to the press within hours. Tina was not permitted to go home, but was called for further interrogation, this time at the offices of Mexico City's chief police inspector, Valente Quintana, a 'thin, little worm-like man', who was virulently anti-Communist and had a reputation for being very tough. Following the interrogation, she was still unable to go home because her apartment had been sealed by the police. After spending the night with friends, Tina awoke to find that Quintana had leaked his hypotheses to the press, claiming that the killing was 'of a passionate nature' and that she was concealing the murderer's identity. Accompanying a story in *El Universal* was Edward Weston's portrait of her, which he had prophetically described years before as 'the face of a woman who has suffered, known death and disillusion … '

When she arrived at her apartment in the morning, Tina found it was not only besieged by the press, but also under 24-hour police

Tina being interrogated by Mexican police, 1929 (Valente Quintana seated in middle)

ENRIQUE DIAZ PHOTO

surveillance. Plainclothes agents of the stern police chief, Casimiro Talamantes, did not allow her to change her clothes, but immediately took her down to the street where Mella had been shot and put her through a step-by-step re-enactment of the assassination. After this painful ordeal, Talamantes took her back to the Zamora Building for a thorough search of her apartment.

The police could hardly have appreciated the decor – Tina's photograph of the iconographic hammer and sickle on the wall, a few feet from a portrait of Karl Marx, Mella's copies of the works of Lenin and the revolutionary slogans written on the whitewashed wall above the bed. They ransacked through her few personal belongings – the green crystal vase, a cherished gift from Xavier Guerrero; a Weston portrait of her mother, which she kept on the dressing table; the large leather trunk she had packed to come to Mexico with Edward, a lifetime ago. They found and confiscated the nude photographs Weston had made of her, as well as her photographs of Julio Antonio and all her personal letters. When she signed a receipt for these and other items, it must have been obvious to Tina that it was unlikely she would see all of them again.

The thousands-strong procession bearing Mella's coffin through the city's streets to the Dolores cemetery had already begun when Tina was taken back to the federal district attorney's office for further questioning. While she was being interrogated, her apartment was searched a second time and the remainder of Mella's belongings taken away. She was later released under armed guard to join the funeral procession and caught up with the crowd just before it reached the cemetery. Striding along with her hands in her pockets beside Luz Ardizana at the head of the funeral, Tina seemed to have aged ten years. Deeply withdrawn into her grief, the brim of her felt cloche hat pulled down to hide a face which had become a mask of sorrow, she stood at the graveside while Diego Rivera and Baltasar Dromundo spoke the final words before the coffin was lowered into the ground.

Despite hours of sleeplessness, interrogation and re-enactment, as well as the trauma of Mella's wake and funeral, not to mention

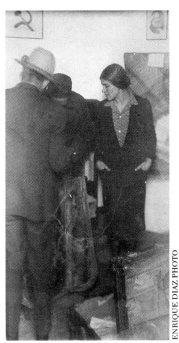

ENRIQUE DIAZ PHOTO

Police searching Tina's home after the assassination, 1929

the assassination ordeal itself, Tina had to rush from the cemetery to keep a five o'clock appointment at Quintana's offices. In the presence of reporters, she was confronted by three police witnesses who claimed that there had been another man with her and Mella on the night of the murder. In cross-examination, Quintana insisted that Tina was lying: 'If you'd tell the truth, *señora*, you could avoid this bother.' He hammered away at her having received letters from Moscow, wanting to know who the mysterious 'X' was who signed them; it was, in fact, her and Guerrero's shorthand for 'Xavier'. Tina was 'visibly upset' when one of Guerrero's letters was read aloud, steadfastly refusing to divulge his identity. The reporters scribbled furiously, seizing upon the letter from the mysterious Mr 'X' and Tina's foreignness as proof of Quintana's original absurd theory 'that she, being Italian, was a Fascist decoy to lure Mella to his doom'.

The interrogation was adjourned and Tina was taken to an adjoining room where she was held under guard. Friends had brought her some pillows and a blanket against the cold and she waited there for hours while Quintana and judge Pino Cámara questioned José Magriñat, the Cuban who had met Mella the night of the murder. Later in the evening, she was brought in to confront Magriñat in a face-to-face cross-examination. Tina was terrified of this man whom she was convinced was responsible for Julio Antonio's murder. Quintana allowed Magriñat himself to challenge her testimony. Tina 'shook noticeably, fidgeting with her hands and feet; she wanted to smoke but could barely light the cigarette. Magriñat stared her down, as though trying to dominate her and her appearance seemed to indicate he succeeded.'

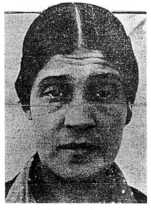

Tina on the day of Mella's funeral, 1929

It was midnight before the hearing was adjourned. Tina was to be allowed to return to her apartment under guard and had been sent to collect her things when she was suddenly called back to Quintana's offices. She was now to be questioned by a Dr Maximilian Langsner, a charlatan American hypnotist and telepathist visiting Mexico. Langsner's claim to fame was his supernatural ability to drive a Chrysler blindfolded through downtown Mexico City's rush-hour traffic as a promotion for a local car dealership! Passing himself off as a 'criminal psychologist' and 'trying to employ his magnetic powers to obtain the truth from her', he interrogated Tina until one o'clock in the morning. He

doubted her claim that she did not see the killer's face, questioned whether or not she truly loved Mella and asked her whether she was a Communist. Having concluded his examination, he was all too willing to give his considered opinion to the Mexican newspapers: 'This,' he declared, 'is a crime of passion.'

Tina returned to her apartment and was placed under house arrest. She was unable to sleep and spent the entire day pestered by the press, who wanted an 'exclusive' with 'the interesting Italian'. The headlines of the all the major Mexican newspapers over the weekend showed the tilt the media was taking. Hinting at a love triangle, 'The Murder of Julio A. Mella: Crime of Politics, or Passion?,' they made out she was witholding the truth: 'Tina Modotti Refuses to State Who Killed Julio Mella.' She was always referred to as 'the Italian', as though that predisposed her to involvement in dark and bloody deeds. One 'portrait' of her said, 'There had long been, within the depths of her interior world, twisted voices twenty centuries old of tragedy and art.' Her morality was questioned and there were numerous references to her physical appearance, of how 'profoundly attractive' she was or of how well her sweater hugged 'her agile body'.

Reaction from Tina's women friends was immediate. 'The International Centre of Women Activists', led by Graciela Amador, protested over her treatment. It was clear to friends and Party colleagues familiar with the workings of the Mexican press and justice system – although it had probably not yet dawned on Tina – that Quintana's investigation had nothing to do with finding Mella's assassin. Quintana was notorious for his persecution of Communists and his aim, together with right-wing sectors of the administration, was to discredit the Mexican Communist Party. Tina was to be the scapegoat and by putting her on trial they would attempt to show that Communists were not only dangerous criminals lacking morality, but that their doctrine was fundamentally un-Mexican and expounded by exotic foreigners. Two other important factors were involved: Mexicans' traditional mistrust of foreigners and the deep-seated belief that foreign women were 'loose', little more than *femmes fatales* who enticed men to their doom.

None the less, there were some powerful Mexicans who were outraged at Tina's treatment and they began pulling political strings. By Saturday, someone had managed to influence Adolfo Roldán, personal secretary to President Emilio Portes Gil, who cabled the Mexican president regarding Tina's predicament: 'Tina Modotti companion Mella has been imprisoned and is treated with harshness that inspires compassion for her dejected state as result nervous shock

stop.' The friend behind the scenes was undoubtedly Mexico City Mayor José M. Puig Casauranc, who was close to the *Mexican Folkways* group and whose children Tina had photographed.

Monday morning dawned with the press campaign continuing unabated. Police had leaked the photographs taken from Tina's apartment to the press and, with the headline 'Tina Modotti holds the Real Key to Mella's Murder', *Excelsior* emphasized that a photograph of a Colt .45 pistol had been discovered there, while it was claimed that a .45 calibre bullet had been found at the murder scene. The paper also published a photo of Mella's baby daughter with a caption noting she was 'in Cuba with the wife of the victim', juxtaposed with Tina's photograph of a partially-clothed Mella, lying down with his eyes closed. The absurd caption showed the lengths to which the press was going: 'Photographic study made by Tina Modotti of Julio Antonio Mella while alive, in order to give them both an idea of what Mella would look like after he was dead.'

The press had also misconstrued that a blue envelope found in Tina's flat, which bore her name and address and a hand-drawn map of how to arrive at the Zamora building, had been given by Tina to the killers before the murder. It turned out to have been drawn by Julio Antonio himself for a new maid who had arrived to work for them that week and did not even match the route he and Tina had taken the night of the assassination.

There were some glimmers of hope for Tina, however. New witnesses testified that they had heard Mella exclaim that the Machado dictatorship was responsible for his murder. German journalist Fritz Bach came forward and told police he had bought Xavier Guerrero's pistol from Tina months earlier, after which Beals gave a newspaper interview confirming he was present at the time. In any case, a ballistics report determined Mella was shot with a .38 calibre gun and not a .45, as had been reported.

In retrospect, it seems astonishing that given their behaviour, Tina still trusted the Mexican press. She seems to have naïvely believed that by co-operating

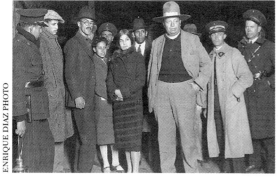

Reconstruction of Mella's assassination with Tina and Diego, 1929

fully with them and Quintana, Julio Antonio's killer would be brought to justice and the scandal-mongering would stop. To this end she gave an extensive interview to *El Universal*, saying she did 'not want to cover up her love life any more' and detailing her relationships since her marriage to Robo.

On Monday night, she participated in an independent reconstruction of the murder along with Diego Rivera, Paca Toor, Beals, Luz Ardizana and *Machete* editor Gómez Lorenzo. At the scene, Rivera chided reporters: 'What kind of a country are we in? This thing of a hypnotist intervening in the investigation, as has just occurred, borders on the comic.' Tina also protested over

> the statements that a morning paper put into my mouth. None of it is true. I have not said that my true love is in Moscow … I also beseech you not to continue referring to my 'lovers', but to my 'companions'. It is not that I reject the first term, it is just that the second is more appropriate. I would like things to be clear and honourable.

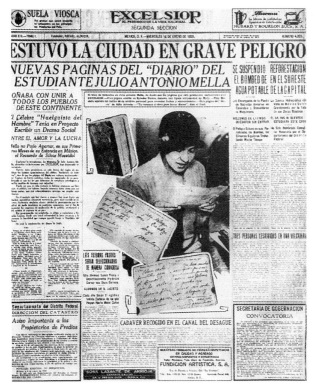

*Tina reading from
her personal letters
in court, 1929*

Quintana's fabricated stories of anonymous letters and phone calls from the *passionate Italian*'s mysterious lovers appeared in the next morning's papers along with a devastating editorial attack by *Excelsior* on Tina's morality. Weston's nude photographs of Tina and hers of Mella, which had been seized by the police, had been turned over to the newspaper's editor, who wrote that they were an 'indecorous display which would be fine for shameless ruffians and gangsters, but not for an "apostle" of communism, a saviour of the people'. In no uncertain terms, the editorial blamed Tina for having dragged Mella to the shameless depths of nudity. The existence of such photographs, said the editorial, was sufficient evidence for 'decent people to deny Mella posthumous honours and relegate his young woman to the category of those female specimens who sell or hire out their love'.

To complement the editorial, the paper began publishing a series of embarrassing extracts from Mella's personal diaries. The newspaper ridiculed his youthful dreams of revolution for Cuba and personal glory for himself. Worse for Tina must have been the publication of his candid accounts of his desires for and affairs with several other women, even though they had all been prior to his meeting her.

Shortly before noon on Tuesday 15 January, Tina arrived under police escort at the chambers of Judge Pino Cámara for more than two hours of questioning that focused on her relationship with Mella. She looked tired in her black skirt, grey sweater and black felt hat with the two silver-coloured cherry ornaments. Acting for the prosecution was a young lawyer named Telesforo Ocampo Jr who was out to make a reputation for himself. He wasted no time homing in on what he knew would mean newspaper headlines and publicity for himself: Tina's sexuality and her politics. After a few preliminary questions, he asked:

'Don't you consider it an affront to a person or a lover to carry on an amorous correspondence with another? In other words, in the midst of intimate relations with one person, is it not an affront to write love letters to another?'

'Yes, I would think so.'

'Were you very fond of Guerrero?'

'At one time, yes … '

'Can you tell us if Guerrero was very fond of you?'

'Yes, I can affirm that. But the love that he had for me was less than that for the fundamental thing in his life, what he felt for the revolu-

tion, being ready to sacrifice himself for that.'

Frustrated in this approach, the lawyer tried another:

'When you began the intimate relationship with Mella, had you broken off completely with Guerrero?'

'Yes, however, I did continue sending him, weekly, newspapers for his activities ...'

'Afterwards, did you receive any money from him?'

'Yes, one day a cheque for 25 dollars arrived. I have already said that when he left I contributed a bit for the journey ... I knew he was getting the money together to send it to me. I wouldn't accept it. Although I didn't return it, I divided it up among needy friends ... I have always been scrupulous [in making sure] that no man gave me money and that's why I've always worked. Nor do I like it when a man takes money from a woman. Guerrero's case was very special, it was about helping him for the cause.'

Ocampo probed further, obviously hoping he would turn up a 'passion motive' or domestic strife:

'Did you ever tell Mella about your relationship with Guerrero?'

'Yes, right from the start, since I was really torn up about it.'

'How did Guerrero behave with you, in intimate terms? Was he tender or did you have difficulties?'

'Yes, he was very tender and we had absolutely no difficulties.'

That same night, Quintana's excesses caught up with him and he was fired from his post on the orders of President Portes Gil. The mayor, Puig Casauranc, seems to have been influential in the sacking. His office issued a statement to the press, saying that 'To eliminate suspicion and in view of the charges of partiality' Quintana had 'agreed' to be replaced.

Nevertheless, the following day the most personal details of Tina's life were on display to be read not only by her photographic clients, but also by Party comrades, few of whom shared her liberated sexual mores: 'THE SENTIMENTAL PROBLEM OF TINA MODOTTI', read an eight-column, boldface banner headline in *El Universal*, above a photo of Tina being interrogated and a reproduction of the first page of Mella's love letter to her from Veracruz; 'The Intimate Life of Mrs Modotti,' chimed in *La Prensa*; the most vindictive, *Excelsior*, ran a photograph of her in court, reading aloud from her personal letters confiscated by the police, alongside photographs of entries from

Mella's diary, made years before he had even met Tina.

Tina's friends and fellow Communists came to her defence. The *Excelsior* attacks, in particular, drew angry responses. The international women's group published a statement two days later, signed by Concha Michel and Luz Ardizana among others. Outraged that Tina had been called a fascist, Vittorio Vidali wrote a public letter under his pseudonym, 'Enea Sormenti', emphasizing her and her family's history of anti-fascist work. Diego Rivera and the famous painter-cartoonist Miguel Covarrubias went personally to see the editor of *Excelsior* to explain that the nude photographs of Tina were works of art. Carleton Beals, in an attempt to deflect the attack against her and get the investigation back on the right track, 'publicly charged, as did others, that Mella had been assassinated in connivance with the Mexican police'.

On the evening of 16 January, at the exact time that Mella was murdered, the judge assembled a multitude of police investigators and experts on Abraham González Street for a final re-enactment of the killing. This time, however, a new witness, Tina's neighbour Antonio Ojeda, was brought forward. He said he had seen a man approach Tina and Mella from behind and fire the fatal shots. After enacting the murder again, police experts determined, within just 24 hours of Quintana's sacking, that the three witnesses whose testimony had contradicted Tina's version had been *confused*. They had thought they had seen her with two men because of the heavy shadows cast from the street lamp on the corner. The following day José Magriñat was arrested to stand trial for Mella's murder.

Despite her acquittal, the press attacks continued the next day. In a final stab at Tina's character, *Excelsior* published a vindictive editorial which gave play to the editor's fantasies about 'liberated' foreign women. She was, it said, a

> woman who ... lights her match in the half light of passionate chambers. Drama goes with her, has been born with her and will die with her ... If Mexico were an essentially literary land, eloquent little volumes of juicy romantic substance would be circulating, bound with shadow, like those other novelettes which assault the dreams of the traveller on the trains of Europe: '*La brai* [sic] *histoire de la Mata Hari!*'

Tina after her acquittal, 1929

15

The Fire Extinguished

Julio Antonio Mella's murder and the five days that followed before she was acquitted irrevocably changed Tina's perception of the world and her place and role in it. Although she emerged emotionally battered and mentally exhausted from the experience, it served to make her stronger. 'What does not kill me, strengthens me,' she would later write to Edward Weston, quoting Nietzsche. If previously she had been a photographer committed to a cause, Tina had now become a revolutionary with a particularly personal mission.

Revolutionaries world-wide had already begun the glorification of Mella's memory. The mental picture of the martyr was given a physical visage with the profile portrait Tina had made of him. It was reproduced poster-size on the front page of a special edition of *El Machete* and from there travelled around the world to become the most recognized image of the dead revolutionary. At a protest rally in Madison Square Gardens, postcards of the photograph were distributed among the participants. It was also used on badges produced by the Mexican Communist Party and sold to raise funds. At home, Tina kept the same photograph 'in a simple, narrow black frame over her desk, with a tiny, freshly cut rose placed over the top of the frame'. She even went so far as to hang his death mask on her wall.

By now, Tina was pessimistic that

ENRIQUE DIAZ PHOTO

Tina addressing memorial meeting for Mella, 1929

Mella's killer would ever be caught, much less convicted, but instead of being depressed as a result she was driven to a new zeal for the causes Mella had embraced, vowing to honour his memory 'not weeping, but fighting!' A few weeks after his death, she attended a conference formally constituting the new CSUM labour federation, which Mella had co-founded. Then, exactly one month after his murder, she addressed a six-hour memorial meeting at the Hidalgo Theatre, where a Russian choir sang *Immortal Victims* and Eisenstein's *October* was screened. Wearing a light overcoat with a stylish scarf, Tina opened the meeting. Julio Antonio Mella, she told the assembly, was one of those whose murders can cause the earth to quake and tyrants to tremble: ' ... we honour his memory and pledge to continue his path until obtaining victory for all the exploited of the world.'

In doing so, Tina had not turned her back totally on art, and the early months of 1929 brought a spate of international recognition. In February, her photographs were published by the prestigious avant-garde Paris journal *transition*. In the same month, *Creative Art* published a review by Carleton Beals, describing her photography as 'more abstract, more intellectual, more ethereal' than Weston's. He also noted a significant transition in her work: she had recently come to consider her ideal to be 'a perfect snapshot. The moving quality of life rather than still studies absorbs her.'

Perhaps in pursuit of her new ideal, but more likely in an attempt to recuperate from her recent ordeal, Tina left for a brief trip, far from Mexico City to the hot, tropical lowlands of Oaxaca. In the towns of Juchitán and Tehuantepec, where there still remained the vestiges of a matriarchal enclave, she made what she herself considered to be mainly 'snapshots' of the *Tehuanas*, the tall, proud and independent women of the Tehuantepec Isthmus. With their long flowing hair and multi-coloured flowered skirts, their midriff-length blouses exposing their warm, smooth flesh, the *Tehuanas*, a true feast for the eyes, exuded fecundity. Tina photographed these latter-day fertility goddesses with their plump naked children grafted to their bodies as they bathed in the river and walked to market with their brightly painted *yecapixtle* gourds on their heads. She marvelled at how quickly and gracefully they moved, carrying everything from a box of pills to live iguanas in this manner. The women enchanted Tina to such a degree that the only men she photographed on her trip were among the crowd at a festival in Juchitán.

It is clear from the reference in Beals' review that Tina considered the term 'snapshot' to mean impromptu, rather than 'amateur' photography. While she would send some of the Tehuantepec

Women in the marketplace,
Tehuantepec, 1929 [TM]

Mother with baby in Tehuantepec,
1929 [TM]

Woman from Tehuantepec carrying
yecapixtle, *1929 [TM]*

Fiesta in Juchitán, 1929 [TM]

Woman and children bathing,
Tehuantepec, 1929 [TM]

photographs to Weston for inclusion in an exhibition he was arrang-
ing, she was aware that they were not up to her usual standard:

> I am sending you a few snapshots done in T[ehuantepec], forgive me
> but I am just sending from the ones I happen to have duplicates on
> hand, of course I have many more done while there, but alas, mostly
> are in the same condition as the ones I am sending you, either messy or
> moved …

Tina returned to the Mexican capital fortified and determined to
carry on with her political work and photography. But despite her
show of courage she was lonely and unhappy. In early April, she
wrote to Weston, lamenting that she could not be beside him for a
few moments,

> to be able to give vent to all the pent up emotions which gnaw at my
> heart – you might not agree with all I would say – that does not matter;
> but you would understand the tragedy of my soul and feel with me –
> and that, not everybody can do!

Then, immediately pulling herself together and renewing her
resolve, she put aside a momentary weakness:

> But I cannot afford the luxury of even my sorrows today – I well know
> this is no time for tears; the most is expected from us and we must not
> slacken – nor stop halfway – rest is impossible – neither our consciences
> nor the memory of the dead victims would allow us that – I am living in
> a different world, Edward – strange how this very city and country can
> seem so utterly different to me than it seemed years ago! At times I
> wonder if I have really changed so much myself or if it is just a kind of
> superstructure laid over me. Of course, I have changed my convictions,
> of that there is no doubt in the least …

She had been joined by someone whose convictions matched her
own, her brother Benvenuto, her 'precious *camarada*', who had
arrived in Mexico to provide her with emotional support for a few
months. In fact, prior to Mella's assassination, Tina's family had
moved to Los Angeles, where frictions with Mercedes had led
Benvenuto, Yolanda and Tina's mother to plan to join Tina in Mexico.
Although it is unclear if Vittorio Vidali had met any of the other fami-
ly members before 1929, he seems to have displayed paternal inter-
est in the Modotti family since at least the summer of 1928, when he
offered Party work in Mexico to Benvenuto, an ardent Communist
militant.

Tina had thrown herself into political work, joining the editorial
committee of Red Aid's new magazine, *Mella*, and participating in

Palm trees, c. 1929 [TM]

*Photomontage
for* El Machete
and New Masses,
1929 [TM]

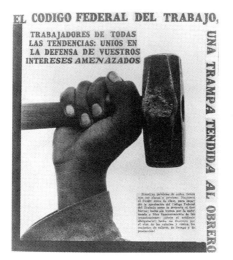

EL CODIGO FEDERAL DEL TRABAJO,

TRABAJADORES DE TODAS
LAS TENDENCIAS: UNIOS EN
LA DEFENSA DE VUESTROS
INTERESES AMENAZADOS

UNA TRAMPA TENDIDA AL OBRERO

the organization's Sunday excursions outside Mexico City. In April, she accompanied a Red Aid delegation to the town of Tizayuca to photograph the initiation of the Party's presidential election campaign. The town was obviously a Communist stronghold and a red flag was raised above the town hall for the event. Peasants from throughout Mexico arrived in the early morning, carrying huge flags and banners, and the largely Indian San Bartolo Cuautlalpan brass band played revolutionary songs. Young Communist militants led a march through town, carrying an enormous framed copy of Tina's portrait of Mella, which Red Aid had donated to the town. Diego Rivera and Siqueiros rode into the square on white horses to give speeches from the wooden kiosk to enthusiastic cheers. Tina duly recorded it all with her camera, but in a photograph of her taken that day she looks weary and unsteady as she stands among the crowd, supported by Diego.

In the enthusiasm of the moment, it might have seemed the revolution was around the corner. But in fact the Mexican political situation had become very tense in the aftermath of a failed military uprising. As what promised to be a tumultuous May Day approached, tensions mounted. The CROM unions had a dispute with the government and opted not to march, so the CSUM seized the opportunity and turned out 40,000 demonstrators. Tina made several photographs of the march, including one of Diego with Frida Kahlo, who was dressed in the subdued fashion Tina had recommended. The government called out the police *en masse* and the result was a bloody confrontation, with many participants and Party leaders beaten and imprisoned. Another crisis loomed for the government, as university students, led

by supporters of José Vasconcelos' presidential bid, prepared to strike at the National University.

With university turmoil brewing, Moscow's envoys in Mexico apparently decided the time for rebellion had come and that it should take the form of a peasant revolt. In mid-May, peasant leader José Guadalupe Rodríguez attended a meeting at Tina's apartment with Vittorio Vidali and others. Whether or not the 'revolution' was called for at this meeting, or if and how the government got wind of it, is unclear. But within days the military had assassinated Rodríguez and other peasant leaders, including some from rural Red Aid cells. The government's initiation of a crackdown on the Communists represented an entirely new situation for Tina. When she had first become involved with the Party, it was not only tolerated by the authorities but had close ties with progressive government officials. Now government repression, while still selective, had become the rule. A harbinger of what was to come was a raid on Party headquarters on 6 June and the closure of *El Machete*.

Tina was becoming less and less successful at combining her Party commitments with her art and long-standing friendships. Monna Alfau complained that 'We do not see her as often as we would like to, but we know that she is busy all the time. She never comes to see us or goes to see anybody.' Her friends were increasingly artists and intellectuals who were either Party members or fellow travellers, though *Folkways* kept her in touch with non-Communist intellectuals like Xavier Villarrutia, Salvador Novo and Moises Sáenz, all of whom had their portraits done by her.

Red Aid rally, Mexico, c.1929 (Luz Ardizana second from right) [TM]

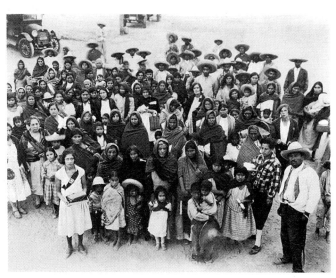

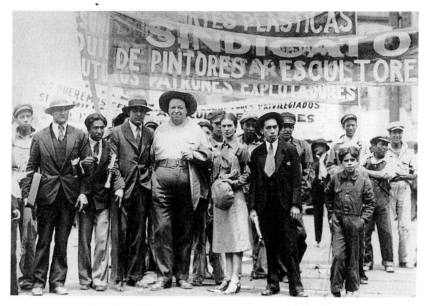

*Diego Rivera and Frida Kahlo
with members of the artists'
union on the May Day march,
1929 [TM]*

In 1929, a number of American visitors arrived to see Tina. Among them was Joseph Freeman, a young Communist journalist and writer, whose cover in Mexico was as correspondent for TASS. Freeman soon fell in love with Ione Robinson, a very pretty 19-year-old American who arrived in mid-June on a Guggenheim fellowship to work as Diego Rivera's assistant. Immediately upon her arrival, Diego 'hustled' the young painter out of her hotel and took her to Tina's flat. Ione was surprised when she actually met her:

> Certainly it was hard to believe, when I saw Tina, that she could be a *femme fatale*, or an accomplice in a sensational crime. I had expected so much that I was disappointed, for she wore heavy blue overalls and her face was without makeup of any kind, accentuating a sallow, brownish skin. Her hair grows too low on her forehead ... but her eyes were really striking, and so was the manner in which she held her mouth half open when she was not speaking ... She even unpacked my clothes for me, and I saw her look at each dress like a nun who has renounced all worldly possessions.

Despite his imminent marriage to Frida Kahlo, Diego soon seduced Ione. The hot-headed Freeman was wildly jealous, even

going after Diego with a pistol. Tina, who was fond of both Frida and Ione, suggested Freeman try to break up the liaison by telling Ione 'that Diego had gonorrhea'! Ione found Mexico's political and artistic milieu disconcerting:

> There is so much activity going on here. A constant stream of people is coming to see Tina – writers, musicians, and painters who all wear overalls with a red star pinned on the front. Everyone is a communist, a 'red,' as you would say; it is evident that one must take sides in Mexico, and the side that the painters are on is red ... even the house where I live seems to be spotted by the police. It has to do with that trial involving Tina, which apparently has not finished yet. Tina has shown me all of Mella's letters and pictures, and told me how he has become a great hero to the Communists. He is like a symbol around which everyone I know in Mexico revolves ...

Tina's life was revolving closely around Mella's memory and her commitment to the revolutionary ideals they had shared placed her at the centre of a political whirlwind. In a letter to Weston, she recognized that the standard of her work was suffering as a result; she 'lacked the necessary leisure and peace to work' and indicated for the first time that she might even abandon her art. It might, she said,

> be more honest on my part to give up all pretenses and not do any more photography, outside of the purely commercial and portraiture work. Yet it is a sacrifice and it hurts me to even think of that, so I go on but the results never satisfy me.

She had known for some time that her position was very insecure in Mexico and that she could be deported as a 'pernicious foreigner' at any point. Perhaps to accumulate money for her expected departure, she continued with her reproduction of the paintings of Mexican artists, who clamoured for her work. Among them were members of the *Contemporáneos* group, whose ideology differed drastically from her own; their magazine of the same name also published her photographs. It was probably through a painter close to this group, Manuel Rodríguez Lozano, the former husband of Nahui Olin, that Tina came into contact with the wealthy arts patron, Antonieta Rivas Mercado. Tina made a series of portraits of her and Rodríguez Lozano, of whom Antonieta was very much enamoured.

Tina's portraiture of Mexican high society at this time also included the Rivas Mercado family and Alice Leone Moats, who arrived for sittings with boxes of clothes from Chanel and Vionnet. She made portraits of both Ione Robinson and Joseph Freeman, and

photographed the young Chicago artist and puppeteer Luis Bunin. To add to her studies of hands, she made an image of Bunin's hands controlling the movements of his marionettes. His controversial *Hairy Ape* puppets, based on the Eugene O'Neill play, were also the subject of a series of her photographs.

Despite her Communist Party militancy and the publicity surrounding the Mella scandal, Tina had more photographic work than she could handle. The Mexican government even offered her the post of official photographer at the National Museum. But she refused on principle, 'both as a member of the Party and companion to Mella it would have been impossible', since the government 'did nothing absolutely' to bring Mella's murder to justice.

In August, although the Portes Gil government, feeling increasingly besieged as the general elections approached, threatened to deport all foreign communists, the Party faced even greater problems. Its July plenary conference was rife with sectarian infighting and reprisals. Purges of 'rightists' supposedly too cosy with the 'bourgeois' government and of Trotskyists began taking place. Ione Robinson noted that Joseph Freeman and his foreign Communist friends were becoming 'terribly critical of Diego'. There were indications, too, that Tina had grown steadily impatient with the tongue-in-cheek radicalism of her longtime friend. Still, when he and Frida were married in late August, Tina lent them her rooftop studio for a party. In typically flamboyant style, Diego supposedly pulled out his pistol during the party, wanting to shoot the phonograph, only desisting after Tina's pleading that it had been lent to her by another friend.

Less than a month later, Diego was expelled from the Party. Joseph Freeman apparently bragged that he had presided over the expulsion. Vittorio Vidali also played an important role. He later boasted that he was 'one of those who, together with all the C[entral] C[ommittee] of the C[ommunist] P[arty], did everything necessary to purge the Party of these agent provocateurs … and I am and always will be proud of it!' According to Vidali, Diego was expelled because he belonged to a group that used the writings of Bucharin and Trotsky 'to give a "political" appearance to [their] selling out … ' Diego's Trotskyist sympathies were already well known. He had portraits of the revolutionary leader on the walls of his home and within weeks of his expulsion he publicly announced his support for him.

Tina accepted without question the Central Committee's position on Rivera's expulsion: 'Diego is out of the Party,' she wrote to Weston,

Hands of the puppeteer, 1929 [TM]

Reasons: That the many jobs he has lately accepted from the government ... are incompatible with a militant member of the P[arty] ... I think his going out of the Party will do more harm to him than to the p[arty]. He will be considered, and he is, a traitor. I need not add that I shall look upon him as one too and from now on all my contact with him will be limited to our photographic transactions.

Despite the harshness of Tina's judgement, she could not have continued to be close to Rivera and remained within the Party even if she had wanted to, given the purges that were taking place. After Diego's expulsion, Ione was questioned about her relationship to the painter by Soviet Ambassador Makar and warned about continuing to work with him – and she was not even a Party member. Tina's position with respect to Rivera's expulsion reveals not only a lack of sophistication regarding the complexity of Comintern politics but also the extent to which the Communist Party now dominated her life. That she had become a kind of Communist 'nun' angered her old friends, like Monna Alfau, who was 'indignant somehow about how Tina has sacrificed everything to this damn Communist Party'.

Later that autumn, Tina secured the imposing National Library building as the venue for her first one-woman show. A former colonial monastery, by virtue of remodelling, the building had lost some of its splendour to the adjacent Hotel Monte Carlo. Knowing that it would probably be her last exhibition in Mexico because of the government's repeated threats to deport foreign Communists, Tina made haste to mount dozens of prints for the early December opening. 'You know I feel pretty sure,' she had written to Weston in September,

> that ere long I will be going [to Europe]; everything tends that way and to tell you the truth I begin to feel restless ... I am thinking strongly to give a exhibit here in the near future, I feel that if I leave the country, I almost owe it to the country to show, not so much what I have done here, but especially *what can be done*, without recurring to colonial churches and charros and chinas poblanas, and the similar trash most fotographers [sic] have indulged in ...

Tina had mobilized her network of friends and acquaintances to organize the exhibition. Baltasar Dromundo convinced the university rector, Ignacio García Téllez, to sponsor it. Paca Toor ran an advertisement in *Folkways* and, five days before the opening, handsome, printed invitations were distributed. One went to President Emilio Portes Gil, who declined to attend. Not surprisingly, since accompanying the invitation was Tina's manifesto on photography printed in

strident red ink, with a curious inscription on the top right-hand corner. It was, in fact, the same quote on art and revolution that appears in part in her photograph of Mella's typewriter. The quote's attribution must have raised some eyebrows, for the author was none other than Leon Trotsky, already the pariah of Communist Parties worldwide. In hindsight, it is difficult to comprehend why Tina used a quote from Trotsky, which could well have jeopardized her Party future. Was it naïvety, a lack of understanding of doctrinal infighting? Or, an act of defiance, a homage to Mella, for whom it seems to have had special significance, and to his Trotskyist sympathies? Did Tina at one point share these sympathies? Whatever the case, when the manifesto was reprinted a few weeks later in *Mexican Folkways*, the quote had, interestingly, been removed.

Baltasar Dromundo was of most help to Tina in organizing her exhibition. The young law student had admired Mella tremendously and was deeply affected by his murder. He and other university students continued to meet Tina after the tragedy, and despite being married, with an infant daughter, Baltasar soon became enamoured of her, 'sending her flowers, serenading her, writing poetry to her'.

Left at home with a newborn daughter, Baltasar's wife, Rosa, was deeply hurt by her husband's, and Tina's, disregard for her feelings:

> She used to phone him at the house and he would [immediately] leave. It didn't matter to him at all that I was jealous ... and she was absolutely oblivious ... I was a young little thing of eighteen and she didn't even take me into account.

Apparently, Tina wrote Baltasar letters in which she

> spoke in such an exalted manner ... of her amorous interest [in him], an intellectual and amorous interest, but without wishing to make any commitment. She spoke of her freedom and of how she could never belong to anyone.

That the vibrant, outgoing, emotionally generous Tina had inexorably changed is clear from an inscription she wrote at this time on a Weston portrait in which she looks very anguished. She sent the photograph to Dromundo, apparently in response to some amorous proposal he had made:

> Baltasar – no words could better express than the look on this face the sadness and pain I feel at not being able to give life to all the marvelous possibilities I envision. The seeds of which already exist and only await the 'sacred fire' which should emanate from me, but which when I look for it, I find it extinguished. Allow me to use the word defeat in this

case, I will tell you that I feel defeated for having nothing else to offer and for 'having no more energy for affection'. I have to admit this, I, who have always given so much of myself ...

Those who knew Tina at this time, Dromundo included, noted a strong tendency for self-effacement not previously evident in her character, probably both a reaction to the total invasion of her privacy during the Mella trial and an attempt to shake the 'Mata Hari' reputation which had dogged her since. A photograph of her made during her exhibition shows her withdrawn yet not distracted, unable or unwilling to bring forth a smile. Her body hidden in a high-necked, long-sleeved, dark sweater, her arms crossed in a defensive posture, she leans against the wall where her prints are hung, almost directly under the centre-piece, her portrait of Julio Antonio Mella. There seems to be a new reserve, almost a wariness in her gaze, as though unwilling to expose more of herself than the very minimum required for the occasion.

Tina had set a serious intellectual tone for the exhibition with the her statement 'On Photography', in which she refers to the camera as a 'tool' and describes herself as producing 'not art but honest photographs'. Weston's influence is still reflected in her disdain for the 'majority of photographers [who] still seek "artistic" effects, imitating other mediums of graphic expression', or for those 'who continue to look myopically at the twentieth century with eighteenth century eyes'. But the manifesto's last paragraph indicates the extent her political idealism had moved her photography beyond formalist concerns and into the social realm:

> Photography, precisely because it can only be produced in the present and because it is based on what exists objectively before the camera, takes its place as the most satisfactory medium for registering objective life in all its aspects, and from this comes its documental value. If to this is added sensibility and understanding and, above all, a clear orientation as to the place it should have in the field of historical development, I believe that the result is something worthy of a place in social production, to which we should all contribute.

The exhibition, which was well-received by the Mexican press, was inaugurated on 3 December by the university's rector. Philosophy professor José Román Muñoz, a former Prepa director, spoke on 'Photography and the New Sensitivity', while Concha Michel contributed to the occasion with renditions of 'Revolutionary Songs'. The prints, which included virtually the entire body of Tina's work,

were displayed in a staggered pattern about the walls. The tone of the closing night on Saturday 14 December was more strident. Hand bills were printed with 'TINA MODOTTI' in large, boldface type, advertising free admission and billing it as 'THE FIRST REVOLU-TIONARY PHOTOGRAPHIC EXHIBITION IN MEXICO!' That the closing speakers were Dromundo and Siqueiros, one a noted student leader, the other a Communist muralist-agitator, gave overtones of a protest meeting rather than an artistic gathering, a move which may well have been calculated to rally support in the face of renewed government repression.

Tina at her 1929 exhibition

16

The Circle Closes

During the winter of 1929, Tina's home was placed under constant police surveillance, as it was suspected of being an underground meeting place for Party leaders and a contact point for Latin American exiles. Nicaraguan rebel leader Augusto C. Sandino was in Mexico City at the time and apparently Tina volunteered to go to Nicaragua and participate in his struggle to liberate the country from US domination. He, it seems, did not think that such a good idea and discouraged her from taking such a step.

It was her high profile and non-Communist contacts that had protected Tina from imprisonment thus far. She was one of the few Party members who could work openly, as more and more were imprisoned. 'Tina carried on the work of Red Aid, supplying the prisoners with foodstuffs and such.' Her tasks also expanded to include more dangerous work. Pablo O'Higgins remembered a secretly arranged meeting with Tina in broad daylight, in the Alameda Park, 'in front of a church [where] she wanted to deliver a letter for the Party. She was surrounded by the police, in a very difficult and foolhardy situation, but she pulled it off magnificently.'

Among those detained just as Tina's exhibition closed was the important Central Committee member Julio Rosovski, whose arrest threw the Party leadership into a panic. Because of his incredible memory, Rosovski had been given the responsibility of memorizing the names and telephone numbers of hundreds of clandestine Communist operatives. It was Tina's job to visit him and smuggle out the information. According to Rosovski, on every visit she brought him a bottle of milk with a double top:

Between the first and second [tops] there was a space and when I returned the empty bottle to her I wrote the names and addresses

on a very thin piece of paper in between the tops. Even though we hadn't spoken by telephone [about it], Tina understood why I would need the bottles of milk and what they were used for and that's how I sent out information the entire time I was in prison.

But the Mexican police had not only wanted to catch Rosovski, they were also looking for Vidali. A master of disguise and false identity, he continued to elude them as less prominent foreign Communists were arrested and deported. Vidali's friend, the artist Ignacio Aguirre, later recalled that Vidali took great pleasure in his talent for disguise and often wore dress suits to look more formal and mask his mission as a professional revolutionary. The more conservative the better, apparently – Vidali preferred dark suits because they made him look like 'a gentleman'.

Tina was still convinced that she would soon be leaving Mexico and was fairly sure about where she would be going. Germany seemed an attractive choice and the February 1930 issue of *Deutsches Magazin von Mexiko* published several of her photographs along with an interview given some time previously, which mentioned that 'Tina Modotti desperately wants to go to Germany. Within three months she will travel there to settle in Berlin or Munich.' It also noted that she admired the work of Käthe Kollwitz and George Grosz. These were not the only German artists whose work she admired. Manuel Alvarez Bravo remembers Tina enthusiastically showing him a book of the photographs of Albert Renger-Patzsch. The book was probably *Die Welt ist Schön*, which had a profound effect on German art photography.

Meanwhile, as repression against the Communist Party increased, relations between the Soviet Union and Mexico deteriorated. Violent anti-Mexican demonstrations led by Communists during his visit to the United States angered President-elect Pascual Ortiz Rubio and on 1 February the government asked Ambassador Makar to leave, severing the diplomatic conduit between Moscow's agents in Mexico and the Soviet Union.

Four days later, the pretext that Tina had long expected might be used for her arrest materialized when a fanatical young Roman Catholic, Daniel Flores, shot and wounded Ortiz Rubio on the day of his inauguration. The government used the incident to attack its opponents, particularly the Communists. Police squads raided Party meeting places and arrested members nationwide. In a raid on the CSUM offices, they arrested Siqueiros and other members, including Tina's maid, María Guadalupe Hernández. In the days of tension that followed, even leftist sympathizers were suspect and Carleton

Beals was violently hauled away by the military police. Vidali, who 'had received orders to return to Moscow', continued to elude the police dragnet laid for him. Tina was not so lucky.

On the afternoon of Friday 7 February, three police commanders showed up at her home and took her to the neo-Gothic police head-quarters on Revillagigedo Street. The following day the press reported that several Communists had been arrested: 'At the top of the list among those captured is Tina Modotti, the woman who found herself involved in the scandalous murder of the student Julio Antonio Mella.' After being held in solitary confinement for five days, Tina was moved to the Lecumberri prison where she attempted to smuggle out a letter to a friend in New York, the US Communist militant Beatrice Siskind. In the letter, which prison authorities intercepted, she narrated exactly what had occurred:

> They kept me at the Police headquarters till Thursday the 13th and then brought me at the *Penitenciaria*: Penitenciary, where only the already sentenced prisoners are kept usually. I repeat, I am strictly incomunicado. I asked if I could have callers and meals from outside but to no avail. Now I will not enter into details about the physical discomfortures – they are pretty bad as you can suppose, a regular cell of iron and stone, an iron cot without mattress, an ill smelling toilet right in the cell, no electric light, and the food, well, the usual food of prisons, I guess. But all this is nothing compared to my mental anguish in not knowing anything from the comrades. I especially worry about the foreign ones, whose names I won't mention, but perhaps you know which I mean. I don't mind this suffering and am prepared to stand it as long as necessary but I would like that it served something from the standpoint of our propaganda. I am sure the comrades nor anybody else know I am here … My health is so far good – though I feel weak for lack of better food. I just eat the indispensable food to keep up. It still all seems like a bad dream to me and at times I feel my mind going around but I control myself by sheer will-power, whose capacity, in me, I had never before realized.

Tina had had only one visitor before being transferred, Mary Doherty, who had been told by Mexico City mayor Puig Casauranc to go to the jail and see how she was. For the second time, Puig had come to Tina's defence in her hour of need. According to Mary, Puig's concern for Tina was a result of his being 'delighted with the picture' Tina had made of his children. She recalled that she visited Tina 'several times' and 'cried and cried and cried' when she got home, because she was so shocked at the prison conditions: 'There was Tina in the prison in a cell and yelling to me out the window, you

know, crying, wanting to get out.'

In a letter she tried to smuggle out to Mary, also intercepted, Tina suggested she contact José María Lozano, the progressive lawyer who had represented her in the Mella case, asking her to 'tell him that at the moment I have about 400 pesos [200 dollars], which I had been saving for my trip. But I can get more. Ask him what he can do?'

Over the next few days, the only person besides Mary Doherty to get in to see Tina was Luz Ardizana. With Lola Alvarez Bravo, Luz went to the prison gates to see 'what we could take to her, arguing [with guards] that since we were women, well, there were many things that a woman might need that can't be discussed with just anyone … ' After 13 days, Tina was released and given just two days to leave the country. She was apparently refused a US passport because she would not renounce her political activity, but procured an Italian one valid only for a return journey to fascist Italy. She returned to the Zamora Building upset over the haste with which she was made to pack and say goodbye to friends. Manuel and Lola Alvarez Bravo went to see her and Lola remembers that two policemen guarded her constantly and she seemed

> so different from how we knew her, so hurt, with such a deep pain, so pale and exhausted; well, the harm they had done her was such that even the guards felt bad at times, and once when I was with her they went out on the balcony to give her a bit of space and peace. They stayed on the balcony smoking and killing time until we finished chatting with her, said goodbye and left.

Some of Tina's friends and acquaintances wondered if the suffering she was going through was really worth it. The day she was deported, Anita Brenner commented in a letter to Weston, 'I hear Tina is again a martyr.' Likewise, Mary Doherty wrote that

> Tina was putting herself through this ordeal for the sake of Humanity … I suppose 'the movement' needs its martyrs and Tina makes a very effective one but it does seem to be too dreadful to have this sort of underworld drama being acted out seriously so close to home. I still can't believe that all these happenings of the last year or more have anything to do with our Tina.

Mary was among the last to say goodbye to Tina. In her account to Weston, she noted that Paca Toor, one of Tina's most supportive friends, was in California at the time. On the last day, Mary recalled

Tina's leaving the house on Abraham González. This curious collection

of secret police and other culprits, weeping servants and Paca's [maid] Leonora in a *pulque* stupor (unable to keep up under the strain – she's so sentimental) and Tina dressed in character, blue shirt and tam o' shanter. Eugene [Pressly] and I officiating in an amazed sort of way.

What she could not take with her or sell, Tina gave to friends. The fate of her most valued possessions, her cameras, is still the subject of discussion. But it appears she gave or sold one of them to Mary Doherty or Eugene Pressly, a friend of Mary's who had worked as a translator for the US embassy and for the Guggenheim Foundation. That would explain how Katherine Anne Porter, Doherty's friend and later Pressly's wife, could write in 1931 that she owned a camera 'once used by Tina Modotti, who could work marvels with it'. Which camera this was is unclear, since Tina took her Graflex with her and the Alvarez Bravos both recall ending up with Tina's 8×10 camera, which Lola has identified as 'the same camera that Weston had used and which I bought from Tina Modotti'.

Before leaving, Tina wanted to say goodbye to Fred Davis, whose Sonora News Company had moved to a small room above the Sanborns 'House of Tiles' restaurant. The guards, towards whom Tina felt no malice, even giving one her kitchen stove, acquiesced and accompanied her and Mary Doherty to the restaurant where she bade Davis a fond farewell. Tina did not expect to see the Alvarez Bravos again after leaving her flat, but was delighted when they came to the station to see her off. They brought along their little boy, Diego, and Manuel remembered it as a being a 'very emotional moment'. When it came time for the train to leave, Tina caressed the little boy's head and, kissing him, said, 'I am going now, but I hope to come back to see you, and Mexico, again, but a Mexico of other, more favourable circumstances than these.'

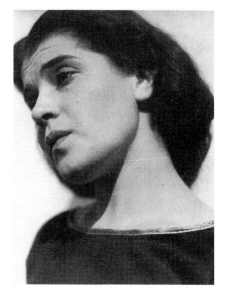

Weston portrait given by Tina to Baltasar Dromundo, December 1929

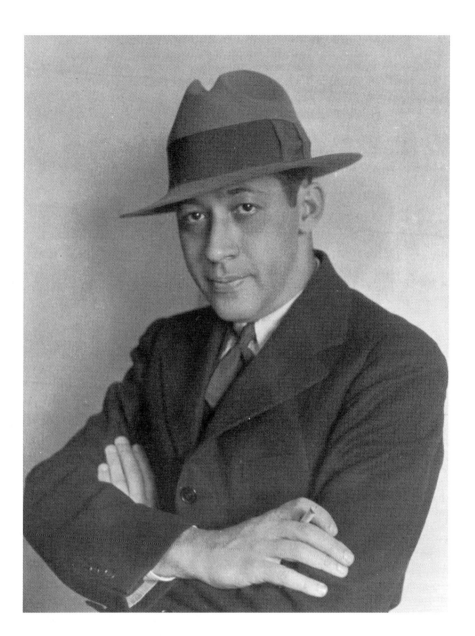

Joseph Freeman, 1929 [TM]

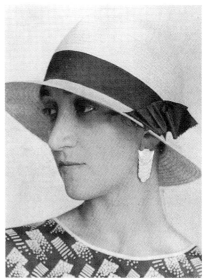

Antonieta Rivas Mercado, 1929 [TM]

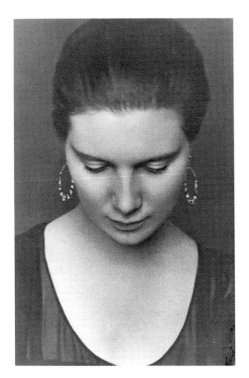

Portrait of an unidentified woman [TM]

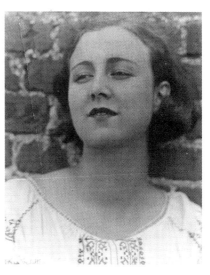

Ione Robinson, 1929 [TM]

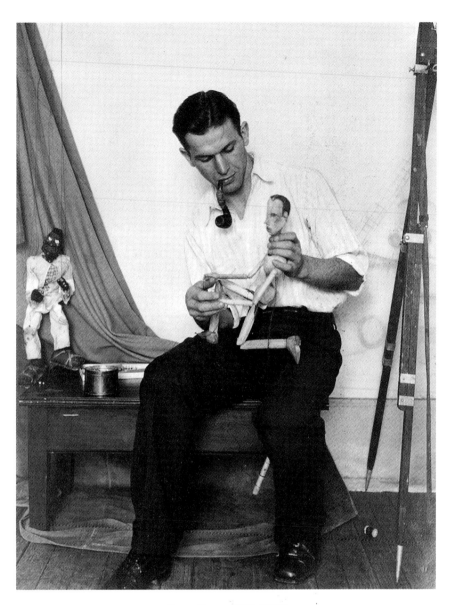

Louis Bunin, 1929 [TM]

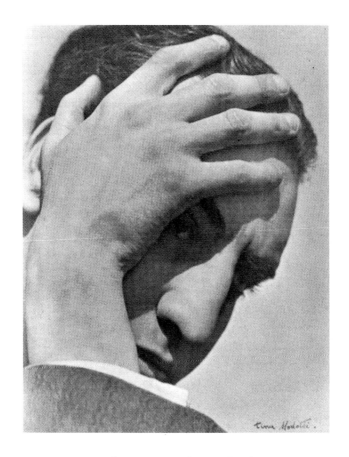

Baltasar Dromundo, 1929 [TM]

17

Upheaval in Europe

An ancient, rat-infested cargo ship that creaked and groaned in the water, the SS *Edam* was embarking on its thirty-fourth transatlantic return voyage under the command of a Dutch captain named Jochems. Tina and her two fellow deportees, Johann Windisch and Isaak Abramovich Rosenblum, had been booked into third-class cabins. Right away Tina was disheartened to learn that the journey would take six weeks. Worse still, she was not travelling as a normal passenger, but as a virtual prisoner to be 'strictly watched in all ports and not allowed to touch shore'.

The boat chugged north along Mexico's Gulf coast and docked first at the steamy port of Tampico, where a mysterious passenger came on board. He carried the passport of Jacobo Hurwitz Zender, the exiled Peruvian journalist Tina had known well in Mexico, but the man who boarded the *Edam* was not Hurwitz. It was another young man, stockily built, with coarse features and a receding hairline, who should have been immediately recognizable to Tina. Had he not been so well disguised, she would have known right away that it was in fact her Communist mentor and fellow Italian, Vittorio Vidali.

There had been little time for Vittorio to contact Tina in Mexico City prior to her departure. It would, in any case, have been too dangerous for him because of her constant police escort. It is even feasible that Tina had been imprisoned in order to lure Vidali; the police might have thought they could trap him, had he attempted to contact or see her. Vidali later explained his appearance on the *Edam*: 'Just when I was about to flee, the Party called me [and] told me, "Look, accompany Tina ... we are terribly afraid they'll take her to Italy ... " ' Even before leaving Mexico City he had informed Moscow of his plan: 'The messages had reached their destination and they assured me that there would be no difficulty in disembarking in

Holland and in crossing the border by train en route to Berlin.'

Tina was well-liked and treated kindly by the *Edam*'s crew and passengers. Despite her condition as a detainee, she was given a pleasant cabin, and could eat with the other passengers and walk freely about the boat. In the long hours aboard ship, she spent a lot of time reading and writing but she also talked to Vidali at length, recalling her past and discussing her future. She brought out her Graflex to make photographs as well, including one of him standing at the ship's railing.

While Vittorio enjoyed the twilight hours aboard the *Edam*, he sometimes found Tina sombre as the sun set across the ship's stern. She disliked the evening hours, because 'After sunset, night falls … I prefer the sunrise.' Nevertheless, she loved the black night skies and the brilliance of the stars above the ocean, once exclaiming 'How beautiful! I would like to have had as many children as there are stars!' Tina suffered at not being able to have children; doctors had apparently diagnosed the cause as an 'infantile uterus'. It was, in fact, fibroid tumours that had made her unable to conceive thus far and kept her childless for the rest of her life.

Writing to Weston during her journey, she wryly described her recent experiences:

> I hope, Edward, that you got a good laugh when you heard I was accused of participating in the plan to shoot Ortiz Rubio – 'Who would have thought it, eh? Such a gentle looking girl and who made such nice photographs of flowers and babies.'

According to 'the vile yellow press', she wrote,

> all kinds of proofs, documents, arms and what not, were found in my house; in other words everything was ready to shoot Ortiz Rubio and unfortunately, I did not calculate very well and the other guy got ahead of me … this is the story which the Mexican public has swallowed with their morning coffee, so can you blame their sighs of relief in knowing that the fierce and bloody Tina Modotti has at last left forever the Mexican shores?

She was particularly bitter about having had so little time to leave the country. In a letter to the Peruvian magazine *Amauta*, she complained that

> after having lived for seven years in the Mexican Republic and having, through my work as a photographer, demonstrated my interest and sympathy for [the Mexican] people, they could at least have given me a

few days to deal satisfactorily with my personal affairs, which have suffered grave damage …

When the ship docked in New Orleans, she was besieged by reporters, but after her Mexican experience she had obviously lost her innocence about the press:

The newspapers have followed me, and at times preceded me – with wolf like greediness. Here in the US everything is seen from the 'beauty' angle – a daily here spoke of my trip and referred to me as to a 'woman of striking beauty' – other reporters to whom I refused an interview tried to convince me by saying they would just speak 'of how pretty I was' – to which I answered that I could not possibly see what 'prettiness' had to do with the revolutionary movement nor with the expulsion of communists – evidently women here are measured by a motion picture star standard – .

The *Edam* had arrived in New Orleans on Shrove Tuesday, at the height of the raucous Mardi Gras celebrations. But Tina was unable to enjoy the festivities. On personalized stationery, with a pale green imprint of her photograph of the ear of corn, bandolier and sickle, she wrote to Weston that US immigration officials had placed her in an alien detention centre for eight days, 'that is till the damned boat gets through its loading and unloading'. The holding area was:

a strange mixture between a jail and a hospital – a huge room with many empty beds in disorder which give me the strange feeling that corpses have laid on them – heavy barred windows and door, constantly locked this last one. The worst of this forced idleness is, not to know what to do with one's time – I read – I write – I smoke – I look out of the window into a very proper and immaculate American lawn with a high pole in the center of it from which top the Stars and Stripes wave with the wind – a sight which should – were I not such a hopeless rebel – remind me constantly of the empire of 'law and order' and other inspiring thoughts of that kind.

Next the *Edam* headed across the Gulf of Mexico, reaching Havana the next day. Ironically, this was Tina's first contact with Mella's beloved Cuba, to which he had hoped to take her one day. The country was still under the Machado dictatorship and port authorities ensured that Tina and the other Communist deportees could not roam the island while the *Edam* loaded cargo by holding them at the Tiscornia military base for the three-day duration. On 15 March, a local newspaper ran a brief notice with the headline, 'COMMUNISTS DEPORTED FROM MEXICO CONTINUE THEIR VOYAGE TO EUROPE TODAY: AMONG THEM, THE MISTRESS OF JULIO

With Tina making headlines in the ports of call, it was easy to track her progress en route to Europe. The Party had been correct to suspect the Mussolini government would be awaiting her arrival. The Italian embassy in Mexico had cabled Rome on 24 February when she had left Veracruz and the authorities knew she was on her way to Germany, but were not sure where she would disembark. When the ship docked at Rotterdam on 1 April, Vidali, who had remained incognito throughout the voyage, left Tina and Isaak Rosenblum in their quarters and went on deck to disembark. Tina, ashen-faced with fear, gave him a farewell embrace, saying 'Who knows ... anything can happen, we might not even see each other again.'

As Vidali waited to go ashore, two lawyers came aboard, accompanied by the local secretary of International Red Aid. Minutes later an Italian appeared, who Vidali alternately identifies as either the Italian Consul General or an agent of Mussolini's secret police, OVRA, the 'Organization for the Verification and Repression of Anti-fascists'. He watched undetected as the man explained that

> he had come for a woman 'deported' from Mexico, an Italian named Tina Modotti ... [that] the authorities must ensure her transfer [to an Italian ship] under guard because they were dealing with a dangerous communist, a terrorist, sought by the Italian police ...
>
> The two lawyers began chuckling; the inspector asked him if he had made the necessary application to the authorities in question, that is, the Interior Ministry, for his request to be honoured. He looked at us furiously: 'But she is an Italian citizen and she has an Italian passport. My government, the Italian fascist government, chief of which is *Il Duce*, Benito Mussolini, has summoned her.'
>
> The inspector was calm: 'You can represent whoever you like but there are two Red Aid lawyers here. They have arranged for Mrs Modotti to be able to remain in Holland for twenty-four hours and have obtained authorisation which permits her to enter Germany and take advantage of that country's asylum rights.'

Tina finally disembarked safely and went to a pre-arranged meeting place where she was received by her Dutch colleagues. There was a party that night and she was showered with gifts and flowers. Following her close call with Italian security, she was thrilled to be 'truly free. I will work, I will build a new life, I will be a good communist militant. I can't wait to begin.' Following their celebration late into the night, Vidali recalls, 'the three of us – Tina, Isaac and I – returned to the hotel, we felt secure and confident in the future.'

The optimism was not to last for long, however. Berlin in April

1930 was sinking deeper into the economic and moral quagmire which began with Germany's defeat in World War I. The 1929 Wall Street crash had pushed the global economy into depression, leading foreign creditors to call on Germany for immediate loan and war-reparation payment. Tina's arrival there coincided with a spate of suicides resulting from the massive devaluations and skyrocketing inflation that made life a desperate, frantic struggle for survival and drove people beyond the brink of despair.

German Communists had followed their failed 1923 uprising with parliamentary sniping at the Weimar Republic's social democracy. By April 1930, all semblance of Social Democratic stability had disappeared and Berlin's reputation as a haven for radicals was crumbling under attack from Hitler's National Socialist Party and its conservative allies. Masses of bitterly frustrated Germans flocked to the rallies of this new messiah, which frequently ended in violent street battles. Despite her anti-fascist activity in Mexico, this was Tina's first direct contact with the raw reality of fascism.

She had arrived in Berlin by train from Holland in the first days of April, hoping to be able to earn her living as a photographer, even though her main objective was to be somewhere she could 'be most useful to the movement'. It seems Tina was totally unprepared for the situation she encountered: 'The strain shows on the people; they never laugh, they walk the streets very gravely, always in a hurry and seem to be constantly conscious of the heavy burden which weighs on their shoulders.' She was also ill-prepared for the climate, with

German youth group, 1930 [TM]

freezing temperatures and no sunshine during her first ten days.
Homesick for Mexico and bitter about having to start over, she complained to Weston that 'for one coming from Mexico the change is rather cruel. But I know that the wisest thing is just to forget sun, blue skies and other delights of Mexico and adapt myself to this new reality, and start, once more, life all over ... '

The first people she looked up were the Wittes, a German couple she had met in Mexico. They offered her a place to stay and even had a room prepared for her, but she refused their offer, probably because she did not want to expose them to the risk of having a militant Communist house guest. Vittorio Vidali remained in the city only a few days before heading for Moscow. He recalls that when he left Tina was very 'silent', perhaps disturbed by the panorama before her. Nevertheless, she rejected his insistent offers to accompany him to Moscow. She wanted to become self-sufficient and, perhaps, make a visit to Italy to see her family. Steeling herself after a brief bout of depression, she wrote to Weston in May: 'I have enough self confidence and must not undervalue my capacities.'

Virtually coinciding with her arrival was an exhibition of the Berlin 'Worker-Photographers' Union', an organization with its own magazine, *Der Arbeiterphotograph*. Both were funded through International Workers' Relief, then the German equivalent of Red Aid, which was run by the flamboyant 'Patron Saint of Fellow Travellers', Willi Münzenberg. His control over funds from Moscow had helped make him the top propagandist of the German Communist Party and he was adept at co-opting the loyalties of a broad range of leftist German and foreign artists and intellectuals by publishing their works in his *Neue Deutsche Verlag* publishing house. His immensely popular weekly *AIZ* (*Arbeiter Illustrierte Zeitung*), enthusiastically embraced the graphic potential of photography in conveying its message.

Tina's ties with Red Aid brought her into contact with this substantial infrastructure. In addition to her links to *AIZ*, which published several of her photographs, she had joined and received a press credential from *Unionfoto*, the Berlin agency which distributed the work of both Soviet and German worker-photographers. Her political connections also facilitated her meeting what Vidali described as 'a group of architects interested in photography', undoubtedly from the Bauhaus school. In 1929, the Bauhaus's director, the Swiss-German architect Hannes Meyer, had created a formal programme of photographic studies at the institute. Tina also met Lotte Jacobi, a fourth-generation photographer who had acquired a reputation for her

modern portraiture. She would eventually be able to work out of Lotte's studio, but for the moment she had found herself a cheap private room with the luxury of running water, a rarity in Berlin in 1930.

However, Tina soon ran into difficulties that led her to question the practicality of being a photographer in Berlin. She was shocked at the enormous taxes charged for opening a small business – a serious obstacle to her starting up her own photographic studio – and it is clear from her letters that the technical problems were also considerable. The Europeans used completely different-sized cameras, film and paper. Her prized Graflex became a double hindrance: not only was it now a technical burden, but its resale value was nil. Film for it had to be ordered directly from the United States and large quantities of specially cut paper had to be purchased. She also had difficulty finding photographers willing to share a darkroom, so was forced to buy her own darkroom equipment.

Tina had only 420 dollars with her when she arrived in Berlin and these expenditures were a considerable financial drain. Through Weston, she contacted the journalist cum art patron Alma Reed, probably to ask for payment for the photographs she had made of Orozco's work. Lola Alvarez Bravo remembers Tina writing to her and to others in Mexico at this time to get Antonieta Rivas Mercado to send her the money she owed her. It appears that some of the photographic work Tina had done for the Rivas Mercado family had not been paid for. But Antonieta had her own problems and was languishing in a New York hospital in the wake of José Vasconcelos' failed presidential bid. Within a year, her obsession with the former Education Minister would drive her to suicide in the nave of Notre Dame cathedral.

Tina later recalled being 'so cold and hungry and lonely' in Berlin and less than two months after her arrival, she wrote to Weston 'This present period is very nearly killing me.' Still, she preferred not to fall back on commercial portraiture for her income, a preference reinforced by the existence of literally hundreds of good portrait photographers in Berlin. She did receive an offer

> to do 'reportage' or newspaper work, but I feel not fitted for such work. I still think it is a man's work in spite that here many women do it; perhaps they can, I am not aggressive enough.
> Even the type of propaganda pictures I began to do in Mexico is already being done here; there is an association of 'worker-photographers' (here everybody uses a camera) and the workers themselves make those pictures and have indeed better opportunities than I could ever have, since it is their own life and problems they photograph. Of

Schon Wieder *(Once Again)*, 1930 *[TM]*

Germans at the
Zoo, 1930 [TM]

course their results are far from the standard I am struggling to keep up in photography, but their end is reached just the same.

Feeling increasingly adrift in Berlin's photographic world, it seemed that everything – even the dull natural light of Berlin – was stacked against her. The tone of complaint which permeated her correspondence with Weston and the Alvarez Bravos at the time began to sound as though she were paving the way for abandoning either Berlin or photography, or both:

I feel there must be something for me but I have not found it yet. And in the meantime the days go by and I spend sleepless nights wondering which way to turn and where to begin. I have begun to go out with the camera but *nada* [nothing]. Everybody here has been telling me the graflex is too conspicuous and bulky; everybody here uses much more compact cameras. I realize the advantage of course; one does not attract so much attention; I have even tried a wonderful little camera, property of a friend, but I don't like to work with it as I do with the graflex; one cannot see the picture in its finished size …

Her aversion to using a smaller camera was because she felt it

would only be useful if I intended to work on the streets, and I am not

so sure that I will. I know the material found on the streets is rich and
wonderful, but my experience is that the way I am accustomed to work,
slowly planning my composition etc., is not suited for such work. By the
time I have the composition or expression right, the picture is gone.
I guess I want to do the impossible and therefore I do nothing.

Politically, Tina appears to have kept a low profile in Berlin, proba-
bly to avoid detection by the Italian embassy and OVRA informers.
Aware of the precarious situation facing political exiles, she wanted to
feel as though she could pick up and go whenever she wanted, or
whenever she 'was forced to'. She cautioned Weston not to write her
name on envelopes sent to the address she had given him. Even
friends visiting Berlin were unaware of her exact whereabouts.
Ernestine Evans wrote to Ella Wolfe that despite her efforts, 'I can't
find Tina or any news of her.' She did eventually find her, however,
because in August the British writer Ella Winter wrote to Weston
that 'Yesterday I ran into Tina Modotti. She has been in Berlin four
months. I am taking some shoes for her to Ramírez [Rosovski], to
Moscow. We talked of you as you may imagine. She was visiting
Ernestine Evans.'

Perhaps more revealing is Anita Brenner's account. In Germany on
a part-honeymoon, part-Guggenheim fellowship excursion, Anita said
that at the time Tina gave her 'the willies'. Apparently, they met in
Hamburg where Tina was operating under a certain amount of secre-
cy.' The previous year, even Tina herself had questioned her new
habits and lifestyle: ' ... are they just the result of living in a certain
environment, or have they really taken the place of the old life?'
During the summer of 1930, she was still sufficiently detached from
her new persona to be concerned that she might appear a little
strange to those outside her political milieu. Writing to Weston from
Berlin, she refers to his new love, Sonia Noskowiak, and self-
consciously enquires, 'Does she think I am a crazy nut?'

A clue to Tina's political work at the time comes from Baltasar
Dromundo: 'I remember perfectly that she gave me to understand
she was being required to do something very different: on behalf of
Red Aid, she was [being asked] to fight fascism ... ' Vidali and other
Italian Communist leaders confirmed that despite the danger
involved, Tina was intent upon returning to Italy to work clandestinely
against Mussolini. Among the trips she made that summer was one to
Switzerland, though the purpose of her journey is unclear. She sent
both Manuel Alvarez Bravo and Baltasar Dromundo letters from
there and Dromundo recalled her having been in Switzerland on Red
Aid work. Alvarez Bravo remembers that in one letter, Tina said 'she

had seen some festival there that made her recall the Mexican festivals; she said it was another world'.

A photograph Tina made that summer, of billowy cloud forms above an alpine village, has been identified as taken in Bavaria or Switzerland. It is possible she made the trip to obtain false travel papers. Switzerland was a centre for providing Communists with such documents for travel in Europe. Another possibility is that she hoped to meet up with her mother and sisters there. Assunta Modotti had been unhappy in California for some time and on 4 April, just three days after Tina arrived in Europe, she and Mercedes had renewed their Italian passports, asking for permission to travel to 'Germany, Austria, France, Switzerland and the [Italian] Kingdom'. The passports were issued with the stipulation that they were valid for only six weeks' travel, with Italy as a final destination. If it was Tina's plan to meet them in Switzerland, it is unlikely she ever realized it. Later letters from her mother and Mercedes indicate they never saw each other again after Tina left California in 1926.

Tina had planned a Berlin exhibition of her work in the autumn: 'By then I ought to have something of Germany to include, which would all be very good, if only I begin to work soon. Otherwise all I will have is "merda" [crap].' She made several photographs in the next months, none of them very distinguished. She even tried some street photography, turning a rather vicious eye on Berliners. In one of the images, an obese couple looks at an animal in a cage, begging the question which should really be the object of our curiosity. In another, excessively clothed nuns unabashedly walk past a nude statue. A photograph found recently among the papers of the *Unionfoto* director, Eugen Heilig, shows 'Tina M. working' in a felt hat, sweater and mid-length skirt, on the sandy beach of a lake, focusing with her bulky Graflex in a situation where a compact Leica would seem more appropriate.

Lotte Jacobi not only allowed Tina to use her studio, but also offered to distribute her photographs through the small agency she ran. She was so enthusiastic about Tina's work, she encouraged her to have an exhibition. One of those who attended was Czech journalist Egon Erwin Kisch, who remembered that the exhibition was in Jacobi's studio and that the photographs shown, primarily the prints Tina had brought with her from her show in Mexico, 'surpassed [Jacobi's] own work'. Tina's photography, he said, 'through the insight of goodwill, makes the world more visible.'

In early October, when Tina's six-month, non-renewable visa was about to expire, Vidali returned to Berlin, again under the guise of Jacobo Hurwitz. He found Tina looking thin and pale. The money

she had brought with her from Mexico was about to run out. When she asked him to help her return to Italy, he told her that he himself had already asked the Party for permission to do likewise and could help her. However, he stipulated that if her situation in Germany did not improve within a month, she accompany him to Moscow. He was very enthusiastic about life in the Soviet Union, which after an earlier visit he had envisioned in glowing terms, describing 'the Red soldiers marching with their rebellious songs, with proud, intelligent faces; and the armed youth and the children who discuss politics … A new society, great, magnificent, raises its superb towers above the old and decrepit.' He must have been persuasive in his arguments, for within two weeks Tina had left Germany and was en route to Moscow in his company.

PART IV

1936 – 1942

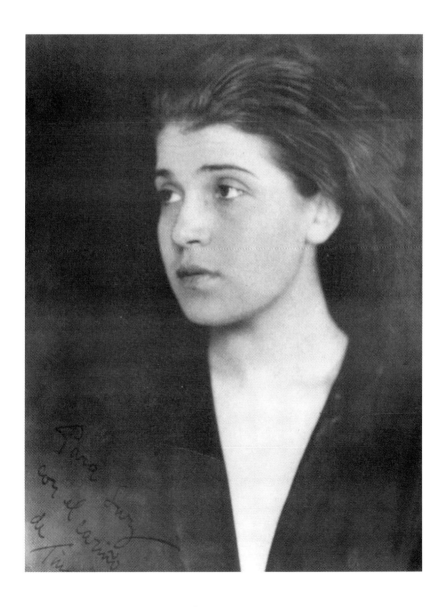

Portrait of Tina
Photographer: Edward Weston, 1924

18

A Different Person

At Moscow's Alexandrovsky station, Tina and Vittorio were met by their friend from Mexico, Julio Rosovski, who accompanied them along the city's main boulevard, the Tverskaya. Running uphill from Red Square, the Tverskaya was the pulse of the city, the first street seen by every new visitor heading from the station to the hotel district and the site of virtually all revolutionary parades. Under Lenin's pluralist New Economic Policy of the early 1920s, the Tverskaya had been a tumultuous thoroughfare lined with restaurants, gypsy cellars, hotels and a government-run gambling casino.

But when Tina arrived, during the first of Stalin's Five Year Plans, the Tverskaya was a shell of its former self. Imposed austerity showed in the boarded-up shop windows, dilapidated buildings and potholed streets. Forced agricultural collectivization had caused severe food shortages and workers could not meet the fantastic production quotas decreed by over-enthusiastic government planners. Rather than revise its projections, the Stalinist bureaucracy stubbornly attempted to rally the masses behind triumphalist slogans like 'The Five Year Plan in Four Years', which when translated into Soviet shorthand on bill-boards and posters became the mind-boggling

$$`2 + 2 = 5`$$

Tina was allotted a tiny room in the Hotel Soyusnaya, where Vittorio and Rosovski were already living. The hotel was right on the Tverskaya, only a few blocks from Red Square, the very centre of the world socialist movement, and within a few days Tina was able to participate in the gigantic parade commemorating the October Revolution:

> Moscow was inundated with flags; a sea of people lined up in the
> streets, carrying flags, banners, giant photographs of Lenin, Stalin,

Marx, Engels. [There was] great exuberance and real enthusiasm. Tina had never seen anything like it and was moved, electrified.

Her first weeks in Moscow were full of excitement. In the last letter she ever wrote to Weston in January 1931, she described her new life:

I have been living in a regular whirlpool ever since I came here in October, so much so that I cannot even remember whether I have written to you or not since my arrival ... I have never had less time for myself than right now; this has its advantages but also drawbacks ... There would be so much to write about life here, but *no hay tiempo* [there is no time] – I am living a completely new life, so much so that I almost feel like a different person, but very interesting.

The Hotel Soyusnaya was an imposing edifice, inhabited mainly by foreign trade unionists and Red Aid delegates. The rooms were small, with no running water. There was a long roster to use the communal bathrooms and there was no restaurant. Cooking in the rooms was frowned upon, but most foreigners ignored the rules and Tina was no exception. The ambience of foreigners and Party faithful in which she moved is glowingly described by Vidali as a round of parties, concerts and exhibitions but there was also the reality of deteriorating housing and public transportation, as well as constant food shortages. 'Tina did not complain if meals were scarce or if from time to time we had to resort to the black market to obtain a bit of bread, some slices of salami or two eggs,' recalled Vidali. To pay for these 'luxuries', however, they had to rifle through their suitcases to find a spare item of clothing to sell.

Not far from the Tverskaya was the Hotel Lux, 'infested with rats and the hidden microphones of the secret police'. As the main Comintern residence, it at least had a cafeteria and Tina sometimes ate there with visitors. One Lux resident, Aurora Andrés, a young Party militant from Spain, met her shortly after her arrival: 'I found her very timid, very modest. She arrived as the widow of Mella ... I saw her, you know, when she went to official functions, Comintern things, and at the hotel, as well, she would come to see friends and colleagues ... '

Tina's first trip to the Lux had been to see Xavier Guerrero. By all accounts, she was outraged when her attempt to smooth over their strained friendship was totally rebuffed. He listened silently to her explanation, but refused to discuss the matter, saying that as far as he was concerned she no longer existed. Of course, since she had not received the angry letter he had sent to Mexico, she was unprepared for his reaction.

If her role as the 'widow' of a martyred revolutionary gave Tina immediate credibility, the rumour mill was already painting her relationship with Vittorio Vidali as more than friendship. Vidali said it was a misunderstanding when, in late 1930, he was called before the grey-haired, bespectacled head of International Red Aid, Lenin's still-formidable former secretary, Yelena Stassova, on charges of polygamy. Apparently, before leaving Moscow for Berlin, Vidali had had a 'brief' affair with Paolina Hafkina, the daughter of a Russian friend. When he returned in October, Paolina was seven months pregnant. He insisted that she was still 'his only woman'. What he did not admit to himself, he later said, was that he was falling in love with Tina.

In Moscow, International Red Aid was known by its Russian acronym, MOPR, 'The International Organization for Aid to Revolutionaries'. Its leading officials insisted it was an international, humanitarian, 'non-Party organization', which aided political prisoners and their families and dependants, and provided refuge in the Soviet Union for the victims of oppression. However, from its 1922 inception, the organization had been a dependency of the Comintern and served its goals world-wide. While it purported to aid all persecuted revolutionaries, in practical terms its support was channelled towards Communist Party members only and its political objectives of increasing class consciousness and building 'international proletarian solidarity' were synonymous with the principal aims of the Soviet Communist Party.

It was at Stassova's suggestion that Tina began to work at Red Aid's headquarters in Moscow, ostensibly as a translator and reader of foreign newspapers in the Latin-European section, which comprised Spain, Portugal and Italy. However, within a short time she had won the mighty Stassova's confidence and visitors to the main Moscow office found that 'behind the vigorous figure of the "old Bolshevik", as Stassova was affectionately called, was [Tina], diminutive, sweet, discreet and smiling'.

Vidali says Tina had come to believe that she had not given the movement all she should have and that this 'obsession' caused her to start reading everything she could 'to try and change her mentality … and put into her head a completely different vision of the world from the historical, political and social point of view'. Her duties expanded to include writing articles for German and Soviet Red Aid publications on topics such as Mexican agrarian reform, the plight of widows and orphans, and against fascism. While the themes were worthy, the language and approach was uninspired and sterile, the

underlying goal being to lay down the official Party line.

Another of Tina's tasks was to visit the aged and ailing revolutionary, Clara Zetkin, and she soon became Stassova's liaison with important foreign exiles and Russian intellectuals. In 1932, she went to visit Soviet filmmaker Sergei Eisenstein with Pablo O'Higgins, then in Moscow on a grant from the Soviet Arts Academy. Eisenstein had just returned from the United States and Mexico, where he had been working on his ill-fated film *Que Viva Mexico!*, said to have been influenced by the Weston and Modotti photographs in *Idols behind Altars*. Eisenstein told American film historian Jay Leyda in 1933 that while he admired Tina, he did not see her often. At the behest of Alma Reed, Leyda had brought to Moscow a packet of Tina's photographs, probably of Orozco's murals. Both he and Eisenstein examined the photographs and were favourably impressed. But whether Eisenstein was ever involved with a supposed exhibition of Tina's work at Moscow University, as Vidali later claimed, is not clear.

Just before she chose to devote herself to International Red Aid work, Tina had been offered and had turned down the position of official photographer for the Soviet Communist Party. While she was too devoted to the Party to risk disapproval or expulsion, Tina was too much of an artist to see her work reduced to mere propaganda. Once in the Soviet Union, she must have quickly become aware of the prevailing attitude – that all artistic and intellectual pursuits should be subordinated to the political and economic aims of the regime. Artists were being forced to become cheerleaders for Stalin's policies or else be hounded by critics using the dogma of socialist realism to attack them, on political as well as artistic grounds. Tina's photography did not fit in with Stalinist concepts of what constituted 'revolutionary' art, and as a Party member working with Red Aid, she could not have produced anything *other* than 'revolutionary' art.

Stories like the one propagated by Chilean poet Pablo Neruda, that Tina 'threw her camera into the Moscow River and swore to herself that she would consecrate her life to the most humble tasks of the Communist Party', have little basis in fact. In her letter of January 1931, Tina had asked Weston to try and find a buyer for her Graflex camera because she wanted to sell it in order to buy a Leica. Angelo Masutti, an Italian exile who arrived in Moscow in 1932 says that around this time Tina loaned him a Leica camera, which he did not return for three years. Lotte Jacobi, visiting the Soviet Union in 1932, ran into Tina one day and found her looking unwell. When Lotte asked her if she was taking photographs Tina told her that she was too busy with other work she had been given. Concha Michel was

> was unhappy because there was no [artistic] stimulation there, nothing.
> They did not appreciate her photographic art. They only wanted to use
> her to make some politician's portrait or something, but they didn't let
> her do her artistic work …

It is clear that the 'they' referred to by Concha were Party bureaucrats.

Tina had few qualms about sacrificing her life to the cause. But, as has since been said,

> the one thing she was unwilling to sacrifice for it, apparently, was the
> artistic standard her best work upheld. As a woman, she could become
> – and did become – a political hack. But she could not become a photo-
> graphic hack. When she joined the 'revolution' she was wise enough to
> abandon aesthetics. [Yet] she was willing to violate everything but her
> aesthetic sensibility.

During her time in 1920s Mexico, Tina had come to believe that her photography could be integrated into her political activity, the promotion of socialism and the combatting of fascism. In the very different political climate of Europe in the 1930s, where fascism was a tangible force and socialism a possible reality, the urgency and enthusiasm of the moment plus the dictates of the Soviet Communist Party convinced her this was no longer feasible.

Years later, Vidali said Tina had committed an 'error' in subordinating her photography to politics, in framing her dilemma in terms of the absolutes 'either I do politics or I do photography'. But those closest to him knew that Vidali could not have been very appreciative of her art: 'He was so ignorant about music, painting … He only read things of concern to the Party … If anybody was unartistic it was him; he didn't have an inkling about artistic things.' For Vidali too, it was a question of absolutes – 'love, passion, a home, a woman, everything was subordinated' to the political life.

Tina's decision to set aside her camera, at least temporarily, was taken during her first year in Moscow, probably as early as the summer of 1931. In November, in a letter to Joseph Freeman, Frances Toor told him that

> I heard from Tina some few months ago and she wrote that Life is
> again good to her in matters of love, because there is a new man in her
> life whom she loves and who loves her. She is working in an office and
> has given up photography for the present.

Likewise, Katherine Anne Porter wrote shortly afterwards to Mary Doherty that in the autumn of 1931, she and Eugene Pressly had heard from Tina and

> She said she was living happily with a Mexican that Gene knows, but I do not, and cannot remember his name. I keep thinking Contreras, but that is probably not it … And had a job, and was doing no photography, and had become a 'good bureaucrat.' etc.

The man they were referring to was Vidali, or 'Jorge Contreras', another alias he used in both Mexico and Moscow. Despite his later claims that he and Tina did not become romantically involved until 1933, by the time Tina took her decision to give up photography, they had moved into a room together at the Hotel Soyusnaya. She had finally succumbed to the pull of *campanilismo* and had fallen in love with an Italian. Vidali, the son of Giovanni Battista Vidali, a metal worker, and Bianca Rizzi, a garment worker, was from the impoverished fishing village of Muggia on the outskirts of Trieste, a short distance from Tina's hometown of Udine.

It might seem difficult to comprehend Tina's attraction to this short, stocky, balding man with a reputation for sinister deeds, but tales of his countless affairs show that many women found him attractive. He was extremely ambitious, with 'superhuman driving power' and an 'unbreakable gaiety'. Discounting her marriage to Robo, Tina's deepest relationships were with ambitious men who were leading figures in her fields of interest. In Moscow in 1931, Vidali certainly fulfilled these requisites.

Within a short time, Tina's Red Aid duties took a new and dangerous turn. She was sent on secret missions into fascist Europe, carrying funds for the defence of political prisoners. Her facility for languages equipped her for the task and the Comintern supplied her with forged documents for her first mission to Poland:

> It seemed simple: you went to Warsaw or another city, you looked for the address you had memorised, you turned over the money to the contact person and you left. But if they'd discovered the object of your trip, they'd have put you in prison for at least ten to fifteen years. Tina knew precisely the danger and, nevertheless, completed her mission with amazing nerve …

What Vidali neglects to say in this description, and what must certainly have been known to Tina, was that the discovery of Communist agents usually meant their torture or death.

Missions to Rumania and Hungary preceded several to Spain in

support of imprisoned victims of government repression. According
to Vidali, on one of these missions,

> she was imprisoned for two days in Irún and then they deported her,
> taking her to the border. She handled herself very well with the police,
> just as a real revolutionary should. She said nothing, remained silent
> [and] they had to let her go ... They let her go even though they knew
> that the Guatemalan passport she had in her pocket was forged.

After Hitler won a huge majority vote in Germany in early 1933,
Stalin's paranoia increased dramatically. It was the year of the first
chistka, or cleansing of the Party and government bureaucracies of
suspected 'class enemies'. Tina did not escape suspicion. A member
of the Soviet Communist Party, she had to take part in these public
'confessions', obliged to carry out a 'self-interview in public [to]
"confess all her sins" '. The description fits the account of Italian
Communist Teresa Noce, who described how in the *chistka* process,
each Party member 'one after another, in alphabetical order, was
analysed: their political conduct, their behaviour at work and in their
private life'.

Tina survived the *chistka* to be promoted to a position on the Red
Aid Executive Committee in 1933. In August, she and Vidali were
called before the head of Soviet military intelligence and asked to
join Richard Sorge's espionage ring in Japanese-occupied China.
Tina was to act as the group's photographer, and although she was
not enthusiastic about the task, her acceptance of this highly danger-
ous intelligence work indicates the lengths to which she was now
willing to go in following Party directives and defending the interests
of the Soviet Union. Before Tina and Vittorio could leave for their
new posting, however, Yelena Stassova intervened to keep their
services with Red Aid. Instead of going to China, they found them-
selves dispatched to Paris to run Red Aid's centre for anti-fascist
activities in western Europe.

The Comintern supplied Tina with a Costa Rican passport and she
travelled separately from Vidali via Warsaw, Prague and Geneva,
using the name 'Lina'. The Paris Red Aid office on rue d'Hauteville
operated openly but according to the daughter of the family with
whom they stayed,

> Tina and Vidali lived clandestinely. Yes, they did speak French, with a
> few insignificant errors that hardly caught one's attention. Imagine, we
> didn't even know Tina was Italian. This shows she was not as commu-
> nicative as [Vidali] ... Tina was very different ... it wasn't that she was
> closed, or that she established a distance between herself and others.

Their immediate task was to channel funds to German political prisoners in Nazi jails, but in February 1934 the Austrian Left's armed paramilitary group, the *Schutzbund*, launched a rebellion. The *Schutzbund* 'fought heroically for four days … but all was lost when the government ordered artillery to be used against the municipal housing projects … there were many injured among the peaceful inhabitants'. Tina and Vidali rushed to Vienna as Red Aid's representatives to provide immediate assistance to the victims.

When Vidali was called back to Moscow briefly, Tina returned to Paris, where she ran the Red Aid office and organized publication of a trilingual anti-fascist magazine. Within weeks of Vidali's return to Paris, he was arrested by French secret service agents, accused of being a Soviet spy and deported. Tina realized something was wrong when he did not show up at the Red Aid office. Clearly, she was by now involved in something much deeper than simply Red Aid solidarity work:

> Tina locked the doors and the windows and began to burn all those documents which should not fall into the hands of the police under any circumstance. Luckily, at that moment [fellow worker] Willi Koska arrived [and] realized what was going on. He broke down the door and found Tina, on the point of suffocation, shrouded in a cloud of smoke …

His cover blown, Vidali returned to Moscow and Tina was put in charge of the Paris office. She saw to the organization in August of the 'International Women's Congress against War and Fascism', which brought together 1,000 international delegates, including Stassova herself. In October another crisis erupted, this time in Spain, where an unsuccessful general strike prompted an uprising of Asturian miners armed by the Socialist Party. The Communist Party supported them and the Paris Red Aid office quickly issued a pamphlet with an article highlighting 'Asturias – The First Soviet Republic in Spain'. Tina was apparently dispatched again to Spain, but was turned back at the border and escaped the brutal military repression of the miners' uprising.

As Red Aid committees world-wide rallied to collect funds for the Asturian miners, Tina returned to Moscow, where she confronted a tense situation. Vittorio had clashed with certain GPU bureaucrats and was under surveillance, which automatically extended to Tina. In December 1934, probably to protect him, Stassova sent Vidali on a mission to Spain with funds Red Aid had accumulated for the Asturian miners.

Although he admits Tina was supportive while he was under suspicion, Vidali says she underwent dramatic changes around this time, recalling that in one discussion with Party members, Tina said, 'I'm convinced that the saying "The Party is always right" is correct and necessary.' Perhaps this reflected a 'more rigid' attitude, as Vidali claimed. But, given the prevailing environment of fear, it could well have been said for the benefit of those listening, as a self-protective measure.

Tina remained in Moscow during 1935 while Vidali worked clandestinely in Spain. Fear and suspicion were sweeping the Soviet Union and denunciations and arrests were increasingly commonplace. Friends stopped confiding in each other and there was 'widespread surveillance in the international organizations as well as in the private life of each individual'. When he returned to Moscow that autumn, Vidali found the situation 'intolerably disagreeable, a climate of fear was everywhere, palpable, one breathed it, it could be touched with your hand'. Tina believed that she too was now under some kind of special vigilance, probably due to Vidali's previous problems. How, then, Vidali also found Tina in 'optimum health, happy to see me, affectionate' is perhaps best explained in that his return represented her possible escape from the Soviet Union.

The months of separation, however, had done irreparable damage to their relationship. They had become one of those ' "completely political" couples common within Communist Parties', what Vidali described in hindsight as the kind of relationship 'that with time destroys affection and transforms human beings into something abnormal'. He now felt that the woman who had once described herself to him as being 'beyond good and evil', was truly aloof from him. There was now a 'veil' between them and the metaphor he would come to use to describe his inability to reach Tina is that she was like 'a castle with the drawbridge up'. But it was not only Vidali that Tina had closed out; there were few people now that she would open up to.

In early November 1935, the Moscow bureau of Red Aid suggested to Comintern executive committee member Wilhelm Pieck that Tina be placed in charge of technical and organizational questions, as well as the Spanish and English language sections of the Paris office. But developments in Spain were more pressing. Palmiro Togliatti, the Comintern official responsible for Latin countries, informed Vidali in what was clearly a top-level decision made over Stassova's objections, that he was being sent back to Spain and that Tina was to go with him.

Tina, however, interpreted the move as the Soviet Party wanting 'to

rid itself of two troublesome people', that being the reason they were told to take all their belongings. Party loyalty aside, she knew by then that the Party had other, more disagreeable ways of ridding itself of bothersome types, and told Vittorio with relief on the night before their departure, 'I'm happy to be leaving.' The only things she left behind in Moscow were the last vestiges of her past: her photographs and her camera.

19

Spanish Civil War

While Tina and Vittorio, under the pseudonyms of María del Carmen Ruíz Sánchez and Carlos Contreras, were co-ordinating the political prisoners' amnesty campaign in Spain, they stayed with a young Spanish couple recently recruited to the Party. Matilde Landa and Paco Ganivet allowed their home to be used as a 'safe house', a place for secret Party meetings, where clandestine operatives could change clothes and disguises. Tina, cool-headed and serene, and Matilde, hot-headed and gregarious, both devoted to the 'cause', became almost inseparable friends. They even looked slightly alike: Matilde was taller with close-set, black eyes, but she too had a sensitive mouth and wore her dark hair parted in the middle and twisted back into a bun. The two women worked closely for the 1936 Popular Front victory that allowed International Red Aid and the Spanish Communist Party to work openly, and went on demonstrations together, like the huge May Day celebration in Madrid in 1936.

While Spain was being shaken by widespread land takeovers, constitutional crises and rumours of military coups, Tina was supervising publication of Spanish Red Aid's newspaper, *Ayuda*, touring the countryside to collect information on political prisoners and victims of repression, and writing articles on her findings. The very day of the outbreak of the army rebellion led by General Francisco Franco, she returned from Andalusia to Madrid, narrowly escaping the turmoil which hit the Andalusian cities of Córdoba and Granada. She immediately rushed to the Red Aid office on the Gran Vía, where delegates from throughout Spain were assembled awaiting instructions. Red Aid delegates were sent to their respective trade unions and Party offices, as a chanting crowd demanding arms heaved its way towards the Plaza del Sol, the heart of Madrid.

The following day, Tina was assigned a task which foreshadowed

her 'troubleshooter' role throughout the war. She was designated to help reorganize a private tuberculosis sanatorium which had been expropriated by the Republican government when the nuns who ran it refused to treat wounded militia. Located in the working-class Cuatro Caminos neighbourhood, near the monastery where Vidali, as 'Comandante Carlos', was to forge the fighting force known as the Fifth Regiment, the sanatorium was a massive stone building with tall bay windows and marble floors. Re-named the Hospital Obrero (Worker's Hospital), it was under the jurisdiction of International Red Aid and staffed largely by trusted Communists, including Matilde Landa and a young Cuban woman, María Luisa Lafita. With Franco supporters disguised as volunteer nurses infiltrating Republican hospitals and poisoning wounded soldiers, Tina personally took charge of surveillance in the kitchen to detect attempted poisonings. Her own cover was so clever that she went undetected by virtually everyone, including Mary Bingham Urquidi, the English volunteer head nurse and wife of a Mexican diplomat. Mary was surprised to see that nuns still dared to walk the corridors in their flowing white habits, since she had heard they were being summarily executed by anti-clerical Republicans. On her second day, she bumped into a 'very handsome brunette in a nun's habit which trailed as she walked. She looked at me for a second and then said: "You must be the *real* nurse. How long have you been here?" ' The woman turned out to be a Communist stalwart and not a nun at all!

> As we passed the kitchen, [she] called to a woman inside who was also wearing a long nun's gown. She introduced her as Marie. Marie was French and was in charge of the kitchen and the cooks. She said that she had never had anything to do with kitchens. Her English had a funny accent, a mixture of French and American, due she said, to having lived in Brooklyn, N.Y.
> 'Marie,' I asked, 'Why did you come to work in a hospital?'
> 'I am a Communist,' she answered …

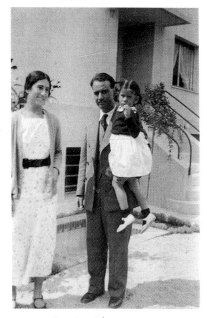

Matilde Landa with husband Francisco and daughter Carmen outside their home in Madrid, 1936

Mary Bingham never learned the true

identity of 'Marie', who was none other than 'María', that is, Tina Modotti disguised as a Spanish hospital nun!

A Catalán doctor, Juan Planelles, who organized care for the flood of wounded during the first weeks of the war, shared the role of 'political director' of the hospital with Matilde Landa. Mary believed that Planelles and Matilde were 'the political backbone of International Red Aid', but those who were informed knew that Tina's role as Moscow's Red Aid delegate was of greater importance. Some of the Spanish Communists referred to Moscow envoys like Tina as *las nanas* (the nannies), those sent to keep an eye on local Party people and train promising cadres. Party militant Aurora Andrés, then the wife of the Spanish Education Minister, Jesús Hernández, believes Tina was one of these foreign *éminences grises*.

When Dolores Ibarruri, *La Pasionaria*, the venerated matriarch of Spanish Communism, was admitted to the hospital with hepatitis, Dr Planelles told María Luisa Lafita that nobody could enter her room

> ' ... except Tina and you. Nothing should be given to her unless it is with my orders ... You will take turns with Tina [and] I will be the attending doctor.'
> I asked him, 'Shall I bring my pistol to the room?'
> He answered, 'Of course.'

Since Tina was a member of the Fifth Regiment's 'feminine battalion' and trained in the use of firearms, supposedly even grenade launchers, it is logical to assume she too would have carried a pistol.

With the fighting in the Sierra de Guadarrama to the north of Madrid, Tina and María Luisa went to evacuate a children's hospital run by nuns in an area under attack from fascist troops:

> One day, some soldiers took up position on a nearby hill, but since they carried our flag the nuns paid no attention. It was only when they began to fire on the hospital that they realized they were fascist troops. They quickly started bringing the children into the enormous interior patio, hoping that the soldiers, seeing that they were women and children, would stop firing. But the attack continued, and the children, one after the other, fell to the ground. They were not only hit by ordinary fire, but by 'dum-dum' bullets ... It was a real bloodbath. [We] had to organize immediately to rescue the few survivors and Tina volunteered for this task. Side by side, under a hail of bullets, we dragged the children towards the patio.

Shortly afterwards, her legs swollen from hours of standing in the hospital kitchen, Tina was suffering from such severe exhaustion that she had to be hospitalized. When she was discharged, she made the

first of many war-time trips to Paris, which was not only pivotal to Red Aid's humanitarian aid effort but also a critical channel of weapon supplies through Mexico's special ambassador, Adalberto Tejeda. Back in Madrid in September, Tina passed out arms to the first Italian volunteers to join the Fifth Regiment, just as Diego Rivera had depicted her in his mural 'In the Arsenal'. By November, with Madrid threatened by a major rebel assault, the government and foreign embassies evacuated the city and, as a ranking International Red Aid official, Tina moved the organization's headquarters to the relative safety and tranquillity of Valencia.

By doing so, she missed the outstanding performance of Vidali's Fifth Regiment in the battle for Madrid. The relentless shelling and aerial bombing of civilian targets had never before been seen in warfare and the Fifth Regiment, a disciplined force Vidali had created out of a raggle-taggle band of militia, was largely responsible for slowing Franco's advance until the arrival of international volunteers turned the tide to save the city.

In the preceding weeks, 'Comandante Carlos' had gained notoriety as the Fifth Regiment's political commissar, or 'comic star', as some snidely quipped. The commissars were no joke, however, serving as guardians of ideological correctness, their task being to stamp out pessimism and disloyalty. An 'inspired organizer as well as a ruthless disciplinarian', Vidali was known to charge about with a pistol in each hand, haranguing the undisciplined militia recruits and ferreting out fascist sympathizers. According to then *New York Times* reporter Herbert Matthews, on the night of 7–8 November, with Franco's troops at the city's gates, 'The sinister Vittorio Vidali spent the night in a prison briefly interrogating prisoners brought before him and, when he decided, as he almost always did, that they were fifth columnists, he would shoot them in the back of their heads with his revolver.' About 1,000 suspected fascists, a number of whom were merely victims of vendetta-like denunciations, were hauled from Madrid's Model Prison and assassinated that night.

In December, when Tina returned to Madrid, she was devastated by news of her mother's death. She had been writing to her mother frequently and sending her money, but the replies had been intercepted by the Italian secret police so she had not heard that her mother was ill. In her grief, she yearned for the support of her family and after an emotional week, she wrote to Mercedes:

> I have to make an enormous effort not to allow myself to be overcome by tears; I want to, I must be, strong. I know that in other circum-

stances I would have been able to see my mother during these last ten years. The idea of this makes me profoundly angry …

241

SPANISH CIVIL WAR

To recover from the emotional blow Tina buried herself in work. Her tasks were myriad, among them her work with the International Brigades, whose base at Albacete she visited several times throughout the war. Red Aid, which for a time had an office in Albacete, also worked closely with the brigades' medical services, and Lincoln Brigade commander Milt Wolfe remembers the volunteers gave 'part of our salary to *Socorro Rojo* [Red Aid] every month, automatically, they took it out … ' The Communist Party was one of the beneficiaries of the funds collected for Red Aid, one brigade doctor reporting that the Party levied a 20 per cent commission on supplies Red Aid provided.

In February 1937, thousands of black-shirted Italian fascist troops advanced on the Mediterranean port of Málaga. Tina and Matilde went with Canadian doctor Norman Bethune's mobile blood-transfusion unit to help evacuate the refugees along the narrow coastal road to Almería. The long column of refugees was continually strafed and shelled by fascist aircraft and tanks and many people simply collapsed by the side of the road in exhaustion and despair. Bethune's unit concentrated on rescuing the women and children and bringing them to the head of the column: 'All along the highway, Tina was gathering up the children, the women. [It was] a terrible thing because they were also bombing Almería … she was extremely effective.' The experience made a lasting impression on Tina. 'I would never have believed I could be so strong and not lose my head in a situation of such collective madness,' she told Vidali.

In typically modest fashion, Tina later credited Matilde's contribution more than her own, praising her friend, at whose side she had been 'the entire time, in Almería and above all on the road from Málaga. She is an extraordinary woman, with an incredible capacity for work.' Indeed, the war had transformed both women into ' "lay nuns" … [who] were more concerned with others than themselves and found their greatest satisfaction in that. Their personal interests became totally secondary.'

During 1937, Tina became the virtual doyenne of International Red Aid in Spain. Usually dressed in dark, simple but elegant clothes, she received visitors in her office in Red Aid's headquarters near the Plaza Castelar in Valencia. Constance Kyle, an American social worker doing aid liaison work, remembers being received by Tina there: 'She looked lovely, very well-groomed, in a good-looking tweed suit, the light from the window behind her desk shining on her

dark hair.' Kyle, who 55 years later was still unaware that 'María' was in fact Tina Modotti, says that María was *the* Red Aid contact in channelling food aid destined for the Republicans: 'María was at the top, possibly [Red Aid] executive secretary. She was very efficient, very effective … a superb organizer. We had orders to co-operate with her anywhere in the Republic.'

The aid puzzle was confusing. Tens of thousands of dollars in cash, medical equipment, food and clothing were being collected abroad and sent to Spain by Republican sympathizers, especially Red Aid's US sister organization 'International Labor Defense'. Shipments were difficult to keep track of in war-time and foreign solidarity groups added to the confusion by indicating the aid was being sent through the 'Spanish Red Cross', their euphemism for Red Aid. It was Tina's responsibility to sort this out and see that the aid arrived safely and was distributed correctly. When the 'North American Committee to Aid Spanish Democracy' frantically queried Red Aid about shipments routed through Marseilles, it was Tina who replied as 'Carmen Ruíz' to dispel the confusion.

She also wrote articles for *Ayuda* under different names, 'Carmen Ruíz' being one of them. Some of these were straight reporting of events, such as solidarity visits by foreign delegations; others were to lay down the Party line, such as the article urging parents to comply with an unpopular measure and send their children to Mexico and the Soviet Union for their safety. One of the hundreds of thousands of children sent out of Spain was Matilde's seven-year-old daughter, Carmen, who went to the Soviet Union.

The Red Aid newspaper,
Ayuda, *in Madrid, 1937*

It was in Valencia that Tina met and began a lasting friendship with Constancia de la Mora, the tall aristocratic granddaughter of former Prime Minister Antonio Maura. Constancia had joined the Party after the outbreak of war and now headed the Foreign Ministry's

press censorship department. As it was her office which censored foreign journalists' articles or helped secure passes to visit the battle fronts, she became a familiar face to correspondents such as Herbert Matthews, Ernest Hemingway and Claud Cockburn, photographers Robert Capa and Gerta Taro and scores of others.

Tina met many of the same correspondents along with foreign intellectuals when she was Red Aid's liaison at the July 1937 international 'Congress for the Defence of Culture against Fascism' in Valencia and Madrid. Some of the 'sympathetic' photographers must have known Tina's real identity, for it was David 'Chim' Seymour, Capa and Taro, the courageous young German photographer killed shortly afterwards, who tried to convince her to return to photography. While some snapshots reportedly taken by Tina in Spain do exist, the overwhelming body of evidence supports Vidali's account of her response: ' "No," María answered, "you can't do two jobs at the same time." '

Although her precise role has never been clear, during the congress Tina worked from the Red Aid and *Ayuda* offices, where she met several Mexican friends and delegates. In addition to her official role, according to Matilde Landa's niece, Luisa Viqueira, '*Se enteró e informaba*' (She found out and she informed). To this end, Tina and Vittorio were a good team, with 'Carlos' the perfect foil for 'María'. While the usually silent Tina seemed shy, Luisa says, 'She wasn't really, it was only a pose.' The gregarious Vidali served 'as a screen

Red Aid Congress in Valencia, 1937 (Tina in upper right-hand corner, 'Commandante Carlos' addressing delegates)

for her'. In fact, it is possible that theirs was now indeed a purely political partnership. With regard to Vidali's more sinister activities, it is not clear whether, as a disciplined Party member, she simply tolerated them, covered them up or kept quiet about them out of fear.

Nobel prize-winner Octavio Paz, then 23 years old, and his 17-year-old wife, writer Elena Garro, attended the 1937 congress in Valencia. While there they frequented a café where they made the acquaintance of a woman linked to efforts to form an enquiry into the disappearance of Andrés Nin. Vidali was suspected of having participated in the torture-disappearance of this Catalán leader, whose pro-Trotsky 'Marxist United Workers' Party', or POUM, was targeted for reprisals because it would not submit to Communist dictates in the conduct of the war. According to Paz, a man identifying himself as an agent of the secret police came to their table one day and asked Elena Garro

> to accompany him to the International Red Aid offices. There, Elena met Tina Modotti ... 'We know that you and your husband are frequenting company which could turn out to be very dangerous,' she said ... advising her that if we continued seeing those sorts of people, the consequences could be very serious for us.

But Elena Garro herself contradicts Paz's version. She describes Tina as being a powerful figure during the Spanish Civil War, but says that when Angélica Arenal, the second wife of muralist David Alfaro Siqueiros, then in Spain as a volunteer, repeatedly told Elena that Tina wanted her to go to see her, she refused, insisting 'I have nothing to say to her.'

In October, when the Republican government was transferred to Barcelona, the Red Aid headquarters went too. From the New Year onwards, Barcelona was subjected to wave after wave of aerial bombardment. The port was virtually defenceless, with just one anti-aircraft gun everyone called *El Abuelo* (Grandpa). After Franco's troops reached the Mediterranean coast in April, despite feeling ill and tired, Tina left Barcelona on a dangerous mission. She went by night in a small launch through enemy-controlled waters to Valencia, now completely cut off from Barcelona by land, to see for herself how Red Aid might alleviate the desperate plight of the refugees there. The war and the disastrous Republican military situation was taking its toll on Tina's health and spirits. A 1938 publication of the French section of Red Aid paid homage to 'María', making a reference to her 'ailing heart', while Enrique Castro Delgado, a leading Republican commander, noted that she had become 'thinner and

sadder than ever with her gaze lost on some unknown horizon'.

In July 1938, the Republicans built a spectacular bridge of boats to cross the Ebro river in a daring, last-gasp offensive that bogged down into eventual defeat. Following a treaty calling for all foreign troops to leave Spain, Tina was in Barcelona on 8 October, when *La Pasionaria* bid farewell to thousands of International Brigade members. The occasion was heart-rending, but Tina put on a brave face, appearing on the dignitaries' platform and toasting the departing volunteers at a reception afterwards. She saved her tears for later, when she told Vidali that:

> It's not right that it should end this way. We fought for nearly three years. I saw combatants from all the battles file past with their units, mutilated and wounded, with bouquets of flowers. But there was no happiness, only sadness on their faces and tears in their eyes ...

As the Republican forces retreated along the Ebro in early November, Red Aid called a national conference in Madrid. On the last day, during heavy aerial bombardment, a shell fell on the Red Aid offices, killing and wounding some of Tina's closest colleagues, including Vidali himself, who lost part of his right thumb and shoulder. Matilde Landa was unhurt and directed the rescue efforts under the continuous shelling. Tina was not in the building at the time, but Vidali said that when he awoke the following day 'in a hospital overflowing with the wounded, I saw Tina asleep with her head on my bed. She had run around all night through the chaos of a devastated Madrid until she found me.'

In early December Tina, accompanied by Matilde, the bandaged Vidali and other wounded colleagues, went back to Barcelona, where she and Matilde were to continue Red Aid work. The journey entailed a harrowing flight from Albacete to Barcelona, over enemy territory heavily patrolled by Italian fighter planes:

> ... a half hour after takeoff, we had to return to the base because the radio wasn't working. Then, during the flight the enemy Fiats chased us and we finally landed outside Barcelona in the middle of a fierce bombardment ... in a flooded field without any indicators. During the entire flight Tina was very calm and the crew praised her behavior ...

Franco sensed victory after the Ebro and on 23 December launched 350,000 troops against Catalonia. The poorly armed and outnumbered Republicans could not hold their lines, refugees poured into Barcelona, which was bombed day and night, and panic gripped the civilian population. In early January, when the government ordered

most employees to evacuate and retreat to the town of Figueras, Tina began mysteriously shuttling back and forth to the French frontier, probably escorting leading Republicans to safety. A friend remembered her appearing in a government office, asking for a lift on a truck ferrying the employees northward: 'She came along for a short stretch and then I lost sight of her … she just disappeared.' On 21 January, Tina's 'Carmen Ruíz Sánchez' Spanish passport was renewed for travel abroad, while Vidali sought Mexican visas for them both from the consulate in Barcelona.

Two days later, with Franco's troops in the suburbs, the government re-located to Figueras and Tina said goodbye to Matilde Landa, who insisted on going back to Madrid to fight on. When the city finally fell, Matilde was arrested, tortured and given a death sentence, later commuted to life imprisonment. After three-and-a-half years confinement in a Catholic convent in Mallorca, on the day she was to be forcibly baptized, the fiercely anti-clerical Matilde either threw herself or fell to her death from the convent roof.

The exodus towards the frontier was hellish and chaotic, with tens of thousands of dejected soldiers and civilians trudging north on a road clogged with trucks, cars and donkeys, amid strafing and bombing by fascist planes. On 25 January, the day Barcelona fell, Tina was on the French side of the border, where she asked Constance Kyle to 'take care of a little errand' for her: '"Carlos" was behind lines and I had to take his passport and typewriter to him … I don't know how, but she knew exactly where he would be standing!'

Three days later, Tina crossed back into Spain and went beyond Figueras to Gerona, where she evacuated the elderly founder of the Spanish Communist Party, Isidoro Acevedo. On 3 February, she secured a French visa from the consulate in Figueras. Gerona fell the following day and aerial attacks on Figueras intensified, with Tina only 'escaping by a miracle' when a bomb destroyed the makeshift Red Aid headquarters. As the enemy advanced on Figueras, Fernando Gamboa, an old friend working with the Mexican embassy, caught sight of her in a deserted village outside the town:

> I told the driver to stop and drive back. The plaza was completely empty, it was totally abandoned. It was about midday … We stopped in front of her and I said, 'What are you doing here, Tinita? What's wrong, why are you here?' … She said, 'I can't leave because I'm waiting for Carlos to arrive with the army and I must leave with him.' … I even joked with her, 'Hey, what do you think you are, a Mexican *soldadera*? Come on, let's go!' 'No, no, no. I'll wait.' 'All on your own?' 'Don't you worry, you know I can handle whatever comes my way …'

Figueras fell on 8 February and the next day Tina joined the wave 247 of refugees crossing the Pyrenees into France. She descended the long grade out of the mountains toward the border 'with no more than the clothes on her back'. At the border she met up with Vittorio. When she saw him, Tina greeted him with the last lines of a poem by her favourite Spanish poet, Antonio Machado:

> And when the day of the final journey arrives,
> and the ship of no return readies to depart,
> you will find me aboard with my baggage light.

Vidali looked at her with surprise and said, 'But Tina, this is not the final journey; this is a only battle lost and in our future there will be many journeys with victory in the end.' Tina simply looked at him and smiled.

20

Without a Country

Tina sailed into New York harbour aboard the HMS *Queen Mary* on 6 April 1939. It was her first visit since she had arrived in the United States nearly 26 years earlier as a young Italian immigrant. She was now 'Carmen Ruíz Sánchez', a widowed Spanish professor, expecting to be met by 'Carlos Contreras', a history teacher, who had arrived three weeks earlier. Although Vittorio had disembarked safely in New York, despite his conspicuous identity as 'Carlos Contreras', he was not waiting to meet Tina on the dock. In his stead was a petite, elegant woman, wearing a stylish hat.

Yolanda Modotti had moved from Los Angeles to New York, where she had gone from being a keen amateur photographer to opening her own small photographic studio on Staten Island. Her estranged second husband, Peter Magrini, had also fought in Spain and, with Tina's knowledge and recommendation, Yolanda herself had tried to go as an ambulance driver, but had her request turned down by Earl Browder, head of the US Communist Party. Yolanda was delighted when Vidali, in order to avoid FBI surveillance, 'assigned' her to meet Tina. Since the fall of Madrid in 1939, however, US immigration officials had apparently become more reluctant to admit Spanish refugees and refused to recognize Tina's transit visa, insisting she continue onward to Mexico. Unaware of the situation, Yolanda waited anxiously:

> I had not seen Tina for thirteen years and there were hundreds of people coming down, slowly, you know how people do when they get off a ship. It must have been five or six hours that I stood there waiting for her and at one point the captain shouted … 'All Aboard' and you should have heard me yelling. I screamed, 'My sister has not come down!' And as I said this I ran up [the gangplank] and they came to push me back and I fought with them … I couldn't [get] to see her. To think that she was there a few feet from me, after thirteen years and they wouldn't let me even touch her!

For Tina it was also a harsh blow; an increasing number of countries were closing their borders to her. She had crossed the French border near Perpignan with thousands of other refugees only to be received with hostility by a government anxious to avoid antagonizing Nazi Germany. A telegram from Moscow had ordered her and Vidali to Paris to work on the relocation of exiles. The unofficial exile rendezvous became the Café Neapolitan on the rue des Italiens, where refugees tried frantically to arrange their futures. Thousands more refugees were in Coullière, where Tina went to visit the frail and ailing poet, Antonio Machado, shortly before his sudden death from pneumonia. Stunned and angered by the treatment of the refugees, Tina asked Italian Communist leaders to allow her to return clandestinely to Italy as an anti-fascist fighter. When they refused, she and Vittorio decided to take Yelena Stassova's advice and not return to Moscow, where foreign Communists had become the target of Stalin's latest purges. They opted instead for the United States and Mexico to work with Spanish exiles.

While awaiting her departure, for security reasons Tina moved to Melun-sur-Seine, a village on the outskirts of Paris, where she stayed at the home of a distinguished French professor, a friend of the Joliot-Curie family of renowned doctors and scientists. Carmen Tagüeña, the wife of Manuel Tagüeña Lacorte, a leading commander in the Battle of the Ebro, recalls Tina introducing her to the Joliot-Curies when they came to visit her. Carmen saw Tina every day when she and Manuel lived in this village prior to their departure for Moscow. She remembers a 'cordial and warmhearted' Tina, who was 'very concerned about our well-being'.

When Tina was refused permission to disembark in New York, she was transferred to a ship bound for Veracruz. Having been deported from Mexico amid such publicity, she was terrified that she would be recognized upon arrival and her real identity revealed. Vidali had already arrived in Mexico and made contact with the recently formed 'Committee to Aid Spanish Refugees', arranging for Tina to be met at Veracruz and brought to Mexico City. Within a few days, they had moved to San Angel, on the outskirts of Mexico City, where they were the guests of Martín Díaz de Cossío, a 58-year-old wealthy former diplomat of Spanish descent, his 26-year-old Mexican wife, Isabel Carbajal, and their two sons.

Mexico City had grown considerably since Tina had lived there in the 1920s and was overrun with American-style 'quick lunch' counters, soda fountains, Fords and Chevrolets. The Communist Party, although legal again, was a shell of its former self, while Stalin's

favourite son was an opportunistic government político and trade union leader, Vicente Lombardo Toledano. The rise of European fascism had fuelled Mexico's own *Sinarquista* movement, which was some 500,000 strong. Enormous Nazi flags hung from some buildings on Madero Street and it was not unusual to find swastika buttons being sold by street vendors or to hear German songs sung in local bars. As World War II approached, Mexico City was increasingly a centre of intrigue and espionage for Nazi and Soviet agents. The latter were so numerous they were soon dubbed Mexico's 'Little Comintern'.

While Tina and Vittorio were staying in San Angel, one of the visitors was Adelina Zendejas. Adelina had known Tina by sight when she was previously in Mexico, but on this occasion, although she thought there was something familiar about this attractive, well-dressed woman, she did not recognize her. When Tina and Vittorio had left the room, Isabel Carbajal turned to Adelina and asked her, ' "Didn't Carmen remind you of anyone?" I said, "No, not really" … "It's someone that you knew. Don't tell anyone, but it is Tina Modotti." '

On May Day 1939, Tina marched in the annual workers' parade along with a large contingent of Spanish Republicans, fists raised in salute to Mexico's progressive President, General Lázaro Cárdenas. Later that day, at a party in the lovely gardens of the home of a mutual acquaintance, she met her old friend Alfons Goldschmidt, back in Mexico as a refugee from Nazism. Goldschmidt's second wife, Leni Kroul, meeting Tina for the first time, remembers she was struck at how serene she appeared compared to the energetic and boisterous Vidali.

Many of Tina's old friendships were now 'off limits' to her, for both ideological and security reasons. Since she was in the country illegally, she could not afford to make her presence widely known. Within the Spanish Communist refugee milieu she felt safe enough circulating as 'María' or 'Carmen', but she avoided her old friends who were not sympathetic to the Communist cause. When she saw Felipe Teixidor in the street one day, she looked the other way, and a visit to Monna Alfau, now his wife, would have been uncomfortable. One of Monna's brothers had been in the Spanish military at the time of the 1936 uprising and was a Franco supporter who had been executed by the Anarchists.

Diego and Frida, with whom Tina had broken in late 1929, were much loathed by the Communists for having welcomed and sheltered the exiled Trotsky in Mexico since 1937. Other friends had

gone over to Trotsky's cause, including Anita Brenner, who had been instrumental in getting Trotsky asylum in Mexico. Tina did go to see her old friend Frances Toor, but Vidali claims the two women quarrelled because Paca chastised her for getting 'mixed up with the Spaniards'. Others say they did not get on because Paca believed that the Communists had ruined Tina's life. The latter seems more likely, since Paca was more than simply averse to the Party. She fraternized with two virulent anti-Communists, the exiled French Socialist Marceau Pivert and Spanish POUM leader Julián Gorkin, and some Mexican Communists considered her to be a Trotskyist.

Within a few weeks of their arrival, Tina and Vidali had to move from San Angel and went to stay with Adelina Zendejas on Morelos Street, just around the corner from where Julio Antonio had been assassinated in 1929. Tina commented to Adelina that she knew the neighbourhood very well and that it pained her to have returned to it. The illusion that she might 'run into Mella' was the only compensating factor.

Shortly after moving into Adelina's, Tina travelled to New York on an American friend's passport. While the precise nature of the trip is unclear, there is little evidence to support the theory that she returned to Europe at this time. Vidali says the trip was to investigate the possibility of their returning together to America, but given the 'top-level commuting between Mexico City and New York' by Comintern agents, it is not inconceivable that Tina was on a confidential mission.

In New York, she met with friends and Party colleagues and was finally reunited with her sister, Yolanda. She also managed to spend some time with her brother Benvenuto, whom she had not seen since 1929. While there, she and Constancia de la Mora, her friend from Spain, stayed at the home of Martha Dodd, the wealthy socialite later accused of being a Soviet spy. Constancia's aristocratic background and role in the Spanish civil war had opened doors for her in the United States. She met with Eleanor Roosevelt several times and became the darling of New York progressives. Her life story and version of events in Spain, *In Place of Splendor*, apparently ghost-written by the popular American writer Ruth McKenney, was destined to become a best-seller. Constancia had previously circulated the manuscript among friends and a Cuban Spanish war refugee who worked with Red Aid in Madrid, Manuel Fernández Colino, remembers that one day she asked him if he had time

to help Tina Modotti on a job ... I accepted enthusiastically, because I had been eager for some time to meet Mella's companion. Can you

imagine my surprise to find out that she was none other than our 'María' from Red Aid?

Constancia's book was an important platform for the Republican cause and although it seems odd that a book ghost-written by such an experienced writer needed so much work, Tina and Fernández Colino apparently spent several weeks correcting the manuscript. Fernández Colino says he never saw Tina happy, 'but then, those weren't happy times'. Constance Kyle, who also saw Tina in New York, insists that reports that Tina was emotionally crushed after the war are exaggerated: 'That depressed stuff [about Tina] is nonsense – none of us were happy about the war, obviously ... but we weren't sitting around weeping.' Tina does, however, seem to have been despondent about returning to Mexico. She wanted to stay in the United States and tried in vain to get the necessary permission from the government. Years later, Benvenuto recalled their parting in New York:

> One night – I'll never forget it – she bid farewell with 'Goodbye'. 'Why do you say "Goodbye",' I asked her, 'instead of "See you later"?' And she replied: *'It's impossible. I'm already dead. I can't live down there, in Mexico.'*

Meanwhile, back in Mexico on the night of 23 August, Vidali was awoken by Adelina Zendejas with the news of the infamous Nazi–Soviet non-aggression pact. He leapt out of bed and paced up and down for hours, saying, 'How are we going to explain this?' When Tina arrived back from New York the next day she hit the roof at the news. Although her political adhesion to Stalin and the Party was very strong, anti-fascism was at the core of her political identity. While Vidali rationalized the agreement, saying the Soviet Union had no choice, Tina totally rejected it: 'That's all fine. But ... me, with Hitler, never!'

To avoid legal problems with the Mexican government, she chose not to renew her membership in the Mexican Communist Party, acting instead as liaison between the thousands of Spanish exiles and the Party's representative, Miguel Angel Velasco, who recalled, 'She never stopped being active, but her principal task was with Red Aid.' She contracted immigration lawyers, solicited funds, obtained clothing, food and cigarettes for the exiles, and for those most distraught her 'presence was soothing, [helping] people come to terms with what had happened'.

In an attempt to get her 1930 deportation decree annulled, Tina relied on crucial help from two important Mexican officials: former

Ambassador to Spain, Adalberto Tejeda, and Interior Minister Ignacio García Téllez, who had sponsored her 1929 exhibition. A good word from Tejeda and her letter to García Téllez secured an interview with the Interior Minister himself. Adelina remembers that Tina put on her best face for the occasion: 'She didn't want them to see her down on her luck so I lent her a hat and gloves, small details that immediately made her look like a real lady ... I remember her radiant face as she left; it seemed as if she had been reborn.' Tina's efforts resulted in President Cárdenas sending her 'a beautiful letter' saying her expulsion was completely annulled and that she would be fully protected by the Mexican authorities. This meant she need no longer be concerned about government reprisals, but there still remained the danger of the scandal-mongering Mexican press.

In January 1940, Tina and Vittorio moved out of Adelina's home into a small flat of 'absolutely Franciscan modesty' on Pedro Barranda Street, in a working-class neighbourhood near the copper-domed Monument to the Revolution. Tina furnished it with 'inexpensive furniture, found in Mexican markets, chosen carefully with a fine aesthetic sense' and there was always 'a little bunch of marigolds, or fresh, simple Mexican flowers, in a little terracotta vase on the table'.

In mid-February, the 'Pan-American Conference for Aid to Spanish Refugees' was held in the *Frontón de México* building, just a few paces from Tina's new home. Prominent Spanish Republicans, American Quaker relief workers and International Brigade members participated in the event. Also attending was Sarah Pascual, a former girlfriend of Mella's, who recalls Tina working as an interpreter at the congress under the name of 'María'. Few who knew her, however, could believe her role was so simple. Luisa Viqueira thinks the interpreter position was a cover, designed to allow her maximum freedom of movement so that she could 'report what was going on' to Party superiors.

The ideological infighting that had plagued the Spanish Republic continued among the refugees. Apart from the occasional assassination, there were frequent and vicious press attacks by the Trotskyists and anarchists against the Communists, and vice versa. Diego Rivera identified Vidali in a newspaper article as one of 'hundreds' of Stalinist agents who had infiltrated Mexico as Spanish refugees. Another of Tina's former friends, Bertram Wolfe, told a friend investigating these agents that 'as to the dry cleaning establishment, Sormenti [Vidali] and Tina are known to us'. Consequently, Tina and Vittorio's real identity became known to their enemies.

The FBI and US Naval Intelligence believed Vidali was involved in a Nazi–Soviet spy ring and a former Spanish Communist general,

Valentín González ('*El Campesino*'), then in Moscow, claims that in August 1939 he sent Vidali a squad of three agents led by Pedro Martínez Cartón, a former colonel in the Republican army, whom he described as a 'cold and unscrupulous man, fanatical and instinctually cruel'. According to González, Martínez Cartón brought Vidali a list of political opponents targeted for assassination, among them Leon Trotsky.

Both Tina and Vidali were close friends of Martínez Cartón and his German wife, 'Carmen Salot', the pseudonym of the International Communist Youth representative in Spain, whose true identity was known only to leading Communists. Tina used Carmen's name and address to receive her mail and in a letter written in April 1940 to Leni Kroul, then living in the United States, she relates that

> Here there is nothing very exciting to tell about. Carmen's baby is getting along splendidly; more babies have been born in the meantime from friends of our big family. Let us hope they will all be future A[lfons] G[oldschmidts]. We need them!

The same letter contains certain veiled references which point to Tina being involved in some kind of undercover work:

> Concerning the novel in which I was interested, I thank you very much concerning your interest, but that edition is really too old to interest me and besides there are all the other details you mention. So let us just drop this idea and maybe I will have a chance later on to pick up a later edition.

Leni believes this reference to a 'novel' was probably in response to some information Tina had asked her for.

The presence of Trotsky in Mexico was a thorn in Stalin's side and an embarrassment to Mexican Communists. Siqueiros, who had renewed his friendship with Tina and Vidali in Spain, recalled later that the plot to murder Trotsky all 'began in Spain'. After Cárdenas granted political asylum to Trotsky, Siqueiros and Vidali attended a Spanish Communist Party meeting at which *La Pasionaria* delivered a virtual slap in the face to Mexicans over the Trotsky affair. Their revolutionary manhood challenged, the hot-headed Siqueiros said he and other members of the Francisco Javier Mina society of ex-combatants in Spain, of which Vidali was a prominent member, 'considered ourselves obliged to carry out our assault and storm the so-called Trotsky fortress in Coyoacán'.

Following a dispute with Diego Rivera, Trotsky had moved out of Frida Kahlo's 'blue house' in Coyoacán into another nearby. On the

night of 24 May 1940, Siqueiros gathered with a group of about 20 Communists and artists at the studios of the Popular Graphics Workshop. He reportedly donned the Hussar uniform he had worn in Spain, complete with flowing cape and phoney whiskers, while his accomplices changed into stolen police uniforms. They managed to sneak into the grounds of Trotsky's home in the dead of night and wildly fired machine-guns through the bedroom windows. Trotsky and his wife, Natalia, dived from their bed to the floor and were miraculously unhurt as the bullets flew overhead. There were victims, however. Trotsky's 11-year-old grandson, Stefan, was badly traumatized and wounded in the foot, and his secretary, Robert Sheldon Harte, was kidnapped by the attackers and later found dead.

While there is no evidence to link Tina to the attack, it is possible that she knew about it beforehand. The flamboyant nature of the assault would certainly have appealed to Vidali's style of action, although when Mexican police later interrogated him about his participation they could not find sufficient evidence to press charges. Nevertheless, the rabidly anti-Stalinist, former Spanish Communist leader Jesús Hernández later accused him of having instigated and handled a Thompson machine-gun in the assault. Hernández claimed to have been in Moscow after news arrived of Vidali's involvement and quoted Comintern chief Palmiro Togliatti as having shouted angrily: 'He was ordered to have nothing to do with it!'

A Time of Turmoil

Pine covered ridges sloped down to the water's edge at Lake Pátzcuaro, where Tarascan Indian fisherman from the island of Janitzio criss-crossed the surface with their enormous butterfly nets. In the summer of 1940, Tina had momentarily left the young American photographer she was travelling with near a group of such fishermen. Approaching them cautiously, with signs and gestures he had asked their permission to photograph them and, since they seemed in agreement, he set up his cameras and began clicking away.

Hardly had he begun, when a young man approached, gesticulating and shouting furiously. It was a predicament the photographer had not anticipated: his Spanish was almost nonexistent, he was in a strange place, a foreigner in a frightening situation. At that moment, Tina reappeared and immediately recognized the gravity of his plight: 'Back out and get into the car, I'll talk to him,' she told him firmly. Then, keeping the young man talking, she slowly backed towards the old Chevrolet, jerked the door open and jumped in as the car sped away.

Amid nervous laughter, she explained the local people's sensitivity to cameras. She had seen this hostility before, 14 years earlier on the shores of this same lake, during the *Idols Behind Altars* expedition with Edward Weston, when his camera nearly ended up in the lake. The memory of that incident prompted her to drop her assumed identity and reveal to her companions that she was not simply 'María', the Spanish Civil War refugee, as they believed, but really Tina Modotti, a photographer herself.

The American photographer was John Condax, and he and his wife, Laura, were in Mexico at the invitation of Constancia de la Mora. She had asked Condax to take photographs for her current book project, documenting President Cárdenas' 'revolution' in

health, education and land reform. In the spring of 1940, the Condaxes drove from New York to Mexico City, where they stayed at Constancia's home on Veracruz Avenue, in a block of flats which was at the hub of the Spanish exile community. It was there that the Condaxes met 'María', whom Constancia had asked to accompany them on their journey throughout Mexico. After arranging to use the darkroom of Robert Capa, in Mexico on assignment for *Time* and *Life* magazines, they left on the first of their forays into the Mexican countryside.

While Tina's role was ostensibly to arrange accommodation, to interpret and to make the necessary contacts, she went beyond that and provided ideas of where and what to photograph, frequently discussing the project's photographic elements with Condax. From June until September, they travelled the length and breadth of Mexico in the Condax's dilapidated Chevy. In northern Mexico, they stayed on a communal *ejido* farm to document Cárdenas's land reform efforts and then visited union offices in Torreon. In central Mexico's *bajio* region Tina and John Condax descended the shaft of a silver mine and the final days of the expedition found them in Veracruz, marvelling at the colourful spectacle of the flying pole dancers of Papantla.

Perhaps it was the similarity between this trip and her 1926 odyssey with Weston which brought out the Tina of bygone days. She was lively and outgoing, in good humour and good health. Pleased as she was to be participating in the project, she was still anxious that her true identity be concealed from others and pleaded with Condax not to take any photographs of her. Her aversion to the camera was by no means total, however, and she was particularly interested in the technical modifications Condax had made to his Graflex. When she had first told him who she was, he had offered her the use of any of

Facsimile of Constancia de la Mora book with John Condax photographs, 1940

his cameras – which included the Graflex, a large-format view camera and a couple of Leicas – but Tina had declined. 'No,' she said, 'I'm not doing any more photography.'

Manuel Alvarez Bravo, who had not heard from Tina since 1931, recalls a similar incident:

> I didn't know she had returned. One day the bell rang at my small studio on Ayuntamiento Street and I went to answer it and there was Tina. And so, she came in, she was just like she had always been, very calm … I offered her a Graflex camera that she admired. And she said, 'No, not any more … '

Manuel believes it was an 'act of will' on Tina's part and says that despite her firm 'No' there was a look of sadness on her face.

On 20 August, while Tina was still working on the photographic assignment with the Condaxes, Trotsky was assassinated. He was killed by Ramón Mercader, a Spanish Communist from Catalonia who had befriended Trotsky's personal secretary and passed undetected by virtually everyone, including Robert Capa, whose room in the small and pleasant Hotel Montejo was just across the hall from Mercader's. The Trotsky murder was a terrible embarrassment for the Mexican government and resulted in a crackdown on Communists. Vidali again came under suspicion and the Mexican press, fuelled by the accusations of Spanish-exile Trotskyists and anarchists, repeatedly linked him to the crime.

By autumn, Tina had moved house again, this time to a tiny roof-top place she had discovered at 137 Dr Balmis Street, in front of the General Hospital. Vidali chided that it was barely big enough for 'Snow White and one dwarf': a cramped bedroom and a dining-room with space for a breakfast table and two chairs, a toilet and shower that flooded the floor were all squeezed into a small alcove and the kitchen was standing-room only. Friends were aghast, but Tina made the best of it; the rent was a bargain at 50 pesos, and she was enchanted by the views of the snow-capped volcanoes and the solitude of the *azotea*, where she often sat reading and relaxing or sunbathing. She potted geraniums in empty tins and hung them on the whitewashed walls, and adopted a little white dog she called 'Suzi' and a cat she dubbed 'Kitty'. She and Vittorio were so poor that friends who came to eat often brought food with them, or else ate her simple meals of pasta, minestrone or the *polenta* of her youth.

Although she continued with her Red Aid work, Tina left the house less and less, confining herself to tasks like writing and translating. She had become very involved with the 'Giuseppe Garibaldi

Anti-Fascist Alliance', and the mimeograph machine with which they produced bulletins and leaflets could be heard humming away in her tiny bedroom late into the night. She still went on occasional Sunday outings with good friends, all political exiles, like former Republican General Patricio Azcárate and his wife, Cruz Díz, with whom she was especially close; or the exiled Italian Communist Mario Montagnana and his wife, Anna Maria, sister of Comintern leader Palmiro Togliatti; or former Bauhaus director Hannes Meyer and his wife Lena.

On a special outing in honour of a friend of Yolanda, visiting from New York, Tina invited Eladia de los Ríos, a young Spanish refugee woman she had come to treat as a daughter. Yolanda's friend had brought her camera and Tina wanted to photograph the pregnant Eladia:

> So, I arrive with my big belly because I'm three or four months pregnant … and as we went out the door Tina took a lady's Mexican straw hat, really pretty, from the hook where it was hanging and said to me, 'I want to take photos of you with this hat on.'

Once they arrived at their destination,

> María began taking photos of me, but they were like [proper] studies. 'Put yourself up against the trunk of that tree, move over here, over there'; she took lots and I was a little embarrassed and Carlos said to me at one point, 'Did you know that María was a great photographer?' 'María?' 'Yes,' Carlos said. María acted as though she hadn't heard, and just smiled slightly.

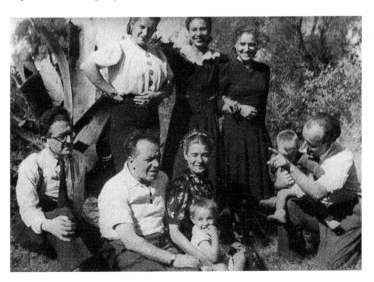

Tina and Vittorio with friends, Mexico, c.1940

But carefree days like these were becoming a rarity. The spring of 1941 brought a distinct physical and mental deterioration in Tina's health. In March, Vidali was picked up by the Mexican police and, after being interrogated, was bundled away to the much feared detention centre known as *El Pocito* [The Little Well]. He spent three weeks there, in solitary confinement in a filthy, rat-infested cell, while Isabel Carbajal, who was becoming increasingly close to him, scurried about under Party orders trying to locate his where-abouts. Tina was so frightened by the news that she could not stop trembling when Isabel told her. She stayed home alone and, convinced the police were watching the house, destroyed all incriminating documents, even the prints and negatives of her photographs of Eladia. She did not want to compromise the young woman by having the police link her to herself and Vidali. As the days went by and Vidali did not reappear, Tina became even more panicked. When he was eventually released, Vittorio returned home to find her

> thin, depressed, with her eyes swollen and red. She told me that after my arrest she had not gone out, truly believing they had assassinated me. The comrades who were close to her told me that they were afraid she was going to become seriously ill.

In the eyes of those who knew him, Vidali was variously seen as 'a buffalo, a bull', a thick-set, overweight man who was at the same time 'sinister, capable of anything' as well as 'a steamrolling personality ... of great brilliance, a man of action' and 'a womanizer'. Some saw him as 'a kind of protector' of Tina, from whom or what is not clear. Vidali himself said that even before going to Spain they had become a purely political couple. But, when describing their sexual life, he claimed they still had 'a generous, complete love, full of fantasy'. The fantasy was probably all his, for as Leni Kroul points out, the sadness many have attributed to Tina in these years came from feeling herself 'a kind of martyr' at being 'forced to stay married' to him. Apparently, Tina also said as much in Spain to Republican General Valentín González. Referring to Vidali, Tina reportedly told him: 'I hate him with all my soul and I have to follow him till death.'

Isabel Carbajal remembers that despite Tina's new legal status she was 'terrified of people finding out who she was ... Primarily she was afraid of involving Vidali or attaching any scandal to his name.' Tina may have had good reason to be afraid of provoking Vidali's disap-proval or wrath. There had been loud quarrels during which he had shown his contempt for her former sexually liberated lifestyle. In a fit of anger he once told her that her friends in Mexico considered her

little more than a high-class whore. Paradoxically, he also once 'described her as a fanatic, too hard and rigid for an open and happy-go-lucky man, a lover of good wine and repasts among friends', as he was. It may be coincidental, but there seems to be no doubt that following a decade of rigid Party discipline and life with Vidali, Tina had become 'ashamed of her past history'.

A serious charge against Vidali consisted of the long-circulating rumours in Mexico that linked him to Mella's murder. In the early 1930s, Cuban *émigrés* in Mexico working in Red Aid were murmuring about that possibility, which had also occurred to several of Tina's former American friends in Mexico. Later, versions that Tina was unwittingly involved in the murder by Vidali were circulated. While Vidali's possible role warrants further investigation, especially in the light of new material on the responsibility of Stalin and his emissaries in the killing of 'troublesome' foreign Communists, there is as yet no firm evidence that Tina was aware of these rumours or believed Vidali was involved.

But there is little doubt that coinciding with the time of his arrest, she did slump into a depression that lasted several months. Tina's health was no longer good; the heart problem and the inflammation of her legs that had bothered her in Spain had worsened due to Mexico City's high altitude. Visitors sometimes found her lying down resting in the middle of the day and the 36 steps she had to climb to her rooftop home also did not help. Eladia remembers her 'climbing [the stairs] from the street, falling onto the sofa to take off her shoes'. She was being seen by a doctor, Enrique Rebolledo Cobos, a mutual friend who, Vidali says, assured him her condition was not serious. Indeed, Vidali seems to have convinced himself there was nothing wrong with Tina, claiming that he 'never saw her ill, with the exception of a few colds'. Friends, however, describe a marked physical change in Tina around this time. Many remember her as being tired, thin and pale. Fernando Gamboa remembered that she seemed to have suddenly aged and her skin had become grey and mottled. She now seldom left the house at all, working at home on her old typewriter on translations for the Party or typing Vidali's weekly columns for Lombardo Toledano's newspaper, *El Popular*. Velasco thought that it was

> perhaps because of her illness [that] I sensed a certain change in her. It wasn't that she had always been a very exuberant woman, she was always somewhat retiring, but that became accentuated ... The last time I saw her she was seated on a chair on the *azotea*. She would be quiet for long periods, she spoke less and less ...

It might be presumed that a source of Tina's depression was Vidali's womanizing but when it became clear that he was spending more time with Isabel Carbajal, who had since separated from her husband, it didn't seem to bother Tina. Some mutual friends were upset and chose sides, quietly dividing into 'Tina's gang and Isabel's gang'. But the two women apparently did not feel that way and remained friends, with Isabel welcome in Tina's home to the extent that she not only arrived for meals, but sometimes even cooked for Vidali there.

Tina's depression seems to have lasted throughout the summer but it appears to have lifted in the final months of 1941, when she began to visit friends and to go out more. She knew of Matilde Landa's imprisonment and went frequently to visit her sister, Jacinta, who was living nearby. Matilde's daughter, Carmen, who had left the Soviet Union and come to Mexico to see her aunt, remembers going to visit Tina, who was thrilled to see her and even made her a pretty Tyrolean dress. Pablo O'Higgins was a frequent visitor, much to Vidali's chagrin, since he suspected the painter of being enamoured of Tina.

Interestingly, she began to expand her circle of friends beyond the small group of exiles and Communists to include some of her friends from the old days. Tensions between her and Xavier Guerrero had abated and while he was away in Chile she became close to his Cuban wife, the designer Clara Porset. She also renewed her contact with José Clemente Orozco, who had been one of her last clients for photographic reproduction work.

That Tina might have been seeking photographic work seems to be borne out by Mary Doherty. While trying to make time to see Tina, Mary said she did

> get Xavier to promise to ask [Miguel] Covarrubias and Rose [Covarrubias] who have had so much and on top of that are still being rewarded Guggenheim fellowships and investing the money in shops in Taxco, etc., to help Tina purchase or to loan her a camera. She had said she'd like to work but that she had no equipment. What X[avier] did finally, if anything, I don't know.

Her renewal of her friendship with her old friend and client Fred Davis was also apparently an attempt to find work, because Mary remembers Fred telling her that on several occasions, including once during late December, Tina went to eat with him and had asked 'for suggestions and a recommendation from him for a job'. According to Fred Davis, who didn't realize how impoverished Tina had become, she 'looked well and was always in good spirits'.

As 1942 approached, even political developments looked more promising. The Nazi–Soviet collaboration was a thing of the past and the United States had just entered World War II. It was a ray of hope for the beleaguered Soviet Union and its supporters, and Tina felt optimistic about the imminent defeat of fascism. On New Year's Eve, she and Vidali attended a party at the home of Chilean poet Pablo Neruda, who had been named Chilean consul in Mexico the year before. Invitations to his frequent parties, with good food and wine and lively political discussion, were much sought after. That night he had invited about 100 guests, many of them political exiles, whose animated conversation was largely about the impending end of the war.

Tina was livelier than usual, spending much of the night chatting with Anna Maria Montagnana. Saying goodbye to Neruda and his wife, Dehlia, she and Vidali left the party in the company of some of the other guests, among them the French writer Simone Tery. Together they walked along the elegant Paseo de la Reforma to see the sun come up on the New Year in historic Chapultepec park. Simone recalled that Tina's first act of 1942 was completely in character. She

> saw an old Mexican lying on the ground in a doorway. People passed him by indifferently, thinking he was drunk. But [Tina] went over to him: 'Why don't you go on home?' she asked him. 'Your family will be worried … '
>
> 'I can't,' answered the man. 'I'm too weak.'
>
> Although she had not slept all night she rushed around to find a hospital that would admit him … She would not go [home] to sleep until she managed to get the poor man, who otherwise would have died in the street from the cold, taken to the Green Cross. That old man, like many others, had no way of knowing that he owed his life to Tina Modotti.

22

A Lonely Death

All week-end long, Spanish refugee children in Mexico City had been looking forward to Tuesday 6 January, when they would celebrate the Feast of the Three Kings, dashing noisily from their beds to the shoes they had left in the hallway or on the window sill, hoping to find them full of sweets and toys. To make sure they would not be disappointed, Tina and her Mexican and Spanish women friends had spent the first evenings of the New Year at each other's homes, making handicraft toys and decorating simple cloth bags for the sweets they hoped to be able to provide for all the children.

On Monday 5 January, Tina worked on two translations: one, an article written by Mario Montagnana on Mussolini and another on the French philosopher Denis Diderot. She also began a letter to a woman friend in the United States, which she left unfinished in her typewriter when she left the house later in the day:

> I have just been at the home of José Clemente Orozco. This great Mexican artist is also a man of great sensitivity ... I nearly, nearly would dare to say that I am delighted that America is also at war with Hitler ... Naturally, this is in jest, but the reality is that in this way I feel much closer to our great struggle ...

In the evening Tina and Vidali planned to go to dinner at Hannes and Lena Meyer's home on Ramón Guzmán Street near the old Colonia train station. The Meyers lived on the second floor of a modern block of flats inhabited by a number of Spanish refugees and Mexican artists, among them Ignacio Aguirre, a member along with Siqueiros, Pablo O'Higgins and Xavier Guerrero of the Popular Graphics Workshop. The two-bedroom flat was decorated in typically stark Bauhaus style. Lena's weaving loom and a draftsman's table

dominated the living room and examples of their architectural and design studies were hung around the walls. The guests soon dwindled to three couples who spent the remainder of the evening together: the Meyers, Patricio Azcárate and Cruz Díz, and Tina and Vittorio.

The six friends talked 'for hours' of 'the genius of Simeone Tomoshenko, of the Soviets' anti-tank traps, of Dimitri Shostakovich's Quintet Opus 57 and '… of the possibility of a trip in the near future from Madrid, Genoa and Udine to Moscow … without passports'. With the United States just one month into World War II, they were already looking beyond the mere defeat of fascism and dreaming of a post-war revolution which would erase Europe's national boundaries. As the night wore on, Vidali excused himself to go to the newsroom of *El Popular*, where he says he had an important meeting. Sometime later, Hannes heard Ignacio Aguirre arrive home and called down, inviting him upstairs to join them, which he did. 'Nacho' Aguirre's accounts of what transpired after that have varied. He is said to have recalled Tina remarking that she did not feel well, to which nobody paid much attention until she repeated it several times. Yet on another occasion, he recalled, 'She didn't seem ill to me.' When Tina finally decided to leave, it was Nacho who accompanied her down to the street to hail a taxi.

It was bitterly cold, as they stood on the corner of Ramón Guzmán and Artes Streets. Within a few minutes, just shortly after one o'clock Tina flagged down a dark-coloured, four-door sedan. The driver, Federico Trejo, pulled over and asked where she was going, and following the local custom of giving a well-known landmark rather than a hard-to-find address, she simply told him the 'General Hospital', which was just in front of her home. Bartering with him for a moment, in her usual fashion, she got the price down from two pesos to one. They headed for the Doctores neighbourhood and as they neared the General Hospital the driver heard what sounded like heavy wheezing coming from the back seat. Realizing that his passenger was seriously ill, Trejo went to find help inside the hospital. When the admitting nurse came out and saw Tina's state, she told him that the General Hospital could not admit her because they had no emergency facilities and that he should take her to the Green Cross Hospital on Victoria Street. It could not have taken Trejo more than a few minutes to drive the mile or so to the second hospital; when they arrived Tina was slumped over in the back seat of the taxi.

Although the Green Cross doctors examined her and realized she was dead, they apparently attempted to revive her with two injec-

tions of either adrenaline or coramine to her heart, but were unsuccessful. Knowing only that an unidentified woman in her forties had been brought to the hospital 'dead on arrival' in the back seat of a taxi cab, they immediately notified the local police headquarters. The officer on duty, Sergio Leopoldo Benhumea, took the telephone call, sent a police agent to investigate and assigned the case a file number. Under Mexican law, an autopsy was required when no physician was present to certify the exact time and cause of death, so an order for an autopsy was also issued. Meanwhile, police at the hospital opened Tina's handbag and found her Mexican immigration letter, from which they discovered her real name and address. The photograph of her stapled to the letter was passed to reporters. She was apparently also carrying with her a small print of her profile portrait of Julio Antonio Mella.

Vidali recalled it being funeral parlour employees who rang the doorbell at 137 Dr Balmis Street in the early morning hours: 'I ran to the entrance convinced that Tina had forgotten her keys. I opened up and found two gentlemen dressed in black who bid me good evening and asked me if I was the husband of Tina Modotti … ' After he had been told the news, Vidali rushed to the hospital where he found Tina's body laid out in a dimly lit room

> with her black tailored suit, the white blouse: her face serene, her eyes closed … She seemed asleep, as if she was waiting for someone to awaken her to go for a walk in the moonlight. [But] Tina was truly dead. I kissed her and left.

Tina's corpse, 1942

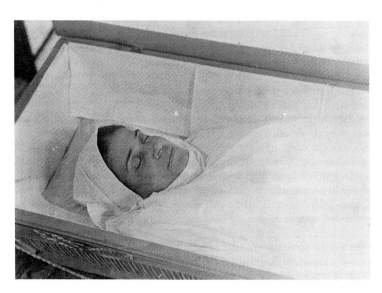

Vidali gave a statement to the police, mentioning Tina's heart condition and giving the name of her doctor. Then, at about four o'clock, he contacted Isabel Carbajal and Pedro Martínez Cartón to tell them of Tina's death and asked them to go to the hospital. Tina's body had now been taken to the Juárez Hospital where forensic specialists performed an autopsy. The news of her death began circulating among friends immediately. Clara Porset telephoned Adelina Zendejas with the news before dawn and Adelina rushed to the Juárez Hospital where she saw Tina's body on the same stone slab she had seen Mella's 13 years before. Apparently, distraught by Tina's death, yet still lucid enough to realize the Mexican press would try to muddy her name and insinuate foul play, Vidali did not return home, but went immediately into hiding at the home of Constancia de la Mora.

His hunch about the press was correct. One newspaper's juxtaposition of front-page photographs of 'the Italian artist Tina Modotti' and Mella were accompanied by the headline: 'UNEXPLAINABLE DISAPPEARANCE OF THE LOVER OF TINA MODOTTI, CARLOS JIMENEZ CONTRERAS.' Tina was identified as the woman 'who achieved notoriety among us for her relationship with the student and Cuban Communist leader, Julio Antonio Mella'. There was a flood of charges of skullduggery and poisoning and rumours of suicide. One paper claimed she had been prescribed 'a certain toxin which leaves no trace in the body', an overdose of which had caused her heart to rupture. Headlines became indictments: 'HER LOVER, WHOSE REAL NAME IS CARLOS SORMENTI, IS A FANATICAL AGENT OF THE GPU ... '

The news stories quickly circulated, with Diego Rivera among those fanning the flames. Some believed Tina had been killed by Stalinist agents because she 'knew too much', but those closest to her believed she had died of a heart attack. These included her brother Benvenuto, whom she had told of her illness on her trip to New York: 'She had a serious heart illness, and this illness killed her. Whoever says anything else is a liar,' he wrote in 1948.

The veteran Mexico City forensic doctor, Armando Zárate, and his young assistant, Dr José Sol, making known their initial autopsy findings, said they had discovered what was then termed a 'generalized visceral congestion'. In other words, multiple internal organs had been damaged due to a state of physical trauma, which could have been brought on by any of several factors, heart failure or poisoning among them. However, upon examining the stomach cavity, the doctors found no indication of toxic poisoning. They did find Tina's

lungs congested and filled with fluid, indicating either pulmonary endyma or coronary failure. The fact that the aorta was partially blocked with the plaque common to atherosclerosis would seem to indicate Tina had suffered from a worsening heart condition.

While a heart attack caused by some toxic substance unknown to Mexican medicine at the time cannot be entirely ruled out, Tina's existing heart condition could have been exacerbated by the meal and wine she had had that night. The forensic doctors were cautious before issuing their final determination, but once they had all the results of laboratory tests in their hands they were certain: 'The generalized visceral congestion, from which Tina Modotti Mondina [sic] died, was caused by the organic lesion of the heart which we observed on practising the autopsy … ' At the relatively young age of 46, Tina did die of heart failure, the precise cause of which is unlikely to ever be determined. A subsequent history of heart problems among her younger brothers and sisters, however, might indicate that it was a congenital problem. Yolanda Modotti suffered from heart problems over the years and both of Tina's younger brothers died of heart disease.

Vidali had left the arrangements of Tina's funeral to Mexican friends. A Weston portrait of her was placed on the bier, amid masses of her favourite calla lilies and other flowers. Shortly before 11 o'clock on 7 January, the funeral procession departed for the Dolores cemetery, beyond Chapultepec castle in the hills overlooking Mexico City. Hundreds of people watched as the coffin, draped with a flag bearing the hammer and sickle, was lowered into the grave. Her old friend, the engraver Leopoldo Méndez, agreed to carve the headstone with a profile of Tina and the words of a poem written in her memory by Pablo Neruda. Outraged by the press attacks on Vidali, and hoping his fame would lend support to his friend, Neruda dedicated it to him and sent it for publication to several of the city's newspapers.

Most of those attending the funeral were Party comrades, but friends from Tina's earlier days in Mexico also came. Pablo Neruda read his poem about her, Pedro Martínez Cartón spoke a few emotional words of thanks to 'María' on behalf of the Spanish exiles, while Mario Montagnana spoke glowingly of her anti-fascist work. Textile workers in Puebla baptized a new loom 'Tina' in her honour and the Anti-Imperialist League and the Mexican Communist Party created cells with her name.

But Tina the militant was not long in the grave before Tina Modotti the photographer was resuscitated. The first retrospective of her work, organized by a committee of Mexican and foreign artists,

opened at the *Galería de Arte Moderno* on 18 March. Manuel Alvarez Bravo, who had been so inspired by her work, wrote a glowing tribute to her photography in the catalogue that accompanied the exhibition. The show contained 50 photographs which friends had lent for the occasion. Among them were Tina's photographs made during her 1924 visit to Tepotzotlán, the *Flor de Manita* which Jean Charlot had praised and the lilies she had shown in Guadalajara, the images of Indian women and their plump babies, the workers reading *El Machete*, her icons of the Mexican revolution and the renowned portrait Edward Weston made of her, the one he had once described as depicting the face of a woman 'whose maturity will bring together the bitter-sweet experience of one who has lived life fully, deeply, and unafraid'.

Archway and patio,
1924 [TM]

NOTES

Titles which appear in full in the select bibliography have been abbreviated here. The following abbreviations have been used:

AB: Anita Brenner
AGN: Fondo Presidentes, Archivo General de la Nación, Mexico City
AP:IH: Archivo de la Palabra, Instituto Histórico, Dir. de Estudios Históricos, INAH, Mexico City
AP:IIM: Archivo de la Palabra, Instituto de Investigaciones Dr José Ma. Luis Mora, Mexico City
BB: Betty Brandner
BL: Bancroft Library, University of California, Berkeley
BM: Benvenuto Modotti
BOR: Modotti, Tina, ed., *The Book of Robo* (Los Angeles, 1923)
BS: Beatrice Siskind
BWC:HIA: Bertram D. Wolfe Collection, Hoover Institution Archives, Stanford University
CB: Carleton Beals
CBC: Carleton Beals Collection, Boston University
CC: Vidali, Vittorio, *Comandante Carlos* (Ediciones de Cultura Popular, Mexico City, 1986)
CEMOS: Centro de Estudios del Movimiento Obrero y Socialista, Mexico City
CGP: Caroline Gordon Papers, Princeton University Library, Princeton University
CTM: Comitato Tina Modotti, Udine
CW: Chandler Weston
DEW:I; *DEW:II*: Newhall, Nancy, ed., *The Daybooks of Edward Weston: I. Mexico; II. California* (Aperture, Millerton, NY, 1973)
EW: Edward Weston
EWA: Edward Weston Archive, Center for Creative Photography, University of Arizona
EW:SP: Maddow, Ben, *Edward Weston: Seventy Photographs* (Aperture/New York Graphic Society, Boston, 1978)
EWO: Newhall, Beaumont, and Conger, Amy, eds., *Edward Weston Omnibus* (Peregrine Smith

Books, Salt Lake City, 1984)
FW: Flora Weston
GM: Giulia Montovani
IAC: Italian-American Collection, San Francisco Archives, San Francisco Public Library
JAM: Julio Antonio Mella
JC: Jean Charlot
JF: Joseph Freeman
JFC:HIA: Joseph Freeman Collection, Hoover Institution Archives, Stanford University
JH: Johan Hagemeyer
KAP: Katherine Anne Porter
MLD: Mary L. Doherty
MM: Mercedes Modotti
PKAP: Papers of Katherine Anne Porter, Special Collections, University of Maryland at College Park Libraries
RC: Rafael Carrillo
RF: Alvarez Bravo, Lola, *Recuento fotográfico* (Penélope, Mexico City, 1982)
RGR: Ricardo Gómez Robelo
RM: Ramiel McGehee
RM: Vidali, Vittorio, *Retrato de mujer* (Universidad Autónoma de Puebla, 1984)
RR: Robo Richey
SAPS: Sala de Arte Público Siqueiros, INBA, Mexico City
SRROC:CU: Spanish Refugee and Relief Organizations Collection, Columbia University, New York
TM: Tina Modotti
VLTM: Barckhausen-Canale, Cristiane, *Verdad y Leyenda de Tina Modotti* (Casa de las Américas, Havana, 1989)
W–HC: Weston–Hagemeyer Correspondence, EWA
XG: Xavier Guerrero
YM: Yolanda Modotti Magrini

An Untimely Death

page

3 *the young man was Julio Antonio Mella*: Details of Mella's assassination reconstructed from government documents and the Mexican newspapers *Excelsior*, *La Prensa* and *El Universal*

5 *Julio has been shot*: CB, *Great Circle*

6 *the life ebb*: Ibid

6 *Leaving the room*: Rafael Carrillo, in Cupull Reyes

Childhood and Immigration

8 *In December 1887*: *Comune di Udine* to Joseph Modotti, 13 September 1972

9 *Assunta Mondini was just seven months younger*: Report 8014, Italian Consulate, San Francisco, 23 December 1930

9 *Mercedes Margherita, was born*:
4 November 1892; ibid

9 *He wanted to have his own
workshop*: YM, interview with author, 24
February 1990

10 *a local photographer who made
portraits*: Photograph of Beppo Modotti
at 15 months

10 *A company which normally made shot-
guns*:VLTM

10 *When the Modotti children started
school*: YM, interview with author, 9
March 1990

12 *he died very young*: Ibid., 27 August
1990

12 *Tina later blamed her limited education*:
La Prensa, 14 January 1929

12 *He must have heard glowing tales*: Ship's
manifest, SS La Gascogne, arr. New
York 21 November 1904

12 *Just before Tina's tenth birthday*: SS La
Touraine, arr. New York 27 August 1906

12 *it was difficult*: YM, in *Tina Modotti:
garibaldina e artista*

12 *had as a classmate*: Eladia de los Ríos,
interview with author,
7 August 1990

13 *Pietro Modotti, a pioneer*: Zannier

13 *She fondly remembered the visits*: YM,
interview with author, 7 March 1990

13 *so beautiful, so young*: GM to YM, 16
April 1956

13 *I remember her so well*: Ibid

13 *By 1911*: Arr. New York 12 April 1911

14 *one night in early winter*: YM, in *Tina
Modotti: garibaldina e artista*

14 *When I was older*: Ibid

14 *the 'ridiculous' hat*: Eladia de los Ríos,
op. cit

14 *She was just 16*: Dep. Genoa 24 June
1913, arr. New York 8 July 1913

15 *In reply to the standard questions*: Ship's
manifest, SS *Moltke*

The Golden Gate

16 *pasta…pendant sausages*: Dillon

16 *Only the more prosperous*: Ibid

16 *a local symbol*: Ibid

16 *My father had to come*: Filmed inter-
view, *Tina Modotti*, Maria Bardischewski
and Ursula Jeshel, Berlin, 1982

17 *where his brother Francesco lived*: Ship's
manifest, SS La Gascogne

17 *thousands of workers*: Goldman

17 *In 1908, the only photographer*: Dillon

17 *Well, we are celebrating*: YM, interview
with author, 24 February 1990

18 *When Tina arrived*: Ibid

18 *they used to use Tina*: YM, interview
with author, 27 August 1990

19 *Modotti is singing again*: Ibid.,
24 February 1990

19 *holding forth about unions*: Ibid

19 *where my father*: In *RM*

20 *the nude painting*: Dillon

21 *unearthly and dreamlike*: Todd

21 *the woman on its top*: Ibid

21 *Edward H. Weston*: Ibid

21 *had his life changed*: Nathan Lyons, in
EWO

21 *more than a gathering*: Todd

21 *the two young people*: L'Italia,
16 October 1918

21 *fine classic features*: Borough

21 *Born in the state of Oregon*: Robo's
death certificate, 10 February 1922,
Mexico City

To the Opera!

22 *admired and applauded*: L'Italia,
5 September 1917

23 *But in early July*: Ibid., 20 July 1917

23 *great popularity*: Estavan

23 *Tina did not have much of a voice*: YM,
interview with author, 9 March 1990

23 *This evening*: L'Italia, *4 September 1917*

24 *Tina Modotti, the pretty signorina*: Ibid.,
5 September 1917

24 *The first letters*: Ibid., 4 December
1917

25 *La signorina*: Ibid., 11 February 1918

25 *she had great reviews*: Ibid., 14 February
1918

25 *Portanova was inspired*: Ibid.,
27 February 1918

26 *Grand Patriotic Festival*: Ibid., 24 May
1918

26 *signorina Tina Modotti*: Ibid., 29 May
1918

26 *beautiful little work*: Ibid., 6 July 1918

27 *The part of Marta Regnault*: Ibid., 29
August 1918

28 *a permanent theatre*: Ibid.,
17 August 1918

28 *a Hollywood career*: Gabrielli, 'La mia
storia', IAC

28 *They all came to Hollywood*: Argentina
Brunetti, interview with author, 9 March
1990

28 *The numerous frequenters*: L'Italia, 16
October 1918

Kindred Spirits

32 *Robo found a job*: Estavan

33 *Tina affectionately dubbing her mother-
in-law*: YM, interview with author 9
March 1990; Rose Richey to TM, 25
December 1928

33 *When they stepped off the ferry*: YM,
Ibid

34 *a magnificence*: Newhall, in 'Introduction', *DEW:I*

34 *not very tall*: In Caronia and Vidali

34 *labouring monk-like*: Valle

35 *exquisite tapestries*: Vera de Córdova, 'Las Fotografías como Verdadero Arte'

36 *the nuns of the perpetual adoration*: TM to BB, *c.*1920, EWA

36 *lover of poetry*: Cowper Powys

36 *weak amateur[s]*: In Hopkins

37 *Rodion Romanovitch Raskolnikoff*: Nemesis García Naranjo, in 'Presentacíon' in *Satiros y amores*, 1984

37 *calibre as an artist*: *Variety*, 3 December 1920

40 *extremely bright*: *EW:SP*

40 *through McGehee's contacts*: Ibid

40 *a bronze medal award*: Nathan Lyons in *EWO*

40 *in 1918 his work was exhibited*: Maddow, op. cit

40 *a little shack*: *The American Magazine*, 1914; quoted ibid

40 *the American idea*: Ibid

40 *intellectual anarchist*: 1956 interview, Hagemeyer Oral History, BL

41 *a good deal of kissing*: Maddow, op. cit

41 *I spent Saturday night*: TM to BB, *c.*1920, EWA

41 *vaguely lost expression*: Winter

41 *the most terrible … friends and Saki*: RGR to EW, 19 February 1922, EWA

42 *Like all persons*: In 'Biographical Sketch', *BOR*

42 *A man cannot*: Ibid

42 *Equally interested*: Ibid

43 *She later described*: Maria Luisa Lafita, in *VLTM*

43 *days of 1920*: *DEW:II*

43 *Tina is wine red*: *BOR*

43 *late afternoon*: TM to EW, 27 January 1922, EWA

44 *Once more I have been*: TM to EW, copied onto unpublished page of EW's daybook, 25 April 1921, EWA

44 *slow and absorbent*: Newhall, in 'Introduction', *DEW:I*

44 *Life has been very full*: EW to JH, 18 April 1921, W–HC

44 *One night after*: TM to EW, copied onto unpublished page of EW's daybook, 25 April 1921, EWA

Art, Love and Death

45 *Oh! I hope he does something*: TM to JH, 17 September 1921, W–HC

45 *strikingly sexless*: Janet Malcolm, in *EWO*

45 *Since so many*: Maddow, 'Venus Beheaded: Weston and his Women'

46 *a very timid caretaker*: José Rodríguez, in *EWO*

48 *they were able to hide their affair*: EW to FW, 1 September 1923, EWA

48 *like an electric fan*: Roi Partridge, quoted by Newhall in *DEW:I*

48 *His oldest son, Chandler*: CW, interview with author, 18 August 1990

48 *The people whom he loved*: In 'Biographical Sketch', *BOR*

48 *the Mexican racial tendency*: Gale, 'How's Mexico Now?' in *Gale's Magazine*, March 1919

49 *The brains and imaginations*: *DEW:I*

49 *She has your address*: EW to JH, 13 August 1921, W–HC

49 *the impressions left to me*: TM to JH, 17 September 1921, W–HC

50 *made me think of you*: TM to EW, in EW to JH, 10 September 1921, W-HC

50 *I have not seen your friend*: TM to JH, 17 September 1921, W-HC

50 *Edward: with tenderness*: TM to EW, 27 January 1922, EWA

51 *the hours which will still be ours*: Ibid

51 *artist's paradise*: RR to EW, 23 December 1921, EWA

51 *work by children*: Ibid

52 *some artists and newspapermen*: RGR to EW, EWA

52 *Tina's portraits*: Ibid

52 *post notices*: RR to EW, 23 December 1921, ibid

52 *to have some new prints*: RGR to EW, EWA

52 *He was seen at public gatherings*: Valle

52 *he had been hospitalized with smallpox*: Robo's death certificate, op cit

52 *to the General Hospital*: Ibid

52 *almost violent*: Valle

52 *at 8.30 on the evening*: Death certificate, op. cit

52 *too weak or too unlucky*: In 'Biographical Sketch', *BOR*

53 *She was slim; elegant*: Lupe Marín, interview with Elena Poniatowska

54 *Sarcastic, unruly and whimsical*: CB, *Glass Houses*

54 *photographs brought by Miss TIna Modotti*: 'Boletín', Ministry of Public Education, Vol.I, No.2, 1922

54 *In a double-page spread*: Vera de Córdova, 'Las Fotografías como Verdadero Arte'

54 *A couple of weeks earlier*: Valle

54 *She wrote to Edward*: In EW to JH, 6 April 1922, EWA

54 *her father died suddenly*: Death certificate, 14 March 1922, State of California

54 *An obituary in the local Italian press*: Unidentified newspaper clipping, 15 March 1922

NOTES

California Interlude

55 *Mercedes and Yolanda*:
Crocker–Langley Directory, 1922

55 *Yolanda now unhappily married*:
Gabrielli, 'La mia storia', IAC

55 *Benvenuto and Beppo had refused*: YM,
interview with author,
27 August 1990

55 *a moment of mysticism*: RM

55 *I hesitated long*: TM to JH, 7 April 1922,
W–HC

56 *Fond as I am*: Ibid

56 *A local newspaper*: Borough

57 *blaming herself*: Margrethe Mather to
RM, in *DEW:I*

57 *Going back to photography*: TM to EW,
*c.*8 January 1928, EWA

57 *mostly, though not wholly , a
lesbian*: EW:SP

58 *They found the increasingly restrictive
laws*: El Universal Ilustrado, 27
September 1923

58 *According to Ben Maddow*: EW:SP

58 *I looked out at the black night*: Ibid

59 *For Miss M. d'Harcourt*: University of
Virginia Library

59 *Turnbull filmed the exhibition*: CW to
FW, 29 October 1923, EWA

60 *Edward saw it as an 'opportunity'*: EW
to FW, 1 September 1923, EWA

60 *By early January*: EW to JH,
11 January 1923, EWA

60 *a verbal 'contract'*: EW to RM, 1924, in
EW:SP

60 *teach Tina photography*: Ibid

60 *apprentice*: DEW:I

60 *room and board*: EW to FW, 22 February
1924 and 22 April 1924, EWA

60 *a lot of responsibility*: EW to FW, 22
February 1922 EWA

60 *trial marriage*: EW to JH,
15 November 1924, W–HC

60 *There was a big hoo-hah*: YM,
interview with author, 24 February 1990

60 *A long period of personal conflict*: DEW:II

61 *We leave for Mexico in March*: EW to
JH, 11 January 1923, W–HC

61 *on a little adventure*: EW to JH, 9 April
1923, EWA

61 *to be in charge of the studio*: Ibid

61 *Notes in Hagermeyer's diary*: EWA

61 *Together or with Tina*: DEW:I

62 *They spent ten days together*: Maddow,
'Venus Beheaded: Weston and his
Women'

62 *She literally was on her knees*: ibid

62 *I have seldom loved*: EW to RM, in
EW:SP

62 *meticulously packed his bulky
camera lenses*: EW to JH, n.d., W–HC

62 *horrendous… to witness*: CW, interview
with author, 18 August 1990

62 *till finally only the gleam*: DEW:I

Strange New World

65 *It was the smells*: CW, interview with
author, 18 August 1990

65 *colorful and inefficient*: DEW:I

65 *cut through silent, glassy waters*: Ibid

66 *cool patios*: Ibid

66 *Strange how one can understand*: Ibid

66 *My Anglo-Saxon reserve*: Ibid

67 *Will you come with me*: Ibid

67 *American service and comfort*: Mexican
Folkways, Vol.II, No.2

68 *Now Tina is not thin*: DEW:I

69 *standing naked on the sunlit patio*: Ibid

69 *ordered calm of Glendale*: Ibid

69 *an old inlaid chest*: Ibid

69 *There wasn't yet such a hatred*: Monna
Alfau Teixidor, interview with Claudia
Canales, 1980, AP:IIM

70 *uncommon common denominator*: Reed

70 *pursuit of the upper part of this girl*:
Porter, in López

72 *down to earth*: CW, interview with
author, 18 August 1990

72 *items Tina had bargained for*: CW to
FW, 25 September 1923, EWA

72 *a fine friendship*: EW to FW,
1 September 1923, EWA

72 *dark-skinned señorita*: Ibid

72 *Barefoot, kimono-clad*: DEW:I

Mexican Odyssey

75 *Ambling ponderously*: CW,
interview with author, 18 August 1990

76 *Tina posed for more portraits*: CW to
FW, c. October 1923, EWA

76 *with everyone helping*: CW to FW,
15 October 1923, EWA

76 *Long life to your work*: guest book,
EWA

76 *snickering over nudes*: DEW:II

77 *Another friend who visited*: Monna
Alfau Teixidor, interview with Claudia
Canales, 1980, AP:IIM

77 *Germán and his wife, Lola*: Rivera
Marín

77 *See? What I have*: TM to JH,
27 February 1924, W–HC

77 *I wish I could sign with my name*: EW
to JH, 28 February 1924, W–HC

78 *Xavier Guerrero nosed out*: Charlot,
Mexican Mural Renaissance

80 *vulgar*: DEW:I

80 *She smoked my pipe*: Ibid

80 *maids, seamstresses*: Dromundo, Rescate
del tiempo

80 *Throwing lit cigarettes*: Ibid

80 *a bizarre place*: CB, *Glass Houses*
81 *funded by the Mexico City Police*: Walsh
82 *loaded with papers*: Guerrero, in Charlot, op. cit
82 *Contributors to the first issues*: El Machete, 1924
82 *the last of the overalled dandies*: List Arzubide
82 *a theory of images*: Ibid
82 *Picturesque woman for travel*: El Universal Ilustrado, 12 November 1925
83 *Weston taught her his basic method*: Manuel Alvarez Bravo, interview with author, October 1989
83 *This 'coupon'*: TM to CB, 29 June 1924, CBC
83 *assignments and commercial jobs*: CW, interview with author, 18 August 1990
83 *some architectural things*: Ibid
84 *One cell was the meeting place*: Felipe Teixidor, interview with Claudia Canales, AP:IH
84 *She printed from an enlarged positive*: DEW:I
84 *just friends for that twilight hour*: Ibid
84 *distracted Dad from his attentions*: CW, interview with author, op. cit
87 *some of the tragedy*: DEW:I
87 *a woman who has done a lot of things*: El Universal Ilustrado, c. 1924, EWA
88 *Monna Alfau and Felipe Teixidor believed*: Monna Alfau and Felipe Teixidor, interviews with Claudia Canales, AP:IH, AP:IIM
88 *a man now identified as*: Germán List Arzubide, interview with author, November 1992
88 *Between acts Pepe and I*: DEW:I
90 *Tina Modotti – your apprentice*: guest book, EWA
90 *dear "apprentice"*: DEW:I
90 *lose nothing by comparison*: Ibid
90 *You must not decide now*: Ibid
90 *Chandler… desperately wanted to stay*: CW, interview with author, op. cit

Out of the Shadow

92 *already I have been hurt*: TM to EW, 27 December 1924, EWA
92 *worthy*: Ibid
92 *Tell me – please*: Ibid
92 *I – Tina Modotti*: December 1924, EWA
93 *Someday I surely want*: TM to EW, 30 December 1924, EWA
93 *a gentle abstract presence*: TM to EW, 29 December 1924
93 *the only ones he had kept*: Ortega, 'La Muerte de Mella' in Revista de Revistas, 15 November 1931
98 *scandal erupted*: in RM

98 *Tina was a very beautiful woman*: Rafael Carrillo, interview with Elena Poniatowska
98 *would like a life like Tina's*: AB diary, January 1927
98 *Tina Modotti – profession – men!*: Felipe Teixidor, interview with Claudia Canales, AP:IH
98 *precious work*: TM to EW, c. 8 January 1928, EWA
99 *some nice photos*: JC to EW, 27 March 1925, EWA
99 *the white massed purity of roses*: CB, 'Tina Modotti'
101 *I felt a protest*: TM to EW, 2 April 1925, EWA
101 *a new ardour*: Ibid
104 *women are negative*: TM to EW, 7 July 1925, EWA
104 *an anti-fascist*: Jorge Fernández Anaya, interview with author, 12 January 1990
104 *evolution or revolution*: DEW:II
104 *a new Communist group*: DEW:I
110 *full of enthusiasm*: CW, interview with author, 18 August 1990
110 *anti-fascist fighter*: Jorge Fernández Anaya, interview with author, 12 January 1990
113 *Dressed as a 'suffragette'*: El Sol, August 1925, EWA
113 *she shows us her marvelous reproductions*: El Sol, 31 August 1925
114 *more real: the rough is rough*: Siqueiros, 'Una Trascendental Labor Fotográfica
114 *and Tina in second*: DEW:I

'Manyfold Possibilities'

115 *[Edward], Tina and her sister*: CB, Glass Houses
116 *You, under that palm*: MM to CB, c.September 1926, CBC
116 *Tina later referred to Beals*: TM to CB, 20 November 1927, CBC
116 *Sensuous, simple and powerful*: CB,Glass Houses
116 *sensuous curve*: DEW:I
116 *suspension of the publication*: Weisman, Alan, 'The Eye Thinks', Los Angeles Times Magazine, 24 June 1990
117 *Italian anti-fascist group*: VLTM
117 *I just feel impotent*: TM to EW, 23 January 1926, EWA
118 *Consuelo is to introduce me*: Ibid
118 *I am going to work hard*: Ibid
119 *She was 'bursting'*: TM to EW, 25 January 1926, EWA
119 *left for Los Angeles via Carmel*: MM to CB, 3 February 1926, CBC
119 *looking over old things of mine*: TM to EW, 9 February 1926, EWA

120 *Tina Modotti, his pupil*: Rivera, 'Edward Weston and Tina Modotti'

121 *rather nerve racking*: AB diary, 13 May 1926

123 *led by an·old hag*: DEW:I

123 *greasy hands of lecherous priests*: Ibid

124 *The two photographers*: AB, *Idols Behind Altars*

124 *Tina did a good deal of this work*: AB, in Vestal

124 *little brown Indian girl*: DEW:I

124 *a nice plaything*: Ibid

125 *Nahui Olin, whom Tina had photographed*: RF

125 *flowers, parrot, dogs*: AB diary, 1926

128 *figured with great success*: Vera de Córdova, 'El Arte Moderno en Mexico'

130 *We have all believed*: Doherty, in *DEW:I*

130 *The leaving of Mexico*: DEW:I

130 *You are that to me Edward*: TM to EW, 14 November 1926

Photography and Revolution

131 *oh so busy with copies*: TM to EW, 22 March 1927, EWA

131 *there had been rumours*: JC to EW, 27 March 1925

132 *Diego Rivera's 'megaphone'*: AB diary, 27 May 1927

132 *Tina got hers*: Ibid., c.June 1927

132 *I shall by all means show*: TM to EW, 26 June 1927

132 *He was planning a film*: Rosa Elena Luján de Traven, interview with author, 15 May 1990

133 *to simplify life*: AB diary, 1927

133 *mystic radicalism*: Ibid

133 *It was you who opened my eyes*: TM to XG, 15 September 1928

133 *During the week*: Francisca Moreno, interviews with author, 12 January and 28 November 1990

133 *took me to the Russian embassy*: Ibid, 12 January 1990

136 *I did not have*: TM, in *RM*

136 *hearing singing*: CB, *Glass Houses*

136 *As [the] party broke up*: Ibid

137 *Tina goes hard*: JC to EW, 15 August 1927

139 *His impact on the Mexican Communist Party*: Valentin Campa, interview with author, 7 October 1990

139 *had a long talk*: Vidali, in *VLTM*

139 *Tina dear*: EW to TM, 11 January 1928, in VLTM

141 *It was apparently made*: Mexican Folkways, Vol.IV, No.1, 1928

142 *making photographs of the paintings*: Everett Gee Jackson, interview with author, 1 May 1992

142 *black betrayal on Tina's part*: AB diary, 27 October 1927

142 *Tina was very enthusiastic*: Germán List Arzubide, interview with author, 12 January 1991

142 *looked so aghast*: Gabriel Fernández Ledesma, interview with Elena Poniatowska

142 *a perfect synthesis*: Gustavo Ortiz Hernán, *El Universal Gráfico*, 1929

146 *he left her his .45 calibre pistol*: La Prensa, 14 January 1929

Enemies of Tyranny

147 *the paper's vision*: RC, interview with author, 14 June 1990

147 *'propaganda' photos*: TM to EW, 23 May 1930, EWA

148 *his real name: Excelsior*, 15 and 16 January 1929

148 *Adonis of the Left*: Adelina Zendejas, interview with author, 22 January 1990

151 *introspective and silent*: Alejandro Gómez Arias, in Cupull Reyes

151 *At one point*: Baltasar Dromundo, in *VLTM*

151 *come and talk with us*: José Muñoz Cota, interview with author, 16 May 1990

151 *'transgression' against Guerrero's trust*: JAM to TM, 11 September 1928

151 *their baby daughter, Natalia: Excelsior*, 16 January 1929

152 *One might think*: Baltasar Dromundo, interview with Elena Poniatowska

152 *I'm sorry about your clothes*: XG to TM, 24 June 1928

152 *Alex Gumberg*: Ernestine Evans to CB, 1928, CBC

152 *I don't agree*: XG to TM, 24 June 1928

152 *the meeting place for comrades*: RM

152 *the contact in Mexico*: in *VLTM*

152 *very effective*: YM, interview with author, 24 February 1990

155 *most of the work*: Julio Rosovski, interview with Hector Delgado, CEMOS

155 *Mexican section*: Julio Rosovski, interview with Teresa Gurza, CEMOS

155 *a great prison: El Machete*, 19 May 1928

155 *she addressed a packed hall*: Ibid., 7 November 1928

155 *respect for her work schedule*: Lola Alvarez Bravo in *Excelsior*, 7 September 1983

155 *Tina looked 'tortured'*: Doris Heyden, conversation with author, 22 February 1991

156 *keyboard which you have socialized*: JAM to TM, 11 September 1928

156 *And you, you little liar*: BM to TM, 18 October 1928, in *VLTM*

156 *Contrary to popular belief*: Alejandro Gómez Arias, in Cupull Reyes

156 *She also influenced Frida's appearance*: Ibid

156 *it was Tina who brought together*: Herrera

156 *he pulled out his gun*: Frida Kahlo, in ibid

156 *wearing her gift*: Alejandro Gómez Arias, in Cupull Reyes

159 *Bandiera Rossa*: Teresa Proenza, interview with Elena Poniatowska

159 *about what we have together*: JAM to TM, 11 September 1928

159 *After months of torture*: Ibid

159 *When I think of the pain*: TM to XG, 15 September 1928

160 *this has been my greatest concern*: Ibid

160 *Received your letter*: El Universal, 16 January 1929

160 *why this flurry of insults*: RC, interview with author, 27 September 1990

161 *We were very happy*: La Prensa, 14 January 1929

161 *Tina had a party meeting*: Adelina Zendejas, in Cupull Reyes

161 *box camera inherited from Weston*: RF

161 *In her help to artists*: JC, 'Foreword', in Orozco, *The Artist in New York*

162 *at all, and I tell him so*: TM to EW, 18 September 1928, EWA

162 *enemy of tyranny*: La Prensa, 14 January 1929

162 *You KNOW NOTHING*: JAM to TM, 11 September 1928

162 *When Mexican Communist leaders*: RC, interview with author, 27 September 1990

162 *Mella's group in Mexico*: RC to Bert and Ella Wolfe, 4 December 1928, BWC:HIA

163 *an insulting resignation*: Ibid

163 *Some, like Rafael Carrillo*: RC, interview with author, 27 September 1990

163 *Mella has always had*: RC to Wolfes, op. cit

164 *entered ahead of [Mella]*: Adelina Zendejas, interview with author, 22 January 1990

164 *The photograph that Tina made*: La Prensa, 21 January 1929

164 *Tina arrived for the meeting*: Adelina Zendejas, interview with author, 22 January 1990

Trials of Love and Death

167 *THE PASSION MOTIVE*: El Universal Gráfico, 11 January 1929

167 *standing guard over the corpse*: El Universal, 12 January 1929

168 *thin, little worm-like man*: CB, *Great Circle*

168 *of a passionate nature*: Excelsior, 12 January 1929

168 *the face of a woman*: DEW:I

169 *If you'd tell the truth*: Excelsior, 13 January 1929

170 *that she, being Italian*: CB, *Great Circle*

170 *shook noticeably*: La Prensa, 13 January 1929

170 *Passing himself off*: El Universal, 13 January 1929

170 *This is a crime of passion*: El Universal, 14 January 1929

170 *the interesting Italian*: El Universal, 12 January 1929

170 *The Murder of Julio A. Mella*: Ibid

170 *Tina Modotti Refuses*: Excelsior, 13 January 1929

170 *There had long been*: Excelsior, 16 January 1929

171 *The International Centre*: La Prensa, 13 January 1929

171 *Tina Modotti…has been imprisoned*: 12 January 1929, AGN

171 *whose children Tina had photographed*: Mary L. Doherty, interview with Thomas F. Walsh, ca. 1982

171 *Photographic study*: Excelsior, 14 January 1929

171 *It turned out to have been*: El Universal, 3 February 1934

172 *she gave an extensive interview*: El Universal, 15 January 1929

172 *What kind of a country*: Excelsior, 15 January 1929

172 *the statements that a morning paper*: Ibid

173 *indecorous display*: Ibid

173 *decent people*: Ibid

174 *Don't you consider*: Excelsior, 16 January 1929

174 *When you began*: Ibid

175 *Did you ever*: Ibid

175 *To eliminate suspicion*: El Universal, 16 January 1929

175 *publicly charged*: CB, Great Circle

176 *woman who…lights her match*: Excelsior, 16 January 1929

The Fire Extinguished

177 *What does not kill me*: TM to EW, 25 February 1930, EWA

177 *in a simple, narrow black frame*: Robinson

177 *not weeping, but fighting!*: El Machete, 16 February 1929

178 *we honour his memory*: Ibid

178 *more abstract*: CB, 'Tina Modotti'

178 *She marvelled*: Laura Condax, interview with author, 23 October 1990

178 *I am sending you*: TM to EW, 17 September 1929

183 *to be able to give vent*: TM to EW, 5 April 1929, EWA

183 *But I cannot afford the luxury*: Ibid

183 *precious camarada*: Ibid

186 *We do not see her*: Monna Alfau to EW, 2 March 1929, EWA

186 *Certainly it was hard*: Robinson

188 *that Diego had gonorrhea*: JF to Paca Toor, *c.*1929, JFC:HIA

188 *There is so much activity*: Robinson

188 *lacked the necessary leisure*: TM to EW, 4 July 1929, EWA

188 *be more honest*: Ibid

188 *pernicious foreigner*: TM to EW, 5 April 1929, EWA

189 *both as a member*: TM to EW, 17 September 1929, EWA

189 *terribly critical of Diego*: Robinson

189 *when he and Frida were married*: Andrés Henestrosa, interview with author, 8 December 1989

189 *Joseph Freeman apparently bragged*: Robinson

189 *He later boasted:* 'J. Contreras' (VV) to JF, 1 June 1932, JFC:HIA

189 *According to Vidali*: Ibid

189 *Diego is out*: TM to EW, 17 September 1929, EWA

191 *indignant somehow*: Monna Alfau to EW, 18 September 1929, EWA

191 *you know I feel pretty sure*: TM to EW, 17 September 1929, EWA

192 *sending her flowers*: Rosa Rodríguez, interview with author, 15 June 1990

192 *She used to phone him*: Ibid

192 *spoke in such an exalted manner*: Ibid

192 *Baltasar – no words*: TM to Baltasar Dromundo, 20 December 1929, in *VLTM*

193 *Tina had set a serious intellectual tone*: TM, 'On Photography'

The Circle Closes

195 *Tina carried on the work*: Julio Rosovski, interview with Hector Delgado, CEMOS

195 *in front of a church*: Pablo O'Higgins, interview with Elena Poniatowska

195 *Between the first and second*: Julio Rosovski, interview with Teresa Gurza, CEMOS

196 *Vidali preferred dark suits*: Ignacio Aguirre, interview with author, 13 June 1990

196 *the February 1930 issue of Deutsches Magazin von Mexiko*: VLTM

196 *Manuel Alvarez Bravo remembers*: Manuel Alvarez Bravo, interview with author, October 1989

196 *In a raid on the CSUM offices: Excelsior*, 14 February 1930

196 *Carleton Beals was violently*: Britton

196 *had received orders*: CC

196 *three police commanders*: TM to BS, 17 February 1930, AGN

196 *At the top of the list: La Prensa*, 8 February 1930

197 *They kept me at the Police headquarters*: TM to BS, 17 February 1930, AGN

197 *Tina had had only one visitor*: Mary L Doherty, interview with Thomas F. Walsh, ca. 1982

197 *There was Tina*: Ibid

197 *tell him that at the moment*: TM to MLD, *c.*15 February 1930, AGN

197 *what we could take to her*: Lola Alvarez Bravo, interview with Claudia Canales, 17 November 1977, AP:IIM

197 *She was apparently refused*: RM; VV to YM, 11 August 1982

198 *so different from how*: RF

198 *I hear Tina is again a martyr*: AB to EW, 22 February 1930, EWA

198 *Tina was putting herself*: MLD to EW, 15 May 1930, EWA

198 *Tina's leaving the house*: Ibid

198 *once used by Tina Modotti*: KAP to Caroline Gordon Tate, 28 August 1931, CGP, Correspondence, Box 36, Folder 2

198 *the Alvarez Bravos both recall*: Manuel Alvarez Bravo, interview with author, 7 December 1989; *RF*

198 *the same camera*: RF

198 *she bade Davis*: Manuel Alvarez Bravo, interview with author, October 1989

199 *very emotional moment*: Ibid

199 *I am going now*: RF

Upheaval in Europe

204 *strictly watched*: TM to EW, 9 March 1930, EWA

204 *Had he not been so well disguised*: VV, interview with C. Ruíz-Funes, April–May 1979, AP:IH

204 *Just when I was about to flee*: Ibid

204 *The messages had reached their destination*: RM

205 *After sunset*: Ibid

205 *How beautiful!*: Ibid

205 *infantile uterus*: Ibid

205 *fibroid tumours*: Autopsy report, 6 January 1942, Mexico City

205 *I hope, Edward*: TM to EW, 9 March 1930, EWA

205 *the vile yellow press*: TM to EW, 25 February 1930

205 *after having lived*: TM, 'La Contrarrevolución Mexicana'
205 *The newspapers have followed me*: TM to EW, 9 March 1930, EWA
206 *that is till the damned boat*: Ibid
206 *a strange mixture*: Ibid
206 *COMMUNISTS DEPORTED*: 'Diario de la Marina', 15 March 1930, in *VLTM*
206 *Who knows*: RM
207 *he had come for a woman*: Ibid
207 *truly free*: Ibid
207 *the three of us*: Ibid
207 *be most useful*: TM to EW, 14 April 1930, EWA
207 *The strain shows*: Ibid
208 *for one coming from Mexico*: Ibid
208 *I have enough self-confidence*: Tm to EW, 28 May 1930, EWA
209 *Patron Saint of Fellow Travellers*: Gross, Willi Münzenberg
209 *a group of architects*: RM
209 *Tina had only 420 dollars*: VLTM
210 *so cold and hungry*: KAP to MLD, c.1932, PKAP
210 *This present period*: TM to EW, 23 May 1930, EWA
210 *to do 'reportage'*: Ibid
210 *I feel there must be something*: Ibid
210 *would only be useful*: Ibid
210 *was forced to*: Ibid
213 *I can't find Tina*: Ernestine Evans to Ella Wolfe, c. June 1930, BWC:HIA
213 *Yesterday I ran into Tina Modotti*: Ella Winter to EW, 8 August 1930, EWA
213 *are they just the result*: TM to EW, 5 April 1929, EWA
213 *Does she think I am a crazy nut?*: TM to EW, 28 May 1930
213 *I remember perfectly*: VLTM
213 *she had seen some festival*: Manuel Alvarez Bravo, interview with author, October 1989
213 *Germany, Austria, France*: Report 8014, Italian consulate San Francisco, 23 December 1930
214 *By then I ought to have something*: TM to EW, 23 May 1930, EWA
214 *Tina M. working*: VLTM
214 *surpassed Jacobi's own work*: Tina Modotti: garibaldina e artista
214 *through the insight of goodwill*: Ibid
214 *the Red soldiers marching*: VV to 'Nino', 10 September 1927, in Gallagher

A Different Person

217 *Moscow was inundated*: RM
218 *I have been living*: TM to EW, 21 January 1931, EWA
218 *Tina did not complain*: RM
218 *they had to rifle through their*

suitcases: Carmen Tagüeña, interview with author, 24 September 1992
218 *infested with rats*: CC
218 *I found her very timid*: Aurora Andrés, interview with author, 5 November 1990
219 *behind the vigorous figure*: Simone Tery in *Tina Modotti: garibaldina e artista*
219 *to try and change her mentality*: VV, interview with C. Ruíz-Funes, April–May 1979, AP:IH
220 *threw her camera*: Neruda
220 *Angelo Masutti, an Italian exile*: Silvano Castano interview with Angelo Masutti, 1992
220 *was unhappy because*: Concha Michel, interview with author, 8 July 1990
220 *the one thing she was willing*: Kramer, 'Tina Modotti's Brief but Remarkable Career'
221 *either I do politics*: VV interview with C. Ruíz-Funes, op. cit
221 *He was so ignorant*: Isabel Carbajal, interview with author, 2 December 1990
221 *love, passion, a home*: VV, interview with C. Ruíz-Funes, op. cit
221 *I heard from Tina*: Frances Toor to JF, 12 November 1931, JFC:HIA
221 *She said she was living happily*: KAP to MLD, 1932, PKAP
222 *It seemed simple*: VLTM
222 *she was imprisoned*: VV, interview with C. Ruíz-Funes, op. cit
222 *self-interview in public*: Isabel Carbajal, interview with author, 30 July 1990
222 *one after another*: VLTM
223 *Tina and Vidali lived*: Cecile Rol-Tanguy, in *VLTM*
223 *fought heroically for four days*: Langer
223 *Tina locked the doors*: VV, in *VLTM*
223 *Asturias–the first Soviet Republic in Spain*: SRI, Paris, October 1934
224 *I'm convinced*: RM
224 *widespread surveillance*: Ibid
224 *intolerably disagreeable*: CC
224 *optimum health*: RM
224 *'completely political' couples*: Ibid
224 *beyond good and evil*: CC
224 *a castle with the drawbridge up*: RM
224 *In early November 1935*: VLTM
224 *To rid itself*: RM
225 *I'm happy to be leaving*: CC
225 *The only things she left*: RM

Spanish Civil War

226 *Matilde Landa and Paco Ganivet allowed their home*: VV, 'Yo conocí a Matilde..'; Luisa Viquiera interview with author, 9 May 1991
226 *May Day celebration*: Vidali, 'Yo conocí a Matilde ...'

227 *very handsome brunette*: Bingham Urquidi
227 *As we passed the kitchen*: Ibid
227 *the political backbone*: Ibid
228 *las nanas*: Aurora Andrés, interview with author, 5 November 1990
228 *éminences grises*: Ibid
228 *except Tina and you*: María Luisa Lafita, in *VLTM*
228 *feminine battalion*: RM
228 *One day, some soldiers*: María Luisa Lafita, op. cit
229 *inspired organizer*: Matthews
229 *Vidali was known to charge about*: Cockburn, *A Discord of Trumpets*
229 *The sinister Vittorio Vidali*: Matthews
229 *I have to make an enormous effort*: TM to MM, December 1936, in *RM*
229 *part of our salary*: Milt Wolfe, interview with author, 1 September 1990
229 *a 20 percent commission*: Dr d'Harcourt, interview with Fredericka Martin, 15 May 1971
230 *All along the highway*: VV, interview with C. Ruíz-Funes, April–May 1979, AP:IH
230 *I would never have believed*: RM
230 *the entire time*: Ibid
230 *'lay nuns'*: Santiago Alvarez, in *VLTM*
230 *She looked lovely*: Constance Kyle, interview with author, 27 October 1990
230 *María was at the top*: Ibid
230 *When the 'North American Committee…'*: 'Comisión Internacional de Solidaridad' letter, 18 September 1937, SRROC:CU
232 *'No,' María answered*: RM
232 *Se entero e informaba*: Luisa Viqueira, interview with author, 9 May 1991
232 *she wasn't really*: Ibid
233 *to accompany him*: Cacucci
233 *I have nothing to say to her*: Garro
233 *ailing heart*: 'La croix rouge de la democratie espagnole' in *Secours Populaire*, quoted in *VLTM*
233 *thinner and sadder than ever*: Castro Delgado
233 *The occasion was heart-rending*: Aurora Arnaís, interview with author, 3 August 1990
234 *It's not right*: RM
234 *Matilde Lande was unhurt*: VV, 'Yo conocí..'
234 *in a hospital*: CC
234 *a half hour after takeoff*: RM
234 *She came along for a short stretch*: Eladia de los Ríos, interview with author, 7 August 1990
234 *Vidali sought Mexican visas*: Elena Vázquez Gómez, conversation with author, 1 April 1991
235 *take care of a little errand*: Constance Kyle, interview with author, 27 October 1990
235 *escaping by a miracle*: RM
235 *I told the driver to stop*: Fernando Gamboa, interview with author, 28 November 1989
235 *with no more than the clothes*: RM
235 *But Tina, this is not the final journey*: Ibid

Without a Country

236 *Yolanda herself had tried to go*: YM, interview with author, 24 February 1990
236 *I had not seen Tina*: Ibid
237 *cordial and warmhearted*: Carmen Tagüeña, interview with author, 24 September 1992
237 *Within a few days, they had moved*: RM; and Carlos Vidali, conversation with author 1 December 1989
237 *Little Comintern*: Reinhardt
238 *'Didn't Carmen remind you of anyone ?'*: Adelina Zendejas, interview with author, 22 January 1990
238 *When she saw Felipe*: Felipe Teixidor, interview with Claudia Canales, AP:IH
238 *one of Monna's brothers*: Ibid
238 *Anita Brenner*: Octavio Fernández Vilchis, interview with author, 20 June 1992
238 *mixed up with the Spaniards*: VV, interview with C. Ruíz-Funes, April–May 1979, AP:IH
238 *Others say they did not get on*: Francisco Luna, interview with author 19 March 1991
238 *considered her to be a Trotskyist*: RC, interview with author, 27 September 1990
238 *'seem into Mella'*: Adelina Zendejas in Cupull Reyes
239 *top-level commuting*: Reinhardt
239 *reunited with her sister*: YM, interview with author, 9 March 1990
239 *While there, she and Constancia*: Constance Kyle Lamb, interview with author, 27 October 1990
239 *She met with Eleanor Roosevelt*: Carmen Donósorio Roces, interview with author, 1 August 1990
239 *Ruth McKenney*: John Condax, interview with author, 23 October 1990
239 *to help Tina Modotti*: VLTM
239 *but then, those weren't happy times*: Ibid
239 *That depressed stuff*: Constance Kyle, interview with author, 27 October 1990
239 *One night*: BM

239 *He leapt out of bed*: Adelina Zendejas, interview with author, 22 January 1990

240 *That's all fine*: RM

240 *She never stopped being active*: Miguel Angel Velasco, interview with author, 30 December 1989

240 *presence was soothing*: Ibid

240 *She didn't want them*: VLTM

240 *a beautiful letter*: VV, interview with C. Ruíz-Funes, op. cit

240 *absolutely Franciscan modesty*: Eladia de los Ríos, interview with author 7 August 1990

240 *inexpensive furniture*: Leni Kroul, in VLTM

240 *a little bunch of marigolds*: Eladia de los Ríos, op. cit

240 *Tina working as an interpreter*: Sarah Pascual, interview with Elena Poniatowska

240 *the interpreter position was a cover*: Luisa Viqueira, interview with author, 9 May 1991

241 *Diego Rivera identified Vidali*: Excelsior, 14 September 1939

241 *as to the dry cleaning establishment*: Bert Wolfe to Martin Temple, 5 April 1940, BWC:HIA

241 *The FBI*: Gallagher

241 *he sent Vidali a squad*: González

241 *Here there is nothing*: TM to Leni Kroul, 16 April 1940

241 *Concerning the novel*: Ibid

241 *began in Spain*: Siqueiros, *Me llamaban el Coronelazo*

242 *Vidali was a prominent member*: Kiesling

242 *considered ourselves obliged*: Siqueiros, op. cit

242 *Hernández later accused him*: Hernández, Jesús, '¡PIDO LA PALABRA!' in *ABC, Mexico City*, n.d., SAPS

242 *He was ordered*: Gallagher

A Time of Turmoil

243 *Back out and get into the car*: John Condax, interview with author, 23 October 1990

244 *She was lively and outgoing*: John and Laura Condax, 23 October 1990

244 *'No,' she said*: John Condax, op. cit

244 *I didn't know she had returned*: Manuel Alvarez Bravo, interview with author, October 1989

245 *act of will*: Ibid

245 *Snow White and one dwarf*: RM

245 *She and Vittorio were so poor*: Eladia de los Ríos, interview with author, 7 August 1990

245 *Tina left the house less and less*: Miguel

Angel Velasco, interview with author, 30 November 1989

245 *So, I arrive with my big belly*: Eladia de los Ríos, op. cit

246 *María began taking photos*: Ibid

246 *Tina was so frightened*: Isabel Carbajal, interview with author, 30 July 1990

246 *her photographs of Eladia*: Eladia de los Ríos, op. cit

246 *As the days went by*: RC. interview with author, 22 November 1989

247 *thin, depressed*: RM

247 *a buffalo*: Matilde Mantecón, interview with author, 17 July 1990

247 *sinister, capable of anything*: Ibid

247 *a steamrolling personality*: Adolfo Sánchez Vázquez, interview with author, 22 January 1990

247 *a womanizer*: Castro Delgado

247 *a kind of protector*: Fernando Gamboa interview with author, 28 November 1989

247 *a generous, complete love*: RM

247 *a kind of martyr*: Leni Kroul, interview with author, 15 November 1992

247 *forced to stay married*: Ibid

247 *I hate him with all my soul*: Gorkin, *El Asesinato de Trotsky*

247 *terrified of people*: Isabel Carbajal, interview with author, 30 July 1990

247 *There had been loud quarrels*: Flor Cernuda, in *VLTM*

247 *high-class whore*: Elena Poniatowska, in Cacucci, 'Fuego, sombra y silencio; and interview with author, 2 May 1990

247 *described her as a fanatic*: Elena Poniatowska,. in Cacucci

247 *ashamed of her past history*: Isabel Carbajal, interview with author, 2 August 1991

247 *Cuban émigrés*: Octavio Fernández Vilchis, interview with author, 20 June 1992

248 *Visitors sometimes found her*: Eladia de los Ríos, op. cit

248 *Eladia remembers her*: Eladia de los Ríos, in *VLTM*

248 *never saw her ill*: RM

248 *she seemed to have suddenly aged*: Fernando Gamboa, op. cit

248 *perhaps because of her illness*: Miguel Angel Velasco, op. cit

248 *Tina's gang*: Aurora Arnaís, interview with author, 3 August 1990

248 *But the two women*: Carmen Donosório Roces, interview with author, 1 August 1990

248 *Matilde's daughter*: Carmen López, letter to author, 14 March 1991

248 *Pablo O'Higgins*: Isabel Carbajal, interview with author, 30 July 1990

249 *get Xavier to promise*: MLD to KAP, 28 February 1942, PKAP

249 *for suggestions and a recommendation*: Ibid

249 *looked well*: Ibid

249 *Tina felt optimistic*: 'Tina' in *Hoy*, 17 January 1942

249 *Invitations to his frequent parties*: Ninfa Santos, interview with author, 16 January 1990

249 *saw an old Mexican*: Simone Tery in *Tina Modotti: garibaldina e artista*

A Lonely Death

250 *To make sure*: Adelina Zendejas, interview with author 22 January 1990

250 *two translations*: 'Tina' in *Hoy*, 17 January 1942

250 *I have just been*: Ibid

250 *The six friends talked*: Hannes Meyer in *Tina Modotti: garibaldina e artista*

251 *Hannes heard Ignacio*: Ignacio Aguirre, interview with author, 13 June 1990

251 *She didn't seem ill*: Ignacio Aguirre, interview with author, 9 January 1990

251 *Tina flagged down*: El Nacional, 7 January 1942

251 *she got the price down*: Ibid

251 *two injections*: Autopsy report, Mexico City, 6 January 1942

251 *The officer on duty*: El Nacional, op. cit

251 *order for an autopsy*: Death certificate, issued 9.20 a.m., 6 January 1942

251 *The photograph of her*: In *El Universal Grafico*, 6 January 1942

252 *She was apparently also carrying*: Ibid

252 *I ran to the entrance*: RM

252 *with her black tailored suit*: Ibid

252 *Vidali gave a statement*: El Nacional, op. cit

252 *he contacted Isabel*: Isabel Carbajal, interview with author, 30 July 1990

252 *Clara Porset telephoned*: Adelina Zendejas, op. cit

253 *UNEXPLAINABLE DISAPPEARANCE*: La Prensa, 7 January 1942

253 *who achieved notoriety*: El Nacional, op. cit

253 *a certain toxin*: La Prensa, 8 January 1942

253 *HER LOVER*: Ibid

253 *Diego Rivera*: Zohmah Charlot to Edward Weston, 23 August 1945, EWA

253 *She had a serious heart illness*: BM

253 *generalized visceral congestion*: Autopsy report, 6 January 1942

253 *The generalised visceral congestion*. Appendix to autopsy report, 19 February 1942

253 *Yolanda Modotti suffered*: YM, interview with author, 27 August 1990; YM to Social Security Administration, 10 March 1976

253 *both of Tina's younger brothers*: Benvenuto: William Stern, Manhattan Borough Registrar, New York, to YM, 24 February 1963; Giuseppe: California Department of Health Services, Death Cert. No. 75–167656

254 *The show contained 50 photographs*: El Universal, 21 March 1942

254 *whose maturity will bring together*: DEW:I

SELECT BIBLIOGRAPHY

Books and Catalogues:

ABC: Doble diario de la guerra civil (Prensa Española, Madrid, 1979).

Abrahams, Edward, *The Lyrical Left* (University Press of Virginia, Charlottesville, 1986).

Alvarez Bravo, Lola, *Recuento fotográfico* (Penélope, Mexico City, 1982).

Attanasio, Sandro, *Gli italiani e la guerra de Spagna* (U. Mursia, Milan, 1974).

Baldwin, Gordon, *Looking at Photographs: A Guide to Technical Terms* (J. Paul Getty Museum, Malibu, California, 1991).

Barckhausen-Canale, Cristianne, *Verdad y Leyenda de Tina Modotti* (Ensayo Premio 1988; Casa de las Américas, Havana, 1989).

Barea, Arturo, *The Forging of a Rebel: The Clash* (Flamingo/Fontana Paperbacks, London, 1984).

Beals, Carleton, *Mexican Maze* (Lippincott, Philadelphia, 1931).

—*Glass Houses* (Lippincott, Philadelphia, 1938).

—*The Great Circle* (Lippincott, Philadelphia, 1940).

Bingham Urquidi, Mary, 'Mercy in Madrid', unpub. manuscript.

Bolloten, Burnett, *The Spanish Revolution* (University of North Carolina Press, Chapel Hill, 1979).

Brenner, Anita, *The Wind that Swept Mexico* (University of Texas Press, Austin, 1943).

—*Idols Behind Altars* (Biblo & Tannen, New York, 1967).

Britton, John A., *Carleton Beals* (University of New Mexico Press, Albuquerque, 1987).

Broue, Pierre, and Temime, Emile, *The Revolution and the Civil War in Spain* (Faber and Faber, London, 1972).

Bynner, Witter, *Journey with Genius* (John Day, New York, 1951).

Cacucci, Pino, 'Fuego, sombra y silencio', unpub. manuscript.

Caronia, Maria, and Vidali, Vittorio, *Tina Modotti: fotografa e rivoluzionaria* (Idea Editions, Milan, 1979).

Castells, Andreu, *Las brigadas internacionales de la guerra de España* (Ariel, Barcelona, 1974).

Castro Delgado, Enrique, *Hombres made in Moscú* (Publicaciones Mañana, Mexico City, 1960).

Charlot, Jean, *The Mexican Mural Renaissance, 1920–25* (Yale University Press, New Haven, 1963).

Cinel, Dino, *From Italy to San Francisco: The Immigrant Experience* (Stanford University Press, Palo Alto, 1982).

Cockburn, Claud, *A Discord of Trumpets* (Simon & Schuster, New York, 1956).

—*Crossing the Line* (MacGibbon & Kee, London, 1959).

Conger, Amy, *Edward Weston in Mexico* (Albuquerque, University of New Mexico Press, 1983).

Constantine, Mildred, *A Fragile Life* (Rizzoli, New York, 1983).

Cowper Powys, John, *Autobiography* (Simon & Schuster, New York, 1934).

Crocker–Langley Directory, San Francisco, 1904–30.

Cupull Reyes, Adys, *Julio Antonio Mella en los Mexicanos* (Ediciones El Caballito, Mexico City, 1983).

De la Mora, Constancia, *In Place of Splendor* (Harcourt, Brace, New York, 1939).

—'Mexico is Ours', unpublished manuscript.

Dennis, Peggy, *The Autobiography of an American Communist* (Lawrence Hill, Berkeley, 1977).

Dillon, Richard, *North Beach: The Italian Heart of San Francisco* (Presidio Press, San Francisco, 1985).

Dos Passos, John, *Años inolvidables* (Seix Barral, Barcelona, 1984).

Dromundo, Baltasar, *Mi Calle de San Ildefonso* (Guarania, Mexico City, 1956).

—*Rescate del tiempo* (Imprenta Madero, Mexico City, 1980).

Eisenstein, Sergei M., *The Film Sense* (Harcourt, Brace and Jovanovich, New York, 1975).

EW:100: centennial essays in honor of Edward Weston (Friends of Photography, Carmel, 1986).

Fagen, Patricia, *Transterrados y ciudadanos* (Fondo de Cultura Económica, Mexico

SELECT BIBLIOGRAPHY

City, 1975).

Fischer, Marooskha, *My Lives in Russia* (Harper & Brothers, New York, 1944).

Fuentes, Norberto, *Hemingway en Cuba* (Letras Cubanas, Havana, 1984).

Fyrth, Jim, *The Signal was Spain* (Lawrence and Wishart, London, 1986).

Gall, Olivia, *Trotsky en Mexico* (Era, Mexico City, 1991).

Gallagher, Dorothy, *All the Right Enemies* (Rutgers University Press, New Brunswick, 1988).

Garro, Elena, *Memorias de España 1937* (Siglo XXI, Mexico City, 1992).

Givner, Joan, *Katherine Anne Porter: A Life* (Simon & Schuster, New York, 1982).

Goldman, Emma, *Living My Life: Volume One* (Dover, New York, 1970).

Gómez Robelo, Ricardo, *Satiros y amores* (Premia, Mexico City, 1984).

—and Díaz Dufoo, Carlos Jr., *Obras* (Fondo de Cultura Economica, Mexico City, 1981).

González, Valentín R., *La vida y la muerte en la URSS* (Avante, Mexico City, 1951).

Gorkin, Julián, *Canibales políticos* (Quetzal, Mexico City, 1942).

—*El asesinato de Trotsky* (YMASA Editora, Barcelona, 1971).

Gross, Babbette, *Willi Münzenberg* (Michigan State University Press, East Lansing, 1974).

Gruening, Ernest, *Mexico and its Heritage* (Greenwood Press, New York, 1968).

Gumina, Deanna Paoli, *The Italians of San Francisco, 1850–1930* (Center for Migration Studies, New York, 1978).

Gunn, Dewey Wayne, *American and British Writers in Mexico, 1556–1973* (University of Texas Press, Austin, 1974).

Henstell, Bruce, *Los Angeles: An Illustrated History* (Knopf, New York, 1980).

Herrera, Hayden, *Frida: A Biography of Frida Kahlo* (Harper and Row, New York, 1985).

Herman, David L., *The Comintern in Mexico* (Public Affairs Press, Washington, DC, 1974).

Hernández, Jesús, *Yo fuí ministro de Stalin* (América, Mexico City, 1953).

Hopkins, Kenneth, *The Powys Brothers* (Farleigh Dickinson University Press, New Jersey, 1967).

Ivens, Joris, *The Camera and I* (International Publishers, New York, 1969).

Jackson, Everett Gee, *Burros and Paintbrushes* (Texas A&M University Press, College Station, 1985).

Johnston, Verle B., *Legions of Babel* (Pennsylvania State University Press,

University Park, 1967).

Kiesling, Wolfgang, *Brücken nach Mexiko* (Dietz Verlag, Berlin, 1989).

Kirk, Betty, *Covering the Mexican Front* (University of Oklahoma Press, Norman, 1942).

Langer, Marie, *From Vienna to Managua: Journey of a Psychoanalyst*, trans. Margaret Hooks (Free Association, London, 1989).

Leon, Maria Teresa, *Memoria de la melancolía* (Bruguera, Barcelona, 1982).

Levin, Isaac Don, *The Mind of an Assassin* (Greenwood Press, Westport, 1979).

List Arzubide, Germán, *El movimiento estridentista* (Federación Editorial Mexicana, Mexico City, 1982).

López, Enrique, *Conversations with Katherine Anne Porter, refugee from Indian Creek* (Little, Brown, Boston, 1981).

Los Angeles City Directory, 1915–30.

Lyons, Eugene, *Assignment in Utopia* (Harcourt, Brace, New York, 1937).

MacMillan, Dougald, *transition: The History of a Literary Era, 1927–38* (Braziller, New York, 1978).

Maddow, Ben, *Edward Weston: Seventy Photographs* (Aperture/New York Graphic Society, Boston, 1978).

Martínez, Romeo, and Campbell, Bryn, *I Grandi Fotografi: Tina Modotti* (Gruppo Editoriale Fabbri, Milan, 1983).

Martínez Verdugo, Arnoldo, *Historia del comunismo en México* (Grijalbo, Mexico City, 1985).

Massing, Hede, *This Deception* (Duell, Sloan and Pearce, New York, 1951).

Matthews, Herbert, *Half of Spain Died* (Scribner, New York, 1973).

Matthias, Leo, *Ausflug nach Mexiko* (Berlin, Die Schmiede, 1926).

Michel, Concha, *Dios principio es la pareja* (B. Costa Amic, Mexico City, 1974).

Modotti, Tina, ed., *The Book of Robo* (Los Angeles, 1923).

Musacchio, Humberto, ed., *Diccionario enciclopédico de México* (Andrés León Editor, Mexico City, 1990).

Nepomuceno, Eric, *Hemingway: Madrid no era una fiesta* (Altalena, Madrid, 1978).

Neruda, Pablo, *Confieso que he vivido* (Planeta Mexicana, Mexico City, 1989).

Newhall, Beaumont, and Conger, Amy, eds., *Edward Weston Omnibus* (Peregrine Smith Books, Salt Lake City, 1984).

Newhall, Nancy, ed., *The Daybooks of Edward Weston: I. Mexico; II. California* (Aperture, Millerton, NY, 1973).

Orlov, Alexander, *The Secret History of*

Stalin's Crimes (Random House, New York, 1953).

Orozco, José Clemente, *Mi autobiografía* (Ediciones Occidente, Mexico, 1945).

—, Foreword by Jean Charlot, *The Artist in New York*, (University of Texas Press, Austin, 1974).

Parmenter, Ross, *Lawrence in Oaxaca* (Peregrine Smith Books, Salt Lake City, 1984).

Peláez, Gerardo, *Partido comunista mexicano: I [Cronología 1919–1968]*, (Universidad Autónoma de Sinaloa, Culiacán, 1980).

Peters, J., *The Communist Party: A Manual of Organization* (Workers' Library, New York, 1935).

Porter, Katherine Anne, *Outline of Mexican Popular Arts and Crafts* (Young & McCallister, Los Angeles, 1922).

Powell, T.G., *Mexico and the Spanish Civil War* (University of New Mexico Press, Albuquerque, 1981).

Rascón, Víctor Hugo, *Tina Modotti y otras obras* (SEP, Mexico City, 1986).

Rather, Lois, *Bohemians to Hippies* (Rather, Oakland, 1977).

Reed, Alma, *The Mexican Muralists* (Crown, New York, 1960).

Regler, Gustav, *The Owl of Minerva* (Rupert Hart Davies, London, 1959).

Reinhardt, Günther, *Crime without Punishment* (Hermitage House, New York, 1952).

Richardson, R. Dan, *Comintern Army* (University Press of Kentucky, Lexington, 1982).

Rivera, Diego, with Gladys March, *My Art, My Life: An Autobiography* (Dover, New York, 1991).

Rivera Marín, Guadalupe, *Un río, dos riveras* (Alianza Editorial Mexicana, Mexico City, 1989).

Robinson, Ione, *A Wall to Paint On* (E.P. Dutton, New York, 1946).

Saborit, Antonio, *Una mujer sin país* (Cal y Arena, Mexico, 1991).

Sánchez Salazar, Leandro A., *Murder in Mexico* (Secker and Warburg, London, 1950).

Schneider, Luis Mario, *Obras completas de Antonieta Rivas Mercado* (SEP, Mexico City, 1986).

Sozialarchiv, *Tina Modotti: Photografien & Dokumente* (Exhibition catalogue, Berlin, 1990). Essays, Reinhardt Schultz, et al.

Smith, Susan, *Made in Mexico* (Knopf, New York, 1930).

Sontag, Susan, *On Photography* (Dell, New York, 1979).

Siqueiros, David Alfaro, *Me llamaban el Coronelazo* (Grijalbo, Mexico City, 1977).

Spratling, William, *File on Spratling* (Little, Brown, Toronto, 1967).

Stark, Amy, ed., *The Letters from Tina Modotti to Edward Weston* (The Archive, No.22, Center for Creative Photography, University of Arizona, Tucson, 1986).

Tagüeña Lacorte, Manuel, *Testimonio de dos guerras* (Oasis, Mexico City, 1974).

Tery, Simone, *Aquí el alba comienza* (Astro, Mexico City, 1944).

Thomas, Hugh, *The Spanish Civil War* (Hamish Hamilton, London, 1977).

Tina Modotti: garibaldina e artista (Circulo Culturale 'Elio Mauro', Udine, 1973).

Todd, Frank M., *The Story of the Panama–Pacific International Exposition*, 5 Vols. (G.P. Putnam's Sons, New York, 1921).

Townsend, Ludington, *John Dos Passos: A Twentieth Century Odyssey* (E.P. Dutton, New York, 1980).

Vidali, Vittorio, *Retrato de mujer* (Universidad Autónoma de Puebla, Puebla, 1984).

—*Comandante Carlos* (Ediciones de Cultura Popular, Mexico City, 1986).

Walsh, Thomas F., *Katherine Anne Porter and Mexico* (University of Texas Press, Austin, 1992).

Whelan, Richard, *Robert Capa* (Knopf, New York, 1985).

Whitechapel Art Gallery, *Frida Kahlo and Tina Modotti* (Exhibition catalogue, London, 1982) Essay, Laura Mulvey & Peter Wollen.

Willet, John, *Art and Politics in the Weimar Period* (Pantheon, New York, 1991).

Winter, Ella, *And Not to Yield* (Harcourt, Brace & World, New York, 1965).

Wolfe, Bertram D., *Portrait of Mexico* (Covici-Friede, New York, 1937).

—*Diego Rivera: His Life and Times* (Knopf, New York, 1939).

—*The Fabulous Life of Diego Rivera* (Stein & Day, New York, 1969).

—*A Life in Two Centuries: An Autobiography* (Stein and Day, New York, 1981).

Womack, John, *Zapata and the Mexican Revolution* (Knopf, New York, 1968).

Zannier, Italo, *Fotografia in Friuli, 1850–1970* (Chiandetti, Udine, 1979).

Articles and Pamphlets

André, Linda, 'Body Language: Frida Kahlo and Tina Modotti' in *Exposure* 22, Summer 1984.

Beals, Carleton, 'Tina Modotti' in *Creative*

286

Arts 4:2, February 1929, New York.
—'Tina Modotti: Communist Agent', unpub. typescript, Carleton Beals Collection, Boston University.
Borough, R.W., 'Art, Love and Death: Widow Must Sell Batiks' in *Los Angeles Examiner*, 12 May 1922.
Caballero Puck, 'Weton [sic], el Mago del Lente, nos Abandona' in *El Universal Ilustrado*, 7 October 1924, Mexico City.
Casanovas, Martí, 'Anécdotas revolucionarias' in *30/30*, 10 July 1929, Mexico City.
Cheron, Philippe, 'Tina Stalinissima' in *Vuelta* 82, September 1983, Mexico City.
D'Attilio, Robert, 'Glittering Traces of Tina Modotti' in *Views*, Summer 1985, Boston.
Debroise, Olivier, 'Tina Modotti fotógrafa, una evaluación' in *Siempre*, 1983, Mexico City.
Duell, Prentice, 'A Note on Batik' in *California Southland*, 1921.
Estavan, Lawrence, ed., 'The Italian Theatre in San Francisco', San Francisco WPA Theatre Research Project, typescript, June 1939.
Gabrielli, Guido, 'La mia storia', typescript, 1980, Italian-American Collection, San Francisco Archives, San Francisco Public Library.
—'La Vera Storia del Teatro Italiano a San Francisco dal 1918 al 1923', typescript, n.d., Italian-American Collection, San Francisco Archives, San Francisco Public Library.
Gálvez Cancino, Alejandro, 'Julio Antonio Mella: un marxista revolucionario' in *Críticas de la Economía Política* 30, 1986, Mexico City.
Glueck, Grace, 'Art: 2 Unusual Women' in *The New York Times*, 4 March 1983.
Hellman, Roberta, and Hoshino, Marvin, 'Tina Modotti' in *Arts Magazine* 51, April 1977.
Higgins, Gary, 'Tina and Edward' in *Creative Camera* 314, February–March 1992, London.
Hooks, Margaret, 'Major Cultural Archive Unearthed in Mexico City' in *The Mexico City News*, 15 April 1991.
—'Tina Modotti: fotógrafa o revolucionaria' in *El Nacional Dominical*, 4 August 1991, Mexico City.
—'Assignment, Mexico: The Mystery of the Missing Modottis' in *Afterimage* 19:4, November 1991, Rochester, NY.
—'Hearing the Rose Grow: The Life and Art of Tina Modotti' in *México Desconocido* 177, November 1991, Mexico City.
—'Bread and Roses' in *The Observer Magazine*, 23 February 1992, London.

Izquierdo, María, 'Tina Modotti: homenaje posthumo' in *Hoy* 268, 11 April 1942, Mexico City.
Kramer, Hilton, 'Turning the Legend of Tina Modotti into a Soap Opera' in *The New York Times*, 8 June 1975.
—'Tina Modotti's Brief but Remarkable Career' in *The New York Times*, 23 January 1977.
'La Bella y Genial Artista Italiana Tina Modotti, Y Su Excelso Arte Fotográfico' in *El Sol*, August 1925, Guadalajara.
'Las Pequeñas Grandes Obras de Tina Modotti' in *El Universal Ilustrado*, 4 November 1926.
Lazar, Jerry, 'The Unknown Weston' in *Los Angeles Times Magazine*, 23 November 1986.
Maddow, Ben, 'Venus Beheaded: Weston and his Women' in *New York*, 24 February 1975.
—'An Ironic Distance', typescript, 31 January 1987.
Modotti, Benvenuto, 'Como mori Tina Modotti' in *L'Unita del Popolo*, 13 November 1948, New York.
Modotti, Tina, 'On Photography' in *Mexican Folkways* 5:4, October–December 1929, Mexico City.
—'La Contrarrevolución Mexicana' in *Amauta* 29, February–March 1930, Lima.
—('Carmen Ruíz') 'En defensa de nuestros niños' in *Ayuda* 44, 13 March 1937, Madrid.
—('Carmen Ruíz') '12 de Febrero 1934: Aniversario del levantamiento obrero de Austria' in *Ayuda* 82, 3 February 1938, Madrid.
—'Meksikanskie Peoni,' pamphlet, International Red Aid Central Committee, Moscow, 1932; Spanish trans. by Martínez Verdugo, Armando, as 'Los peones mexicanos' in *Cemos: Memoria* 40, March 1992, Mexico City.
Mraz, John, 'Tina Modotti: En el camino hacia la realidad' in *La Jornada Semanal* 7, 30 July 1989.
Newman, Michael, 'The Ribbon around the Bomb' in *Art in America* 71:4, April 1983.
'Obras de Tina Modotti' in *Forma* 1:4, 1927, Mexico City.
'Organización y disciplina de lucha: reglamento interior de la local Comunista en la Ciudad de México' in *El Machete*, 25 September 1924, Mexico City.
Paz, Octavio, 'Frida y Tina: vidas no paralelas' in *Vuelta* 82, September 1983, Mexico City.
Rivera, Diego, 'Edward Weston and Tina Modotti' in *Mexican Folkways* 20:1, April–May 1926, Mexico City.

Rochfort, Desmond, 'Tina Modotti and Frida Kahlo at the Whitechapel Gallery' in *Creative Camera* 210, June 1982, London.

Siqueiros, David Alfaro, 'Una Trascendental Labor Fotográfica: la Exposición Weston–Modotti' in *El Informador*, 4 September 1925.

'Tina Modotti: La Magdalena Comunista' in *Hoy*, January 1942, Mexico City.

Toor, Frances, 'Exposición de Fotografías de Tina Modotti' in *Mexican Folkways* 4:5, October–December 1929, Mexico City.

Valle, Rafael Heliodoro, 'La Muerte de Roubaix de l'Abrie-Richey' in *El Universal Ilustrado*, 9 March 1922.

Vera de Córdova, Rafael, 'Las Fotografías como Verdadero Arte' in *El Universal Ilustrado*, 22 March 1922.

—'El Arte Moderno en México' in *El Universal Ilustrado*, 14 October 1926.

Vestal, David, 'Tina's Trajectory' in *Infinity* XV:2, 1966.

Vidali, Vittorio, 'Yo conocí a Matilde...', typescript, 1944.

Periodicals Consulted:

Arbeiter Illustrierte Zeitung (AIZ), Berlin, 1928–31
Ayuda, Madrid, 1935–9
Creative Art, London and New York, 1927–30
CROM, Mexico City, 1927–30
Excelsior, Mexico City, 1929–30, 1939–42
Forma, Mexico City, 1926–8
Gale's Magazine, Mexico City, 1918–20
Hoy, Mexico City, 1939–42
Labor Defender, New York, 1926–7, 1934–9
L'Italia, San Francisco, 1913–19
Los Angeles Examiner, 1919–23
The Los Angeles Times, 1919–23
El Machete, Mexico City, 1924–9
Mexican Life, Mexico City, 1925–31
Mexican Folkways, Mexico City, 1924–30
El Nacional, Mexico City, 1942
New Masses, New York, 1927–30
Novedades, Mexico City, 1940–2
El Popular, Mexico City, 1939–42
La Prensa, Mexico City, 1929–30, 1939–42
Revista de Revistas, Mexico City, 1939–42
San Francisco Chronicle, 1917–18
San Francisco Examiner, 1917–18
transition, Paris, 1929–30
El Universal, Mexico City, 1924, 1929–30
El Universal Gráfico, Mexico City, 1929–30
El Universal Ilustrado, Mexico City, 1922–32

Archives Consulted:

Alice Leone Moats Collection, Boston University.
American Film Institute Research Library, Los Angeles.

Archivo de la Palabra, Instituto de Investigaciones Dr José Ma. Luis Mora, Mexico City.
Archivo de la Palabra, Instituto Histórico, Dir. de Estudios Históricos, INAH, Mexico City.
Archivo General de la Nación, Mexico City.
Archivo Histórico de la SEP, Mexico City.
Ateneo Español de México, Mexico City.
Australian National Gallery Collection, Canberra.
Bancroft Library, University of California, Berkeley.
Bertram D. Wolfe Collection, Hoover Institution Archives, Stanford University.
Biblioteca Nacional, Mexico City.
British Film Institute, London.
Burnett Bolloten Collection, Hoover Institution Archives, Stanford University.
Carleton Beals Collection, Boston University.
Caroline Gordon Papers, Princeton University Libraries.
CENDIAP, Instituto Nacional de Bellas Artes, Mexico.
Centro de Estudios Filosóficos, Políticos y Sociales 'Vicente Lombardo Toledano', Mexico City.
Centro de Estudios del Movimiento Obrero y Socialista, Mexico City.
Charlot Collection, University of Hawaii at Manoa.
Comitato Tina Modotti, Udine.
Department of Special Collections, University of California, Los Angeles.
Dwight W. Morrow Papers, Amherst College Library, Amherst, Mass.
Edward Weston Archive, Center for Creative Photography, University of Arizona.
El Universal.
Ella Winter Papers, Columbia University, New York.
Ernest Gruening Papers, University of Alaska, Fairbanks.
Excelsior.
Family History Center, Church of Jesus Christ of the Latter Day Saints, Los Angeles.
Fototeca del I.N.A.H., Pachuca, Mexico.
Francisco Luna Collection.
Frank Tannenbaum Papers, Columbia University, New York.
Fredericka Martin Collection on the Spanish Civil War, Mexico City.
Galería de Arte Mexicano, Mexico City.
George Eastman House, Rochester, New York.
Hemeroteca Nacional, Madrid.
Hemeroteca Nacional, UNAM, Mexico City.
Italian-American Collection, San Francisco Archives, San Francisco Public Library.
Instituto de Investigaciones Estéticas, UNAM, Mexico City.

SELECT BIBLIOGRAPHY

Joaquín Maurín Collection, Hoover Institution Archives, Stanford University.
John Cowper Powys Papers, Colgate University.
Joseph Freeman Collection, Hoover Institution Archives, Stanford University.
The J. Paul Getty Museum, Malibu.
The Labadie Collection, University of Michigan.
La Prensa.
Margaret Herrick Library, Academy of Motion Picture Arts & Sciences, Beverly Hills.
Marx Memorial Library, London.
Sala de Arte Público Siqueiros, INBA, Mexico City.
Museo Diego Rivera, Mexico City.
National Archives, Washington, DC.
Papers of Katherine Anne Porter, University of Maryland at College Park.
Prometheus Research Library, New York.
The Sadakichi Hartmann Papers, University of California, Riverside.
San Francisco Performing Arts Library & Museum.

Secretaría de Relaciones Exteriores, Mexico City.
Social Sciences Research Library, Los Angeles.
Spanish Refugee and Relief Organizations Collection, Columbia University, New York.
Spanish Civil War Collections, Brandeis University, New York.
SUSI eV, Berlin.
The Tamiment Institute Library, New York University.
Trotsky Exile Papers, Harvard University.
Biblioteca, Universidad Autónoma de Puebla, Mexico.
US Department of State Records, Washington, DC.
Waldo Frank Papers, University of Pennsylvania.

Weston–Hagemeyer Correspondence, Edward Weston Archive, Center for Creative Photography, University of Arizona.

PERMISSIONS

The author and publisher gratefully acknowledge the following for permission to include material:

Extract from *The Cantos of Ezra Pound* Copyright © 1962 Ezra Pound, reprinted by permission of New Directions Publishing Corporation and Faber and Faber Ltd; extracts from *Half of Spain Died* by Herbert L Matthews, Copyright © 1973 Herbert L Matthews reprinted with the permission of Charles Scribner's Sons, an imprint of Macmillan Publishing Company; extracts from the *Edward Weston Omnibus* by Nathan Lyons and Janet Malcolm, Copyright © the authors, reprinted with the permission of Gibbs Smith Publisher, Peregrine Smith Books; extracts from *Retrato de Mujer* by Vittorio Vidali, Copyright © 1984 Universidad Autónoma de Puebla reprinted with permission of Benemérita Universidad Autónoma de Puebla; extracts from *Edward Weston: Seventy Photographs* reprinted with the permission of *Aperture*; extracts from the foreword by Jean Charlot in *The artist in New York: Letters to Jean Charlot and Unpublished Writings (1925–1929)* by Jose Clemente Orozco, translated by Ruth L Simms, Foreword and Notes by Jean Charlot, Copyright © 1974, reprinted by permission of the University of Texas Press; extract from *A Wall to Paint On* by Ione Robinson, published by EP Dutton, Copyright © 1946 Ione Robinson, extract from *The Story of the Panama-Pacific International Exposition* by Frank Morton Todd, Copyright © 1921 Frank Morton Todd, reprinted by permission of GP Putnam & Sons, New York, extract from *Glass Houses* by Carleton Beals, Copyright © 1938 Carleton Beals, reprinted by permission of JB Lippincot Co., extract from *The Great Circle* by Car-leton Beals, Copyright © 1940 Carleton Beals, reprinted by permission of JB Lippincot, extract from *Idols Behind Altars* by Anita Brenner, published by Biblo & Tannen, New York, Copyright © 1967 Anita Brenner, extract from *Confieso Que He Vivido* by Pablo Neruda, pulished by Planeta Mexicana, Mexico City, 1989, Copyright © Pablo Neruda, reprinted by permission of Carmen Barcells S.A., extract from *Commandante Carlos* by Vittorio Vidali, published by Ediciones de Cultura Popular, Mexico City, Copyright © 1986 Vittorio Vidali, translation Copyright © Cristina Campora, extract from *Retrato* in *Poesia y Prosa de Antonio Machado* published by Espase-Calpe S.A., Madrid, 1989, reprinted by permission of Jose Rollan Riesgo, extract from *Tina Modotti: fotografa e rivoluzionaria* by Maria Caronia and Vittorio Vidali, Copyright © 1979 Maria Caronia and Vittorio Vidali, reprinted by permission of Idea Editions, Milan, extracts from *All The Right Enemies: The Life and Murder of Carlo Tresca* by Dorothy Gallagher, Copyright ©1988 by Rutgers, The State University, reprinted by permission of Rutgers University Press; extract from *Fuego, Sombra, Silencio* by Pino Cacucci, Copyright © Pino Cacucci, extracts from unpublished manuscript Mercy in Madrid by Mary Bingham de Urquidi, published as *Misericordia en Madrid*, Mexico, B Costa–Amic Editor, Copyright © 1975 by the author, reproduced with the permission of Victor L Urquidi; extracts from *Verdad y Leyenda de Tina Modotti* by Christiane Barckhausen–Canale, Copyright © 1989 Ediciones Casa de las Américas, reprinted by permission of Casa de las Américas; extracts from the letters of Mercedes Modotti and Ernestine Evans to Carleton Beals reproduced

ACKNOWLEDGEMENTS

The research and writing of this book could never have been completed without the help and co-operation of many individuals, institutions and organizations. My deepest appreciation for their exceptional encouragement and contribution to Diana Anhalt, Beth Alvarez, A. W., Toby Ann Behrenberg, Elizabeth Cuellar, Renata von Hanffstengel, Carmen López and Ninfa Santos.

I would also like to extend special thanks for their help to the following individuals: María Asúnsolo, Bob D'Attilio, José Benítez, Bern Boyle, Arturo García Bustos, Luciana Cabarga, Christiane Barckhausen-Canale, Alejandro Gálvez Cancino, Andrew M. Canepa, Miguel Capistrán, Concha Caraballo, Bruno Cosolo, Rob Doll, Damian Dovarganes, Maravilla Dromundo de Padilla, David Drucker, Ian Dryden, Jean Duckles, Enzo, Helen Feinberg, Moe Fishman, Peter Gellert, Elena Vázquez Gómez, Daniela Spenser Grollova, Doris Heyden, Ginny Iliff, Walter Kiesling, Leni Kroul, Rina Lazo, Olinka Ledesma, Ben Maddow, Adriana Malvido, Adrián Mendieta, John Mraz, James Oles, Francesca Patai, José Puche Alvarez, Vicente Cuarián Ruidiaz, Jenny Rossiter, Antonio Saborit, Irme Schaber, Reinhardt Schultz, Eve Sodo, Antonio Teixidor, Riccardo Toffoletti, Marvel Toor, Victor L. Urquidi, James Vallender, David Vestal, Vlady, María Walsh, Beth Gates Warren, Gabriela Yanes and Eleazar Zamora.

In particular, I would like to thank Carlos Vidali for permission to view and make copies from his collection of photographs; Susannah Glusker Brenner for allowing me to consult and providing me with notes from the Anita Brenner diaries; Ceri Higgins and Elena Poniatowska for access to their interview material and Philippa Brewster for her encouragement and support in the early stages of this project.

In thanking those who were so generous with their time in granting extensive interviews, I must acknowledge the invaluable contributions of Germán List Arzubide, Manuel Alvarez Bravo, Rafael Carrillo, Yolanda Modotti Magrini, Francisco Peñafiel, Miguel Angel Velasco, Chandler Weston and Ella Wolfe.

My gratitude for also having shared their knowledge and memories

ACKNOWLEDGEMENTS

of Tina Modotti and her contemporaries to Ignacio 'Nacho' Aguirre, Bill Alexander, Jorge Fernández, Anaya, Aurora Andrés, Aurora Arnaís, Alberto Beltrán, Gilberto Bosques, Argentina Brunetti, Valentín Campa, Concha Caraballo, Isabel Carbajal, Luis Cardoza y Aragón, María Luisa Tejeda Chardi, Zohmah Charlot, John Condax, Laura Condax, José Muñoz Cota, Charles Curtis, Rebecca Drucker, Gabriel Figueroa, Fay Fuquay, Benita Galeana, Fernando Gamboa, Eli de Gortari, Andrés Henestrosa, Felix Ibarra, Eileen Dwyer Jackson, Everett Gee Jackson, Leni Kroul, Constance Kyle Lamb, Rosa Elena Luján de Traven, Francisco Luna, Ernesto Madero, Concha Mantecón, Matilde Mantecón, Carmen Marín de Barreda, Guadalupe Rivera Marín, Fredericka Martin, Concha Michel, 'Mura' Agueda Serna Morales, Francisca Moreno, Conlon Nancarrow, Nefero, María Jesús de la Fuente O'Higgins, Gabriela Orozco, Yuri Paperov, Dolores Pomar, Fausto Pomar, Caridad Proenza, Eladia de los Ríos, Carmen Donosório Roces, Rosa Rodríguez, Carmen Tagüeña, Alfonso Taracena, Raquel Tibol, August Troiani, Adolfo Sánchez Vásquez, Carlos Zapata Vela, Octavio Fernández Vilchis, Thomas F. Walsh, Milton Wolff, Enrique Arriola Woog, Adelina Zendejas and Tomás Zurián.

For their kind co-operation and the privilege of consulting and reproducing archival material, I am deeply indebted to Terence Pitts and Amy Rule at the University of Arizona's Edward Weston Archive and Center for Creative Photography; Margaret Goostray, Carleton Beals Collection, Special Collections, Boston University; Arnoldo Martínez Verdugo, Centro de Estudios del Movimiento Obrero y Socialista, Mexico City; and Riccardo Toffoletti, Comitato Tina Modotti, Udine.

At Pandora, for their encouragement, enthusiasm and effort my appreciation and thanks to Eileen Campbell, Karen Holden, Georgia Hughes, Rosamund Saunders and Caroline Hotblack.

Finally, I am most grateful to my husband, Michael Tangeman, without whose invaluable assistance and constant support this book could not have come into being.

INDEX